Journey of the Three Jewels

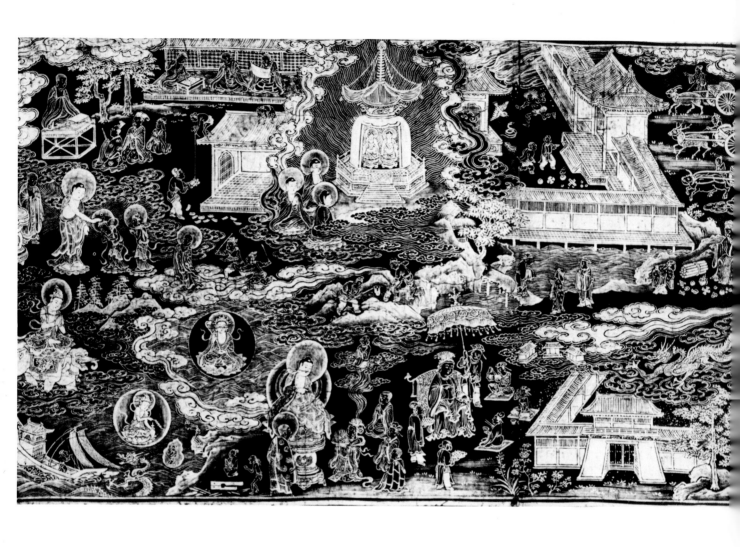

13. Illustrated Frontispiece to the Lotus Sutra

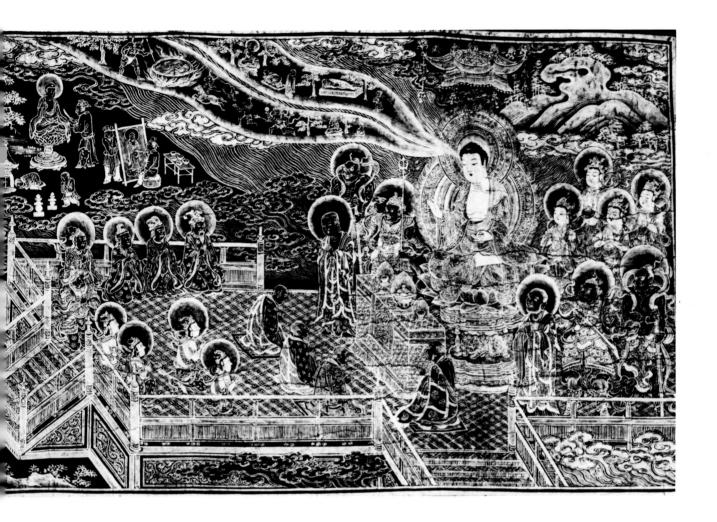

JOURNEY
OF THE
THREE
JEWELS

Japanese Buddhist Paintings from Western Collections

by John M. Rosenfield
and Elizabeth ten Grotenhuis

THE ASIA SOCIETY
In association with John Weatherhill, Inc.

JOURNEY OF THE THREE JEWELS is the catalogue
of an exhibition shown in Asia House Gallery in the
fall of 1979 as an activity of The Asia Society to further
understanding between the peoples of the United
States and Asia.

This project is supported by grants from the National
Endowment for the Arts, Washington, D. C., a Federal
agency, the Mary Livingston Griggs and Mary Griggs
Burke Foundation, and the Andrew W. Mellon
Foundation.

Library of Congress Cataloguing in Publication Data:

Rosenfield, John M.
 Journey of the three jewels.
 Catalogue of an exhibition held at Asia House Gallery,
New York, in the fall of 1979.
 Bibliography: p. 201
 Includes index.
 1. Painting, Buddhist — Japan — Exhibitions.
2. Painting, Japanese — Exhibitions. I. ten Grotenhuis,
Elizabeth, joint author. II. Asia House Gallery,
New York. III. Title.
ND1050.R67 755'.9'43 79-15072
ISBN 0-87848-054-4

CONTENTS

EDITORIAL NOTE

Buddhist terminology appears here in transliterations from Sanskrit, Chinese, and Japanese sources indicated by the abbreviations S, C, and J, respectively. Because of the international character of the faith and the shifting frames of reference, no attempt has been made to put the terms into a single usage. A glossary at the end defines and explains the major terms.

With the exception of authors who publish in English, all Japanese and Chinese personal names are given in the traditional East Asian manner, with the family name first.

The abbreviation T before a number in reference to Buddhist texts refers to the number in the Taishō Shinshū Daizō-kyō.

All translations not specifically identified are those of the authors.

FOREWORD

When Buddhism came to Japan from China and Korea in the sixth century A.D., it was accepted with remarkable rapidity. In less than one hundred years it was firmly established as the religion of Japan, and to this day, Buddhist philosophy continues to be an important element in the beliefs and aesthethics of the country.

Some of the factors that brought about the successful transplantation of Buddhism to Japan had little to do with the religion itself. The Japanese were interested in new ideas and looked to China as the most highly developed culture of the time. Buddhism was recognized as a unifying force which could help to achieve certain political ends, and during the regency of Prince Shōtoku (574–622) Buddhism was officially endorsed by the state itself.

When art is created for religious purposes, it has always played an important role in the spread and maintenance of the faith it serves, and this was especially true in the case of the Buddhist arts of Japan. Of all the arts, painting was a particularly effective vehicle for this purpose. In the beginning, because the Chinese Buddhist writings could be read by only a few scholars, it was necessary to accompany them with easily understood pictorial representations. The paintings could be readily transported, shown, and stored. In addition, as the Japanese pursued increasingly complex strands of Buddhist philosophy, much of the imagery could only be properly represented in paintings. Inspired by profound belief, the Buddhist painters of Japan created an art of tremendous visual interest. In terms of subject matter alone these paintings are wonderfully rich. Of central importance are the Buddhas, among them the historical Buddha, Śākyamuni; Yakushi, the Buddha of healing; Amida, the Buddha of the Western Paradise; and Maitreya, the Buddha of the future. They are accompanied by bodhisattvas, disciples, the Four Heavenly Kings, and numerous lesser guardian deities, and important sages and monks. There are sumptuous views of paradise, vivid depictions of hell, and lively narrative scrolls that illustrate various important Buddhist texts. On another level, it is interesting to note the way in which the content of these paintings has been governed by the various Buddhist philosophies as they developed in Japan. Each can, therefore, also be looked upon as a document which records a specific Japanese interpretation of Buddhist doctrine whether it be Zen, Pure Land, mainstream Mahayana, or Esoteric in inspiration.

Because there is a seemingly endless variety in these works, "Journey of the Three Jewels" could not begin to survey the entire field of Japanese Buddhist painting. As our guest curators point out, the exhibition was chosen to show the great quality of examples that exist in collections in the United States and Europe, and to bring new information about these paintings to light.

The idea for such an exhibition was suggested by former associate director of the Gallery, Virginia Field. She felt that it would be a beautiful and scholarly offering provided we could name the right guest curator. We were immensely pleased when John Rosenfield, Abby Aldrich Rockefeller Professor of Fine Arts at Harvard University and a member of the Gallery's Advisory Committee, agreed to undertake the project, in collaboration with Elizabeth ten Grotenhuis, one of his very able and talented students.

From several standpoints, "Journey of the Three Jewels" was also the journey of these two scholars. In the first place, they did travel, thanks to a generous planning grant received from the Burke Foundation which enabled them to visit all of the collections represented here and a number of others as well. Secondly, as they became more and more intimately involved with the subject of the exhibition, new discoveries were made, dates were adjusted, long accepted attributions were discarded, and hitherto unknown or unrecognized works were brought into new prominence. What they present here is a fresh approach to a fascinating subject.

The undertaking is the result of a combination of generous support, the efforts and knowledge of members of the museum community, and the work of a dedicated staff. We thank the scholars who assisted in the research for the catalogue and the many lenders who so willingly shared these fine paintings with us. We are also grateful to Thomas Maytham, Director, and Ronald Otsuka, Curator of Oriental Art, The Denver Art Museum, whose efforts have made it possible to send the exhibition to Denver. As always, my staff has followed through on all of the complex details that such an international effort requires, and I thank Sarah Bradley, Terry Tegarden, Kay Bergl, and Carol Lew Wang for their efficiency and hard work. The importance of the exhibition will be additionally enhanced by the information programs to be prepared by Mahrukh Tarapor, and installation designer Cleo Nichols and his crew continue to distinguish themselves as artists and craftsmen of great talent. I am also grateful to Otto Nelson for his willingness to supply his fine photographs to us on short notice.

Lastly, we gratefully acknowledge the essential financial support we have received from the following sources: the Mary Livingston Griggs and Mary Griggs Burke Foundation for a planning grant and a general support grant, the Andrew W. Mellon Foundation for a grant to cover part of the costs of publishing this catalogue, The Starr Foundation for a grant to pay for the installation design and construction, the National Endowment for the Arts for an aid to special exhibitions grant, the National Endowment for the Humanities for a grant to cover the costs of the information program, and John W. Gruber for a generous gift toward catalogue publication costs. This assistance has made possible a thoughtful and illuminating study of one of the most compelling forms of Asia's traditional arts.

Allen Wardwell
Director
Asia House Gallery

PREFACE

When Japan was opened to the outside world in the last half of the nineteenth century, Westerners soon recognized that Buddhist arts were among its greatest cultural achievements. The American scholar and collector Ernest Fenollosa wrote in his notebook on August 4, 1885, while standing before a painting of Amida and two bodhisattvas in the Chion-in in Kyoto, that it is ". . . beautiful in color. One of the finest Buddhist paintings . . . very pure, elevated, noble, and devoted; the work of an inspired priestly soul, the Angelico of Japan. Must have a copy." (Unpublished manuscript, Houghton Library, Harvard University).

Fenollosa intended to order a hand-painted copy in a government-sponsored project to record Japan's heritage of fine old paintings, but he, like other Western and Japanese collectors, also sought to buy devotional pictures, especially hanging scrolls. Buddhist temples, impoverished in the social and economic turmoil of the 1870s and 1880s, desperately needed money and gave up works of art to clandestine agents. In this way, hundreds of fine Buddhist pictures were taken from their original contexts and converted into commodities in the art trade. Eventually, many found their way to the West.

One of our purposes in this exhibition is to restore some of the paintings in Western collections to a more suitable, if temporary, context. To be sure, the setting will not be that of a darkened Buddhist votive hall, where a picture might be hung for a solemn ritual in an atmosphere pervaded by the musty aroma of incense and flickering candles, the sonorous monotone of the chanting priest, and the muted ringing of the altar bells. In an American gallery, we can provide at best only the proper level of subdued lighting and a minimum of visual distraction, but the paintings themselves create their own religious milieu, projecting an authentic impression of their original aesthetic and spiritual intention.

The study and exhibition of the arts of the ancient East may appear at times to be an exercise in sentimental antiquarianism intended to convert the exotic, fossilized products of an older culture into expensive collectors' items. Nothing could be further from our intention. We have sought to explore, rather, the conditions of the interplay between artistic creativity and a science of the human spirit within a social setting in which spiritual values had great importance.

The title of our exhibition, Journey of the Three Jewels, expresses the international character and extraordinary mobility of the objects and ideas with which we are dealing. The term Three Jewels (tri-ratna in Sanskrit, sambō in Japanese) is an ancient designation of the original components of the Buddhist community in India: the Buddha, the Enlightened One who was the historic founder of the faith; the Law, the body of his teaching referred to as the Dharma; and the Community, or Saṃgha, the organization of monks and their lay supporters. As the religion spread, people of all Asian nations would refer to this triad as the Three Jewels. As the established religion of Japan, Buddhism inspired the fine paintings in our exhibition, paintings that bear many traces of the journey of the Three Jewels from the Indian homeland through Central Asia, China, and Korea. The basic leitmotif of our exhibition is the manner by which Japan, drawing from the international idioms of Buddhist imagery, created a national tradition of religious painting that is one of the most eloquent and subtle in the world.

In this exhibition and catalogue, we make no attempt to give a complete and systematic survey of Japanese Buddhist painting. The subject is enormous, as vast and complex as would be a review of Italian Christian painting from the catacombs of Rome to the churches of the Counter-Reformation. Moreover, large categories of material are not available in Western collections, where the great majority of paintings date from the Kamakura period and later. Even among these, a number of important works, especially in the sphere of Buddhist portraiture, were too fragile to be packed and shipped.

What we are presenting is an introduction to the subject based on works of the highest artistic quality and state of preservation available to us. Thus, if an important subject matter type could not be represented here by a work of high quality, we felt obliged to leave that theme out of the exhibition. Enough paintings were available to us, however, so that we could organize them according to major divisions in Japanese Buddhist ideology: the mainstream of Mahayanism, the Esoteric sects, medieval Pure Land and popular Buddhist creeds, and finally the Zen sect. We also make no attempt to write a summary history of Japanese Buddhism here. The reader will find excellent ones by Masaharu Anesaki, Byron Earhart, Charles Eliot, and Joseph Kitagawa listed in our bibliography. Instead, we offer a series of short essays related to both the pictures at hand and the major issues in the study of Japanese Buddhist painting at large: the evolution of style and artistic technique, the varieties of spiritual content. We are especially pleased that a large number of paintings are being shown to the general public for the first time, and that we are bringing to the fore other important works that have not received the attention that, in our view, they deserve.

In the preparation of this exhibition and catalogue, we have been assisted by many generous colleagues. Our greatest debt, however, is surely owed to Miss Yanagisawa Taka of the Tokyo National Art Research Institute, leading authority on Japanese Buddhist painting, who consulted with us in the selection and explanation of the materials shown and wrote the analysis of the Aizen mandala in the Burke collection (no. 19). Her gentle understanding of the problems of an exhibition of this kind, coupled with her profound knowledge of the material, were of utmost importance to us. We must also acknowledge the generous assistance of Professor Donald Shively and the Japan Institute, Harvard University, in enabling Miss Yanagisawa to come to this country for the study of Japanese Buddhist paintings. We wish to thank Masatoshi Nagatomi, Professor of Buddhist Studies at

Harvard, for his assistance with doctrinal issues, and Fumiko E. Cranston, Research Assistant in the Fogg Art Museum, for entry no. 48 and countless other contributions.

Harvard graduate students in East Asian arts rendered important assistance in research and interpretation of individual entries: Laurel Brook (no. 16), William Klingelhofer (no. 15), Samuel Morse (nos. 1, 3, 13), Anne Nishimura Morse (no. 52), and Cynthia Packert (no. 2). We wish to thank Marie Carden for her care in the preparation of the manuscript and Julia White of the Rubel Asiatic Research Collections for help in assembling research materials. Katharine O. Parker contributed greatly with her patient skills as editor. Our friends Sylvan Barnet and William Burto gave us much helpful criticism with the manuscript.

Our colleagues in the Museum of Fine Arts, Boston, have been unstinting in their help: Jan Fontein, Director and Curator of Asiatic Art; Togano-o Shōzui, Fellow for Research in Japanese Buddhist Painting; Money Hickman, Fellow for Research in Japanese Art; Yasuhiro Iguchi; and W. J. R. Dreesmann for his assistance with entries 4, 53, and 55–58. At The Art Institute of Chicago, Jack Sewell, Curator of Oriental Art, and his staff were most cordial and cooperative; at The Cleveland Museum of Art, we were given every assistance by Dr. Sherman Lee, Wai-kam Ho, Michael Cunningham, Henry Kleinhenz, and Mrs. Jean Cassill; we are particularly grateful for the opportunity to use the museum's copy of an unpublished translation of the Japanese text of the *Yūzū Nembutsu Engi*. At the Nelson Gallery in Kansas City, Laurence Sickman and Marc Wilson were extremely cooperative and helpful.

At Princeton University, our close friend and colleague Christine Guth Kanda, Assistant Professor of Japanese Art, generously contributed to the writing of entries 5, 6 and 24, and wrote entries 34 and 35. In New Orleans, Kurt and Millie Gitter were extremely helpful to us. In New York, we were greatly assisted at The Metropolitan Museum of Art by Julia Meech-Pekarik and by Raoul Birnbaum, who wrote entries 27, 28 and 29. Professor Miyeko Murase of Columbia University contributed in many ways, especially in the preparation of entry no. 19. Kimiko and John Powers were, as always, understanding and helpful. We are deeply indebted to Mrs. Mary Burke for her generous sympathy, and to Andrew Pekarik as well; Joseph Rankin of the Spencer Collection, The New York Public Library, was unfailingly courteous and cooperative. In San Francisco, the staff of the Asian Art Museum, Yoshiko Kakudo in particular, were cordial and helpful; at the Seattle Art Museum we are much indebted to Henry Trubner and William Rathbun. In Washington, Dr. Thomas Lawton, Director, and Ann Yonemura of the Freer Gallery gave generously of their time, as did John Gruber. Abroad, Beatrix von Ragué and Roger Goepper, Museum für Ostasiatische Kunst in West Berlin and in Köln, respectively, were exceptionally cooperative and helpful to us.

We are profoundly grateful to The Asia Society for the opportunity to present our vision of Japanese Buddhist painting in the West. To Allen Wardwell, Director, and Sarah Bradley, Assistant Director of Asia House Gallery, we must express our most cordial thanks for their encouragement and their skill and patience in organizing the exhibition and catalogue.

John M. Rosenfield

Elizabeth ten Grotenhuis

LENDERS TO THE EXHIBITION

The Art Institute of Chicago
The Art Museum, Princeton University, Princeton, New Jersey
Asian Art Museum of San Francisco; The Avery Brundage Collection
The Brooklyn Museum
Mary and Jackson Burke Collection
Mary and Jackson Burke Foundation
The Cleveland Museum of Art
Fogg Art Museum, Harvard University, Cambridge, Massachusetts
Kurt and Millie Gitter
John W. Gruber
Houghton Library, Harvard University, Cambridge, Massachusetts
The Metropolitan Museum of Art, New York
Museum für Ostasiatische Kunst, Köln
Museum für Ostasiatische Kunst, Staatliche Museen Preussischer Kulturbesitz, Berlin (West)
Museum of Fine Arts, Boston
Nelson Gallery–Atkins Museum, Kansas City, Missouri
The New York Public Library
Robert J. Poor
Kimiko and John Powers
Seattle Art Museum
The University of Michigan Museum of Art, Ann Arbor, Michigan

INTRODUCTION
Image, Style, and Doctrine

D espite their aspirations, no Japanese Buddhist monks or laymen of premodern times are known to have visited India. Unlike their Chinese counterparts, such as the famous pilgrim Hsüan-tsang (ca. A.D. 596 – 664) or the seventh-century ambassador Wang Hsüan-t'se, no Japanese prayed at Bodhgayā before the tree of Śākyamuni's enlightenment, or mourned the Buddha's death at the shrine at Kuśinagara. No Japanese religious leader saw with his own eyes the Ganges River or the Himalayas, both of which figure so prominently in Buddhist legend and cosmology. Very few Indian missionaries and no major works of Indian religious art reached Japan.[1]

Although it was remote, psychologically as well as physically, from the origins of the Buddhist creed, Japan became, and has remained, one of the chief bastions of the faith. It has preserved the atmosphere and ethos of the faith's historic past perhaps better than any other Buddhist nation accessible to outsiders. Unlike China, where foreign invasions and internal disorders have taken a tragic toll of religious monuments, Japan has preserved intact many of its historic monasteries and their contents. Among them—the buildings and gardens and statues, paintings, ritual implements, ceremonial robes, and banners — are expressions of Buddhist ideals that attain the highest levels of artistic subtlety and originality.

These remarkable achievements, however, are largely a thing of the past. Contemporary Japan no longer possesses the climate of belief that sustained traditional Buddhist arts in past centuries. Together with the industrialized nations of the West with which it is now closely linked, Japan has wholeheartedly endorsed science and technology, and has entered into a nonreligious phase of its culture. This does not mean, however, that Buddhism has been swept into total oblivion. The Buddhist faith continues to play a number of significant roles in modern Japan. It continues to provide settings for most of the major rites of human passage, especially those of death and the funeral. Even though some of the more ancient sanctuaries have been converted largely into tourist attractions, many great temples still flourish and attract throngs of pious devotees. Buddhist practices and ideals have survived, perhaps subconsciously, in the "new religion" movements that, seeking to address the

realities of the new age, have grown out of the Japanese need for group identity. Buddhist imagery pervades the modern Japanese novel; the practice of pilgrimage to Buddhist holy sites has been revived.

The Japanese are aware that the pulse of twentieth-century life differs from that of their classical past as much as the Rome of today differs from that of Raphael, or that of Augustus Caesar. From Japan as well as from the West, the industrial age has extracted a terrible payment for its deliveries of great wealth, of power, of physical comfort, and of rapid communications. The price has been the despoiling of the Japanese landscape in the search for raw materials and building sites, the breakdown of personal relationships into economic ones, the creation of colossal and congested cities, the commercialization and mechanization of almost all facets of life. The Japanese are increasingly alarmed at the cost, and are responding vigorously with a national consciousness long molded by Buddhist ideals and values. The Buddhist faith in Japan is being transformed by this latest of the challenges it has faced in its long journey, but only time will tell what the changes will be.

In the meanwhile, the remains of the Buddhist civilization of Japan have been surprisingly well preserved, with many works of sculpture and painting in their original contexts. They can still be related to the precise rituals that they were made to serve. Through the study of patronage, it is possible to understand the social forces that sustained generations of temple builders, sculptors, and painters. Through stylistic analysis of the surviving works, it is possible to see how, generation by generation, Japanese artists gained the experience by which they created a brilliant national tradition of Buddhist painting.

The Style of Classical Buddhist Painting

The basis of the international style of East Asian arts was formed in China in the closing decades of the sixth century A.D., as the long period of political division and conflict within that country came to an end. Stylistic elements from India had merged with native Chinese forms to produce a unified aesthetic system that, with the rise of the powerful and expansive T'ang dynasty from 618, was adopted by Korea and Japan as well as by the Buddhist kingdoms of Central Asia.

Buddhist paintings of the late sixth and seventh centuries are rare, save for the wall paintings of Tun-huang and compositions engraved in stone for temple buildings in Ch'ang-an. The oldest surviving Japanese paintings in this mature style are the murals of the Kondō at Hōryū-ji, dated approximately to the 680s and 690s. More precisely, they survived until 1949, when they were almost entirely destroyed by fire; fortunately, however, good photographs had been taken. From these various works, the basic character and intention of Buddhist devotional painting in the classic T'ang style can be defined.

In the classic style the Buddhist painter sought to imbue his images with the effects of sublime and opulent splendor, of richness beyond measure, of exaltation and jubilation, but also of serenity. This aesthetic quality was connoted by the Sanskrit words alamkāra or vyūha (the Japanese sōgon, literally adornment and majestic manifestation), which suggested that ornament and artistic beauty were the outward manifestations of the inner truths of the faith.[2] This attitude, expressed in all of the early Mahayana texts, is especially evident in the Lotus Sutra, foremost in popularity among the scriptures of Northern

Buddhism. The twenty-fourth chapter, to cite but one example, introduces a certain bodhisattva named Gadgadasvara (Fine or Wonderful Sound). When he appears, he is accompanied by the sounds of divine music and a rain of precious jewels; he is described as having eyes like the broad, great petals of the green lotus. The combined beauty of a hundred thousand myriads of moons will not exceed the beauty of his face; his body is the color of pure gold, his majesty imposing and glorious.

To bring the art of painting into harmony with such visionary conceptions, East Asian painters employed a system of idealization of the human form, based on harmonic, mathematical proportions, that had been perfected in India in the Gupta period (A.D. 320–600) and adapted to Chinese painting techniques. The deities were shown as youthful and svelte, even to the point of weightlessness, their faces given introspective, compassionate expressions, their features shown without traces of mortality, age, egoism, or other human imperfections (no. 8). To suggest their suprahuman character within the framework of the human form, the painters used, for example, the perfect oval of an egg as the model for the shape of the head, the sinuous countercurve of a bow for the line of the eyebrows, and the geometric harmony of the lines of a conch shell as a model for the folds of the neck. The lines used to define parts of the body were mathematical and without variation in width, quite unlike the calligraphic, idiosyncratic brush lines in Chinese secular painting. The technical term for this style, taken from Chinese painting texts, was "iron wire line" (J tessen).

Spatially, most devotional paintings were placed in a timeless setting suggesting a paradise or a place far removed from the realm of everyday experience. Linear and atmospheric perspective were used sparingly, the compositions usually given no more illusionistic depth or recession than was necessary to enclose the deity and attendants in a convincing envelope of space.

Despite the fact that the Buddhas themselves were shown in monastic robes, the imagery as a whole was suffused with suggestions of luxury and grace. Attendant figures were heavily bejewelled, their scarves and drapery flowing in the rhythmic patterns of effortless motion and ease. Buddhist painters used intense and opulent pigments, prepared from local materials or imported from other parts of Asia.[3] Deep ultramarine blue (gunjō in Japanese) was made of powdered lapis lazuli, or azurite, that was mined chiefly in Iran and Afghanistan; blue was also made from the vegetal indigo dye (ai). Yellows were made of natural earth pigments (ōdo, yellow ochre), and from the transparent gamboge, a gum resin produced in Southeast Asia, or from the intensely yellow arsenic trisulphide, or orpiment (sekiō). Greens (rokushō) were made of malachite, the natural carbonate of copper; intense orange red (shu) from cinnabar, the ore from which mercury is refined; crimson red (entan) from lead oxide; and red brown (bengara) from iron oxide. White came from fine white clay, from powdered sea shells (gofun), or from lead oxide (enpaku); and black from traditional sources such as carbonized bone or wood.

Gold and silver were ground into powder, mixed with glue, and painted directly on the paintings, but gilding also appeared in a far more elaborate technique known as kirikane, or cut gold leaf.[4] The technique, seen in T'ang period painting from Tun-huang and on Japanese sculpture of the eighth century, did not come into prominence in Japan until the

end of the tenth century, when it became an extremely important decorative element in Buddhist painting. It was also uncommonly difficult. Exceedingly thin sheets of gold leaf, sometimes strengthened by an underlayer of silver leaf, were cut into intricate patterns — concentric lozenges, interlocking swastikas, lotus vine motifs — and then pressed onto a silk surface with a burnisher. The skills of kirikane application evolved in time; by the thirteenth century, kirikane designs covered the entire robes of full standing figures; some paintings have as many as twenty different designs in cut gold leaf.

There is little concrete historical information about the organization and operation of Buddhist painting workshops, but it is possible to make some inferences on the basis of Japanese works of the late twelfth and thirteenth centuries. Surviving are a large number of drawings which served as models or instructions to the workshop, which were made by distinguished monks who specialized in iconographic and artistic matters (no. 30). The drawings give all basic symbolic details and stipulate the colors to be employed. In the case of paintings on silk, the drawings were copied onto the cloth in thin ink and then, often working from the back (urazaishiki) as well as from the front of the silk, the painters began to add opaque whites or yellows to areas of the body and garments. Most of the pigment would then be applied to the front of the silk, to background areas, to cover the figures, and as detailing. Soon after the beginning of the process, the silk would be mounted on a paper backing, which would itself begin to receive pigments in the interstices of the rather open weave of the fabric.[5] It is quite possible that, in the larger ateliers, more than one craftsman worked on a picture and that the senior and most skilled master executed the most important sections, especially the form-defining outlines and the last details of faces and hands.

Although sumptuous and visionary effects predominated in the classic T'ang style and its offshoots, a considerable degree of pictorial realism was also employed to depict figures of lesser sanctity, such as guardians, disciples of the Buddha, and distinguished monks (no. 3). This manifested itself in the scowling faces of the guardians, with their knotted brows and open mouths and muscular bodies; and the Buddha's disciples were given highly individualized portrait-like features. Realism had appeared in Indian Buddhist sculpture, especially in the Gandhāra style centered in northwest India and Afghanistan; but the even stronger native Chinese predilection for naturalism, found in non-Buddhist art forms such as tomb figurines, came into use in the subordinate figures. The discrepancy between idealism in the more sacred deities and realism in subordinate ones was nonetheless artistically held in balance. It was not out of keeping with one of the basic principles of Mahayana thought of the day, that of nonduality: to treat one thing as exclusively holy and another as profane would be an error, for Ultimate Reality transcends holiness and profaneness and all other such dualities.

Buddhist Narrative Painting

Realism of another kind appears in narrative imagery, a separate branch of painting given prominent use in Buddhist communities. A clear distinction should be made between devotional pictures (J sonzō) and those that illustrate a story (monogatari-e). The former are normally highly idealized images of deities intended for use in ritual. As a rule, the

compositions are frontal, symmetrical, and timeless in setting—the foci of deep concentration as they serve as the objects of ritual and prayer. The latter illustrate events of historical or legendary importance to the faith, and appear most commonly as long, horizontal handscrolls (emakimono); they also are found in mural paintings and in hanging scrolls.

Throughout the Buddhist world, religious narrative painting has always tended to be closely linked with secular arts. In India, the best example of this is found in the fifth- or sixth-century wall paintings at Ajantā, where master painters from one or more royal courts were employed to illustrate Buddhist legends.[6] Although these artists were trained in the canons of proportion and style of devotional imagery, they imbued their compositions with the strong flavor of court life and especially of the Indian theater, rendering in detail the palace pavilions and gateways, the fancy woven textiles and jewelry of women, and the dramatic postures and exaggerated facial expressions of participants in the legends.

The distinction between devotional and narrative painting appears even more clearly in China in the eighth-century wall paintings of the Thousand-Buddha Caves at Tun-huang.[7] Devotional pictures of the great deities were executed in the classic, hieratic manner, whereas a more realistic style derived from Chinese court painting was used for narrative scenes: the biography of Śākyamuni, the travels of Hsüan-tsang, or episodes of the twenty-eight chapters of the Lotus Sutra. There, the human figures were made small in scale and in a wide variety of natural postures; landscape elements were painted with strong modeling in light and dark, and with pronounced recession into depth.

In Japan, although devotional paintings were usually made by monks or professional artists who specialized in that idiom, Buddhist narrative paintings were often done by court artists. Tokiwa no Mitsunaga, for example, was an archetypal Japanese aristocrat-painter who was active in the 1170s as superintendent of the imperial painting atelier and who was granted the high court rank of the junior fourth grade. Even though surviving works from his hand are difficult to certify today, he must have painted in the manner of the famous *Bandainagon* scrolls; the same style is found in Buddhist narrative scrolls such as those of the *Hungry Ghosts*, the *Legends of Mount Shigi*, and the *Legends of the Kokawa-dera*.[8]

Because Buddhist narrative painting in Japan was so closely linked with the arts of the court and ruling classes and was so strongly realistic in tenor, a number of scholars feel that it should not be considered as Buddhist art. This view is needlessly restrictive. Narrative painting demonstrates how deeply the faith penetrated into the fabric of Japanese culture, and how Buddhist values were communicated to a broad public.

Buddhist Doctrines

Buddhism, like Christianity, has undergone a long and complex evolution, and has been divided into many ideological and local units. Its most fundamental division, akin to that between Roman Catholic and Protestant Christianity in Europe, lies between its Northern and Southern traditions. The former, found today in Tibet, China, Korea, and Japan, is a loose grouping of texts, ritual practices, and beliefs that calls itself Mahayana, literally the Large or Great Vehicle, to indicate that it offers the possibility of salvation to large numbers

of people. It is also called the New Wisdom School to distinguish it from the more puritanical and monastic Southern Buddhist tradition, represented today by the Way of the Elders (Theravada), to which it gave the derogatory appellation of Hinayana (Lesser Vehicle). Southern Buddhism was also practiced in north and east Asia, in China, Japan, and Korea, but it did not flourish there, surviving instead in South and Southeast Asia as the dominant form of the faith in Sri Lanka, Burma, and Thailand.

The differences between the two Vehicles are many, and have often been explored by students of Buddhism.[9] Of primary significance, for example, is the Theravada view that the best path to enlightenment lies in becoming a monk or nun. Mahayana, on the other hand, maintains that an ordinary layman can reach enlightenment through the assistance of the great pantheon of compassionate deities. Theravada maintains that the everyday world as experienced by our senses is illusory and impure, and the art forms of this branch of Buddhism have thus tended to be more strongly idealistic in character. Mahayana asserts that sense experience is linked with ultimate religious values, and thus Mahayana arts historically have become increasingly empirical or naturalistic. Theravada believes in the eternal continuity of the Dharma and, therefore, that prior to Gautama Śākyamuni, founder of the faith, there had been other Buddhas who lived and preached among men and that there will be another Buddha in the future; but it insists that only one Buddha can exist at any one moment. Mahayana, on the other hand, believes in the permanent presence of the Dharma in all spheres of existence, and asserts that there have been countless Buddhas and other deities in existence at all times in order to assist men and women in their search for salvation. For this reason the art forms of Mahayana Buddhism depict a far richer pantheon than do those of Southeast Asia.

Historically, these points of doctrinal dispute are important. They condition the climate of belief and religious expression. However, as the faith spread across Asia to different peoples and social strata, such ideological differences were reinforced by ethnic factors. Today, the Buddhist communities of Sri Lanka, Tibet, and Japan, for example, present striking differences in their languages, modes of worship, architecture, and art. Even within Japan itself there are major subdivisions of the faith such as Zen, the Nichiren movement, or the Pure Land sects. Nevertheless, Buddhists everywhere in the world maintain certain basic assumptions and values that preserve the identity of the creed.

Buddhism may be seen as a compendium of knowledge and practices intended to lead men and women to the highest goal of the faith, the attainment of enlightenment (S sambodhi, J satori). Thereupon, they enter into nirvana, the psychospiritual state of utmost tranquility, even-mindedness, and harmony. When enlightened, the person has become a Buddha, liberated at last from suffering and the cycle of rebirth.

All Buddhists accept the notion that the doctrine was taught by a certain ancient Indian prince who may have lived between 565 and 486 B.C. — the dates are not precisely fixed. Called Gautama Siddhārtha, sage of the Śākya clan (Śākyamuni), he renounced his official duties and even his family in order to search for the solution to a great puzzle or problem he discovered when he was young. According to his legendary biography, he had been raised in the utmost luxury, suited to his station as crown prince, but when he encountered persons engaged in harsh labor, or those who were ill and aged, or dead, he began to speculate on

the inexplicable nature of human life—its impermanence, pain, and insubstantiality. After years of searching for an explanation, he discovered the Four Noble Truths that are the heart of his teaching: that all existence involves sorrow and suffering, that the source of suffering is craving and desire, that to eliminate suffering one must eliminate craving, and that the cessation of desire comes through the eight-fold path of correct behavior. Upon realizing these truths, he obtained supreme enlightenment; but rather than retreating from the affairs of man, he was moved by compassion to preach his doctrine and to assemble a community of followers.

Gautama's legendary life and virtues form the basic paradigm for the Buddhist ideal of human behavior: his compassion, his wisdom, his renouncing worldly wealth and status in order to seek the truth, his self-discipline and meditations. This is true even though Mahayana thinkers came to see Gautama less as a mortal and more as a deity or even as only one of many divine manifestations of the transcendent principles of the creed.

Also of fundamental importance among the basic Buddhist doctrines are saṃsāra (the birth, death, and rebirth of an individual) and karma (literally, work or action). Buddhists look upon the cycle of birth and reincarnation as a misfortune, as a painful bondage to mundane existence to be escaped through the attainment of nirvana. They interpret karma as the system of moral causality that ensures that an individual's good or bad actions will be rewarded or punished either in this life or in the next. The doctrine of karma is subject, however, to different levels of interpretation and speculation. To cite one example, it became possible for beings who possess great stores of merit—Śākyamuni himself, or one of the great bodhisattvas, or even a wise and generous layman—to intervene in the affairs of a person who is suffering because of poor karma, to transfer to the unfortunate one some of their own stores of merit. Thus, a sin-ridden person might expect to be reborn in a lower stage of existence unless assisted by either his own merit-making activities or those of his descendants, or through the gift of grace from a divine source. The doctrine of karma can be directly or indirectly associated with a great number of Buddhist images, either as representations of the different levels of reward or retribution—paradise or hell or the appearance of a savior-deity—or as instruments by which a pious donor accumulates merit either for himself or for others through commissioning and giving a statue or painting to a sanctuary.

Within the matrix of commonly held beliefs, the ideological differences among schools and sects of Buddhism have been strong. Nonetheless, certain ancient Indian values continued to assert themselves even where they had apparently been submerged. In East Asia, for example, where Buddhism had become virtually a state creed, reinforcing the authority of the throne, the status of a monk remained in a sense higher than that of a ruler. For a Japanese emperor to abdicate the throne to become a monk was seen as a virtuous deed, even when the entry into religious life disguised a cynical political purpose.

Monasticism has played a powerful role in the history of the faith. Gautama gave up his wealth, luxurious comfort, and the joys of family life in order to engage in a spiritual search. His Four Noble Truths were rooted in the realization that ordinary worldly existence is precarious and painful. Human beings are freed from this state when they realize Ultimate Truth, but this realization requires a discipline of the self that has seemed to be most easily achieved within a monastic environment. Thus, millions of men and women have entered

monastic orders throughout Asia to follow a life of abstinence and personal poverty. Yet despite this strong flavor of austerity, Buddhist communities and adepts have impressed outsiders as remarkably cheerful and even joyous. The practical tenor of the faith has been largely that of fulfillment, of inner security, and of compassion for others.

One of the most enduring ideals in Buddhism, first recognized in India early in the history of the faith, is that excellently made works of art can convey fundamental principles of the creed. The artist can communicate a religious message not only by depicting religious symbols but also by creating a suitable aesthetic atmosphere. The Buddhist equation of religious and artistic values has nowhere been so eloquently stated as by the prominent Japanese monk Kūkai (774–835), in his *Memorial on the Presentation of the List of Newly Imported Sutras* of 806:

> The law (dharma) has no speech, but without speech it cannot be expressed. Eternal truth (tathatā) transcends color, but only by means of color can it be understood. Mistakes will be made in the effort to point at the truth, for there is no clearly defined method of teaching, but even when art does not excite admiration by its unusual quality, it is a treasure which protects the country and benefits the people.
>
> In truth, the esoteric doctrines are so profound as to defy their enunciation in writing. With the help of painting, however, their obscurities may be understood. The various attitudes and *mudrās* of the holy images all have their source in Buddha's love, and one may attain Buddha-hood at sight of them. Thus the secrets of the sutras and commentaries can be depicted in art; and the essential truths of the esoteric teaching are all set forth therein. Neither teachers nor students can dispense with it. Art is what reveals to us the state of perfection.[10]

NOTES

1. The most prominent Indian to reach Japan was Bodhisena, brought back in ca. 756 by a Japanese delegation to China. He was installed with great ceremony in the Daian-ji monastery in Nara, attended the dedication ceremonies of the bronze Daibutsu statue in 752, and helped found the Ishiyama-dera near the modern Otsu city, where he died in 760 at the age of 57 years. There is no evidence that his impact upon the Japanese was comparable to that of foreign teachers in China such as Kumarajiva (334–409 or 413) or Amoghavajra (died 774). Mochizuki Shinkō (ed.), *Bukkyō Daijiten,* vol. 5 (Tokyo, 1935).

2. Dietrich Seckel, *Grundzüge der buddhistischen Malerei* (Tokyo, 1945), pp. 57–74.

3. Akiyama Terukazu in *Bijutsu Kenkyu,* no. 144 (October 1947); no. 168 (March 1952); no. 220 (January 1962).

4. Dietrich Seckel, "Das Gold in der japanischen Kunst," *Asiatische Studien/Études Asiatiques,* 12 (1959): 83–94.

5. The silk fabric used for Japanese Buddhist painting varied according to date, and certain very general characteristics may be observed. The fabrics tend to become increasingly coarse and loosely woven from the twelfth through the fourteenth centuries. However, in the Muromachi period, a more densely woven, lustrous silk fabric was developed and used along with the older, gauzelike material. In more specific detail, from the twelfth century onward, Buddhist painters normally used a plain weave silk with a doubled thread in the warp. Most of the painting silk made before the middle of the Kamakura period (ca. 1275) had a warp count of not less than 20 threads to the centimeter, with about the same number of threads used for the horizontal weft. From the second half of the Kamakura period, there are often fewer than 20 warp threads to a centimeter, the most common number being 18; by the late fourteenth and fifteenth centuries, the warp count had dropped to only 14 or 15 threads in contrast to a greater number of weft threads, which are also three or four times as thick owing to the number of filaments of silk combined into one strand. The silk of the Muromachi period usually has a tough, enduring quality and a coarse surface, but a new kind of weave, called nerinuki, was developed in which fine, glossed silk threads were used for the weft, giving the finished fabric a lustrous finish. This latter type of silk may be seen in Buddhist paintings of the Muromachi period and later. Okazaki Jōji, *Jōdo Kyōga,* Nihon no Bijutsu vol. 43 (Tokyo, 1969), pp. 133–134.

6. Ghulam Yazdani, *Ajantā,* 8 vols. (Oxford, 1930–1955); Benjamin Rowland, Jr., *The Ajanta Caves* (New York, 1963), pp. 7–10.

7. Matsumoto Eiichi, *Tonkōga no Kenkyū* (Tokyo, 1937), pp. 213–249.

8. Okudaira Hideo, *Shigisan-engi,* Nihon Emakimono Zenshū vol. 2 (Tokyo, 1958); Tanaka Ichimatsu, *Bandainagon-ekotoba,* ibid. vol. 4 (Tokyo, 1961); Umezu Jirō, *Kokawadera engi; Kibi Daijin Nittō-e,* ibid. vol. 5 (Tokyo, 1962); Ienaga Saburō, *Jigoku-zōshi; Gaki-zōshi, Yamai-zōshi,* ibid. vol. 6 (Tokyo, 1960).

9. Edward Conze, *Buddhism: Its Essence and Development* (Oxford, 1951); Conze, *Buddhist Thought in India* (London, 1962), pp. 195–237; Nalinaksha Dutt, *Aspects of Mahāyāna Buddhism* (London, 1930); Étienne Lamotte, *L'Enseignement de Vimalakīrti* (Louvain, 1962), pp. 37–59.

10. William Theodore de Bary (ed.), *Sources of the Japanese Tradition* (New York, 1958), pp. 141–142.

CHRONOLOGY

Japan

ANCIENT
 Asuka (A.D. 552–646)
 Early Nara (646–710)
 Late Nara (710–794)
 Early Heian (794–898)
 Late Heian (898–1185)

MEDIEVAL
 Kamakura (1185–1336)
 Northern and Southern Courts, Nambokuchō (1336–1392)
 Muromachi (1392–1568)
 Momoyama (1568–1603)

RECENT
 Edo (1603–1868)

MODERN
 1868 to date

China

 Former, or Western, Han (206 B.C.–A.D. 8)
 Hsin (A.D. 8–25)
 Later, or Eastern, Han (25–220)
 Three Kingdoms (220–280)
 Six Dynasties (222–589)
 Sui (589–618)
 T'ang (618–907)
 Five Dynasties (907–979)
 Northern Sung (960–1127)
 Southern Sung (1127–1279)
 Yüan (Mongol) (1279–1368)
 Ming (1368–1644)
 Ch'ing (1644–1911)

Korea

THREE KINGDOMS
 Silla (57 B.C.–A.D. 668)
 Paekche (18 B.C.–A.D. 660)
 Koguryŏ (37 B.C.–A.D. 668)
 United Silla (ca. 668–935)
 Koryŏ (918–1392)
 Yi (1392–1910)

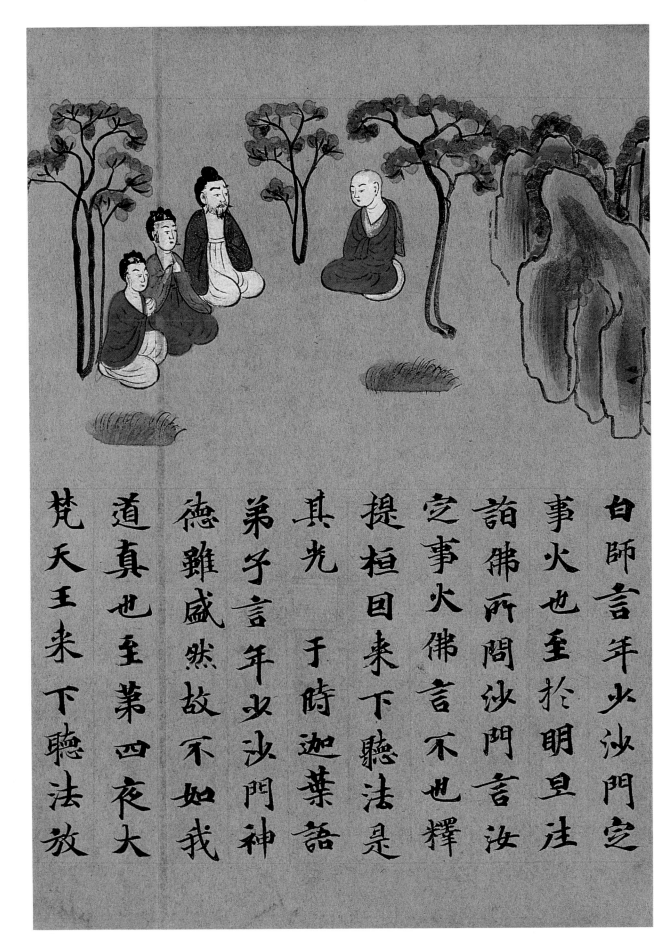

梵天王来下聴法放
道真也至第四夜大
德雖盛然故不如我
弟子言年少沙門神
其先　于時迦葉語
提桓曰来下聴法是
定事火佛言不也釋
詰佛所問沙門言汝
事火也至於明旦注
白師言年少沙門定

1. Śākyamuni Questioned by the Three Kāśyapa Brothers

25

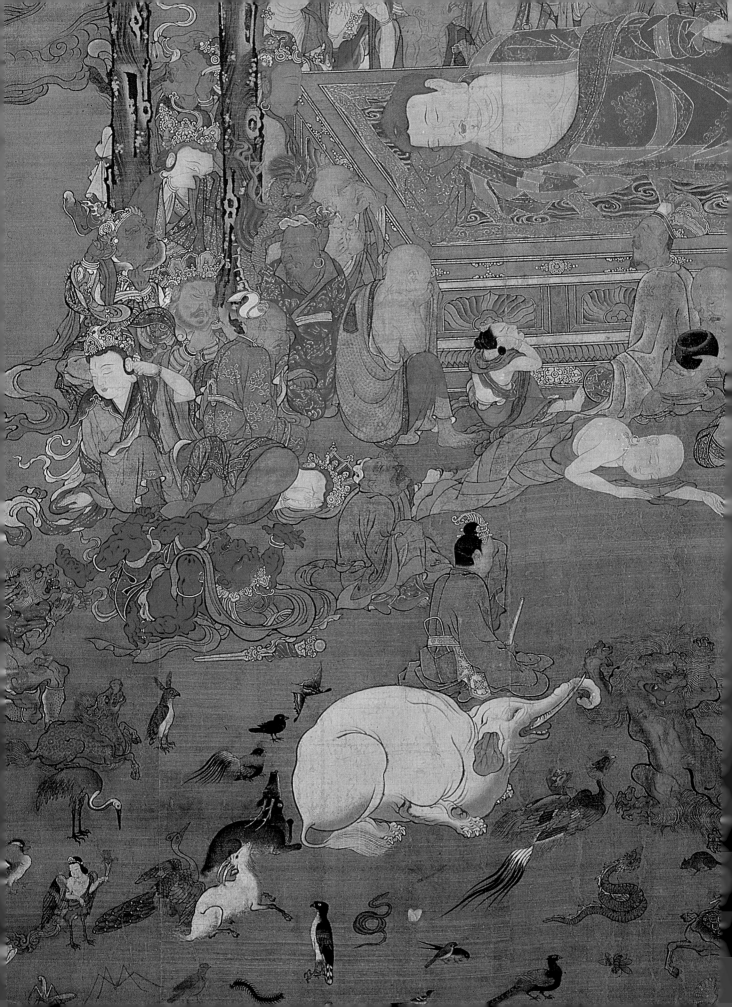

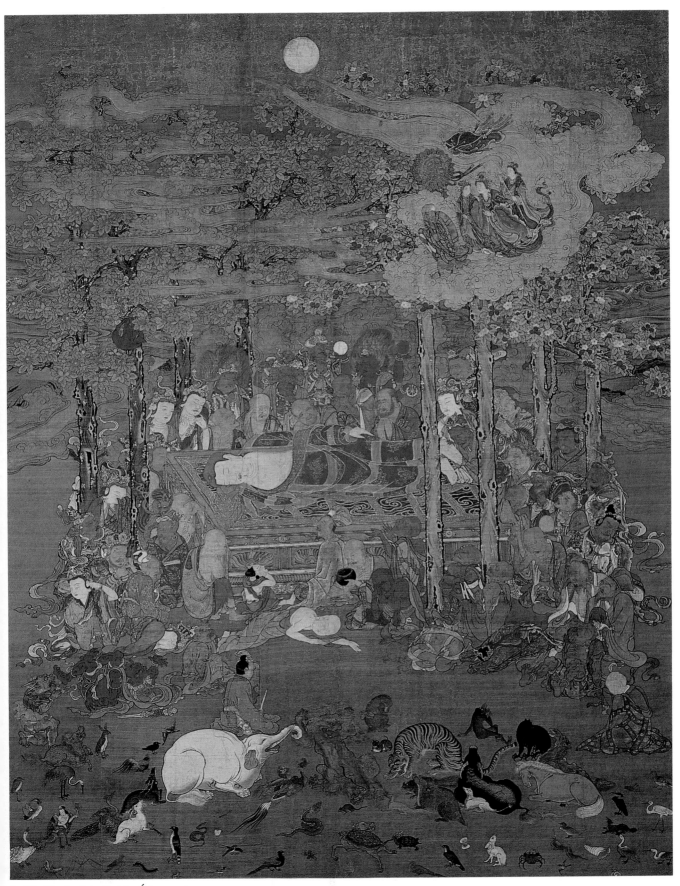

2. The Death of the Buddha Śākyamuni

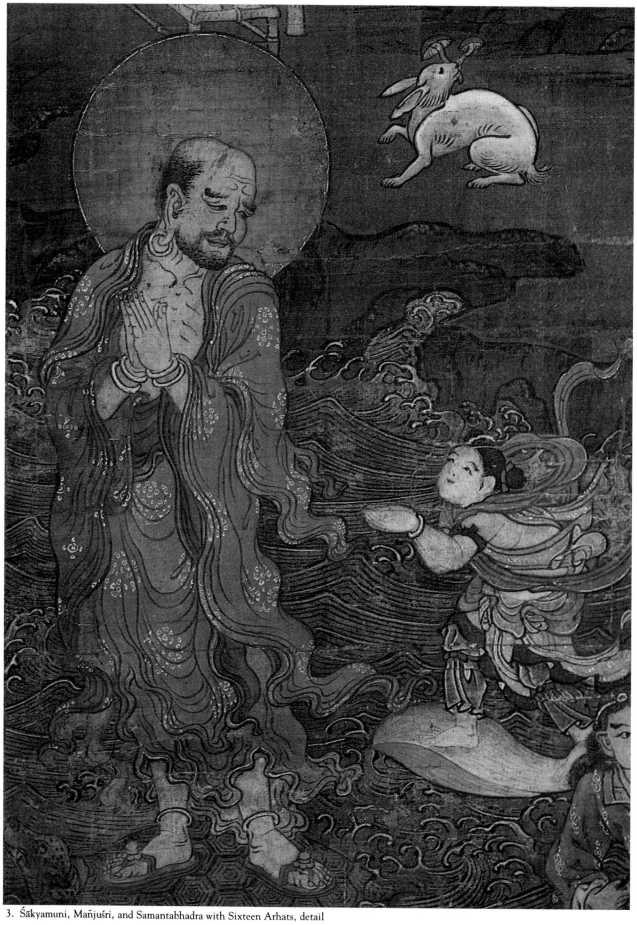

3. Śākyamuni, Mañjuśri, and Samantabhadra with Sixteen Arhats, detail

28

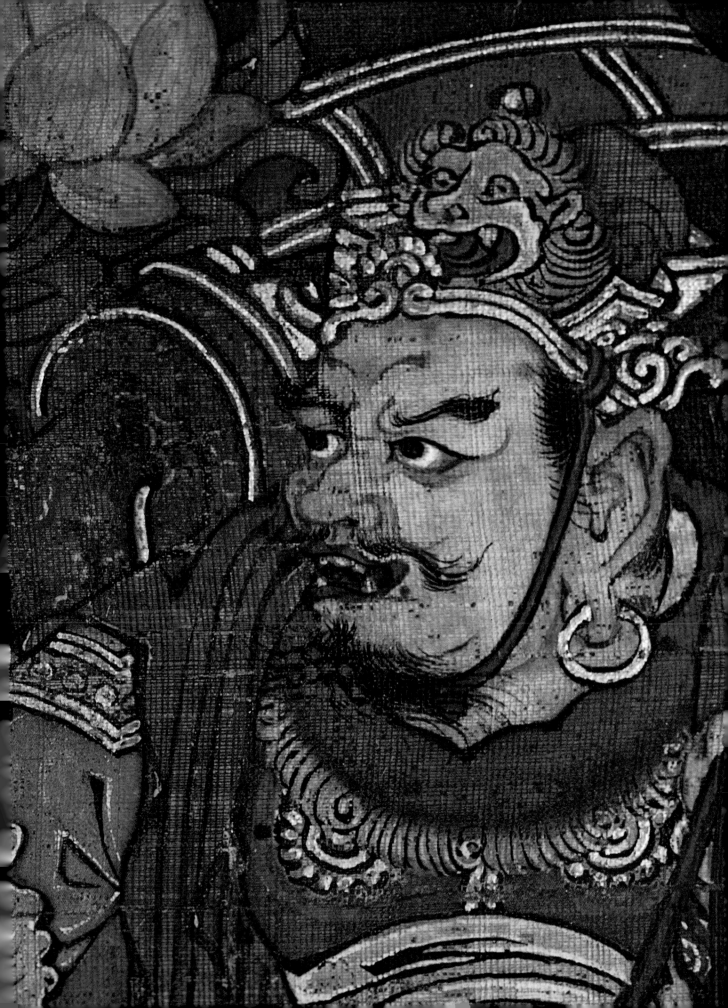

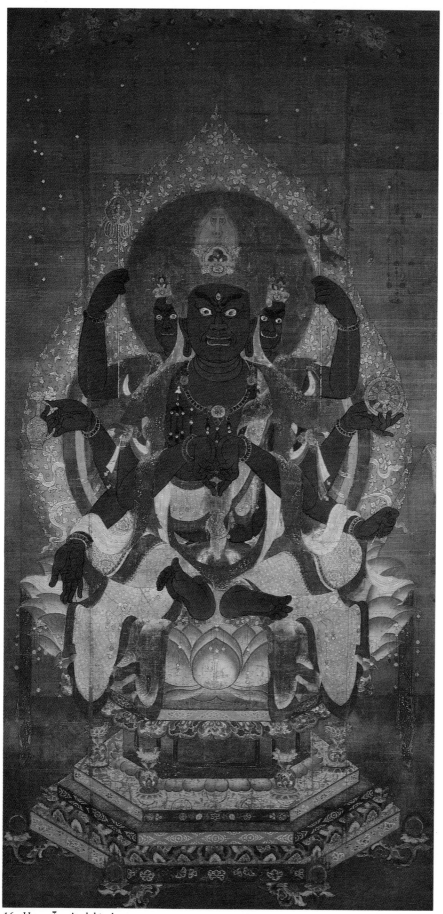

16. Hayagrīva Avalokiteśvara

20. Mandala of Vaiśravaṇ

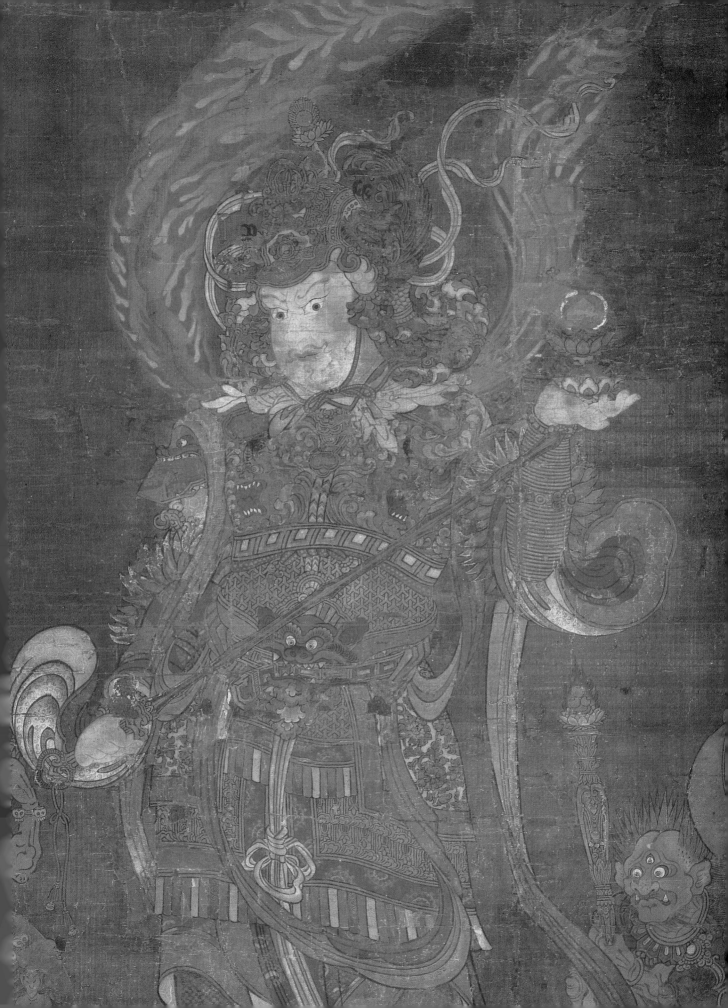

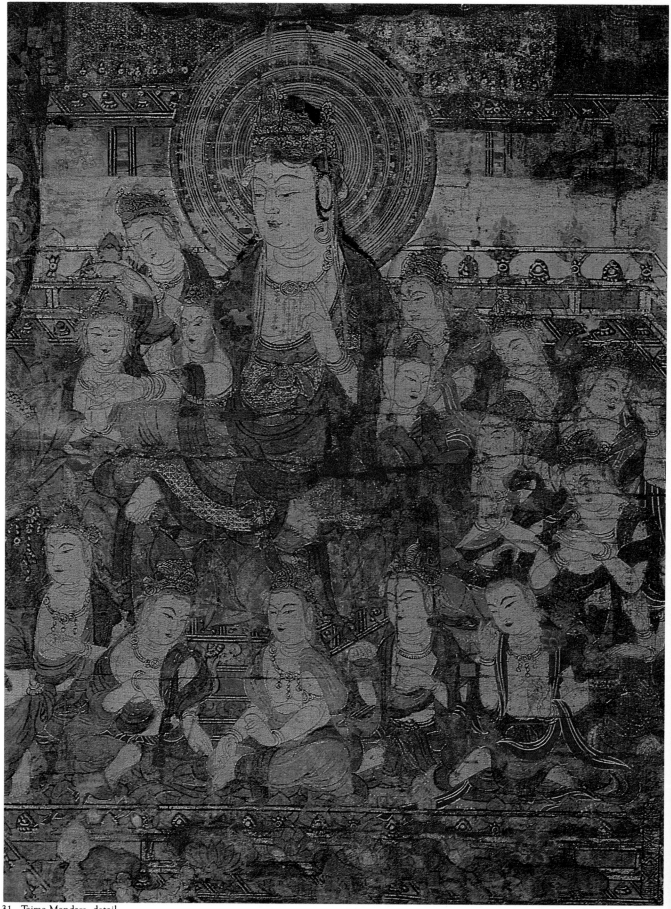

31. Taima Mandara, detail

32. Descent of the Amitābha Trinity, detail of Avalokit

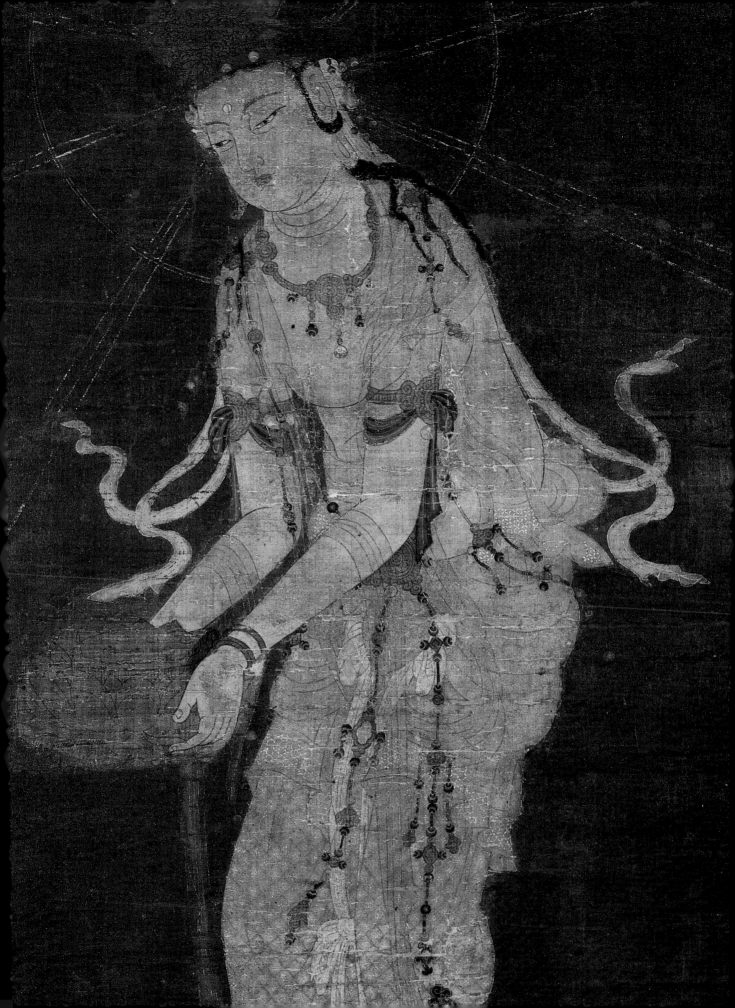

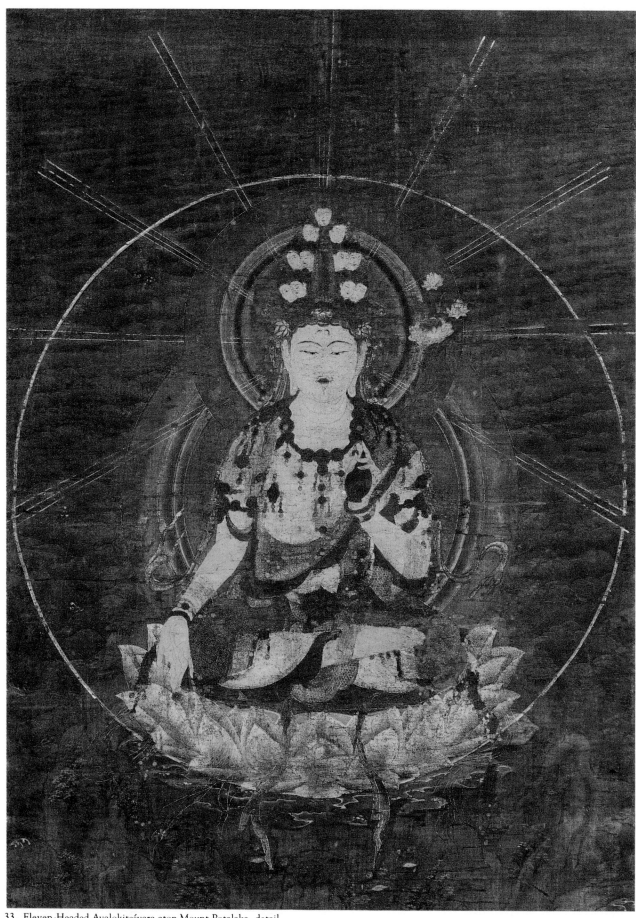

33. Eleven-Headed Avalokiteśvara atop Mount Potalaka, detail

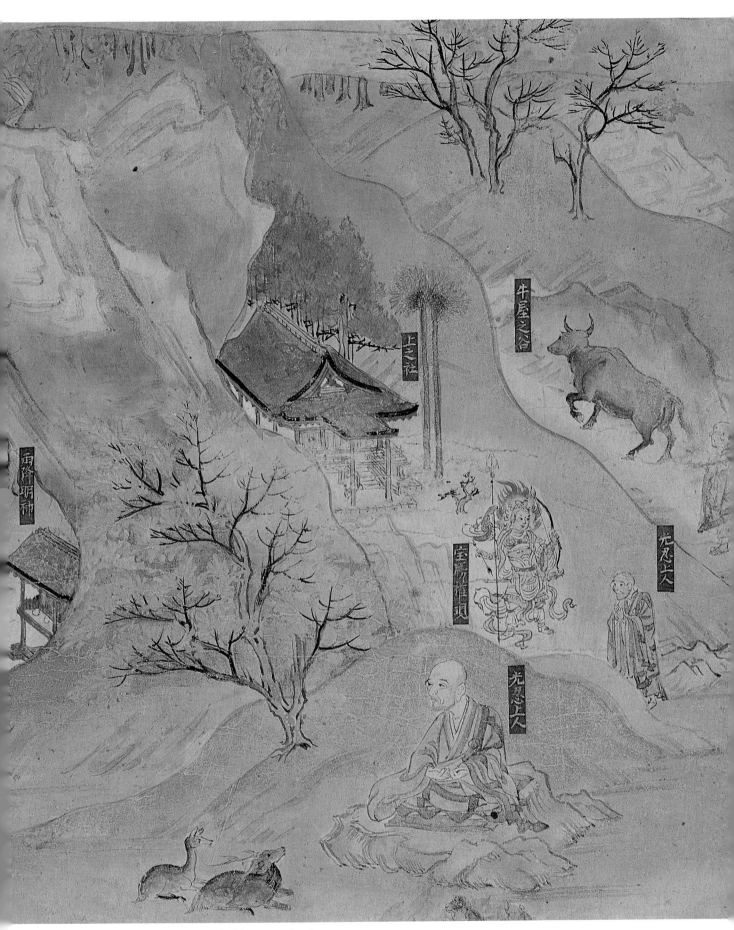

牛屋之谷

上之社

雨降明神

宝前権現

充念上人

光忍上人

43. The Monk Kōnin Meditating in the Mountains, detail

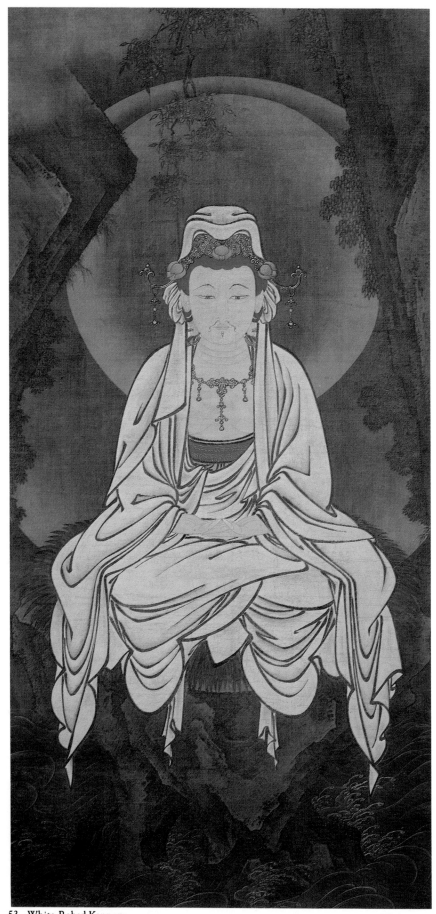

53. White-Robed Kannon

PART ONE
The Mahayana Mainstream

The Buddhist faith was already a thousand years old when, in the sixth century A.D., it reached Japan. During that millennium it had spread by sea to Southeast Asia and overland through Central Asia to China and Korea, adapting itself in each region to different social and intellectual conditions, and learning to coexist with local creeds. It had also evolved internally from a doctrine intended for ascetics withdrawn from society into a broad, universal creed appealing to all sectors of the social order.

When it was introduced into Japan, the process of adaptation to East Asian cultural and intellectual values was already far advanced. Major Buddhist centers had developed around the courts of the Toba Wei rulers of northern China and of the Liang kingdom, whose capital was at Nanking. The religion had been formally adopted by three Korean kingdoms, Koguryŏ in the north in 372; Paekche in the southwest in 384; and Silla in the southeast in 528. In 552, the ruler of Paekche sent a gilt bronze votive image to Kimmei, twenty-ninth emperor of Japan. It came with holy texts, ritual implements, and a memorial that praised the Buddhist creed in the following terms: "This doctrine is among all doctrines the most excellent. But it is hard to explain, and hard to comprehend. . . . From distant India it has extended to the three Hans [the three kingdoms of Korea], where there are none who do not receive it with reverence. . . ."[1] Emperor Kimmei leaped with pleasure upon receiving these pious gifts, saying that he had never before listened to so wonderful a doctrine; moreover, he praised the severe dignity in the countenance of the statue of the Buddha.[2]

Socially, early Mahayana in Japan, as was true in China and Korea, was a religion primarily of the ruling classes, one that secured both their personal well-being and also the prosperity and safety of the state. Examples of the intimately personal role of the faith are the religious acts performed over a four-month period when the Emperor Temmu, renowned for his wise and just reign, was taken gravely ill in the summer of 686.[3] At the beginning of the illness, the sutra of Yakushi, the Healing Buddha, was recited in the Kawara Temple south of the imperial palace, and courtiers held a retreat within the palace to pray for his recovery. A delegation of high officials led by a senior prince of the blood was sent to the Asuka Temple, oldest Buddhist sanctuary in Japan, to present valuable gifts and to request that the awesome power of the Three Jewels of the faith be invoked to obtain the emperor's cure. High-ranking prelates were repeatedly invited to the palace to conduct penitential services. During this same period, many offerings were also made to Shinto shrines, especially that of the Great God of Sumiyoshi near the modern Osaka, but the records emphasize the Buddhist activities. On one occasion, one hundred monks were invited into the palace to read the Sutra of Limitless Light, and amnesty was granted to prisoners and debtors. To benefit the emperor, seventy people were selected to enter monastic life; three days later one hundred people followed them. A chapter from the Lotus Sutra was expounded in the Official Great Temple (Daikan Daiji); one

hundred statues of the Bodhisattva Kannon were set up within the palace, and five days before the emperor's death all princes of the blood, ministers of state, and ranking courtiers assembled in the Kawara Temple to offer vows for the saving of his life.

So strong was the initial imprint of the early form of Mahayana on the minds of the Japanese that it never faded from memory or practice. All subsequent ideological developments, such as Esoterism or the popular Pure Land creeds or Zen, were outgrowths of this system and were active or latent within it when it first reached Japan. In the eighth century, Mahayanism was organized into six doctrinal schools in the new capital at Nara.[4] In later centuries these schools lost their influence and some even lost their identity, but the ideals of the Mahayana mainstream were intertwined with those of later schools and traditions, so much so that it is frequently difficult to determine whether a given work of art was produced for a mainstream Mahayana context or for one of its offshoots. The basic cultural values, the deities worshiped, and the social customs of this early stage of belief have continued within the fabric of Japanese religious life until the present.[5]

The Mahayana Pantheon

Early Mahayana stressed the idea that a vast pantheon of Buddhas and bodhisattvas exists in order to assist mankind on the path to nirvana. The number of the deities described in the sutras was far too great to comprehend, but certain figures, at differing levels of sanctity, caught the imagination of East Asian monks and laymen; as a consequence their texts and imagery were prominently featured.

The highest ranking were the fully enlightened Buddhas, called tathāgatas in Sanskrit (J nyorai). They had already attained nirvana and, in principle, were removed from the affairs of men. Their identification with other-worldly values was symbolized in sculpture and painting by the wearing of monastic robes and the absence of jewelry. First among the tathāgatas, of course, was Śākyamuni, the Indian prince who was the historical founder of the faith (nos. 1–3), and the model or paradigm for the Buddhas who existed outside of conventional history and time. The Healing Buddha (S Bhaiṣajyaguru, J Yakushi), whose cult was little known in India, became popular when his legendary vows to cure the physical and spiritual ills of mankind struck a responsive chord throughout East Asia (no. 30). The Buddha Amitābha, or Amitāyus (J Amida) was the Lord of Infinite Light, or Infinite Life (no. 31); he presided over a paradise in the West into which the faithful could expect to be born and, in an atmosphere of perfect repose and beauty, receive the teaching that would enable them to attain nirvana. Amitābha emerged as a prominent deity in China in the early fifth century A.D., and from that time on was the object of increasing devotion among monks and ordinary laymen.

One step down the hieratic order were the bodhisattvas, literally, enlightenment beings, who served as active agents of the tathāgatas. Moved by deep compassion, the bodhisattvas would intervene in the affairs of this world in a manner akin to that often ascribed to Christian saints while maintaining an ethereal character like that of angels and archangels. The bodhisattvas shared many traits, particularly their selfless compassion and power to assist the faithful in any kind of difficulty. They could assume any form appropriate to their mission. Buddhist texts describe them in such guises as old men, beautiful women, divine children, or animals or demons. Most often they appear as resplendent princely beings. In essence, however, they transcend the limitations and distinctions of ordinary mortal existence. Emblematic of their worldly powers and skills are the rich jewels and ornaments that they wear in Buddhist imagery. One of the first of the bodhisattvas to be prominently worshiped was Maitreya (J Miroku), scheduled to become the next fully enlightened Buddha to live and preach in this world. While awaiting his time to come to earth, he dwells in the Paradise of the Satisfied (Tuṣita) Gods and dispenses the Buddhist Law to those reborn there. In China in the fifth century, pious Buddhists believed that Maitreya would soon appear to pacify and unify the world, and they fervently prayed that they might accompany him on his mission.

Even more widely adored was the Bodhisattva Avalokiteśvara (J Kanjizai, or Kannon), perhaps the single most popular focus of Buddhist devotion in all of East Asia. The etymological meaning of his name is now somewhat obscure; perhaps it was originally Avalokitasvara, connoting the lord who responds to the prayerful sounds of mankind.[6] He was the agent of Amitābha who often conveyed those who had died to the Western Paradise; he took numerous forms — as many as thirty-three are listed in the Lotus Sutra (nos. 16, 24, 33, 52, 53).

Two important bodhisattvas, Mañjuśrī (J Monju) and Samantabhadra (J Fugen), were often linked together (no. 3). The center of Mañjuśrī's cult was in China, on Mount Wu-t'ai in Shansi province, which was thought to be his sacred abode. Pilgrims from Japan as well as from India and Tibet journeyed there in hope of seeing Mañjuśrī, for he was said to reveal himself to the faithful and to take unusual forms: as a wretched old man, as a pregnant woman, or as a resplendent, handsome young prince astride a golden lion (nos. 5, 6). Mañjuśrī embodied the wisdom of Mahayana, whereas Samantabhadra, his counterpart, embodied its practice. The name Samantabhadra, meaning universally worthy, suggests the benevolent character of this deity, who came into particular prominence as the guardian of those whose devotions were focused on the Lotus Sutra (no. 7).

Another of the popular bodhisattvas was Kṣitigarbha (J Jizō), whose name means literally earth treasury or storehouse (no. 8). Although Kṣitigarbha seems to have developed as an Esoteric Buddhist deity, so great was his appeal throughout East Asia that he became part of the Mahayana mainstream as a protector of women in childbirth, guardian of travelers and of warriors in battle, and savior of those suffering the torments of Hell. He was depicted usually in the guise of a monk with shaved head, but his face was given the ideal and perfect beauty of a bodhisattva.

The next step downward in the order of sanctity was the large class of lesser deities or godlings called devas in Sanskrit (J ten). Four deva kings, for example, were thought to protect symbolically a Buddhist sanctuary from dangers arising from the four cardinal points of the compass and to record the good and evil deeds of the faithful; these Four Divine Kings (J shitennō) thus became standard figures on Buddhist altar platforms in East Asia. Their appeal was both religious and sociopolitical; it was so strong, in fact, that they became protectors of the faith and, indeed, of an entire Buddhist nation. When Japanese traditionalists resisted the importation of the Buddhist creed in the 580s and the issue provoked a short-lived civil war, the pro-Buddhist faction invoked the mystic powers of the the Four Divine Kings: "Oh! all ye Heavenly kings . . . aid and protect us, and make us to gain the advantage."[7] When that faction, led by Soga no Umako and Prince Shōtoku, triumphed in the test of strength, the two leaders fulfilled their vows and built a Temple of the Four Divine Kings (Shitennō-ji) in the province of Settsu, the modern Osaka, which became one of the most prestigious of all Buddhist sanctuaries in Japan. The chief of the Four Kings was the guardian of the north, Vaiśravaṇa in Sanskrit (J Bishamon), who in his own right became the object of an independent cult as chief guardian of a city or region and protector of the faithful (nos. 20, 22).

The class of devas was indeed vast. It included deities who originally had been charged with high symbolic meaning, such as Indra and Brahma, emblems of the traditional Indian religious creeds that were made subordinate to Buddhism (no. 21). It also included deities from Indian folk religions who came as part of the Buddhist pantheon to Japan and evolved once again into elements of popular religion; some were even accepted as Shinto deities. Among this latter group were the goddess of abundance and beauty, Śrī-lakṣmī (J Kichijō-ten); goddess of music and learning, Sarasvatī (J Benzai-ten); goddess of human fertility and protector of children, Hāritī (J Kariteimo, or Kishimo-jin); and lord of the wealth and well-being of householders, Pāñcika, or Mahākāla (J Daikoku-ten).

A Note on Philosophy

Behind the popular deities and a religion of ever increasing concern for the masses lay the deeper strata of philosophic discourse: the realms of logic, cosmology, and eschatology that engaged the interests of leading Buddhist thinkers. Concerns of this kind powerfully affected the Buddhist vision of the relationship of man and the world around him and, in the end, affected the manner by which that vision was embodied in the visual arts.

Lucid and detailed expositions of the principles of Mahayana philosophy are available in Western languages.[8] However, one concept that was shared by all branches of Buddhism should be touched upon here, for it is the implicit content of many if not all Mahayana Buddhist images and a powerful factor in Buddhist aesthetics. It is the austere and paradoxical concept that Ultimate Reality, the source and matrix of all being, cannot be comprehended by the ordinary faculties of the human mind or body, and yet expresses itself in concrete experience or symbols. This basic reality defies the capacity of the human mind to recognize it, because it has no outward signs, no traits, no color or form. It may be called the Absolute, or the Body of the Law (dharma-kāya). The Sanskrit term śūnyatā, connoting emptiness or the void, was used in early Mahayana philosophical texts to designate Ultimate Reality as the zero point, which is like infinite space and which can embrace everything both negative and positive, in a nondual transcendence. Numerous treatises such as the prajñā-pāramitā literature explored the implications of śūnyatā and examined the concept from many viewpoints so that the student might begin to grasp its awesome magnitude.

The teachings in the prajñā-pāramitā sutras are highly abstract. In essence, the texts speak of the six attributes a bodhisattva must bring to perfection on his path toward full enlightment or Buddhahood. These are the perfections of generosity, morality, patience, vigor, concentration, and wisdom. The most exalted is the perfection of wisdom, which involves the ability to understand the characteristics of all phenomena: the fact that all things in the universe are interdependent; the conditions that generate their appearance and disappearance; and finally, the ultimate unreality of their individual existences. Enlightened beings understand that the ultimate unreality, emptiness or śūnyatā, is the one and only Reality. They comprehend intuitively that all duality—between subject and object, affirmation and negation, sacred and profane—disappears before the fact of this Absolute Truth.

NOTES

1. W. G. Aston (trans.), *The Nihongi*, vol. 2 (London, 1896), pp. 65–66.

2. Ibid.

3. Ibid., pp. 376–380.

4. In the order of their introduction to Japan: (1) Jōjitsu (Satyasiddhi) in 625, joined with the Sanron; (2) Sanron in 625, based on three treatises of Mādhyamika, rival headquarters at Gangō-ji and Daian-ji; (3) Hossō (Yogācāra, or Vijñānavāda) in 653, headquarters at Kōfuku-ji; (4) Kusha in 658, based on the Abhidharma-kośa of Vasubandhu, no headquarters temple; (5) Kegon (Avataṃsaka) in mid-eighth century, based on the Avataṃsaka-sūtra, headquarters at Tōdai-ji; and (6) Ritsu (Vinaya), brought in 764 by the Chinese monk Chien-chên, emphasized rules and precepts of Mahayana monasticism, headquarters at Tōshōdai-ji.

5. For a systematic review, see M. W. de Visser, *Ancient Buddhism in Japan*, 2 vols. (Leiden, 1935).

6. Giuseppe Tucci, "Buddhist Notes: à propos Avalokiteśvara," *Mélanges Chinois et Bouddhiques*, IX (1948–1949): 173–219.

7. Aston, *Nihongi*, p. 114.

8. Richard Robinson, *Early Mādhyamika in India and China* (Madison, WI, 1967); Étienne Lamotte, *L'Enseignement de Vimalakīrti* (Louvain, 1962); Edward Conze, *The Large Sutra on Perfect Wisdom* (Berkeley, 1975); Robert A. F. Thurman, *The Holy Teaching of Vimalakīrti* (University Park, PA, 1976).

1. Śākyamuni Questioned by the Three Kāśyapa Brothers

From an Illustrated Sutra of Cause and Effect, Past and Present (Kako-genzai E-inga-kyō)

Ca. A.D. 760–770
Ink and colors on paper
Section of handscroll mounted as hanging scroll;
26 × 18.5 cm
Collection of Kimiko and John Powers

This small picture, taken from a long horizontal narrative scroll, depicts Gautama Śākyamuni as a young monk seated facing three brothers of the Kāśyapa family, members of an order of Brahman recluses. Gautama had visited their hermitage in order to challenge their religious authority and to convert them to his creed. Each evening, a miracle demonstrating his superior powers had taken place—he spent the night in a flaming building, or tamed an evil serpent into a jar. The scene depicted here takes place after the events of the third night, which are described in the text, beginning with four lines that precede the current fragment:

(On the third night, Indra descended to hear the dharma, and gave forth a great radiant brightness like the rising sun. A disciple of the Kāśyapas, seeing from afar the heavenly light at the side of the Tathāgata,) said to his master, "The young recluse definitely worships fire." At dawn, [the Kāśyapas] rushed to the place where the Buddha was, and said, "You definitely worship fire." The Buddha replied, "No. Indra came down to hear the dharma, and the light was his." When he heard this [the elder] Kāśyapa said to his disciples, "Although this young recluse is filled with divine virtue, it is not equal to the truth of my path." On the fourth night, Brahma descended to hear the dharma, and gave forth (radiant brightness like the sun at midday.) . . . (Translation by Samuel C. Morse)

The illustrated scrolls from which this fragment came are among the most treasured relics of early Japanese Buddhist painting. Depicting the events of Gautama's life in the upper register with the text in the lower, written in Chinese in the severe, formal clerical script (kaisho), they are the oldest works of narrative scroll painting preserved in Japan. The style of painting is direct and ingenuous; it is difficult to realize that the illustrations belong to the same era as the grandiose project of the giant bronze image of Vairocana, the Daibutsu of Nara at Tōdai-ji. The simplicity of the

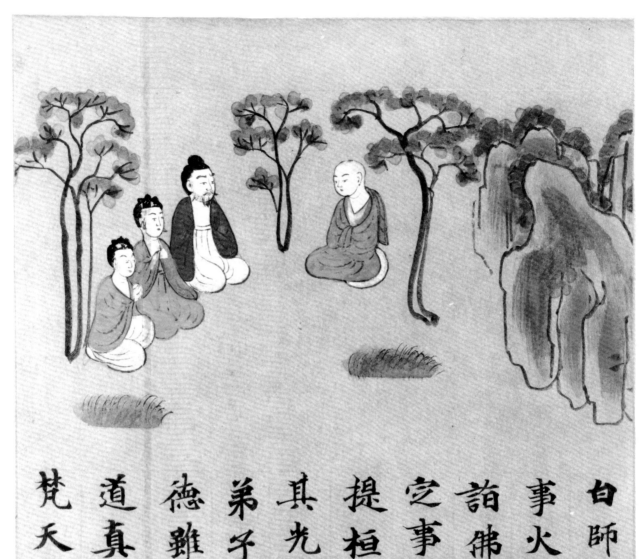

梵天王来下聴法故
道真也至第四夜大
德雖盛然故不如我
弟子言年少沙門神
其先　于時迦葉語
提桓曰来下聴法是
定事火佛言不也釋
詣佛所問沙門言汝
事火也至於明旦注
白師言年少沙門定

1. Śākyamuni Questioned by the Three Kāśyapa Brothers *(color illustration, p. 25)*

42

landscape elements and the naive beauty of the figures reflect the fact that they were copied from older Chinese paintings; these models no longer survive. However, the subtlety of the placement of figures into the landscape as well as the expressive unity of the compositions reflect the artistic sophistication that the Japanese had attained by the middle of the eighth century A.D.

The Buddha's biography is illustrated in separate episodes above the running text. For each event, a distinct architectural or spatial setting is created by the buildings or landforms, which are small in comparison to the size of the human figures, giving the composition a naive or archaic quality. The painting technique is direct and straightforward, with thin washes of ink used to establish the modeling in light and shade. Otherwise the pigments are painted in flat, opaque layers of bright, intense hues. Accompanying this apparent simplicity of style and technique is considerable subtlety of expression. The scenes flow easily from one to another with variations of width and emphasis. The figures are set onto the ground plane in such a way that they establish a clear position in depth and relate to one another in a psychologically meaningful manner.

The title of this work, Sutra of Cause and Effect, Past and Present, suggested that the process by which the Buddha attained enlightenment was the result of his karma, the system of causality by which a person's good or evil deeds affect future events, even in the next life. This text's original Sanskrit versions have not survived, but it was first translated into Chinese by the Indian monk Guṇabhadra, who died in 468. There were originally two versions in Chinese: one in four scrolls, and the other in five. Although both were imported to Japan, the illustrated text is based on the four-scroll version. The text seems to have appealed greatly to the Japanese, for it described the life of the founder of the faith in an attractive and comprehensible form.

The pious Empress Kōmyō ordered the five-scroll set copied in 735; Shōsō-in documents indicate that an illustrated version was made in 756; however, no complete set of the illustrated version has been preserved. Only four separate scrolls have survived, each from the hands of different painters; judging by the style of calligraphy, the oldest must date from the 750s, about the same time mentioned in the Shōsō-in documents. One of the scrolls, in the Hōon-in of Daigo-ji near Kyoto, has a notation on the end of its roller suggesting that it came from the official Sutra Copying Bureau in Nara. A second scroll, in the Jōbon Rendai-ji in Kyoto, closely resembles the first, but is slightly more advanced in the degree of pictorial realism. The third scroll is in the collection of the Tokyo Fine Arts University. The fourth, from which this fragment was taken, once belonged to Kōfuku-ji in Nara, and then to the Masuda Collection before it was sold and cut apart. The third and fourth scrolls closely resemble one another in style. They are simpler in composition and detail, and may have been based on the older Japanese versions rather than the Chinese prototypes.

One of the major art historical problems in the study of the E-inga-kyō is the reconstruction of the lost Chinese paintings that served as their models, for there are strange inconsistencies in the Japanese versions. Costumes, hair styles, and architectural forms can be closely related to Chinese imagery of the late sixth and seventh centuries, whereas the landscape style belongs to the early eighth century. The modeling of the landforms and the masterful sense of spatial recession are comparable to elements in the Tun-huang paintings and to wall paintings in tombs in the Ch'ang-an area, especially the Li Hsien tomb of ca. 706. However, the Japanese artists, as can be seen in this fragment, did not relate the rock and hill forms to the ground plane in the same organic fashion as did their Chinese counterparts; but this is a trait of the native Japanese style. The other inconsistencies may well have been present in the Chinese version of the E-inga-kyō that the Japanese used as a model, for just as the Japanese modified that model as they reproduced it, so the Chinese tradition of copying earlier versions of a scroll may have resulted in the mixing of stylistic elements from different periods.

Published: John M. Rosenfield and Shūjirō Shimada, Traditions of Japanese Art: Selections from the Kimiko and John Powers Collection (Cambridge, MA, 1970), no. 11; Tokyo National Museum (ed.), Nihon no sho (Tokyo, 1978), no. 6; Kameda Tsutomu et al., E-inga-kyō, Nihon Emakimono Zenshū vol. 16 (Tokyo, 1969), pp. 59–60; Shimada Shūjirō (ed.), Zaigai Hihō, vol. 2 (Tokyo, 1969), no. 1.

References: Jan Fontein and Wu Tung, Han and T'ang Murals (Boston, 1976), pp. 90–103; Shensi Provincial Museum and Cultural Affairs Administration (eds.), T'ang Li Chung-jun mu pi-hua (Peking, 1974) and T'ang Li Hsien mu pi-hua (Peking, 1974).

2. The Death of the Buddha Śākyamuni (Mahāparinirvāṇa; Dai-nehan)

A.D. 1452
Ink, colors, and gold pigment on joined pieces of silk
Hanging scroll; 222 × 173 cm
Museum für Ostasiatische Kunst, Köln

In this fine example of one of the most dramatic and universal of all Buddhist image types, Śākyamuni, the historical Buddha, is shown on his earthly deathbed, about to enter the ultimate stage of nirvana. His body painted gold and drawn larger than all other figures in the composition, the Buddha lies on his right side on an ornate platform. At the head of his bier stand four blossoming śāla trees with green leaves; at the foot are four with yellow leaves. In the cloud bank descending from the moonlit sky is the striding figure of his mother, Māyā, attended by servants and a weeping monk. Mourners symbolic of all classes of divine and human beings crowd around the bier, responding in grief or wise resignation to his leaving this earth. Filling the foreground are grieving creatures from the lower orders of sentient existence—sea life, animals, birds, demons, and imaginary beings—demonstrating by their presence the universality of the Dharma.

Two colophons on the back of the painting, one incorporating part of the text of an inscription discovered on the original wooden roller of the work during restoration in 1970, give two possible dates for the creation of the painting: 1392 and 1452. Unpublished research done by Jorinde Ebert and provided by the Köln Museum suggests that the date of 1452 is probably the correct one, and that the work may have been based on an earlier version done in 1392. This 1392 version could be the Nehan painting said to be in the Renge-ji in Kyoto, itself possibly painted by Yūen, whose name appears in the Köln inscription dated in accordance with 1392, but who is otherwise unknown except for his signed and dated (in accordance with 1384) painting of Jizō found in the Hōju-in on Mount Kōya (see no. 8).

Many parallels to the Köln picture may be found among over forty paintings of this theme surviving from the fourteenth and fifteenth centuries A.D., the period of the greatest production of nirvana pictures in Japan. Close in tonality and line quality is another example, in the Nezu Museum, dated in accordance with 1345; so also is the colossal painting nearly nine meters high, at Tōfuku-ji in Kyoto, painted by Kichizan Minchō in 1408. The latter, however, is much more individualistic and dramatic than is the Köln painting, for within the limits of the main elements of the composition, artists were free to inject their own ideas. Different grieving animals were depicted, yet they were dominated, as here, by a large elephant and lion. The postures of the mourners would vary, but Ānanda, the cousin and most learned of the disciples of the Buddha, would most often lie on the ground stricken with sorrow. The names of most of the painters of these works are usually not known, but names of prominent artists do appear: in addition to Minchō, there is Takuma Eiga (active ca. 1310–1315), one of the last masters of his family lineage, and Reisai (active 1430–1450), gifted monk-painter of Tōfuku-ji.

Akin to images of the crucifixion of Christ in the West, the mahāparinirvāṇa of the Buddha has been a central religious and artistic motif in all Buddhist lands regardless of sectarian affiliation. A giant stone statue was carved at the site of his death, Kuśinagara (the modern Kāsia, 56 kilometers east of Gorakhpur, near the Nepal border) at a shrine that was one of the main Buddhist pilgrimage sites in India. Similar large statues are found at Ajantā, at Pollonarrua in Sri Lanka, at Adzina-tepe in Soviet Tadjikistan, and at Tun-huang in western China. In Japan, a most expressive group of stucco statues of the early eighth century depicting the parinirvāṇa were placed in the base of the Five-Story Pagoda of Hōryū-ji, and the texts that describe the event, the Mahāparinirvāṇa sutras, were long known and copied.

Symbolically, the event marked the transition of the historical Buddha from mortal religious leader to eternal, supramundane being. The image was at once a depiction of a historical event, with the grief and sorrow of those that mourn, and also a lesson on the higher

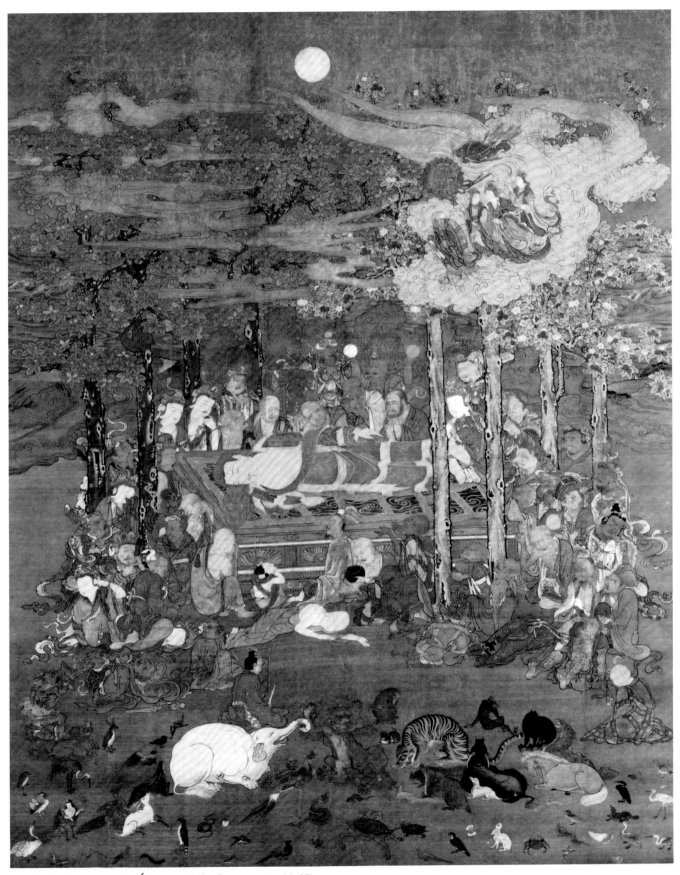

2. The Death of the Buddha Śākyamuni (*color illustrations, pp. 26, 27*)

significance of nirvana for those able to comprehend it. Mahayana stressed the transhistorical character of the Buddha, that the Śākyamuni who had lived and taught on this earth was but a provisional incarnation of a higher, more enduring Buddha principle. Nonetheless, it was he who had most recently brought the Dharma to ordinary human beings and whose life and teachings were its most dramatic lessons.

In medieval Japan, as the Buddhist faith became increasingly concerned with the spiritual welfare of the masses, paintings of the nirvana and annual ceremonies in memory of the death of Śākyamuni became a major focal point of the popular religion. In virtually all major temples, a solemn service in memory of the Buddha's death would be held on the fifteenth day of the second lunar month, a custom that still survives in many places. A painting such as the one exhibited here would be unfurled in a place of public ceremony, usually the Image Hall (Kondō) or Lecture Hall (Kōdō), to serve as the focal point of a day of fasting and worship by monks and laymen, the gathering together of families affiliated with the temple, and the recitation of one of the Nirvana sutras accompanied by the steady tolling of the temple bells. At the close of the day, the painting would be rolled up and stored away until the following year.

Published: Museum für Ostasiatische Kunst der Stadt Köln (ed.), *Meisterwerke aus China, Korea und Japan* (1977), no. 151; *Buddhistische Kunst Ostasiens* (1968), no. 79; Werner Speiser, *Die Kunst Ostasiens* (Berlin, 1956), pl. 53–54; Dietrich Seckel, *The Art of Buddhism,* trans. Ann E. Keep (New York, 1964), pp. 272-273.

References: M. W. de Visser, *Ancient Buddhism in Japan* (Leiden, 1935), pp. 584–590; Kanazawa Hiroshi, *Kao, Minchō,* Nihon Bijutsu Kaiga Zenshū vol. 1 (Tokyo, 1977), pls. 38, 54; Mainichi Shinbunsha (ed.), *Jūyō Bunkazai,* vol. 8 (Tokyo, 1973), pp. 61–65; *Kokka,* nos. 883 (October 1965), 841 (April 1962), 834 (September 1961), 468 (November 1929).

3. Śākyamuni, Mañjuśrī, and Samantabhadra with Sixteen Arhats (Shaka, Monju, Fugen, Jūroku Rakan)

First half of the fifteenth century A.D.
Ink, colors, and gold pigment on silk
Three hanging scrolls mounted on panels;
 each 99.5 × 39 cm
Collection of John W. Gruber

Beautifully preserved and iconographically complete, this set of paintings, exhibited and published here for the first time, presents basic doctrinal conceptions of Mahayana Buddhism and its Zen Buddhist offshoots. Śākyamuni, as a fully enlightened tathāgata, is shown in the central panel, removed from worldly concerns and enthroned above the clouds in Paradise. Flanking him are two bodhisattvas who remain active in this world, intervening on behalf of the faithful and manifesting on earth the Buddha's great virtues. Mañjuśrī, seated enthroned on the back of a lion, embodies the Buddha's wisdom and spiritual insight (nos. 5, 6, 51); Samantabhadra, on his six-tusked elephant, embodies the meditative practices and active teaching of the Buddha (no. 7).

In both side panels are a total of sixteen arhats, aged and wonder-working monks who, in the period between Śākyamuni's death and the coming of Maitreya, remain on earth and sustain the faith. Because of their virtue, they possess supernatural powers and are shown taming wild beasts, walking on water, and performing other prodigious deeds of spiritual and physical prowess. Because they are mortal beings and not yet fully enlightened, they are shown as distinct individuals, most of them ugly and aged as though marked by their long struggle for salvation. Some of the arhats are quasi-historic figures and appear prominently in early Indian Buddhist texts: Rāhula was the only son of Śākyamuni; Piṇḍola was one of his most prominent disciples whom the Buddha chastized for attempting to flaunt his magical powers and whom he forbad to enter nirvana; Nāgasena was the famous teacher of the Indo-Greek king Menander as described in the *Milindapañha,* a major text of the Southern Buddhist (Hinayana) tradition. As monkish ascetics, the arhats symbolized the arduous and lonely path to enlightenment in the Southern Buddhist creed, and were contrasted, as here, with the beatific and ideal grace of the bodhisattvas, who were emblems of the transcendent powers of Mahayana Buddhism.

The concept of the arhats—in groups of sixteen, eighteen, or five hundred—is similar to that of the close historic disciples of the Buddha, who were usually said to be ten in number; indeed, Rāhula appears in both categories. Like the Twelve Apostles of Jesus, the Buddha's disciples and arhats were less holy and wise than their leader, but they were nonetheless charged with sustaining the faith after his passing. Christ's Apostles, for example Saints Peter and Thomas, were mortal and fallible entities, but the arhats evolved into more or less supernatural beings.

Groups of five hundred arhats figure prominently in Buddhist literature to express the notion of advanced monkish adepts. In the Lotus Sutra and other Mahayana texts, five hundred arhats are among the auditors of the Buddha's sermons at the Vulture Peak; after his death, they gathered at the great assemblies of the faith in order to clarify his doctrines. The first of the arhats, Piṇḍola, became the object of an independent cult in East Asia, and to this day he is popularly worshiped in Japan. As a prominent example, a large wooden statue of the arhat sits on the porch of the Hall of the Great Buddha (Daibutsuden) at Tōdai-ji in Nara, and is briefly worshiped by devotees before they enter the awesome presence of the giant bronze image of Vairocana.

In Chinese Buddhist arts, arhats or disciples were relatively prominent, a relic of the familiar values and outlook of Southern Buddhism combined with the native tradition of reverence toward wonder-working Taoist sages. The concept of the arhat took on special appeal to Ch'an Buddhists (see Part Four, Zen Buddhist Paintings), who revived a number of Southern Buddhist attitudes, particularly the emphasis upon seated meditation and personal self-discipline, and who were also influenced by Taoist ideals. Beginning in the Sung period, owing chiefly to the special emphasis given to the arhats in Ch'an Buddhism, their images increased startlingly in number; in Japan, the spread of Ch'an in the thirteenth century resulted in the arhats becoming a major icon-type.

The triptych in the Gruber collection could well have come from a Zen context, although it is now difficult to prove this, and analogous works are found in other Mahayana establishments. The figures of the arhats were actually taken from a number of separate traditions of arhat imagery and mixed together. The figure on horseback in the foreground of the right panel, and the arhat taming a tiger above him near the top, came from the same tradition as the Boston

Museum Nakula (no. 4), going back to the late T'ang period. Several of the arhats in this painting show a striking resemblance to a group of arhats, six remaining of an original set of sixteen, in a handscroll in the Peking Palace Museum. The Peking scroll is attributed to the T'ang artist Lu Leng-chia, but is actually a Southern Sung painting close in style to that of Liu Sung-nien. In the left panel of the Gruber triptych, the figure seated on the waves and, indeed, the entire formulation of the trinity of Śākyamuni, Mañjuśrī, and Samantabhadra in the center recall Southern Sung and Yüan precedents. Possible Chinese prototypes for the trinity may be found in the collections of Kenchō-ji in Kamakura and Nison-in in Kyoto; the latter, of the Yüan period, is particularly close to the Gruber painting in the sharpness of detail and proportion of the figures.

Because of its extraordinarily fine state of preservation, the Gruber triptych offers a rare opportunity to examine painting techniques and color schemes that first became widespread in the thirteenth century and continued in use for several hundred years. In particular, the viewer can see the effects of urazaishiki, applying color from the rear, which established most of the painted portion of the three scrolls. Taking the rabbit or the horse in the right hand panel as examples, the more softly colored areas of the bodies were painted from the back of the silk; the brighter highlights suggesting musculature or shading were painted from the front. All of the bodies of the arhats were painted from the back, with details of facial features—beard, hair, and eyes—done from the front, in black ink, white, or thin applications of other pigments. The clothing was colored with pigments applied from the front, over which designs in contrasting colors or in gold were added. The original sumi outlines for the figures and the folds of the robes are often visible under the thin layer of pigment used to color the garments.

In the bodies and heads of the deities of the central triad, tan (red lead) was applied from behind, and the surface enriched by kindei (gold paint) applied from the front. The red lead background gave the gold a subtle sheen; without it the color would be more strident. The halos of the arhats were painted from behind with green rokushō; green pigment was also applied from the front, creating a contrasting, modeled effect. Similarly, the three halos encircling the central Buddha were painted from behind: a thin mixture of rokushō, finely ground

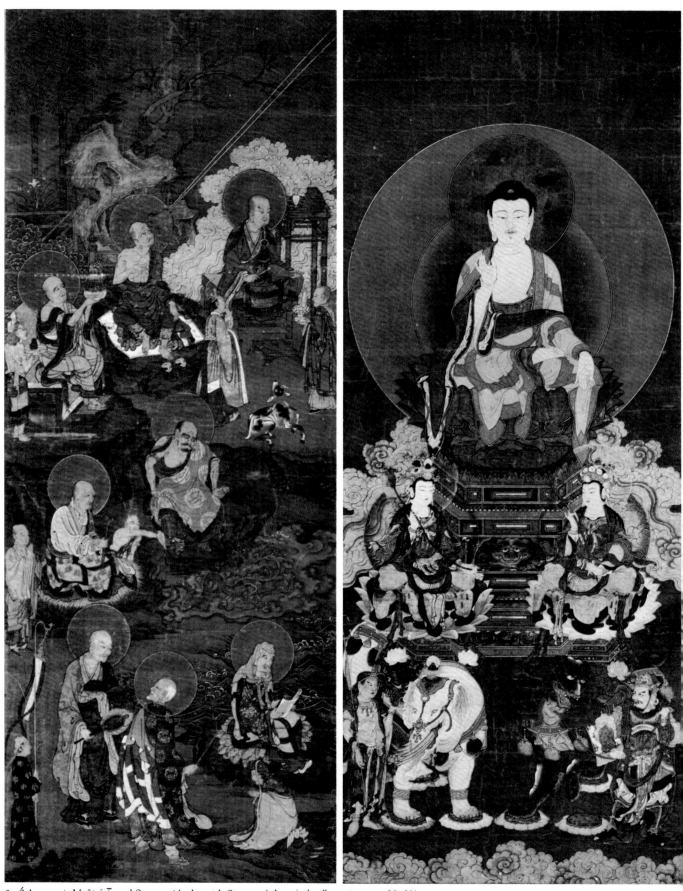

3. Śākyamuni, Mañjuśrī, and Samantabhadra with Sixteen Arhats (color illustrations, pp. 28, 29)

48

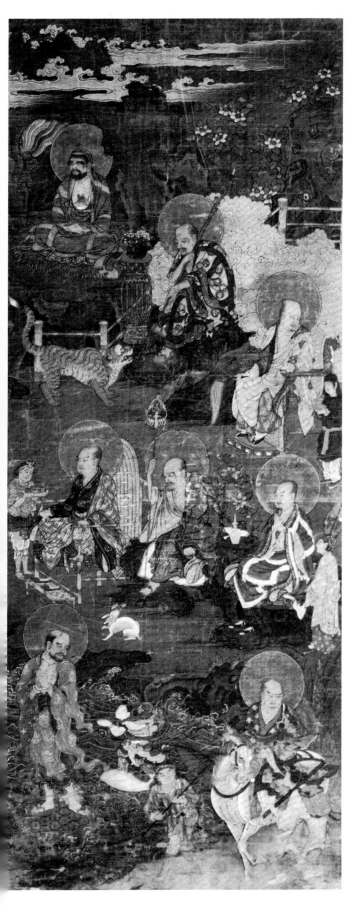

and almost whitish in tone, was applied behind the outer halo; bluish gunjō was used for the inner body halo and the halo behind Śākyamuni's head. These two inner halos were emphasized by the application of gunjō from the front as well.

All the clouds were painted in white from the back. As with the halos of the deities, this created a shimmering yet muted effect. For the waves and the clouds, accent and boundary lines were added from the front of the silk in black ink and various pigments. The overall effect is one of extraordinary richness and subtle modulations.

The process of transmission and copying of Buddhist paintings is made especially clear by the existence of three paintings, extraordinarily close in detail to the Gruber triptych, that were published in 1933 as being in the Asada Collection in Tokyo. The central portion lacks the figures of Mañjuśrī and Samantabhadra, and Śākyamuni and his throne are somewhat more elaborate; but the paintings of arhats are virtually identical in composition and execution, the primary difference being that the Asada painting is filled with even more circumstantial detail. The differences in execution suggest that the Asada painting is somewhat older, but the two sets must have come from the same atelier or else have been very closely linked by a common prototype. Less close but still sharing many of the same elements in different combinations is a pair of paintings of the Sixteen Arhats datable to the Muromachi period still in the collection of the Shōju Raigō-ji near Otsu city.

With such careful adherence to compositional and iconographic programs, paintings such as these are difficult to date precisely. In the Gruber triptych, however, the linear treatment of the clouds, the handling of the waves, and organization of light and dark are those of the best products of traditional Buddhist painting workshops of the first half of the fifteenth century, from which numerous dated nirvana scenes have come (no. 2).

References: *Kokka,* no. 507 (February 1933); Mainichi Shinbunsha (ed.), *Jūyō Bunkazai,* vol. 7 (Tokyo, 1972), figs. 93, 96, 261, 263; *Jūyō Bunkazai,* vol. 8 (Tokyo, 1973), fig. 158; M. W. de Visser, *The Arhats in China and Japan* (Berlin, 1923); Cheng Chen-to (ed.), *Wei-ta-ti-I-shu-ch'uan-t'ung Tu-lu,* 2 vols. (Shanghai, 1955), fifth set pls. 1, 2.

4. The Arhat Nakula (Nakora)

From a set of the Sixteen Arhats (Rakan)

Late thirteenth century A.D.
Ink and colors on silk
Hanging scroll; 85.7 × 35.9 cm
Museum of Fine Arts, Boston; Fenollosa-Weld
 Collection

One of the group of sixteen legendary, wonder-working arhats (no. 3), the wizened Indian sage leans toward a pair of tigers whose turbulent nature has been subdued by his sanctity. Like a tame pet, one of the beasts brings in his mouth a blossom to be added to the bowl of flowers held by the attendant. Against the background of the coarse and darkened silk, a gnarled and twisted tree is established with strong black ink; it grows out of a rocky outcropping that shares the tree's sense of writhing and twisting vitality. The blossoms were painted in strong, pink outlines; the coat of the servant is a yellow-orange, his trousers are white. The painting was executed by a Buddhist master of relatively modest pretentions, but as with the fragment from the E-inga-kyō scroll (no. 1), the extraordinary beauty of this work lies in its straightforward simplicity, its fidelity to ancient traditions, and an inner harmony and purposefulness of its parts.

The inscription identifies the figure as the fifth of the revered ones, Nakula by name, perhaps from south Jambudvipa (literally, the continent of the rose apple tree, the term by which India was designated in Buddhist cosmology). The historical identity of Nakula, unlike that of such arhats as Rāhula or Nāgasena, is unusually vague. In any event, the arhats, apart from Piṇḍola, were symbolically more important as a collective group than as individuals, and the identification of the figure types often varies from painting to painting.

This small picture is one of a complete set of the Sixteen Arhats in the Museum of Fine Arts, Boston, distinguished by their ingenuous style of painting and by the fact that they belong to perhaps the very oldest lineage of formal arhat imagery in Japan, one that can be traced back to the late T'ang period and prior to the onset of the great enthusiasm for the arhats in Ch'an Buddhist circles. Formal devotions to the arhats seem to have begun in T'ang China, at the time of Hsüan-tsang who, in A.D. 645, translated a text describing the Sixteen Arhats and their dwelling places, the Fa-chu-chi (T 2030). In Japan, although incidental images of arhats appear in the Hōryū-ji wall paintings and in other early Buddhist images, the first record of images of arhats being worshiped is one of 1019 for the Shaka-dō of the great temple of Fujiwara no Michinaga near Kyoto, the Hōjō-ji.

The oldest surviving examples of this tradition are a set of sixteen paintings originally from the Shōju Raigō-ji near Otsu city, Shiga prefecture, but now in the collection of the Tokyo National Museum. Registered as a National Treasure and believed to date from the second half of the eleventh century, these paintings reveal their derivation from Chinese prototypes of a considerably earlier date by the style of painting in flat, broad areas of pigment, by the recurrence (as in the Boston picture) of the motif of a figure seated beneath a low tree so familiar in eighth-century Chinese compositions, and by the relatively large scale of both of the figures and circumstantial details. Other members of this tradition are sets of the arhats in the Chōju-ji in Shiga prefecture and at the Kakurin-ji in Hyōgo, both dating from the early Kamakura period, as well as another set, somewhat later in date, preserved in Hōryū-ji. The Boston set belongs to this tradition only in matters of pictorial style; iconographically it is much different. It has no other close parallels and seems to have emerged from a separate and lost tradition of Chinese arhat painting of the eighth to the tenth centuries.

In the great set of arhat paintings now in the Tokyo National Museum, the mainland stylistic elements had already been well absorbed and many traits of native Japanese narrative painting are in evidence. In the Boston paintings, coming over two hundred years later, the assertion of Japanese stylistic traits is even more prominent: the bold application of flat areas of pigment, the lack of spatial recession, and the schematic treatment of the tree trunk, landforms, flowers, and tiger stripes. These traits, when compared to elements in narrative Japanese scroll painting as well as traditional Buddhist imagery, point to a date at the very end of the thirteenth century.

Published: Shimada Shūjirō (ed.), Zaigai Hihō, vol. 2 (Tokyo, 1969), text p. 43.

References: Tanaka Kisaku, "Yamato-e Jūroku Rakan-zō ni tsuite," Bijutsu Kenkyū, no. 58 (October 1936); Hōryū-ji, vol. 5, Nara Rokudai-ji Taikan vol. 5 (Tokyo, 1971), pls. 199–209; Mainichi Shinbunsha (ed.), Kokuhō, vol. 2 (Tokyo, 1964), pls. 81–83; Watanabe Hajime, "Tokyo Bijutsu Gakkō-zō Rakan-ga ni tsuite," Bijutsu Kenkyū, no. 7 (July 1932); Mainichi Shinbunsha (ed.), Jūyō Bunkazai, vol. 8 (Tokyo, 1973), pp. 66–92, 117–130; Sylvain Lévi and Edouard Chavannes, "Les seize Arhats protecteurs de la Loi," Journal Asiatique (1916).

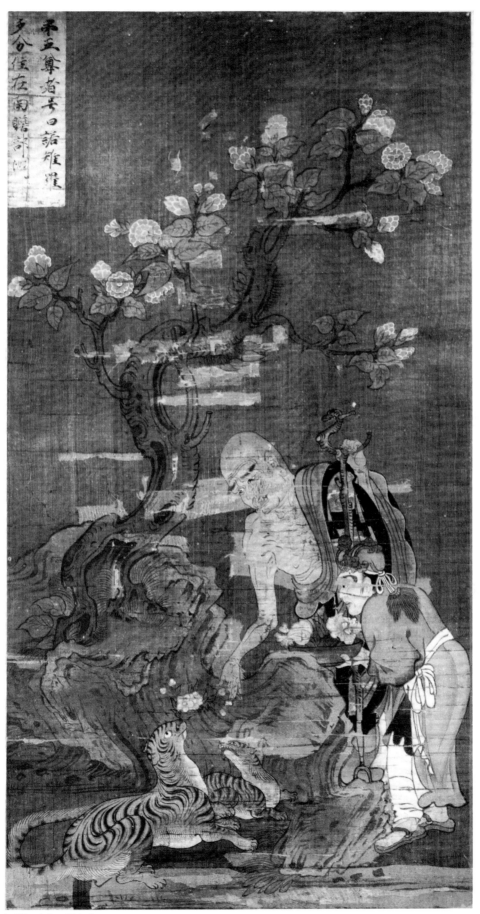

4. The Arhat Nakula

5. Mañjuśrī, the Bodhisattva of Wisdom (Pañca-śikha Mañjuśrī; Gokei Monju)

Mid-fourteenth century A.D.
Ink, colors, gold pigment, and kirikane on two
 pieces of silk
Hanging scroll; 118.1 × 61.3 cm
Collection of Kimiko and John Powers

This painting and the following one are products of the Japanese revival of the cult of the Bodhisattva of Wisdom in the thirteenth and fourteenth centuries A.D. Each depicts the miraculous appearance of the deity in this world, an event often reported by pilgrims to Mount Wu-t'ai in China's Shansi province, regarded as the deity's sacred abode. The Powers' painting shows Mañjuśrī and his lion descending on clouds from an ethereal source; the Cleveland painting shows them on the stone floor (ishi-datami) of a temple hall. These two fine works demonstrate both great similarities and also the subtle nuances of expression possible within the narrow confines of traditional Buddhist painting.

In both paintings, the youthful Mañjuśrī is seated on his lion with his right leg crossed before him and the other pendant. In his right hand he holds a sword, emblem of the victory of knowledge over ignorance, and in the left, a long-stemmed lotus flower supporting a sutra book, a prajñā-pāramitā text. His hair is arranged around his head in five flattened, knoblike coils. His amply fleshed face with its delicate features is shown in a slightly informal three-quarter view. Whereas the bodhisattva is tranquil and his gaze detached, the lion is portrayed in a striding posture with a wide open, growling mouth. The depiction of Mañjuśrī's childlike body and garments with sure, even lines is a visual counterpoint to the sharp, calligraphic modeling of the lion's muscular frame.

The youthful innocence of the bodhisattva and the close intimacy of such representations belie the rich symbolism that underlies them. The Cleveland painting, more than that of the Powers, emphasizes clearly Mañjuśrī's five coils of hair, the pañca-śikha, or gokei in Japanese. The numeral five is a recurrent feature in Mañjuśrī's cult. Mount Wu-t'ai (Five Terrace Mountain) is comprised of five peaks; Mañjuśrī is often shown with four attendants. The five coils of hair stand for the five types of knowledge inherent in the Five Wisdom Buddhas, who are sometimes depicted in or above each tuft of hair. The five coils also symbolize the prayer formula a-ra-pa-ca-na, the five-character mantra that expresses the power and wisdom of Mañjuśrī.

Representations of the Gokei Monju first appear in Japan in the late Heian period. It is possible that the

monk painter Chinkai (1091–1151) of Daigo-ji was instrumental in the spread of such imagery, since some of the most illustrious renderings of the theme, including the so-called "Mañjuśrī Crossing the Sea" of the mid-thirteenth century in the Daigo-ji Kōdai-in, have been traditionally attributed to him. Chinkai was actually thought by his contemporaries to be an incarnation of the Bodhisattva of Wisdom. No painting of the subject by Chinkai survives, but a portrayal of the youthful five-tufted Mañjuśrī in an iconographic scroll dated in accordance with A.D. 1163 by the Ninna-ji monk Kan'yu suggests that it was already popular by this time. Although the depiction of Mañjuśrī as a child subsequently became widespread as part of the broader cult of child deities, the portrayal of the bodhisattva in such a manner stems from the epithet "young prince" (kumārabhūta), which was applied to him from the early stages of his cult in Central Asia and China.

The majority of reliably documented or dated Kamakura period images of Mañjuśrī are associated with the evangelistic monks Eizon (1201–1290) and Ninshō (1217–1303) of Saidai-ji, perhaps the most active and influential religious figures of their day in the Nara region. Saidai-ji records indicate that around 1250 Eizon commissioned a painting of Mañjuśrī and eight child attendants by the Kōfuku-ji ebusshi (master) Gyōson. A badly preserved painting of that subject is kept in the temple; with a limited use of modulated brushwork, it is considerably more conservative in style than the Powers painting. Eizon also commissioned a number of printed copies of the Mahā-prajñā-pāramitā-sūtra, with frontispieces representing a five-tufted Mañjuśrī, which bears a general iconographic relationship to the present work. One, dated in accordance with 1267, is preserved at Saidai-ji and another dated in accordance with 1279, with an inscription by Eizon himself, is in the Spencer Collection of The New York Public Library.

In collaboration with Christine Guth Kanda, Princeton University

Published: John M. Rosenfield and Shūjirō Shimada, *Traditions of Japanese Art: Selections from the Kimiko and John Powers Collection* (Cambridge, MA, 1970), no. 44; Noma Seiroku in *Kobijutsu*, no. 11 (November 1965).

References: Étienne Lamotte, "Mañjuśrī," *T'oung Pao*, 48 (1960); Edwin O. Reischauer (trans.), *Ennin's Diary* (New York, 1955), pp. 226–266; *Saidai-ji*, Nara Rokudaiji Taikan vol. 14 (Tokyo, 1973), pls. 121, 136, 137; *Kōya-san*, *Hihō* vol. 4 (Tokyo, 1966), pl. 37; *Bukkyō Geijutsu*, 62 (October 1966), special issue on Saidai-ji; Ishida Mosaku, *Kodai Hanga*, Nihon Hanga Zenshū vol. 1 (Tokyo, 1961); Takasaki Fujihiko, *Bukkyō Kaiga-shi* (Tokyo, 1966).

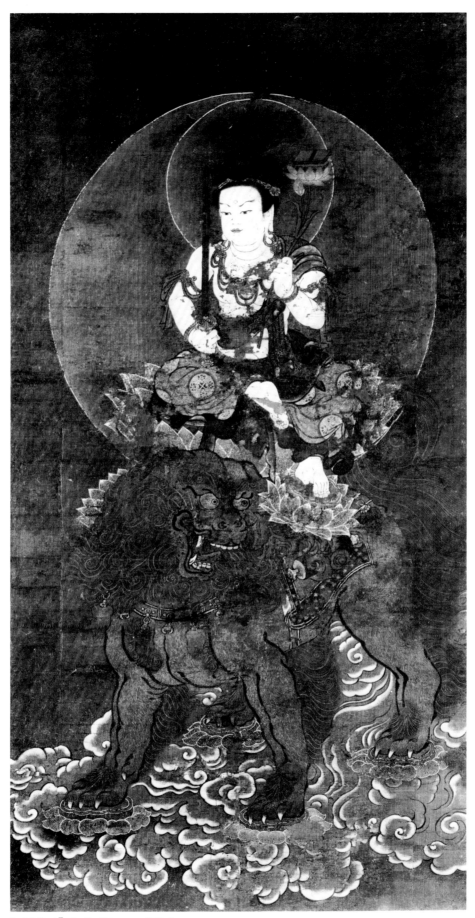

5. Mañjuśrī, the Bodhisattva of Wisdom

6. Mañjuśrī, the Bodhisattva of Wisdom (Pañca-śikha Mañjuśrī; Gokei Monju)

Second half of the fourteenth century A.D.
Ink, colors, gold pigment, and kirikane on silk
Hanging scroll; 121.9 × 42.5 cm
The Cleveland Museum of Art; Purchase, the J. H. Wade Fund

A comparison of this and the Powers painting (no. 5) brings into clear focus the subtle stylistic variations that entered, perhaps unconsciously, into Japanese Buddhist painting workshops. The Powers painting may be slightly older; in general, it is more three-dimensional in effect whereas this painting is more sumptuously decorative. The forms of the human body and drapery in the Powers painting are more nearly organic or representational in quality; the drawing of details such as the lotus pedestals beneath the feet of the bodhisattva and the lion is endowed with a greater sense of amplitude and vigor. In this painting the lion's mane and tail are more two-dimensional, the lion's face more schematic. The previous painting has a greater quantity of cut gold leaf (kirikane) in the garment patterns and lotus leaves; this work relies more on heavy applications of gold paint (kindei).

This image type surely originated in China. A close analogue may be seen in a Sung Chinese painting of Śākyamuni with Mañjuśrī and Samantabhadra preserved in the Kenchō-ji in Kamakura. However, by the time the Cleveland and Powers paintings were created, the type had been given distinctive Japanese traits—stronger decorative effects and a diminished sense of pictorial depth. Moreover, paintings of Mañjuśrī were produced in Japan in large quantities as the bodhisattva became increasingly popular as a protector and spiritual refuge for persons in difficult straits. The monks Eizon and Ninshō of Saidai-ji, for example, were concerned for the well-being of all segments of the population, even lepers, prisoners, and other outcasts. With Mañjuśrī as patron deity, they founded hostels for the sick and homeless and conducted Buddhist services in prisons.

Surviving today are at least three dozen Japanese paintings of Mañjuśrī in the same idiom as the Powers and Cleveland works or in analogous ones. Those that remain in temple collections are chiefly in Esoteric Buddhist contexts, such as on Mount Kōya and at Enryaku-ji and Tōji. One of the chief landmarks of their chronology is a pair of paintings datable through their connection with Monkan Sōjō (1278–1357), an influential and even notorious monk with both Tendai and Shingon affiliations active in the circle of the Emperor Go-daigo. Dated in accordance with A.D. 1334 is a painting of Mañjuśrī and eight boy attendants traditionally attributed to Monkan himself; it is kept today in Tōji. The other, datable to about 1357, is a painting of the Gokei Monju inscribed in Monkan's honor at the time of his death. The Tōji painting is much more florid and elaborate than the Cleveland and Powers paintings, but it is linked to them by basic traits of style such as mode of execution, color scheme, and proportion of the human figure. In all four works, the lions have strongly calligraphic lines far different in quality from those normally found in classical Buddhist painting and symptomatic of the increasing intrusion of ink painting techniques in Buddhist circles.

In collaboration with Christine Guth Kanda, Princeton University

Published: *Bulletin of the Cleveland Museum of Art,* 59 (January 1972): 37.

References: Nara National Museum (ed.), *Nihon Bukkyō Bijutsu no Genryū* (Nara, 1978), painting no. 14; *Bukkyō Geijutsu,* 62 (October 1966), special issue on Saidai-ji; Takasaki Fujihiko, *Nihon Bukkyō Kaiga-shi* (Tokyo, 1966); *Kokka,* no. 352 (August 1919), no. 535 (June 1935), no. 541 (December 1935); *Hiei-zan,* Tendai no Hihō (Tokyo, 1971), pl. 114; Mainichi Shinbunsha (ed.), *Jūyō Bunkazai,* vol. 7 (Tokyo, 1972), nos. 129–139.

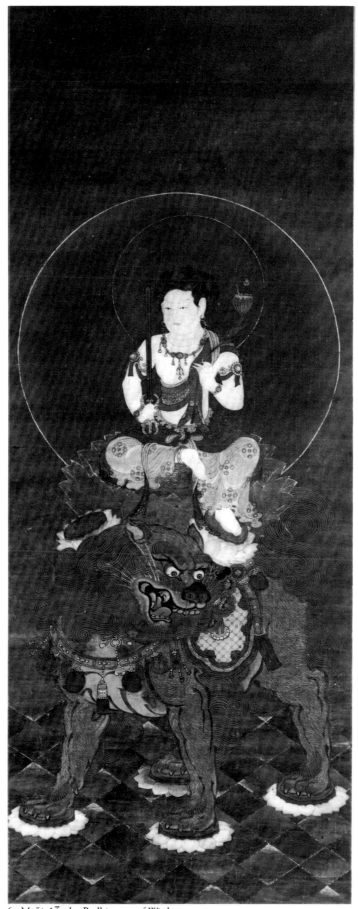

6. Mañjuśrī, the Bodhisattva of Wisdom

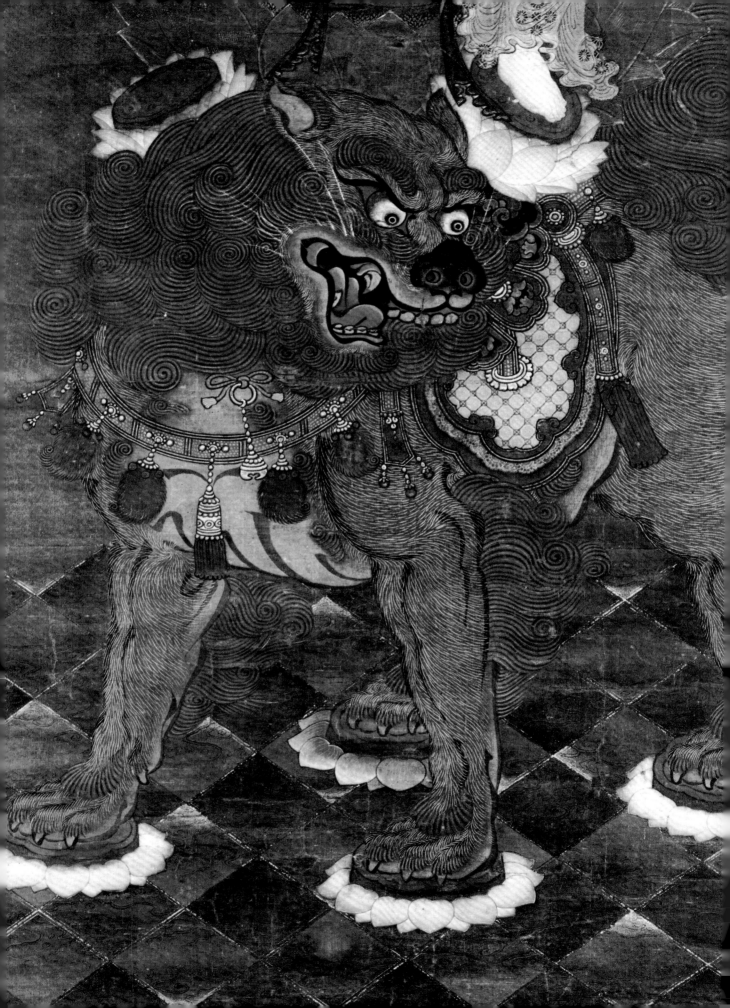

7. The Bodhisattva Samantabhadra (Fugen)

Early fourteenth century A.D.
Ink, colors, and gold pigment on silk
Hanging scroll; 71.4 × 36.8 cm
Asian Art Museum of San Francisco; The Avery
Brundage Collection

The Bodhisattva Samantabhadra (J Fugen) often appears as one of two main attendants flanking the historical Buddha Śākyamuni (no. 3). He is understood to be the personification of the dynamic aspect of Śākyamuni's life—the compassionate and active ministry that was grounded in the Buddha's meditative practice and subsequent enlightenment. His counterpart, Mañjuśrī (J Monju, nos. 5, 6, 51), embodies the Buddha's insight and wisdom (S prajñā).

Two influential texts dealing with Fugen are the Lotus Sutra (in particular, the twenty-eighth chapter) and the Kan-Fugen-kyō (Meditation on the Bodhisattva Fugen), which is added by the Tendai sect to the Lotus Sutra and one other text (the Muryōgi-kyō) to make the Hokke Sambu (Three Scriptures of the Lotus).

The twenty-eighth chapter of the Lotus Sutra introduces this bodhisattva:

> At that time the bodhisattva Universally Worthy (Samantabhadra), who was renowned for awe-inspiring excellence because of his powers of supernatural penetration . . . , came from the eastern quarter. The realms through which he passed all trembled throughout, rained down jeweled lotuses, and resounded with incalculable hundreds of thousands of myriads of millions of kinds of skillfully played music. . . .

This chapter goes on to detail the basic iconography of the deity as he appears in the San Francisco painting, stating that Fugen has vowed to protect those who honor and copy the Lotus Sutra. Fugen himself speaks:

> If that person, whether walking or standing, reads and recites this scripture, at that time I, mounted on a white elephant-king with six tusks . . . will go to that place and, personally revealing my body, make offerings to him, guard and protect him, and comfort his thoughts. (Translations by Leon Hurvitz)

The Kan-Fugen-kyō is a short text purporting to recount the lecture given by Śākyamuni in the Great Forest Monastery at Vaiśālī three months before his death. Here the Buddha discusses the merits of meditating on Fugen and instructs devotees in rites of repentance and purification. A few sentences from this sutra are especially pertinent to the present painting:

> The elephant has six tusks [suggesting the purity of the six sense organs: eye, ear, nose, tongue, body, mind] and, with its seven legs [suggesting the absence of the seven evils: killing, stealing, committing adultery, lying, speaking ill of others, improper language, having a double tongue] supports its body on the ground. Under its seven legs seven lotus flowers grow. The elephant is white as snow, the most brilliant of all shades of white, so pure that even crystal and the Himalaya Mountains cannot be compared with it. (Translation by Bunnō Katō)

Faithful to the descriptions in these texts, the San Francisco Fugen appears mounted on his six-tusked white elephant on a swirl of clouds, as if he were indeed descending from the Jōmyō-koku, the Pure Wondrous Land in the east. The elephant of course had long suggested royalty, wealth, and power in India; white elephants had been considered divine; his six tusks may also recall the six perfections or pāramitās. Three tiny lotus pedestals close to the elephant's four legs suggest the three extra legs of this extraordinary beast mentioned in the Kan-Fugen-kyō, but awkward or distracting to include in a pictorial representation.

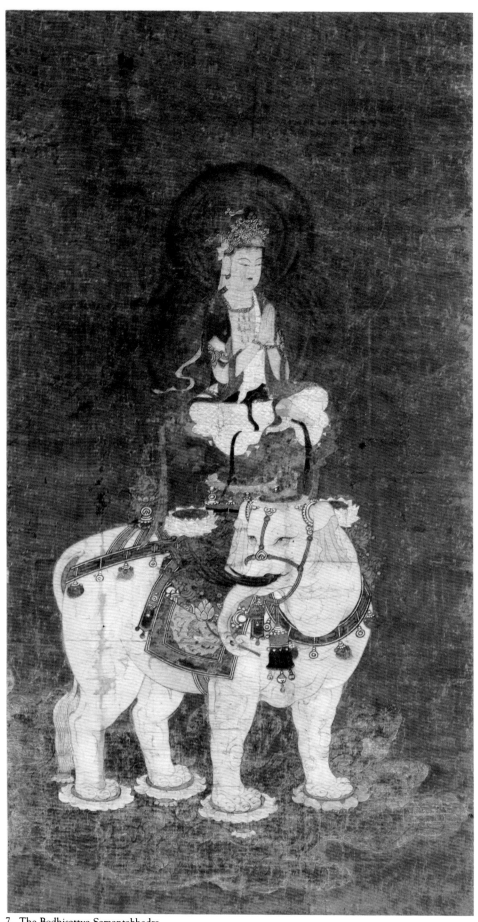

7. The Bodhisattva Samantabhadra

The bodhisattva's attitude is almost that of a raigō or "Welcoming Descent" typical of Pure Land imagery (no. 32), and paintings like this one often appear in Pure Land temples. The Lotus Sutra mentions that Fugen will be especially watchful and protective during the age of the Latter Law (mappō), one of the concepts which encouraged the spread of Pure Land teachings (see Part Three). Fugen was the particular guardian of women, for women are offered enlightenment (once they have been transformed into men) in both the Lotus Sutra and in Pure Land texts. Sometimes Fugen is accompanied in his descent by ten rasetsu-nyo (S rākṣasī), a group of female beings with supernatural power derived from Hindu mythology who appear in the seventh chapter of the Lotus Sutra as guardians of those who promote the text. Fugen and these maidens were arbitrarily joined in the late Heian period because of their protective role. In Esoteric imagery, Fugen also appears as a multiarmed deity mounted on an elephant with multiple heads. One of his functions in this religious context is to prolong the life of the devotee, hence he is called the Life-Prolonging (Enmei) Fugen.

The San Francisco Fugen has suffered damage, but it has been carefully restored. The iconography and overall conception of the image indicate that it follows in the tradition of the famous mid-twelfth-century Fugen in the Tokyo National Museum. The faces of the deity and the elephant, so skillfully handled, suggest Buddhist painting styles of the mid-to-late thirteenth century, but the harness and ornamentation of the elephant seem to be of a slightly later vintage. In some details of facial features and in the slender proportions of the figure, this painting shows close correspondences to the late Kamakura period *Welcoming Descent of Amida and the Twenty-Five Bodhisattvas* in the Shin Chion-in in Shiga prefecture.

References: Kyoto National Museum (ed.), *Jōdo-kyō Kaiga* (Tokyo, 1975), nos. 84, 89; Leon Hurvitz (trans.), *Scripture of the Lotus Blossom of the Fine Dharma (The Lotus Sūtra)* (New York, 1976), p. 332; Bunnō Katō et al. (trans.), *The Threefold Lotus Sutra* (New York, 1975), p. 349.

8. The Bodhisattva Kṣitigarbha (Jizō)

First half of the fourteenth century A.D.
Ink, colors, gold pigment, and kirikane on three pieces of silk
Hanging scroll; 117 × 50.5 cm
Museum für Ostasiatische Kunst, Staatliche Museen Preussischer Kulturbesitz, Berlin (West)

One of the most sympathetic and approachable bodhisattvas in popular Japanese Buddhism, Jizō is shown here in his customary guise as a monk with a shaven head. In his left hand he holds the wish-granting jewel symbolic of his limitless power and desire to respond to the prayers of his votaries. In his right hand is the golden shakujō or monk's staff, with its jangling metal rings at the top. Monks used this staff to announce their approach, for they had to observe a rule of silence when begging for alms. The jangling rings would also presumably frighten away insects and animals on which the monks might inadvertently tread and thereby break the precept not to harm any living thing. The fact that this staff has six rings recalls the Six Perfections that lead to nirvana (J roku-hara-mitsu: generosity, morality, patience, vigor, concentration, and wisdom). More important, it serves to remind the viewer that Jizō is one of the saviors of beings in the Six Realms of Existence (rokudō). Paintings and dramatic literary accounts describe the deity's efforts on behalf of those suffering in Hell (no. 47).

The color scheme of the Berlin painting is delicate and harmonious, with tones of blue, green, and gold dominant on the robes, and with soft shades of peach and tan for the lotus throne. The handling of the designs and effects of transparency on the garments is particularly skillful. The painting must have been cut down at both sides and bottom.

A guide to the chronology of the Berlin painting is a hanging scroll in the Hōju-in on Mount Kōya dated in accordance with A.D. 1384 by an inscription on its back, which also gives the name of the painter, Yuen. The figure of Jizō there, seated in a mountain landscape with waterfall and streams, is more hardened and formalized and lacks the gentle, boyish aspect of the Berlin Jizō; it is probably several decades later in date. A painting of Jizō with composition closely similar to the Berlin work, showing the bodhisattva seated on his throne but without a specific setting, is found in the collection of the Daigo-ji. Neither painting is dated, but most evidence indicates that the Berlin Jizō was done in the first half of the fourteenth century.

One unusual feature of the Berlin painting is the closed lotus flower below the deity's raised right leg; most Japanese examples show an unoccupied lotus

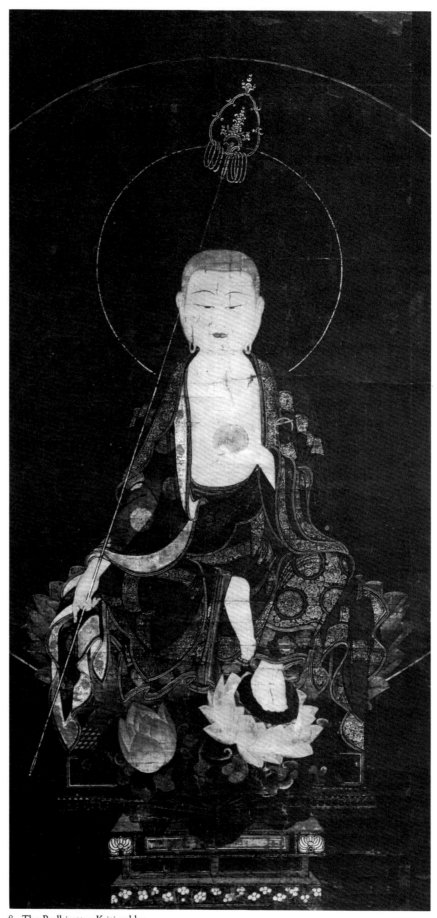

8. The Bodhisattva Kṣitigarbha

pedestal like this one as a fully opened flower. Chinese prototypes for this kind of representation do exist. Relatively close in time to the Berlin piece, for example, is the monumental thirteenth-century wall-painting of an assembly of Maitreya, originally from the Hsing Hua-ssu (southern Shansi province), now in the Royal Ontario Museum in Toronto. Here closed lotus flowers appear below the raised legs of Monju and Fugen, the two chief, seated attendant bodhisattvas.

Worship of Jizō was introduced into Japan during the Nara period. It is recorded that a statue of the deity was dedicated in the Lecture Hall of Tōdai-ji in 747, and sutras dealing with the bodhisattva are mentioned in eighth-century Shōsō-in documents. In the early Heian period, Jizō was revered as one of the Eight Great Bodhisattvas of the Esoteric tradition. He appears in this connection as a bejeweled, ornamented figure, with his counterpart, the Bodhisattva Kokūzō. The name Jizō (S Kṣitigarbha) means Matrix of the Earth, whereas Kokūzō (S Ākāśagarbha) may be translated as Matrix of the Void. Together, the deities represent the union of these two elements in the physical and metaphysical realms.

Pre-Esoteric texts had emphasized the salvific nature of Jizō's mission on earth, and in both China and Japan Jizō gradually became associated with the popular creeds of salvation, appearing in the guise of a monk. But it was not until the end of the Heian period, with the phenomenal rise of Amidism, that his worship became widespread at a popular level in Japan. Jizō became one of the important members of Amida's retinue, often known as Indō (Drawing Up) Jizō, ready to guide beings, particularly those who had fallen into hell, to the bliss and glory of the Western Paradise (no. 47). Revered as the protector of those who are vulnerable to danger—children, travelers, women (especially those in childbirth), and warriors—Jizō has also been invoked in numerous small temples across Japan for a variety of lesser ills: the Hōroku (Baking Pan) Jizō who cures headaches and the Amename (Candy-licking) Jizō who alleviates toothaches; Jizō will also make ugly women beautiful.

Published: Museum für Ostasiatische Kunst, Staatliche Museen Preussischer Kulturbesitz, Berlin (ed.), *Ausgewählte Werke Ostasiatischer Kunst* (Berlin-Dahlem, 1970), no. 83, with further references.

References: M. W. de Visser, *The Bodhisattva Ti-tsang (Jizō) in China and Japan* (Berlin, 1914); Manabe Kōsai, *Jizō Bosatsu no Kenkyū* (Kyoto, 1960); *Daigo-ji,* Hihō vol. 8 (Tokyo, 1968), pl. 102, p. 343; *Kōya-san,* Hihō vol. 7 (Tokyo, 1968), pl. 33, p. 339.

9. Enthroned Preaching Buddha

Chapter 544 of the Greater Sutra of the Perfection of Wisdom (Mahā-prajñā-pāramitā-sūtra; Dai-hannya-haramitta-kyō)
Ca. A.D. 1125; from Chūson-ji, Hiraizumi, Iwate prefecture
Gold and silver pigment on dark blue paper
Frontispiece illustration attached to handscroll; 25.7 × 20.7 cm
The New York Public Library, Astor, Lenox, and Tilden Foundations; Spencer Collection

Throughout the twelfth century A.D., aristocratic families donated to their temples tens of thousands of sutra scrolls, often with illustrated frontispieces. A moving passage from the fortieth chapter of the *Tale of Genji,* entitled Minori (Law, or Ritual), describes one such commission by the doomed Lady Murasaki, Genji's long-time but unofficial consort. For a period of years, Lady Murasaki had put scribes to work making a thousand copies of the Lotus Sutra that she intended to offer to the chapel of Nijō-in, the Palace of the Second Ward, where she often stayed. The work was completed just as her own health was about to fail entirely, and she arranged for a lavish ritual of dedication. With a vast throng in attendance and gifts from the emperor and empress, the dedication ceremony lasted through the entire evening and brought deep consolation to Lady Murasaki and the conviction that she would be born into the paradise of Amida.

As the result of the sheer quantity of these commissions, many of the frontispiece illustrations lack the delicacy and refinement of detail found in other Buddhist paintings of the day. The work exhibited here, for example, was drawn in a cursory, abbreviated manner, but it nonetheless conveys a strong and majestic impression, and is of high art historical importance because of its relatively early date. Śākyamuni is shown seated on a lotus throne, his two hands upraised in the attitude of preaching. He is flanked by a bodhisattva on his right holding a flower, and on his left by another with hands clasped in prayer. Four laymen garbed in the manner of Chinese court officials kneel in the foreground of the composition before the offertory table in front of the Buddha.

This scroll and the two that follow it are part of the once vast holdings of illustrated Buddhist texts donated in the twelfth century to the monastery of Chūson-ji. Located near the city of Hiraizumi in Iwate prefecture in northeastern Honshu, Chūson-ji was the tutelary temple of the local rulers of that distant region, the

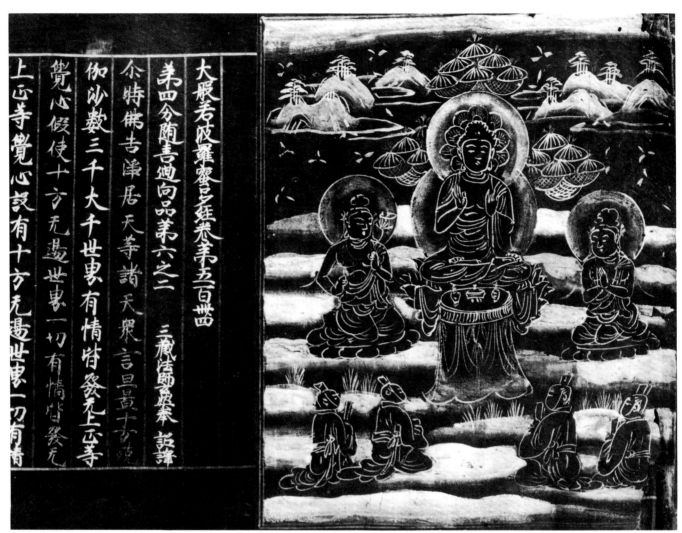

上正等覺心設有十方无邊世界一切有情

覺心假使十方无邊世界一切有情皆發无

伽沙數三千大千世界有情皆發无上正等

尒時佛告淨居天衆言曰量十方殑

弟四分隨喜迴向品第六之二　三藏法師玄奘奉　詔譯

大般若波羅蜜多經卷第五百嶅

9. Enthroned Preaching Buddha

Fujiwara family of Mutsu and Dewa, who were only distantly related to the main branch of the clan ruling in Kyoto. Their military success, as well as the discovery of gold in their domain, had established their power and prosperity. Fujiwara no Kiyohira (died 1126) built the city of Hiraizumi modeled on the Heian capital. He and his son Motohira (died 1157) and grandson Hidehira (died 1187) devoted much energy to building projects in the vicinity of the city, most notably at its principal monastery complex, the Chūson-ji, which by the time of Hidehira boasted more than forty main buildings and three hundred subtemples. Surviving today is one of the most lavish of these structures, whose name, Konjiki-dō (Gold-Colored Hall) conveys well its resplendent appearance, for its interior was covered with gold leaf, lacquer, and mother of pearl inlay. This brilliant flowering of a regional culture, inspired by the aesthetic standards of the Heian capital but possessing its own unique vigor of expression, was unfortunately cut short when Minamoto no Yoritomo destroyed the power of the northern Fujiwara in 1189.

Three major sutra transcriptions, associated with the three generations of Fujiwara overlords, were once housed in the Sutra Repository at Chūson-ji, although most of the scrolls have now been dispersed. The first set of over five thousand volumes, to which this scroll belonged, was the entire Buddhist canon (Issai-kyō, or Daizō-kyō) with accompanying frontispieces. Commissioned by Kiyohira and written in alternating lines of gold and silver characters on indigo paper, it was dedicated to the Chūson-ji on the twentieth day of the third month of the year corresponding to A.D. 1126. Records in the Sutra Repository state that a certain administrator named Renkō supervised the production, and that the scrolls were completed in eight years (between 1117 and 1125) by a group of scribes and artists brought from Kyoto. In 1591 nearly the entire transcription was taken from the temple by the warlord Toyotomi Hideyoshi; 4,296 scrolls and 315 sutra cases were given to the Kongōbu-ji on Mount Kōya, and 240 were deposited in the Kanshin-ji near Osaka.

Only fifteen scrolls and 275 sutra cases from this set remain in the sutra library at Chūson-ji.

The second major sutra transcription is the Issai-kyō transcribed with gold ink on dark blue paper associated with the third generation Fujiwara overlord, Hidehira. The transcription (nos. 10, 11), which seems to have been commissioned in honor of a death anniversary of his father, Motohira, was presumably finished in 1175 and dedicated to the temple in the following year. Of it, 2,724 rolls are now kept in the temple sutra storage. This version seems to have been based on a Sung-dynasty woodblock-printed Issai-kyō probably imported about 1160. A third and less ambitious transcription is also associated with Hidehira and Motohira—the Lotus Sutra copied in gold on indigo paper.

As may be seen in this scroll, the hallmarks of the earliest of the Chūson-ji sutra sets are the large scale of the figures in the frontispiece illustrations and the alternating use of gold and silver lines in the text. By contrast to the later illustrations, the figures in the earlier work are much larger in relation to their setting and in internal proportions as well; they suggest by their more elongated torsos a rather grander conception of bodily proportions. Because of their size, the trinity and the devotees dominating this composition leave little room for the narrative elements that characterize later frontispieces. This painting also lacks the spatial recession apparent in the Hidehira sutras, although distant landscape is suggested by the hills and trees in the background of the composition.

Published: Shigeo Sorimachi, *Catalogue of Japanese Illustrated Books and Manuscripts in the Spencer Collection of the New York Public Library,* rev. ed. (Tokyo, 1978), no. 3.

References: Ishida Mosaku, *Chūson-ji* (Tokyo, 1959); Fujishima Ijiro (ed.), *Chūson-ji* (Tokyo, 1971); *Yamato Bunka,* no. 50 (April 1969), special issue devoted to illuminated sutras; Tanaka Kaidō, *Nihon Shakyō Sōran* (Tokyo, 1953).

10. The Apparition of a Bodhisattva

Chapter 282 of the Greater Sutra of the Perfection of Wisdom (Mahā-prajñā-pāramitā-sūtra; Dai-hannya-haramitta-kyō)

Ca. A.D. 1175
Gold and silver pigment on dark blue paper
Frontispiece illustration attached to handscroll;
 25.6 × 22.7 cm
Houghton Library, Harvard University; Gift of
 Philip Hofer

Among the thousands of Chūson-ji sutra illuminations are a few that are inspired in both conception and execution, and this composition must surely be included among them. Two court nobles are shown kneeling in awe before a resplendent bodhisattva arising in clouds in the diaphanous space between heaven and earth. The fact that these are the only figures in the carefully constructed landscape adds to the power of the piece. Through the modulation of the gold paint, the uppermost edge of the frontispiece suggests a luminous sky, and the halos of the bodhisattva pulsate with radiance. The skillful alternation of the gold and the silver pigment produces a landscape of rocks, landforms, and water that is both restrained and evocative.

This scroll contains chapter 282 of the six-hundred-chapter Greater Sutra of the Perfection of Wisdom (Dai-hannya-haramitta-kyō). It is from the first of sixteen sermons given by the historical Buddha on the Vulture Peak near Rājagṛha; two-thirds of the six hundred chapters of this sutra record this first sermon, which presents the basic teachings of the text—the path of the bodhisattva, the six perfections, the perfection of wisdom as the most sublime perfection leading to an intuitive knowledge of the ultimate reality of existence: emptiness or śūnyatā (see introduction to Part One, A Note on Philosophy).

Opening one of the scrolls commissioned by Fujiwara no Hidehira and completed in 1175, this illustration has an inventive composition with a distinct sense of spatial recession and a strongly narrative flavor. The peculiar amoeba-like shapes of the landforms find a parallel in the illustrated sutra scrolls donated by the Taira family to the Itsukushima Shrine in 1167.

Published: John M. Rosenfield, Fumiko E. Cranston, and Edwin Cranston, *The Courtly Tradition in Japanese Art and Literature* (Cambridge, MA, 1973), no. 23.

References: Ishida Mosaku, *Chūson-ji* (Tokyo, 1959); Fujishima Ijiro (ed.), *Chūson-ji* (Tokyo, 1971).

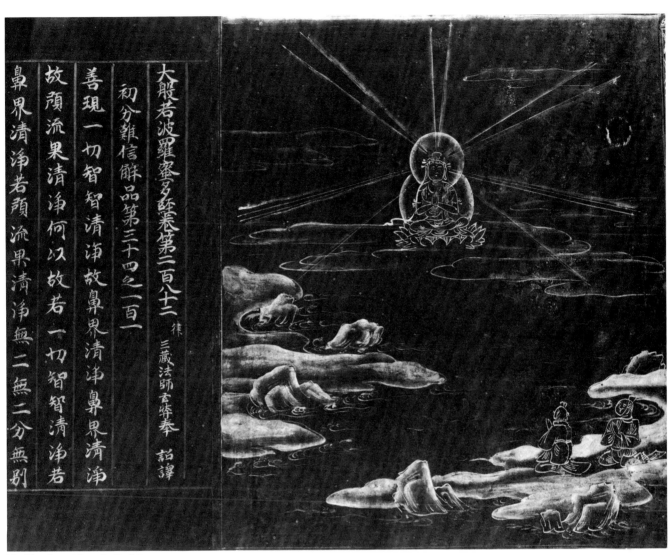

大般若波羅蜜多經卷第二百八十二

初分難信解品第三十四之一百一

三藏法師玄奘奉　詔譯

善現一切智智清淨故鼻界清淨鼻界清淨

故顏流果清淨何以故若一切智智清淨若

鼻界清淨若顏流果清淨無二無二分無別

鼻界清淨若顏流果清淨若

10. The Apparition of a Bodhisattva

11. Buddha Enthroned in a Narrative Setting

Chapter 338 of the Greater Sutra of the Perfection of Wisdom (Mahā-prajñā-pāramitā-sūtra; Dai-hannya-haramitta-kyō)
Ca. A.D. 1175
Gold and silver pigment on dark blue paper
Frontispiece illustration attached to handscroll;
 25.6 × 20.5 cm
The New York Public Library, Astor, Lenox, and
 Tilden Foundations; Spencer Collection

This scroll, like the previous one, belongs to the Chūson-ji sutras associated with Fujiwara no Hidehira; it contains chapter 338 of the Greater Sutra of the Perfection of Wisdom, and is likewise from the first of the sixteen sermons delivered by the historical Buddha on the Vulture Peak.

The scroll has 435 lines of text written in gold ink; silver paint delineates the frame for each line of characters. Although from the same transcription as the previous work, the frontispiece here is quite different both in subject matter and manner of execution, and is, in fact, more characteristic of the transcription as a whole. The bustling composition, with its many narrative elements rapidly executed, renders this scene rather less visionary than the previous one, although it remains of considerable interest nonetheless.

The predominant color is gold, with silver used mostly in mist bands or clouds and small details as the counterpoint. The figures are all done in gold: the enthroned preaching Buddha is flanked by a seated bodhisattva at both right and left, three monks behind, and a kneeling layman off to the right. Another standing bodhisattva has come forward to meet four warriors,

one of whom kneels in prayer; three little boys seem to be fleeing from danger at the lower left. More or less alternating bands of gold and silver suggest hillocks or spits of land, but even here gold predominates and the alternation of color is not as carefully planned or executed as in the Kiyohira sutra (no. 9).

Compared with the Kiyohira Chūson-ji sutra transcription of about fifty years earlier, these two Hidehira-kyō show differences that attest to the development of style within this idiom. The concept of scale is different: the figures are smaller in relation to their settings, somewhat squatter, and certainly not so fluidly drawn. Narrative elements assume far greater importance in the later works. Finally, less attention is paid to the potential interplay between gold and silver, most notably, of course, in the lines of text but also in the juxtaposition of spits of land or sandbars.

The title of the sutra, Dai-hannya-haramitta-kyō, dai sanbyaku-sanjū-hachi [338] appears on the outer cover of the scroll as well as in the first line of text on the inside, just after the frontispiece. But, because it suggests the occasion for human error—a special problem with these rapidly executed, mass-produced scrolls—it is of interest to note that the copyist made a mistake in transcribing the chapter number at the very end of the scroll. Instead of writing 338, he erroneously recorded the number as 328.

Published: John M. Rosenfield, *Japanese Arts of the Heian Period* (New York, 1967), no. 34a; Shigeo Sorimachi, *Catalogue of Japanese Illustrated Books and Manuscripts in the Spencer Collection of the New York Public Library,* rev. ed. (Tokyo, 1978), no. 6.

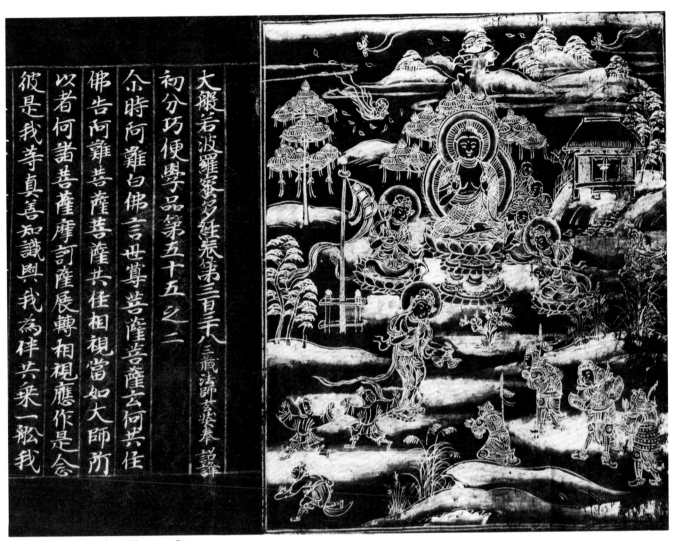

彼是我等真善知識與我為伴共采一舩我
以者何諸菩薩摩訶薩展轉相視應作是念
佛告阿難菩薩菩薩共住相視當如大師所
尒時阿難白佛言世尊菩薩菩薩云何共住
初分巧便學品第五十五之二
大般若波羅蜜多經卷第三百天二藏法師玄奘奉　詔譯

11. Buddha Enthroned in a Narrative Setting

12. Greater Sutra of the Perfection of Wisdom (Mahā-prajñā-pāramitā-sūtra; Dai-hannya-haramitta-kyō)

Chapters 171–180 and 371–380 (frontispieces)
Ca. A.D. 1175
Gold and silver pigment on dark blue paper
Two handscrolls; each 4.4 × ca. 200 cm
Museum für Ostasiatische Kunst, Staatliche Museen Preussischer Kulturbesitz, Berlin (West)

The Museum of East Asian Art in Berlin possesses a group of fifty scrolls and a few fragments from an original set of sixty magnificently ornamented scrolls of the Dai-hannya-haramitta-kyō. Each scroll contains ten chapters of the six hundred chapter text. Dating to the late twelfth century A.D., these scrolls are virtually unique owing to their height (only 4.4 cm high) and the lapidary delicacy with which they were illustrated and written. The traditional history of these scrolls, although partly fanciful, is a good example of the pious fables that often envelop works of religious art.

The documents that accompany the scrolls state that they came from the temple of Jingū-ji in Sumiyoshi, the present-day Osaka, and that they had been copied in the eighth century by the Empress Kōmyō (701–760), wife of the Emperor Shōmu and primary donor of the great Shōsō-in collection. This claim is independently reflected in an old guidebook of the Osaka region, the *Settsu Meisho Zue*, written by Akisato Ritō and published in 1796–1798. The description of the temple, which is affiliated with the Sumiyoshi Shrine, the most important Shinto sanctuary in the Osaka region, states that it was founded by the Empress Kōken in 750 and that it possessed sixty small handscrolls of the Daihannya-kyō, written by Kōken's mother, the Empress Kōmyō. Although the Jingū-ji is an ancient temple, the Berlin scrolls must on stylistic grounds be dated to the last quarter of the twelfth century A.D. They closely resemble in style the Chūson-ji sutra transcriptions associated with Fujiwara no Hidehira (nos. 10, 11) and are entirely characteristic of the style of other late twelfth century sutra illuminations in the use of tiny striations to indicate the hair curls of the Buddha, the facial features drawn in a broad and cursory manner, and the softly illusionistic and yet schematic sense of landscape.

The Berlin frontispieces are basically very similar to one another; the dominant figure is the preaching Buddha enthroned on a lotus pedestal and surrounded by bodhisattvas, monks, and guardian figures. The landforms are indicated by alternating bands of silver and gold; flower petals seem to fall from heaven, adding to the atmosphere of a benign and mystic event. The outer covers of each scroll are decorated with sumptuous designs of gold and silver showing the imaginary hōsōge flowers resembling the peony.

Ornamented Buddhist texts of the twelfth century reveal great variety and ingenuity. The Lotus Sutra was copied on beautifully printed and painted fans that were donated to the Shitennō-ji in Osaka in the early decades of the century. The Emperor Toba, around 1141, commissioned a set of Lotus Sutra scrolls written on papers spectacularly ornamented with gold and silver leaf and given frontispiece illustrations in a secu-

12. Greater Sutra of the Perfection of Wisdom, chapters 171-180, frontispi

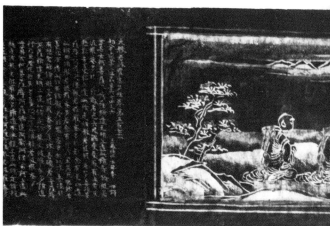

12. Greater Sutra of the Perfection of Wisdom, chapters 371-380, frontispi

lar, courtly style of narrative painting. In 1167, the triumphant military leader Taira no Kiyomori donated an even more lavishly ornamented set of the Lotus Sutra to his family's tutelary shrine, Itsukushima. The Emperor Go-shirakawa (1127–1192) commissioned the entire Buddhist canon to be copied in gold on indigo paper and donated to the Jingo-ji near Kyoto. The Berlin scrolls, an extraordinary tour de force in patience and basic skill, must have originally been ordered by a high-ranking and influential patron.

Published: Museum für Ostasiatische Kunst, Staatliche Museen Preussischer Kulturbesitz, Berlin (ed.), *Ausgewählte*

Werke Ostasiatischer Kunst (Berlin-Dahlem, 1970), no. 83; *Ein Jahrtausend Ostasiatischer Malerei* (Berlin, 1951–1952), no. 35; Stiftung Preussischer Kulturbesitz, Staatliche Museen, Ostasiatische Kunstabteilung (ed.), *Kunst Ostasiens* (Berlin, 1963), no. 98; Shimada Shūjirō (ed.), *Zaigai Hihō* (Tokyo, 1969), vol. 2 (text), p. 46.

References: Edward Conze, *The Large Sutra on Perfect Wisdom* (London, 1961); Conze, *Prajñāpāramitā Literature* (s'Gravenhage, 1960); Étienne Lamotte, *Le traité de la grande vertu de sagesse*, 2 vols. (Louvain, 1949); M. W. de Visser, *Ancient Buddhism in Japan* (Leiden, 1935), vol. 2, pp. 489–519; *Yamato Bunka*, no. 50 (April 1969), special number devoted to ornamental sutras.

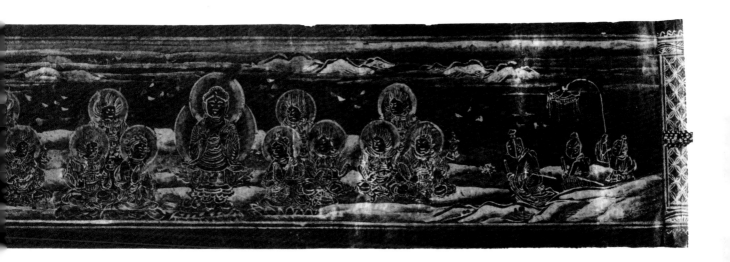

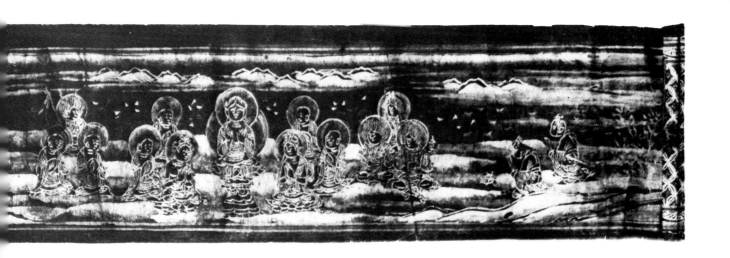

13. Illustrated Frontispiece to the Lotus Sutra

(Saddharma-puṇḍarīka-sūtra; Myōhō Renge-kyō)

First half of the fourteenth century A.D.

Ink, color, and gold pigment on two pieces of
indigo paper

Frontispiece illustration attached to handscroll;
27.9 × 76 cm

The New York Public Library, Astor, Lenox, and
Tilden Foundations; Spencer Collection

Crowded and pulsating with activity, this remarkable frontispiece illustration presents episodes from the twenty-eight chapters of the Lotus Sutra. It begins at the right with the depiction of Śākyamuni enthroned in splendor surrounded by a host of divine beings, guardians, monks, and laymen. Behind him is the silhouette of the Vulture Peak (Gṛdhrakūta) near the Indian city of Rājagṛha, where the Buddha promulgated this as well as other Mahayana sutras. From the ūrṇā on his forehead come two bands of light that reveal both the retribution which men receive for their good and evil deeds, and also the existence of other Buddhas who are the source of the True Law, a feature that is faithful to the text of the introduction to the sutra. In the lower band are depicted living creatures from the six realms of existence (rokudō); in the upper band is a Buddha active in the world, preaching, being worshiped, and undergoing his final nirvana.

One of the most important concepts in the Lotus Sutra is symbolized in the central upper portion of the composition: that of the Ekayana, the One Vehicle, or the one form of Buddhism that subsumes all forms of Buddhism. This doctrine is explained in the form of a parable in the third chapter. In order to entice his deluded and rebellious sons out of a burning house in which they were happily playing, a wise man offered each his favorite beast-drawn cart: a goat cart, a deer cart, and a bullock cart. When the children were safely outside, he gave them instead one great cart which was better than the other three. The burning house signifies the mundane world, filled with suffering and decay; the wise man is the Buddha; and the children are representative of foolish and ignorant mankind. The carts symbolize the three traditional forms of Buddhist practice: the goat cart for the śramana, or Voice Hearers, monks who gain nirvana through the guidance and teaching of others; the deer cart for the Pratyeka Buddhas, those who seek and attain enlightenment by themselves alone; and the bullock cart for the bodhisattvas who seek and achieve enlightenment for the sake of other beings. The One Great Vehicle, represented by the Lotus Sutra, is the latter-day teaching, including and subsuming all previous teachings and divisions of Buddhism, and is therefore the most comprehensive, profound, and compassionate of doctrines. The wise man had to trick his children, but he gave them something far finer than they could have imagined.

Farther to the left is an elaborate stupa giving off rays of light or energy; in its center sit two Buddhas side by side. The motif of the paired Buddhas, which became extremely popular in sixth-century China, was derived from the eleventh chapter of the Lotus Sutra in which appears a Buddha of the remote past, Prabhūtaratna. Although he had not been seen in the world of men for eons, his essential being had remained operant within the monument. Śākyamuni, the Buddha of the present age, caused it to be opened, and the former Buddha invited him to sit by his side. Śākyamuni then said that even though the Buddha of the past had entered nirvana, he had returned to hear this teaching of the Law. In this way, the Buddhas have existed outside of conventional time and space.

Below the stupa at the very lower margin of the composition sits Śākyamuni on a high, elaborate throne. A princess kneels before him offering a plate with flaming jewels. This is the eight-year-old daughter of the dragon king, a prominent figure in the twelfth chapter of the sutra. No one of the assembly can believe what Mañjuśrī (shown in the circle to the upper left of Śākyamuni) has proclaimed: that during a period when he was teaching in the ocean realm, this girl understood the doctrine in a single moment. The dragon princess then appears to affirm that she had indeed attained enlightenment, but the disciple Sāriputra tells her that she is deluded, no woman has ever reached Buddhahood. The princess offers Śākyamuni a priceless gem as a symbol of her wisdom. He accepts it, signifying his agreement and blessing, and she immediately becomes a masculine-appearing bodhisattva, shown in this painting in a cloud bank arising from the princess' head. The meaning is clear: a woman can experience true understanding, but must assume the form of a man before final enlightenment can occur.

Avalokiteśvara, as he is described in the twenty-fifth chapter in the sutra, appears in a circle near the lower left-hand corner of the composition succoring his devotees. He saves men from shipwreck, from the executioner, from fearful beasts and dragons. Above Avalokiteśvara is Samantabhadra as he appears in chapter twenty-eight, the protector of devotees and proponents of the Lotus Sutra, arriving on his white elephant out of the eastern quarter (no. 7).

The art historical analysis of this remarkable illustration involves two separate lines of inquiry. The first is

concerned with the method of narration that crowds together the tiny episodic scenes representing the major religious conceptions of the Lotus Sutra. This mode of condensed pictorial narrative was well established in China by the Sung period. Similar in conception, for example, and datable to about A.D. 1160 is a frontispiece illustration to a woodblock-printed edition of the Lotus Sutra from the city of Ssu-ming near Hangchou. At least three copies of this edition have been found in Japan; its frontispiece illustration also has a summary depiction of crucial events, but the style is more straightforward, less florid and elegant than here.

The second line of inquiry identifies a separate and special tradition of sutra illumination to which this work belongs. The root of the style is the highly realistic and detailed spirit of Sung and Yüan period Buddhist painting of which the Boston *Vaiśravaṇa* (no. 20) is a fine example. The key to the general dating of this lineage is a set of four Chinese illuminated scrolls of the Avataṃsaka-sūtra, now in the Kyoto National Museum and dated corresponding to 1291. Done in gold and silver pigment on indigo paper, these scrolls employ similar conventions for the terrace and balustrade, for example, and the same general mode of composition. Their colophon gives precise data concerning their origins and donation to the Wan-shou-ch'an-sse near Ch'ang-an. This set, however, is extremely rare; no other Chinese examples of the style have come to light, but a large number of illuminated scrolls in this style

have come from Korea and are datable to the late thirteenth and fourteenth centuries. In fact, some Japanese scholars entertain the hypothesis that this style of sutra illumination is of Korean origin.

The scroll in the Spencer Collection was inscribed with the name of a certain Ogura Zeun, who was governor of the province of Kaga and a lay monk (J nyūdō, S upāsaka, literally, path-enterer). Unfortunately, Zeun's dates cannot be determined; however, the Ogura family, an offshoot of a northern branch of the Fujiwara, did not come into being until the middle of the thirteenth century. The Cleveland Museum possesses an illustrated frontispiece to the Lotus Sutra, said to be Chinese of the Sung period, that is remarkably similar to the painting in the Spencer Collection but even more lavishly gilded and detailed.

Published: Shigeo Sorimachi, *Catalogue of Japanese Illustrated Books and Manuscripts in the Spencer Collection of the New York Public Library,* rev. ed. (Tokyo, 1978), no. 19.

References: Kanda Kiichirō, "The Avataṃsaka Sutra Dated 1291," *Bijutsu-shi,* no. 40 (March 1961); John M. Rosenfield, "The Sedgwick Statue of the Infant Shōtoku Taishi," *Archives of Asian Art,* 12 (1968–69): 63–69; Kuo Wei-ch'ü, *Chung-kuo pan-hua-shih-lüeh* (Peking, 1962), pl. 8; *Bulletin of The Cleveland Museum of Art,* 8 (February 1971): 53; The Museum of the Yamato Bunkakan (ed.), *Korean Buddhist Paintings of the Koryŏ Dynasty* (Nara, 1978), pp. 74–100.

13. Illustrated Frontispiece to the Lotus Sutra

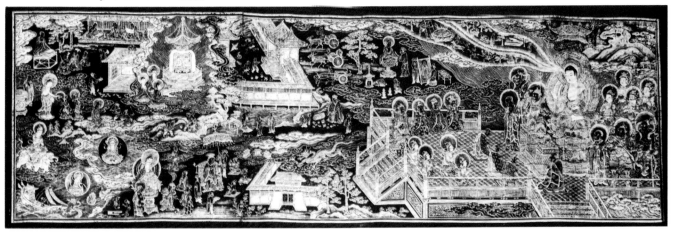

PART TWO
Esoteric Buddhist Images

Comparable to the reception of Marxist socialism in East Asia in recent decades is the speed and enthusiasm with which Esoteric Buddhism was adopted in China, Korea, and Japan in the eighth century A.D. This powerful creed was often called the Vajrayana, the Diamond or Thunderbolt Vehicle; it used the ancient Indo-Aryan vajra; or thunderbolt, to symbolize the diamond-like, indestructible character of the Ultimate Truth that penetrates the darkness of ignorance, that shines with the radiance of illumination. The creed was brought by charismatic missionaries from India and Central Asia to the Chinese court and to such major religious centers as that on Mount T'ien-t'ai south of Hangchou. At about the same time that Esoteric ideas were being accepted in Java, Cambodia, Thailand , and Sri Lanka, its ideas appeared in Kyongju, capital of United Silla, and in the Japanese Heijō capital, the modern Nara. By the early ninth century, Vajrayana had become the dominant form of the faith in Japan, and remained so for two hundred years.

Esoterism offered much to its adherents. It promised that enlightenment is possible in this life, immediately, without long years of asceticism or waiting for birth into a distant paradise. Each person is inherently capable of attaining this state, both through his own efforts and through the grace and compassion of the Buddhas. The keys to achieving this goal are to be found not in the familiar sutras that had been delivered by Śākyamuni while preaching on earth, but rather in the texts that had been transmitted secretly to mankind by the Buddha in his timeless condition of the dharma-kāya. These texts, and their rules for elaborate rituals, offer access to the power of the vast Buddhist pantheon. By the correct performance of rituals and the recitation of magical charms, the deities can be obliged, even coerced, to do the bidding of the priest to ward off the enemies of the state, to protect a soldier in battle, to cure illnesses, or to aid a government figure gain power.[1]

The efficacy of Esoterism rests in large measure upon the concept of the Threefold Mystery (J sammitsu) which, like so much of Esoteric thought, had evolved from earlier Buddhist doctrines. Previously, Buddhists had believed that the forces of karma were manifested through three channels: the individual's mind, body, and speech. Thus, the ways in which a person thinks, behaves, and speaks reveal the rewards and penalties for previous behavior—the workings of karma.

In Esoteric Buddhism, however, the faculties of mind, body, and speech are inherently divine; the individual's thoughts, deeds, and words are actually those of Mahāvairocana. Within each individual are the wisdom, the Buddha-nature, and the ultimate truths of the cosmic Buddha, implanted in mankind through that Buddha's grace and compassion. These gifts, however, are usually obscured, for the individual, holding delusory and false views, is unaware of them; but the tradition holds that he can and should realize them by performing certain rituals. A series of precise and concrete actions can cause the votary to understand the interrelation of himself, the micro-

cosm, and the macrocosm, and the identity of the profane and the sacred that the unenlightened believe to stand in total opposition. Acts that lead to the realization of the indwelling sanctity of the body are ritual hand gestures (mudrā) and seated meditation; expressions of the essence of speech are the mantra and dhāraṇī, mystic syllables and spells intimately linked to deities in the pantheon; and meditation on mandala, representing the mind, that in fact directs the activities of the mind to their divine origins. Esoterism thus suggests that Ultimate Reality may be approached through sensory experiences — bodily through mudrās, verbally through mantras, and mentally through mandalas. When the individual unites himself with Ultimate Reality, through the activity of the Three Mysteries, enlightenment is experienced and the illusory barriers between sacred and profane are eliminated in one transcendent nondual Reality.

One of the doctrinal strands shared by Vajrayana with other forms of Mahayana was the concept of the three bodies (tri-kāya) of the Buddha that had evolved gradually for over half a millennium. This concept might be compared to that of the Holy Trinity in Christianity according to which the Supreme Being is said to assume three distinct forms: God the Father, Jesus the son of God incarnate as a man, and the Holy Spirit as the spirit of God immanent in this world. The three persons of the Christian Trinity—Father, Son, and Holy Spirit—are coequal, indivisible, and eternal. The three bodies of the Buddha, however, differ in their degree of sanctity and function in three different ways: as a human being, as a spiritual principle, and as something in between these two.[2]

In the Esoteric Buddhist view, Gautama had appeared on this earth in the Body of Transformation (nirmāṇa-kāya) to preach among men and women according to their limited understanding at a particular moment in history. He was thus only a temporary projection onto this earth of the Buddha in his timeless, absolute form called the Body of the Law (dharma-kāya), which is also one of the names given to the ultimate, absolute, generative principle of reality in Buddhist philosophy. Directly from the Buddha in the dharma-kāya came the teachings of Vajrayana, which, in the view of Esoteric thinkers, are infinitely more profound than the texts of the Exoteric creeds.

The third member of the Buddhist triad is the saṃbhoga-kāya, translated as Body of Bliss, or Reward. This is the form assumed by Buddhas who have attained enlightenment and who dwell in their Buddha lands or paradises of unstained beauty and perfection. In the saṃbhoga-kāya are such great Mahayana deities as Amitābha and Bhaiṣajyaguru, or Śākyamuni himself after his death and departure from earth (no. 3).

The Esoteric Pantheon

The arts of Vajrayana Buddhism brought major innovations in subject matter, and inspired changes in style as well.[3] Most prominent was the increase in the number of deities depicted. Even though the religious imagination of Mahayana had teemed with hosts of Buddhas and bodhisattvas, the number of deities prominently worshiped and depicted was relatively modest. In Esoterism, however, the vast Buddhist pantheon became more systematically defined and organized. Emblematic of Vajrayana, and one of its two most characteristic image types, is the mandala, the rational and geometric diagram that shows the relationships among the many divine figures (nos. 14, 19, 25, 26).[4] The second image type characteristic of Vajrayana is the jeweled Buddha, the emblem of the manner by which the matrix and essence of existence, the dharma-kāya, reveals itself to mankind (nos. 14, 15). Combining the outward traits of a bodhisattva with the designation of tathāgata, it is a radical departure from earlier Mahayana imagery, which showed the tathāgata clothed in monastic robes, without adornment.

Often depicted as the jeweled Buddha, and indeed the chief element in the entire Esoteric system, is the Buddha Mahāvairocana (J Dainichi), literally, the Great Radiance of Illumination. He is the primordial Buddha, the source of all other divine entities—Buddhas, bodhisattvas, devas, yakṣas, and, in Japan, even the Shinto deities. He is the source of all matter, all energy, of

fundamental consciousness, and of modes of consciousness such as wisdom and compassion. The texts outlining his character do not imbue him with a personality, legendary biography, or paradise to which a human being might aspire. His imagery was never set in a worldly context, as was occasionally the case with the tathāgatas in the Mahayana mainstream. Instead, he remained a great doctrinal abstraction, the dominant figure in Vajrayana Buddhist thought and art. His all-encompassing character is symbolized by his central position in the mandalas and by the signs of both worldliness (long flowing hair and lavish jewelry) and mystic energies (the swirling, radiant lines in the halo behind his head).

Also introduced to Japan with Vajrayana were classes of wrathful deities who expressed the concept of divinity as frightful energy akin to that of the Hindu gods Śiva and Viṣṇu shown in demonic guise. Given multiple heads and ferocious expressions, the deities served the tathāgatas by subduing the physical and spiritual obstacles to enlightenment and by protecting the faithful (nos. 16, 18, 23). Their imagery, incorporating melodramatic effects of flames and somber colors, contrasted strongly with the sumptuous elegance that pervaded the earlier classical T'ang tradition, for the tenor and mood of Esoteric religious devotions strongly affected the stylistic intentions of Buddhist painters.

A large and expandable group of ferocious deities were called in Japan the myō-ō (S vidyārāja, kings of knowledge and lords of magic spells). In the Esoteric tradition, the myō-ō are present as attendants of Dainichi; their prominence in Japanese Esoteric Buddhist symbolism is great, far exceeding their role in the religious texts, a sure indication that they had captured the imaginations of monk and devotee alike. The myō-ō included deities who were emblems of psychospiritual states, such as Acala (J Fudō, the Immovable One), symbolizing steadfastness in the face of delusion and folly; or Rāgarāja (J Aizen, Lord of Passion), the power of enlightenment within the depths of human passions (nos. 18, 19). Others had emerged from local Indian folk religions and mythology and were absorbed into the Esoteric pantheon: Hayagrīva (J Batō, the Horse-Headed Kannon), who was much worshiped in Japan by military men (no. 16); or Mahāmayurī (J Kujaku, the Peacock King); others represented the influences of the stars and planets (nos. 27–29).

The Esoteric pantheon was enormous; over fourteen hundred divine figures of varying character can be found in the two great mandalas[5] (no. 14) that summarize the doctrine of Japanese Vajrayana. The ideology of this creed was complex, intentionally so. It far exceeded the understanding of the average layman, who had to place himself in the spiritual care of monks who had trained for years in the names and meanings of the hundreds of deities, and in the highly dramatic rituals performed before their images. Each of the ceremonies had its own distinct set of altar implements: brass bowls for offerings of grain and oil, flower vases, chimes and ritual bells, thunderbolt emblems, and incense bowls. The priests, intoning prayers and mantras, would kindle fires made of inscribed sticks of aromatic wood in the homa (J goma) ceremony, whose origins lay in the ancient Vedic rituals of India.

Historical Development

Esoteric Buddhism had arisen in India in the fifth century A.D. as part of a larger religious phenomenon called tantrism, which embraced sects of Hinduism as well. The Sanskrit word tantra denotes a loom, framework, or system. Its use in the religious sense implies the drawing together of many disparate beliefs from varying religious sects, geographic regions, and social classes, and combining them into strictly organized systems.

Buddhist tantrism became an international creed, but its arts, although governed by common principles, were by no means uniform in symbolism. As tantrism spread to different nations, it quickly adapted itself to local conditions, absorbing local deities and customs and producing its own masterful teachers such as Kūkai in Japan and Tson-kha-pa in Tibet. Throughout the Indian cultural sphere, for example, female deities such as Tārā, consort of Avalokiteśvara, came into great prominence, reflecting the resurgence there of cults of the ancient mother goddesses and the rise of Hindu female deities such as Durgā. In East Asia, however, female deities did not attain the same prominence. Perhaps this was due to deeply rooted social traditions, but whatever the cause, female nudity and the explicit sexuality of Indian tantrism did not play a major role in Esoteric Buddhist arts in the East (no. 17).

In the transmission of the Vajrayana to Japan, scholars distinguish two separate stages. The first, called zōmitsu, or miscellaneous Esoterism, is characterized by the appearance of separate, unrelated parts of the larger system. The most dramatic manifestation of this phase is the construction in the eighth century of the great bronze image of Mahāvairocana at Tōdai-ji in Nara, as the center of an ambitious system of state Buddhism. The next stage, called manmitsu, or fully developed Esoterism, occurred at the beginning of the ninth century, upon the return to Japan of the highly trained specialists Saichō and Kūkai, who studied in China under leading tantric masters. The mandala became a prominent part of Buddhist symbolism, the full pantheon was recognized, and Esoteric rituals were widely performed, even within the imperial palace.

Two Japanese Vajrayana sects were formally established: Shingon and Tendai. Shingon means literally the True Word, a translation of the Sanskrit term mantra. The Shingon sect was founded by Kūkai, who established its headquarters at the Kongōbu-ji atop the remote Mount Kōya in the Kii peninsula, and who also maintained a large urban sanctuary, the Tōji, in the Heian capital. The headquarters of the Tendai sect, Enryaku-ji, overlooked the capital from the verdant flanks of Mount Hiei. The Tendai sect was an offshoot of the long-established Chinese T'ien'-t'ai school of Buddhism, which had attempted to synthesize all major doctrines of Buddhism into a unified creed. During the time when its Japanese founder, the monk Saichō, studied atop Mount T'ien'-t'ai that school was strongly affected by tantrism. As a result, Japanese Tendai was primarily, but not exclusively, Esoteric in character, and Enryaku-ji also became a major center of Pure Land and Zen practices.

NOTES

1. Yoshito S. Hakeda, *Kūkai: Major Works Translated, with an Account of His Life and a Study of His Thought* (New York, 1972); Chou I-liang, "Tantrism in China," *Harvard Journal of Asiatic Studies,* 8 (1945): 241 – 332; Minoru Kiyota, *Shingon Buddhism: Theory and Practice* (Los Angeles and Tokyo, 1978).

2. Edward Conze, *Buddhism: Its Essence and Development* (Oxford, 1951), p. 34.

3. Takaaki Sawa, *Art in Japanese Esoteric Buddhism,* trans. R.L. Gage, Heibonsha Survey of Japanese Art vol. 8 (Tokyo, 1972).

4. Giuseppe Tucci, *The Theory and Practice of the Mandala* (London, 1961); Tajima Ryūjun, *Les deux grands mandalas et la doctrine de l'ésotérisme shingon* (Tokyo, 1959); Togano-o Shōun, *Mandara no Kenkyū* (Kyoto, 1937).

5. A reproduction of the Kongō-kai mandala may be found in Sawa, *Art in Japanese Esoteric Buddhism,* pl. 10, and also in Tajima, *Les deux grands mandalas et la doctrine de l'ésotérisme shingon.*

14. Mandala of the Matrix World of Great Compassion (Mahākaruṇā-garbhodbhava-maṇḍala; Daihi Taizō Mandara)

Mid-thirteenth century A.D.
Gold pigment, kirikane, and color on three pieces of silk dyed indigo blue
Hanging scroll; 90.3 x 79 cm
Private collection

Publicly exhibited and published here for the first time, this painting is one of the finest Japanese mandalas to have reached the West. It was surely made as part of a pair of scrolls for use in a Tendai sanctuary, its missing counterpart being the Mandala of the Diamond or Thunderbolt World (Kongō-kai). Painted with gold pigment on silk of a dark bluish-purple hue, the intricate composition of over four hundred figures seems to pulsate with a sense of purposive vitality despite the purely geometric character of its division into rectangular sectors. In the precise center sits the primordial deity of Esoteric Buddhism, Dainichi (S Mahāvairocana), the radiant source of every aspect of the universe.

A mandala of this type is the most basic pictorial expression of Esoteric Buddhist ideology. In its symmetry and centrality, it seems to suggest the spiritual equipoise and sense of wholeness that the devotee experiences as he approaches the psychological state of full enlightenment. In its ordered arrangement, it projects rationality; in its complexity, it suggest universality; in the geometric character of its composition, it depicts a sphere of being beyond the everyday world, one that is timeless and sublime.

The Taizō mandala transforms religious values into positional ones. In the central square, or court, are depicted the most sacred of the deities: the Five Wisdom Buddhas who represent the realm of enlightenment, with Dainichi in the center. Between the other four are the Four Great Bodhisattvas who represent the practices leading to full enlightenment. In each of the other eleven large sectors are deities who symbolize spiritual phenomena (such as innate virtue or the triumphant energy of wisdom and meditation) as well as physical ones (the stars and their astral influences, the wind, and the rain). They are arranged in a descending order of sanctity as they approach the outer edge. Included in the outermost border are beings from the lowest stages

of existence — hungry ghosts, and demonic figures who are yet included within the scheme of Dainichi's all-embracing compassion.

The mandala of the Taizō (Matrix or Womb World) shown here, in conjunction with that of the Kongō-kai (Diamond or Thunderbolt World) represented the entirety of the Buddhist cosmos, according to certain schools of Esoteric Buddhism. The Matrix World was understood as signifying something akin to the noumenon in idealist philosophy: the potential, innate, unmanifested aspect of the universe. The Diamond realm was akin to the phenomenon, the visible, dynamic, and tangible aspect of existence, the process of active creation. Together called the Ryōgai Mandara or the Mandala of the Two Worlds, they played a prominent role in the life of the Esoteric Buddhist sanctuary. Novice monks, for example, would be trained to know each deity in the diagrams, its names and symbols and reasons for its placement (nos. 25, 26). Mandalas would be placed on a low altar for a ceremony initiating both monks and laymen into Esoteric Buddhist practice; the blindfolded initiates would stand around one of the two mandalas and cast a flower onto the diagram, thereby establishing a personal relationship with the deity on whom the flower fell. Mandalas would be hung on the walls of chambers for monks to concentrate their attention as they sat for long hours of silent meditation. For public ceremonials, the two mandalas were often displayed facing one another hung on the eastern and western walls, or on either side of the main altar in the sanctuary. Before each mandala would be a large square altar platform set with flowers and incense and dishes and bowls of gleaming brass arranged in patterns denoting the deities selected for worship.

In this painting, kirikane was used to delineate the major vertical and horizontal lines separating the different courts, as well as the lotus petals in the central court. The thick dark red line enclosing the central court provides the only color other than gold. The sumptuous effect of gold paint on the dark blue ground is a trait of East Asian Buddhist painting practiced from the eighth century A.D. onward, a usage that is analogous to the purple codices of the Byzantine tradition.

This mandala, whose figures show hardly any retouching or repainting, seems to be the work of one

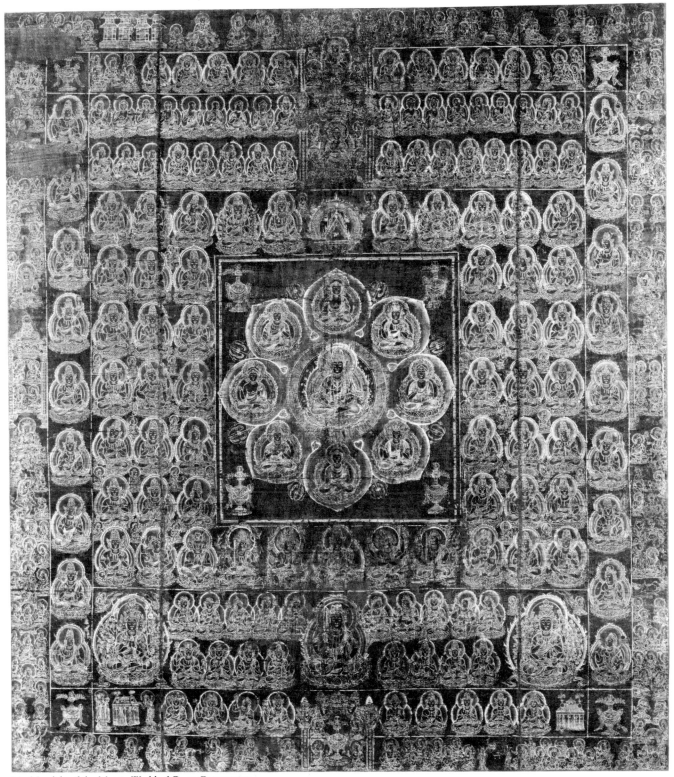

14. Mandala of the Matrix World of Great Compassion

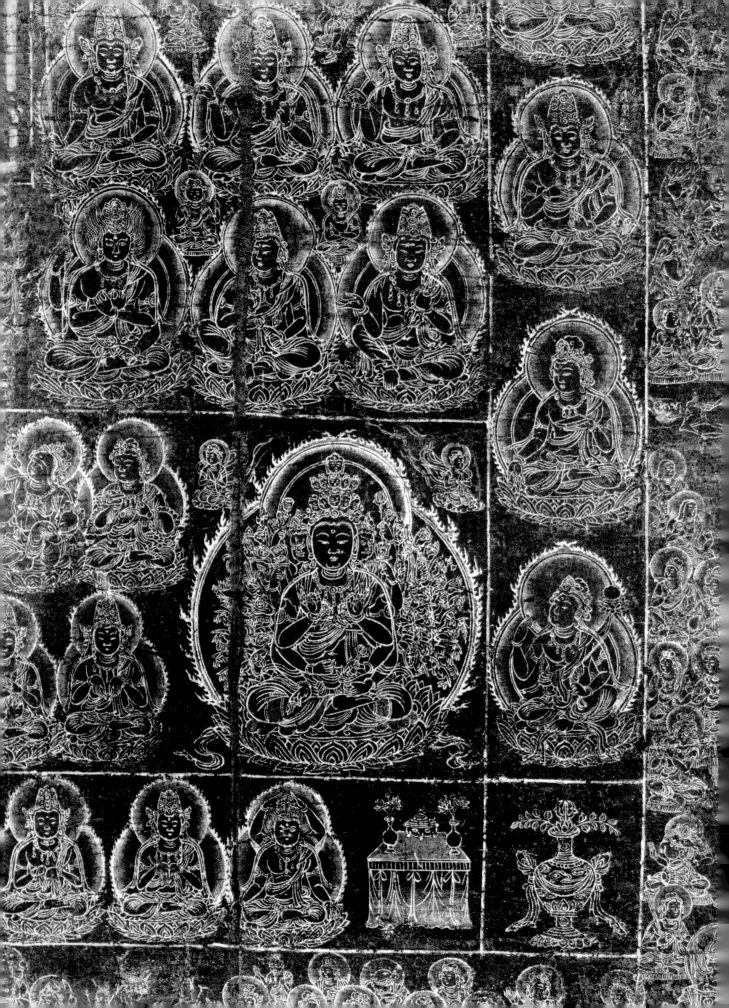

hand. Consistent throughout are the treatment of the line, which displays little modulation; the proportions of the figures, which emphasize width rather than height; and the delineation of facial features, in which the width of small pursed lips is less than the breadth of cursorily sketched noses. Certain similarities to these stylistic features are found in such works as the Chūson-ji sutra frontispieces dated to approximately A.D. 1175 (nos. 10, 11), and in the *Kakuzen-shō*, the great iconographic compendium of the last quarter of the twelfth century. The forms in the *Taizō Mandara* are, however, rather more exaggerated and set, suggesting a slightly later dating for the work. In particular, the very low hairline, and the curvilinear dip of the hairline down into the middle of the forehead, in addition to the use of tiny striations to indicate the hair line—all suggest a Kamakura period dating. Iconographic drawings on Mount Kōya dated to the late thirteenth and early fourteenth centuries show striking resemblances to figures in this mandala.

Remarkably, it can be determined that this painting had been made for use in a Tendai rather than a Shingon sanctuary. It possesses two elements that differ from the orthodox Shingon Taizō mandala introduced into Japan by Kūkai. First of all, the positions of the Buddhas of the east and north (appearing respectively at the top and middle left of the group of figures encircling Dainichi) are reversed. Second, the Tendai Taizō mandala is characterized by the presence of altar tables in front of the two larger multiheaded and multiarmed deities in the lower right and left portions of the composition. Other minor discrepancies between the Shingon and Tendai Taizō mandalas occur in the number of limbs of some of the deities, as well as a few of their attributes. The two Kongō-kai mandalas show less variation. In this configuration, over one thousand figures are arranged in nine smaller square mandala forms, three squares in each of three rows.

References: Ishida Mosaku, *Chūson-ji* (Tokyo, 1959); Tajima Ryūjun, *Les deux grands mandalas et la doctrine de l'ésotérisme shingon* (Paris and Tokyo, 1959); Takakusu J. et al. (eds.), *Taishō Shinshū Daizō-kyō*, vols. 18, 39, 87 (Tokyo, 1924–1928); Takata Osamu et al., *Takao Mandara no Kenkyū* (Tokyo, 1967); Togano-o Shōun, *Mandara no Kenkyū* (Kyoto, 1958); Ishida Hisatoyo, "Ryōgai Mandara (Taimitsukei Ryōgai Mandara no Ikkō Satsu)," *Museum*, no. 172 (July 1965): 8–11; *Kōya-san*, Hihō vol. 7 (Tokyo, 1968).

15. Mahāvairocana of the Golden Wheel (Dainichi Kinrin) also called Ekaksara-usnīsa-cakra (Ichiji Kinrin Bucchō)

First half of the thirteenth century A.D.
Ink, colors, and gold and silver leaf on three pieces of silk
Hanging scroll mounted on a panel; 117.5 × 78.1 cm
Museum of Fine Arts, Boston; Fenollosa-Weld Collection

This image depicts the Esoteric Buddhist vision of the generative principle of the universe, and the composition—in its severe frontality, precision, and symmetry—reflects the intense psychological concentration by which it was addressed in meditation and ritual. Mahāvairocana (Dainichi) is seated poised atop an elegant white lotus pedestal in the center of a large halo, perfectly round with blue and green concentric circles in the center and white in the outer part. On the edge of the halo is a ring of precisely drawn tongues of flame, with a larger swirl of fire at the top. Behind his head is a smaller halo filled with a whorl pattern of lines in subdued tones of red, blue, green, yellow, and white, indicating the emanation of mystic energies. Further symbolizing his role as the source of all being are the Five Wisdom Buddhas, small figures placed in his jeweled headdress.

This image is similar to that which appears in the mandala of the Diamond Realm, the Kongō-kai, in the top center square. It presents Dainichi in the crosslegged meditative posture with his hands in the distinctive Esoteric Buddhist configuration called the chikenin (jñāna-muṣṭi-mudrā), literally the wisdom-fist gesture, in which the right vajra fist encloses the index finger of the left vajra fist. This mudrā has a wide range of symbolic meanings: the left vajra fist represents knowledge in the world of illusion; the right one represents the wisdom of the tathāgata. The union of both vajra fists symbolizes the unity of divine wisdom with the deluded knowledge of mankind. This is similar to the significance of the two main Esoteric mandalas,

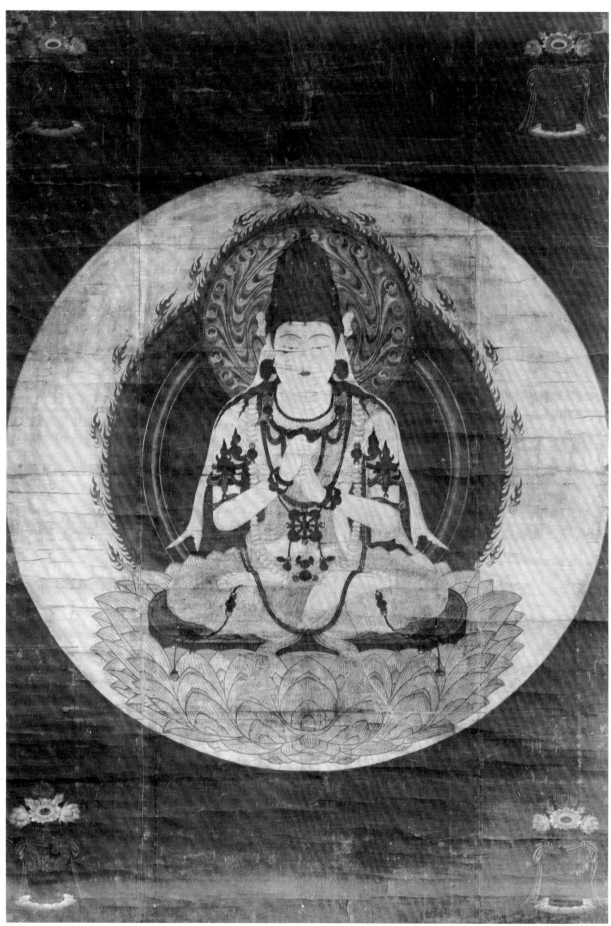

15. Mahāvairocana of the Golden Wheel

which depict the interaction of essence and substance, of being and becoming, of saṃsāra and nirvāṇa—the interaction that demonstrates their fundamental unity.

During the late Heian and Kamakura periods, perhaps in response to the growing appeal of the Amida cult, Dainichi was made the object of private devotion. In front of images such as this, monks would perform rituals to secure a broad spectrum of benefits: to attain an exalted state of spiritual awareness, to ward off illness and danger, or to gain worldly objectives such as a promotion in rank or the defeat of a rival. Owing to the supreme hieratic status of Dainichi, these rituals were believed to be extremely effective, and they were performed for members of the imperial family, ranking courtiers, and military men.

One of the names of Mahāvairocana in this form, Ichiji Kinrin Bucchō, suggests the sources of the mystic powers that ensured the effectiveness of the rituals: (1) the mantra bhrūṃ, the single syllable (ichiji) that contains his spiritual potentiality and that is recited in the ritual; (2) the golden wheel (kinrin), suspended from a chain around his neck, taken from the symbolism of the Indian cakravartin, the universal monarch whose emblem is the wheel and whose sovereignty and law extend without limit; and (3) the wisdom contained in the Buddha's uṣṇīṣa (bucchō), the protuberance or lump atop his head, one of the thirty-two marks of a Buddha's suprahuman status.

Testifying to the popularity of the rituals are approximately twenty late Heian and early Kamakura period paintings of this form known to have survived to the present. Landmarks for their chronology come from a few datable paintings, which allow one to establish a simple, overall principle for judging their stylistic evolution: the earlier works tend to have a strong sense of volume and mass in the human figure; a clear feeling of three-dimensionality in the drawing of subsidiary elements, such as the lotus throne or vase of flowers; and a subtle sense of freshness and originality in the execution of details. In later works, the figures tend to become increasingly flattened and weightless, and subsidiary elements are drawn in a somewhat mechanical way without a distinct sense of depth.

The lower limit to the chronology is established by a pair of mandalas on Mount Kōya said to have been commissioned in A.D. 1150 by Taira no Kiyomori, who drew blood from his own head to mix with the pigments used by the painter Jōmyō. Even though they are full mandalas and not the isolated images of Dainichi under discussion here, the Kiyomori paintings were done in the rather muted, restrained color scheme seen in the Boston Dainichi. However, the volume and three-dimensionality of the Kiyomori paintings are much more pronounced. Datable to approximately A.D. 1200 and also similar in mode of execution and color scheme is the Buddhalocanī (Butsugen Butsumo) painting worshiped and inscribed by the well-known prelate Kōben, or Myōe Shōnin (1173–1232), a work distinguished for the elegance and delicacy of all outlines, for the sense of volume and careful definition of bodily forms.

Foremost among the datable works in this idiom by virtue of its brilliant color scheme and almost perfect state of preservation is the Dainichi of the Kongō-kai kept virtually as a secret image in the Miei-dō of Kongōbu-ji on Mount Kōya. Dated by an inscription on the back in accordance with A.D. 1245, it seems discernibly later in date than the Boston painting. Also in the Boston Museum is another painting of Dainichi of the Diamond Realm that is even earlier than the one exhibited here, perhaps by a quarter of a century. Unavailable for loan to the exhibition, it is close in date to the Butsugen Butsumo of about 1200.

Published: Anesaki Masaharu, Buddhist Art in Its Relation to Buddhist Ideals (Boston, 1915), pl. XIV; Jan Fontein and Pratapaditya Pal, Bosuton Bijutsukan: Tōyō, Sekai Bijutsukan vol. 15 (Tokyo, 1968), p. 157.

References: Kōya-san, Hihō vol. 7 (Tokyo, 1968), pl. 26; Kokuhō, vol. 4 (Tokyo, 1960), pl. 36; Watanabe Hajime in Bijutsu Kenkyū, no. 51 (March 1936); Daigo-ji, Hihō vol. 8 (Tokyo, 1967), pl. 107; E. Dale Saunders, Mudrā (New York, 1960), pp. 102–107.

16. Hayagrīva Avalokiteśvara (Batō Kannon)

Mid-twelfth century A.D.
Ink, colors, and gold and silver leaf on three
 pieces of silk
Hanging scroll mounted on a panel; 165.5 × 83 cm
Museum of Fine Arts, Boston; Fenollosa-Weld
 Collection

Unquestionably one of the noblest examples of
Japanese Buddhist art in the West, this painting of the
Batō Kannon reconciles two somewhat contradictory
aesthetic features. The subject is demonic and fero-
cious, an archetypal expression of Esoteric *terribilità*; the
style of execution, however, is elegant and refined,
filled with the aristocratic and visionary taste of the
late Heian period.

In style, the Boston *Batō Kannon* belongs to a group
of seven or eight distinctive paintings from the mid-
twelfth century A.D. produced either in the same Kyoto
atelier or in workshops linked by training and tradition.
Like the Boston painting, they all depict single deities
with elaborate filigree-like halos, shown in strongly
frontal compositions that fill most of the picture sur-
face; they all share the elaborate hexagonal throne with
lotus pedestal. The throne is of Southern Sung origin,
but in these paintings the coloring has taken on a dec-
orative, nonstructural character that strongly reflects
Japanese taste. The most famous of these works is the
Śākyamuni from Jingo-ji, which is registered as a Na-
tional Treasure and dated roughly between A.D. 1130
and 1160; it is extremely close in detail to the Boston
painting, and the width of the central piece of silk is
identical. Also belonging to this group are the *Jūichi-
men Kannon* in the Masuda Collection, the *Hannya
Bosatsu* in the Tokyo National Museum, and the
Dainichi in the Nezu Museum. Unfortunately, none of
these paintings can be given a precise date, but they
could not have been painted before a group of the *Jūni-
ten* at Tōji firmly dated in accordance with A.D. 1127.
Although these latter pictures were made as replace-
ments of lost originals of the previous century, they
share much of the sense of delicacy, subtle color har-
mony, and refined surface patterns of the others.

Although the Boston painting still retains sumptuous
surface effects equaled by few other pictures of the
Heian period, the viewer must exercise imagination in
order to recreate its original impact, which must have
been even more resplendent, and the technical preci-
sion employed in creating this masterwork astounds the
careful viewer. Not only were all the colors more in-
tense, the painting also shimmered with silver high-
lights as well as with the gold ones that have survived.
Many of the areas that now appear as dark gray spots or
lines were covered with bright silver leaf that has
oxidized and blackened with time—the chains and or-
naments dangling from the overhanging canopy, the
dark round interiors of the flaming jewels at the base of
the throne, the circles that decorate the first geometric
member of the base of the throne underneath the lotus
flower, and the tiny striations on the lotus petals.

Despite the impression of gold in this painting, no
kindei (gold paint) was used, but only kirikane (cut
gold leaf) and kinpaku (gold leaf flecks). Bits of
kirikane lines to delineate the hair are visible in strong
light; the other details—gold flecks in the ornaments
dangling from the canopy and the geometric and floral
motifs on the halo, jewelry, robes, and throne—are all
done in assiduously applied bits of gold leaf.

In the canopy and the outermost, floral aureole, the
background areas were painted in tan (red lead) applied
from behind the silk (urazaishiki). The floral designs on
the canopy were created by applying pigment from the
front, whereas on the halo they were done in kinpaku
and ink, again applied from the front. The brownish
background of the painting is unpainted silk that has
darkened naturally over the centuries; it was custom-
ary in the late Heian period to leave much of the back-
ground silk its natural color or to dye it a faint tint, but
not to cover it with pigment. The ground plane on
which the throne sits, however, was covered with
rokushō (malachite). The halo behind the body of the
deity has an outer concentric circle of green and an
inner one of brown. Although the silk of the head halo
is now greatly abraded and has lost its pigment, we can
presume that originally there was an outer concentric
ring of brown and an inner one of green, which would
have complemented in reverse the color bands on the
halo behind the body, a type of color juxtaposition that
was characteristic of the late Heian period. Typical also
of the late Heian period is the juxtaposition of colors
on the throne base, in combinations of blue and red or
green and purple.

The body of the Batō Kannon is painted a rich and
vibrant color of red that was achieved by mixing shu
(cinnabar or vermillion) and tan. Where a certain kind
of brownish shading appears, near the outlines edging

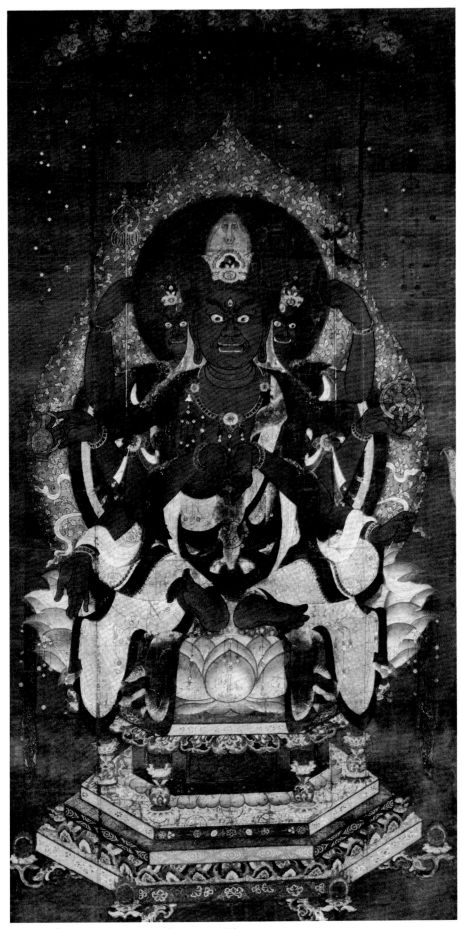

16. Hayagrīva Avalokiteśvara (*color illustration, p. 30*)

83

the arms or in the area of the nose, for example, here the proportion of tan in the pigment is stronger. Except for these shaded portions, however, the proportion of shu in the pigment is greater throughout. There seems to be no repainting of the body; it is possible on close examination to see faintly some of the underdrawing outlining the body. The reddish pigment was applied over this underdrawing, and black bounding lines were added over the red pigment at the end of the painting process. Although the pigment shu is known to adhere strongly to the surface of a painting if applied properly, rarely has a Japanese Buddhist painting eight hundred years old come down to us in such a remarkable state of preservation.

The prominent horse head in the deity's crown is derived from the Sanskrit epithet hayagrīva (literally, horse-necked) given to several fabulous creatures in ancient Indian mythology. The foremost was a horse-headed form of Viṣṇu; a horse-headed savior figure appeared prominently in the Buddhist jātaka stories, the Valahassa Jātaka in particular. Hayagrīva seems to have entered Esoteric Buddhist symbolism as one of the myō-ō, but in the Boston Museum painting, he was most likely one of a set of six incarnations of Avalokiteśvara called in Japanese the Roku Kannon. In the late Heian period, worship of the Six Incarnations of Kannon came into prominence in connection with the concept of the six conditions (rokudō) into which a sentient being is born: as one suffering in Hell, as a hungry spirit, as a demonic being, as an animal, as a human being, or as a fortunate one reborn in Heaven. The Batō Kannon presided over the fate of those born in the form of animals; however, as a deity of great power and angry energy, he was also the object of an independent cult; at a later date, the newly powerful samurai would worship him as protector of warriors and horses. In A.D. 1150, roughly the date of the Boston painting, rules for an elaborate ritual (Batō-hō) to the deity were compiled.

A prototype for the Boston painting may well have been a painting of 1078, showing Batō with three heads and eight arms, attributed to a prominent artist Jōshin. The original has been lost but it was recorded in iconographic manuals such as the Kanazawa Library's *Shoson zuzō* and the *Shike zuzō*, where it was associated with the Hōjō-ji, the vast temple built by Fujiwara no Michinaga (966–1027). No complete sets of the Six Incarnations of Kannon of an early date have survived; however, the Boston Museum possesses such a set from the Muromachi period, small panel paintings that served as doors of an image shrine.

The eight arms of Batō Kannon demonstrate the wide range of symbolic emblems and gestures (mudrā) that convey nuances of meaning to the devotee. The lower two hands form the complex gesture (the Horse Mouth mudrā) with palms pressed together; the index and little fingers are extended, the other fingers bent and joined into the palms with nails touching. The monk and devotee, with their hands in the same position, would recite the mantra, "Oṃ! He who is born from nectar! Hūṃ phat svāhā!" to gain protection against enemies and to remove obstacles to salvation. The deity's middle lower right hand is in the gesture of offering and of fulfillment of the desires of the devotee. In the upper right hand is a monk's staff, the shakujō or "stick with a voice" (see also no. 8). In his upper left hand is a combined hatchet and trident symbolic of resistance to evil and the spread of Kannon's compassion. The bird-headed vase, a form derived from T'ang period metalwork, contains the nectar of the deity's compassion, whereas the round wheel is the emblem of the Buddhist Dharma.

On the original mounting of this painting was a tab of paper bearing the name Kōshō-ji, which designates a small Rinzai Zen temple in Shiga prefecture. Because the temple's religious affiliation and date have little to do with the circumstances for which the painting must have been made, it is possible that the picture had been deposited there in the sixteenth century A.D. during the period of persecution and destruction of the Tendai sanctuaries on nearby Mount Hiei. In anticipation of Oda Nobunaga's burning of Enryaku-ji in 1571, many fine works of religious art were dispersed for their safety, for example the great *Raigō* painting now on Mount Kōya and the statue of the Eleven-Headed Kannon now in the Dōgan-ji, close to the Kōshō-ji.

Published: Jan Fontein and Pratapaditya Pal, *Museum of Fine Arts, Boston: Oriental Art* (New York, 1969), pl. 11; *Kokka*, no. 385 (June 1922), no. 877 (April 1965); Robert T. Paine, *Ten Japanese Paintings in the Boston Museum of Fine Arts* (New York, 1939), pl. 1.

References: R. H. van Gulik, *Hayagrīva* (Leiden, 1935); *Hōbōgirin*, fascicle 1 (Tokyo, 1929), pp. 58–61.

17. The Five Esoteric Ones (Pañca-guhya; Gohimitsu)

Second half of the thirteenth century A.D.
Ink, colors, and gold and silver leaf on three pieces of silk
Hanging scroll; 79 × 65.8 cm
The Cleveland Museum of Art; Purchase, Mr. and Mrs. William H. Marlatt Fund

The Five Esoteric Ones symbolize the Vajrayana doctrine of Mahāsukha, the Great Pleasure, by which the human passions are seen as positive forces leading to enlightenment. Like the painting of Dainichi (no. 15), this composition employs the almost hypnotic format of a strictly frontal and symmetrical image in a geometrically precise, round lunar disc.

In the center of the composition is Kongōsatta (S Vajrasattva), the Diamond Being, holding in his left hand a large vajra (thunderbolt) with five prongs at each end, and in his right a ghaṇṭa, or vajra bell, whose resonant sound carries the essence of wisdom (S prajñā) into the heart of the devotee. Kongōsatta is an emanation of Dainichi; that is to say, it is the form of Dainichi as he is reflected in the mind of man. Kongōsatta thus possesses Dainichi's basic attributes: white color, the swirling radiant halo, and the Five Wisdom Buddhas in his jeweled headdress.

Flanking him on both sides are four consorts (J myōhi, S vidyā), who are female in character but not in appearance, and who symbolize the four constituents of the Great Pleasure and four practical ways of helping others to enlightenment. Each is nimbate and wears a headdress containing the Five Wisdom Buddhas. Each is painted a different symbolic color and assigned a location at one of the four cardinal points of the compass:

Lower left. Dressed in a red skirt, tinted pink in the body, and holding an arrow is Yoku-kongōhi (S Kāmavajriṇī), emblem of desire. Placed on the east, this figure in its positive guise signifies the attraction of enlightenment, the arrow being the arrow of compassion that will restore man's impoverished desire for salvation.

Upper left. The half figure emerging from Vajrasattva's shoulder is Shoku-kongōhi (S Vajra-kikikīlā), sporting, amusement, touch, or dalliance. Placed in the south and colored white, this figure symbolizes reaching out to those in need of enlightenment. In the Cleveland painting, the notion of touching is made explicit by the two arms, which embrace the chest of Vajrasattva, the left hand barely visible over the deity's rib cage, the right one holding the scarf over his chest. In other paintings, the embrace is much more evident.

Upper right. Emerging from the other shoulder is Aikongōhi (S Vijayavajra, Vajrasnehā), love and affection. The figure was originally painted blue-green, but the pigment has darkened. Placed symbolically in the west, it reverses the value of destructive love and becomes a source of compassion for all sentient beings. Rising between it and Vajrasattva, and difficult to see against the latter's swirling halo, is a slender staff with a streamer or ribbon and also a finial in the shape of a fish, the Gangetic crocodile, or makara, an ancient motif of Indian origin used as the banner of the Hindu god of love, Kāma, and suggesting the snares of passion.

Lower right. The full figure seated frontally, hands clenched in a decisive gesture called the vajra fist, is Mankongōhi (S Vajrakameśvara), pride, arrogance, or conceit, or freedom and license. Set in the north and given the color yellow, it reverses the negative implications of the name in order to symbolize the power by which nirvana succeeds.

The five figures, sharing the same white lotus throne and melded into a single compositional unit, are unified in the body of Vajrasattva in an aesthetic sense, reflecting the ideological content of the image. The doctrine of the Mahāsukha is based on the Esoteric interpretation of the Hannya-rishu-kyo (S Prajñā-pāramitā-naya sūtra) one of the fundamental Vajrayana texts, often edited in Chinese, the most widely used version being that prepared about 768 by Amoghavajra. The Five Esoteric Ones are also represented as a single figure as Aizen Myō-ō, the presiding deity of the Rishu-kyō (nos. 18, 19).

86

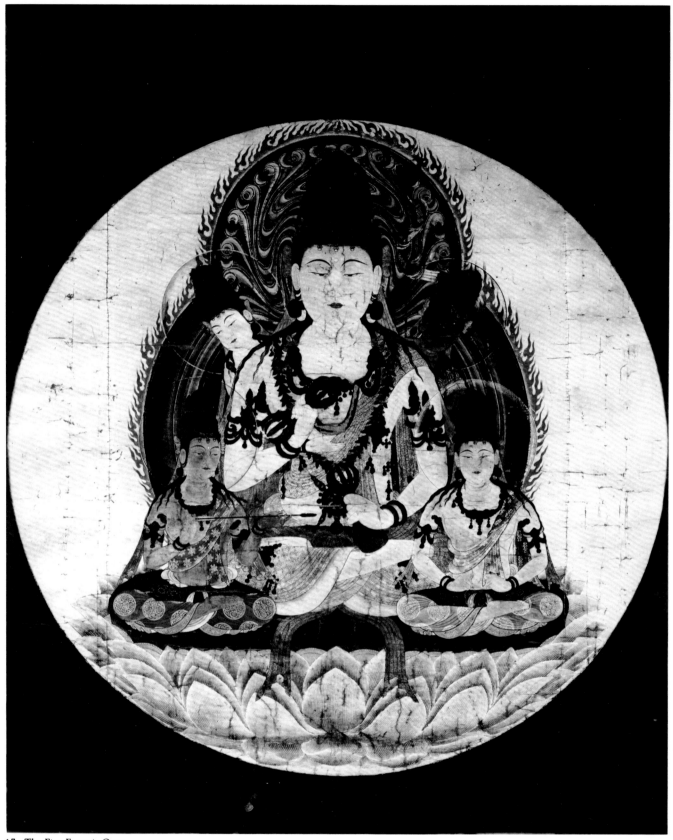

17. The Five Esoteric Ones

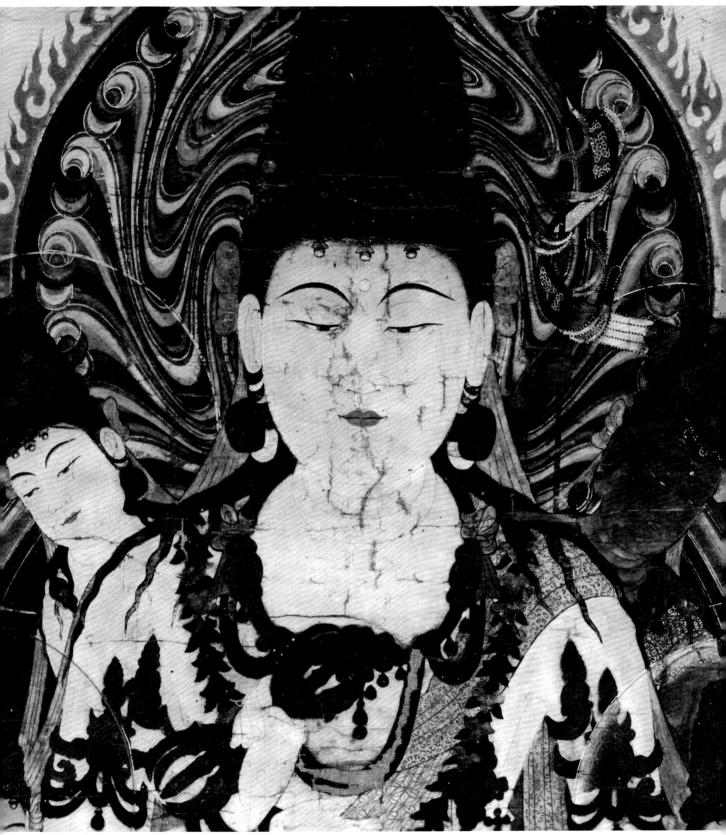

17. Detail

In chronology, this painting belongs very much to the same symbolic and stylistic tradition as the Boston *Dainichi* (no. 15). The richly colored *Dainichi* at Kongōbu-ji, dated to 1245, may be slightly older than this painting, although they share similar qualities in proportions and ornamental spirit.

Originally this painting must have been far brighter and more richly colored than it appears today. It has no urazaishiki (painting from the rear of the silk); pigment was applied from the front. Cut gold (kirikane) was sparingly used in the outlines of the halos and in the lotus petals; the petals were modeled by mineral green (rokushō) mixed with white, the green now somewhat darkened. Large areas of the jewelry and ritual implements were covered with cut gold leaf, some of which has fallen off and all of which has darkened considerably. Gold paint (kindei) was used in the rosettes and floral patterns in the garments of the two figures seated to the side; silver paint (gindei) was used for the intricate patterns over the garment of Vajrasattva. Heavy mineral blue pigment (gunjō) was used in the hair of all the deities as well as in the background.

Published: Sherman E. Lee, "The Five Secret Ones," *Bulletin of The Cleveland Museum of Art*, 49, no. 7 (September 1962): 158–166; *Kokka*, no. 63 (December 1894).

References: Watanabe Hajime, "Gohimitsu-zō," *Bijutsu Kenkyū*, no. 32 (August 1934): 402–404; *Kōya-san*, Hihō vol. 7 (Tokyo, 1968), pl. 26; *Daigo-ji*, Hihō vol. 8 (Tokyo, 1967); *Kokka*, no. 747 (July 1954); Togano-o Shōun, *Rishu-kyō no Kenkyū* (Kōya-san, 1930).

18. Rāgarāja (Aizen Myō-ō)

Ca. A.D. 1400
Ink, colors, and gold pigment on silk
Hanging scroll; 135.1 × 89.4 cm
The Metropolitan Museum of Art; Purchase, Mary Griggs Burke Gift, 1966

The blood-like red of Aizen's body and halo affect the viewer at a viscerally emotional level entirely appropriate to the deity's symbolic meaning: the deepest of carnal passions and ecstatic states are a pathway to enlightenment. Called in Sanskrit Rāgarāja (King of Passion; J Aizen Myō-ō), he is one of the Kings of Bright Wisdom (Myō-ō) whose violent energies are turned against folly, against profane passion, against all obstacles to enlightenment. His face rages with anger, his hair stands rigidly on end, and golden flames project from his body. From his own head emerges that of a scowling lion, and his hands hold Esoteric Buddhist emblems: among them the bow and arrow derived from those of Kāma, the Hindu god of love; and the double-headed thunderbolt and bell seen also in the Gohimitsu image (no. 17), with which Aizen is closely linked in iconographic meaning. Colorful round jewels, emblems of good fortune, spill from the large vase that stands before his lotus throne. The jewels combine on the ground plane to form flaming clusters, and, as symbols of prosperity and replenishment, express the basic Esoteric conception of the unity of the material and spiritual realms. Containing much of the strong sexual content of Indian tantrism, this deity became known in East Asia through a sutra given the short name of Yugi-kyō (T 867) in Japanese, translated into Chinese in A.D. 723–730 by Vajrabodhi, who was one of the first of the great Indian Vajrayana masters to work in China. Strangely enough, Aizen Myō-ō is not featured in the main Shingon and Tendai mandalas. The Japanese became aware of him in the ninth century, and he appears occasionally in Heian period iconographic drawings and manuals, but he did not seem to play a significant role in Japanese religious life outside of the narrow circles of the clergy until the late Heian period, when courtiers, afflicted by problems of love or ambition, would invoke his powers. For example, in order to dispel the anguish and mortification of the Emperor Sanjō (reigned 1069–1072), his chaplain, the monk Ninkai, performed in the palace for seven days a series of Esoteric rituals directed to Aizen, including the reading of the Yugi-kyō. However, as with other individual Esoteric deities, Aizen's protective powers extended over a broad range of material and spiritual matters, and rituals for Aizen greatly increased in number in the turmoil and

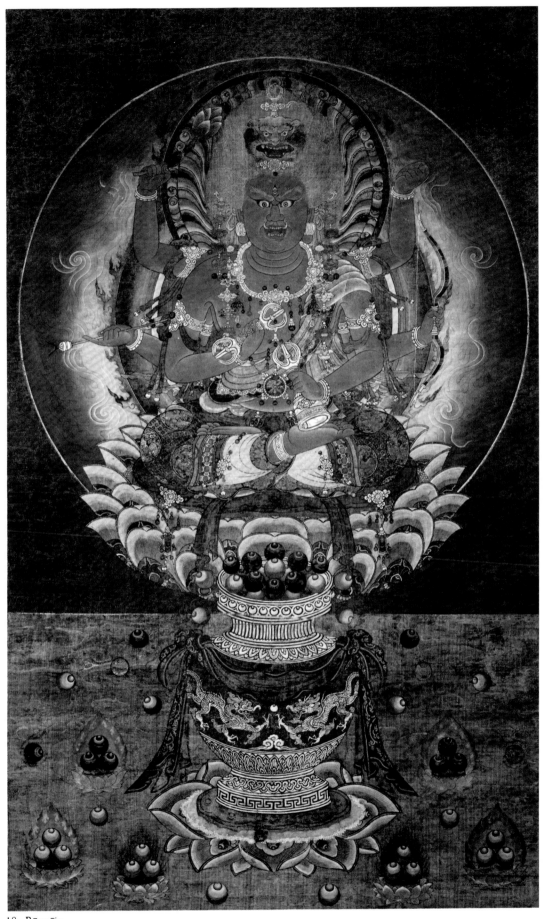

18. Rāgarāja

uncertainties of the collapse of the Heian aristocratic order and the rise of the military regimes of the Taira and Minamoto families.

This painting, from The Metropolitan Museum of Art, was done around the end of the period of Aizen's greatest popularity in Japan, the late thirteenth and fourteenth centuries, especially during the time when Japan lay under the severe threat of invasion by the dreaded Mongols, who had conquered China and Korea. Two actual landings were made, in 1274 and 1281, and the enemy repelled; but the fear of invasion lasted over a much longer period. Japan's religious establishments, both Buddhist and Shinto, were mobilized to bring the might of supernatural forces to protect the empire, and in this effort, Esoteric deities such as Fudō and Aizen were given a particularly prominent role. In the twelfth month of the year corresponding to A.D. 1281, for example, a seven-day ceremony for the protection of the nation was held at the Iwashimizu Hachiman Shrine south of the Heian capital. Over five hundred monks came from Nara and Kyoto for the recitation of prayers and incantations that the invaders' ships be burned and lost. At the climax of the rituals, the celebrated monk Eizon of Saidai-ji (see nos. 5, 6) shot an arrow from his own personal image of Aizen into the air in the western direction in order to focus divine forces in repelling the enemy.

A date of about 1400 for this painting is warranted by the assertive use of moriage, the relief-like application in gold pigment, over Aizen's jewelry, bell and thunderbolt, and throne. The light-and-dark structure of the painting is also somewhat disjointed because of the strong contrast of the dark tones of shu (cinnabar red) on the body and halos with the light ones—the white on the deity's skirt and the extensive areas of gold. A useful point of reference is a painting of the Fugen Enmei at Daigo-ji probably datable to 1383. Even though they differ in subject matter and aesthetic tenor, the two works are closely similar in numerous respects: the drawing of the neck, the handling of the moriage, and the definition of volumes.

Published: Miyeko Murase, *Japanese Art: Selections from the Mary and Jackson Burke Collection* (New York, 1975), no. 16; The Metropolitan Museum of Art, *Masterpieces of Fifty Centuries* (New York, 1970), pp. 37, 170; *The Metropolitan Museum of Art Bulletin*, 25 (October 1960), frontispiece.

References: *Daigo-ji*, Hihō vol. 8 (Tokyo, 1967), pl. 115; *Hōbōgirin*, fascicle 1 (Tokyo, 1929), pp. 15–17.

19. Mandala of Rāgarāja (Aizen Myō-ō)

Dated in accordance with A.D. 1107
Ink on paper
Hanging scroll; 58.4 × 53.3 cm
Mary and Jackson Burke Foundation

Similar in symbolic content to the painting of the Five Esoteric Ones (no. 17), this important dated mandala depicts in the center the ferocious, six-armed Rāgarāja (Aizen Myō-ō), embodiment of carnal passion and desire that has been converted into energy leading to enlightenment (no. 18). Around him are six other deities, a dragon-entwined sword, and a sacred banner capped with a jewel.

A dated inscription is found on the reverse side of the scroll. It gives the title of the mandala as "Aizen Ō Mandara" and a statement at the lower left to the effect that it was copied on the fifth day of the third month of the second year of the Kashō era (A.D. 1107) from a model owned by Sammai Ajari Ryōyū, who had inherited it from his teacher, Ōhara Sōzu Chōen (1016–1081). Both Ryōyū and Chōen were Tendai monks well known for their scholarship of Esoteric Buddhism. This mandala's special relationship to Tendai teachings is substantiated by the fact that it was considered to have been brought from China by the great Tendai pilgrim monk Enchin (814–891). Until about 1955, this painting was in the collection of the Shōren-in in Kyoto, a subtemple of Enryaku-ji, headquarters of the Japanese Tendai sect, and it is interesting to note that the founder of the Shōren-in, Gyōgen (1097–1155), had also been a pupil of Ryōyū.

This particular type of Aizen mandala has long been familiar to students of Buddhist art. It was included in several of the great compendia of Buddhist iconography written in the late Heian and early Kamakura periods, for example in the first scroll of the *Shoson Zuzō*, in scroll 81 of the *Kakuzen-shō*, and in scroll 115 of the *Asaba-shō*. Although the names of the deities shown here were written on the reverse side of the paper, some were erroneously identified, and one must consult the old iconographic manuals to determine their exact identities.

The main deity, Aizen Myō-ō, occupies the central position. He is distinguished from his appearance in other mandalas in that no vase is shown under his large

19. Mandala of Rāgarāja

mandorla, and one of his six hands holds a human head identified as that of a deva in the *Yonjūjōketsu* of Chōen. Beneath Aizen is Kannon, whose symbolic direction is the east. At the lower left side is Daiitoku Myō-ō (S Yamāntaka), who triumphs over death and mortality (no. 23); he is shown with four arms and three heads, and he holds both a sword and a noose; his symbolic direction is the southeast. At the upper left is the twelve-armed Daishō Kongō, considered to be in the southwest.

At the center top is Miroku (S Maitreya), Buddha of the Future depicted here as a bodhisattva. At the lower right is Fudō (S Acala), the Immovable One considered to be located in the northeast; in his flaming halo are Śākyamuni, Mañjuśrī, and Vajrapāni Bodhisattva. In the upper right, the northwest, is Aizen himself, shown here with two heads, one ferocious, the other benign.

This is a superb example of an Esoteric Buddhist drawing. Thin but supple brush lines were executed rather quickly. The limbs and torsos of the deities are lithe and well proportioned; the folds of their scarves and skirts are depicted realistically, conveying the effects of soft material. Their faces are drawn with a minimum of detail, yet they are quite expressive. The softly undulating lines that delineate the burning flames of their mandorlas reveal an easily flowing brush. Such professional handling of the brush, a rigorous restraint in facial expression, and the depiction of the deities with massive chests and knees are clearly reminiscent of early Heian drawings, many of which were modeled after Chinese works. This mandala bears a strong stylistic affinity to the recently discovered wall paintings in the Taishi-dō at Kakurin-ji that date from the early twelfth century A.D.

The dated inscription on the mandala makes it an important research document for students of Buddhist painting. The color notations and the names of Miroku and Kannon on the drawing probably were made by the artist himself, whose calligraphy differs from the notations on the reverse side.

Yanagisawa Taka, Tokyo National Art Research Institute

References: Takakusu J. et al. (eds.), *Taishō Shinshū Daizō-kyō Zuzō*, vol. 3 (Tokyo, 1932), p. 694; vol. 5 (Tokyo, 1933), p. 256; vol. 9 (Tokyo, 1934), p. 302.

20. Mandala of Vaiśravaṇa (Bishamon Mandara)

Early thirteenth century A.D.
Ink, colors, and gold pigment on two pieces of silk
Hanging scroll mounted on a panel; 119.1 × 68 cm
Museum of Fine Arts, Boston; Special Fund for
 Chinese and Japanese Art

This majestic painting of the standing Vaiśravaṇa, divine guardian king of the north, is unique for the sheer richness of its aesthetic and symbolic effects, and for its art historical importance. Somberly dark, its colors keyed on warm reds—cinnabar, rust, and umber—it bristles with a sense of intense energy and mysterious power.

It reveals the very strong stylistic influence of Chinese Buddhist and Taoist painting from the metropolitan region of Shansi, a style best preserved today in monumental wall painting of the early fourteenth century A.D.: at the Yung Lo-kung, for example, or murals from the P'ing-yang region now in the Royal Ontario Museum in Toronto. The influences are most apparent in the heightened complexity of details of clothing, armor, and weapons; in the ferocious demonic faces of the attendant yakṣas to the right; and in the intensified feeling of realism throughout. Lost are the large, harmonic rhythms of the earlier classic style; also the painters made no use of the techniques of delicately cut gold leaf (kirikane) or back painting (urazaishiki) current in the late Heian period.

The stages by which this particular style was absorbed in Japan, and by which the Boston painting may be given an approximate date, are made relatively clear by two well-known works. The oldest is the painting of *Bhaiṣajyaguru* (J Yakushi) *and His Twelve Divine Generals* at the Ochi-in on Mount Kōya, dated by Yanagisawa Taka to the last half of the twelfth century. The attendant figures have much the same demonic energy and complex detail shown in the Boston painting, but the classical system of idealized forms exerted a far stronger influence on the treatment of faces and general composition than here. More securely dated are the paintings, now in the Tokyo University of Arts, on a wooden shrine that once held the statue of Śrī-lakṣmī (J Kichijō-ten) dedicated in 1212 at Jōruri-ji in Kyoto prefecture. There too may be seen the costumes and demonic facial expressions of the Chinese regional style,

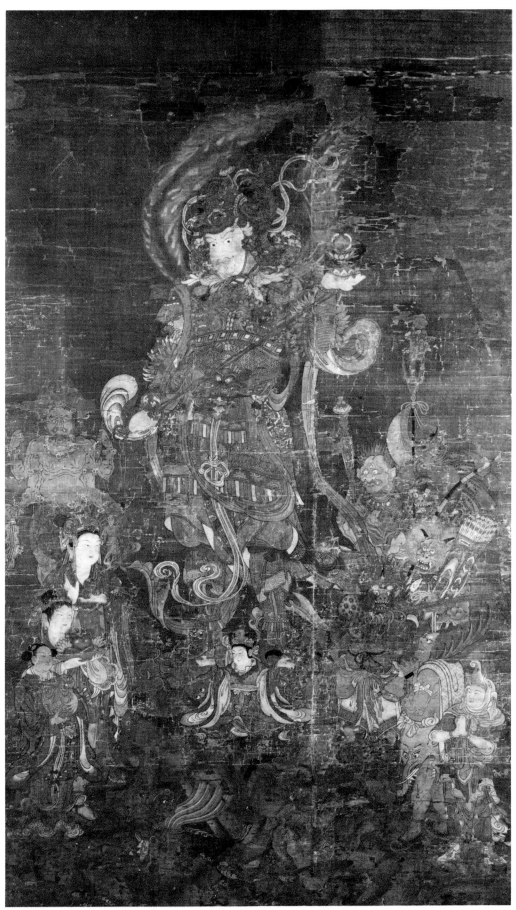

20. Mandala of Vaiśravaṇa *(color illustration, p. 31)*

but the shrine paintings partake of the revival of eighth-century elements that was in vogue in Nara and Kyoto in the early Kamakura period. By contrast, the Boston painting is far more faithful to contemporary Chinese prototypes.

Symbolically, this work demonstrates how Buddhism added layer upon layer of significance to well-established deities as the faith expanded through Central and East Asia. The form of Vaiśravaṇa shown here became linked to the Esoteric strain of ritual and doctrine. He is called Tobatsu Bishamon, the term Tobatsu being a reference to Chinese Turkestan and possibly to the kingdom of Turfan or, more likely, to the once powerful city-state of Khotan, of which Vaiśravaṇa was the tutelary deity. The Chinese pilgrim Hsüan-tsang described in great detail the Khotanese cult of this god and the miracles associated with him. The cult was accepted in China along with other forms of Esoteric Buddhism. In A.D. 742, at the invitation of the Emperor Hsüan-tsung, the Indian missionary Amoghavajra recited twenty-seven times the mantra of Vaiśravaṇa to help lift the siege of the Chinese fortress of An-hsi (forty miles from Tun-huang) by an army of Arabs, Tibetans, and Sogdians. In gratitude, the emperor ordered that images of this form of Vaiśravaṇa be placed in the northeast corner of all major Chinese cities and that the deity be worshiped in all monasteries.

This cult was brought to Japan by Kūkai and his followers in the ninth century. An impressive Chinese wooden statue of Tobatsu Bishamon stood in the second story of the Rashōmon entry gate to the Heian capital, an image that was much emulated throughout the nation. In time, Tobatsu Bishamon became widely worshiped as a personal guardian. The prayer often recited to him, the Dai Bishamon Tennō Darani-giki, invoked his power to ward off illness and physical dangers and to free his devotees from fear, for his majestic power and might can ensure the salvation of all sentient beings.

The Boston painting shows the deity supported by the hands of the Earth Goddess, who plays a salient role in the Khotanese cult of Vaiśravaṇa. Behind her are two half-hidden demons. In his right hand, Vaiśravaṇa holds a very long sword with a ring handle; in his left hand, emblematic of his role as guardian of Buddhist sanctuaries, is a stupa on a lotus pedestal. His body armor is exceedingly complex, with demon heads at his chest and waist. On his helmet are two large parrot wings, which are also prominent in his symbolism in Central Asia and reflect the influence of the Iranian war god Verethragna.

To his right are four frightful, subhuman yakṣas emblematic of the chthonian forces controlled by Vaiśravaṇa. Each bears a warlike weapon: a three-pronged halberd, a club topped by flaming jewels, a long bow and quiver, and a club with sawlike "bear claws." In the foreground, wearing an elephant pelt over his head, is a boylike attendant with hands joined in the gesture of worship.

To Vaiśravaṇa's left stands a yakṣa called Shakumba with four arms, in one of which, held by the hair, is a small human being. Next is the goddess of beauty and abundance, Śrī-lakṣmī, who is occasionally considered the deity's wife. A servant woman presents a basin of flowers and fruit, and in front is a boy attendant, Zeniji in Japanese, with his hair in separate braids over his ears. In the foreground are two dwarflike yakṣa demons. The one to the left is Bilamba, whose name suggests the great wind which is streaming forth from the bowl in his hands. The other, Nilamba, is asleep with his legs crossed before him.

A tradition that this painting came from the Tendai monastery of Enryaku-ji near Kyoto can be neither confirmed nor denied. The cult of the Tobatsu Bishamon was known in Tendai circles, however, and there is record that statues of the deity stood in the Zentō-in and Monju-dō atop Mount Hiei.

Published: Ariga Yoshitaka, *Nihon no Butsuga*, part 2, vol. 8 (Tokyo, 1978); Shimada Shūjirō (ed.), *Zaigai Hihō*, vol. 2 (Tokyo, 1969), no. 12; Jan Fontein and Pratapaditya Pal, *Museum of Fine Arts, Boston: Oriental Art* (New York, 1969), pl. 14; Kakuzo Okakura in *Museum of Fine Arts Bulletin*, 4 (February 1906): 4.

References: Phyllis Granoff, "Tobatsu Bishamon," *East and West*, n.s. vol. 20, nos. 1–2 (March-June 1970); *Hōbōgirin*, fascicle 1 (Tokyo, 1929), pp. 79–83; Samuel Beal, *Si-yu-ki: Buddhist Records of the Western World* (London, 1906), vol. 1, pp. 44–45, vol. 2, pp. 309–311; William Charles White, *Chinese Temple Frescoes* (Toronto, 1940); Shansi Archaeological Administrative Committee (ed.), *Yung-lo-kung* (Peking, 1964); Takata Osamu and Yanagisawa Taka, *Butsuga, Genshoku Nihon no Bijutsu* vol. 7 (Tokyo, 1969), pls. 29, 30; Tanaka Ichimatsu, "Bishamon Tennō-zō . . . ," *Kokka*, no. 868 (1964).

21. Brahma-deva (Bonten)

One of a set of the Twelve Devas (Jūni-ten)

Dated in accordance with A.D. 1407

Hand-colored woodblock print on four sheets of paper

Mounted as a hanging scroll; 105.3 × 37.7 cm

The Art Institute of Chicago; Kate S. Buckingham Collection

The Twelve Devas or Divine Guardians were a popular theme for woodblock print artists in the Muromachi period, but this set in The Art Institute of Chicago is a rarity because it is dated, complete, and of unusually high quality. The date Ōei 14 (corresponding to A.D. 1407), third month, twenty-first day is given in the inscription on the staff held in the upper right hand of Bonten. The inscription also gives a location, presumably the subtemple for which the original blocks were carved and printed: Kokūzō-in, in the Yodagō Jingū-ji, Ōuchi-gun, Sanshū, which is in present-day Kagawa prefecture on Shikoku.

Both this figure of Bonten and the accompanying image of Bishamon are outstanding for their composition and state of preservation. They were originally printed with woodblocks on large sheets of paper made of four smaller sheets joined together with horizontal seams. Three colors were then used to hand-paint these prints: the browns and reds are still clearly visible, but there are also traces of rokushō (malachite green) on the garments (for example, the waist scarves of Bonten and the lower leggings of Bishamon), although this pigment has largely fallen away. Sometimes woodblock prints were covered with such a thick layer of pigment that the original printed lines could not be seen and they were thought to be original paintings, but that is clearly not the case with these two prints, which have, unfortunately, lost a considerable amount of pigment.

Of purely Indian origin, the Twelve Divine Beings (S deva), symbolizing major forces controlling the physical world, played a prominent role in Esoteric rituals. For example images of the Jūni-ten and also of the Five Myō-ō were the primary objects of worship in an elaborate ritual for members of the imperial court and civil administration intended to protect the nation and promote its prosperity. In the Shingon-in, a special chapel within the imperial palace compound, the ritual would be performed on the eighth day of the first month as part of the ceremonies of the new year; the deities would be depicted on hanging scrolls or else mounted on folding screens. The same ceremony would also be performed for the sake of the nation within the Esoteric monasteries themselves; for example, the set of paintings in Tōji that served as the prototype of the pictures

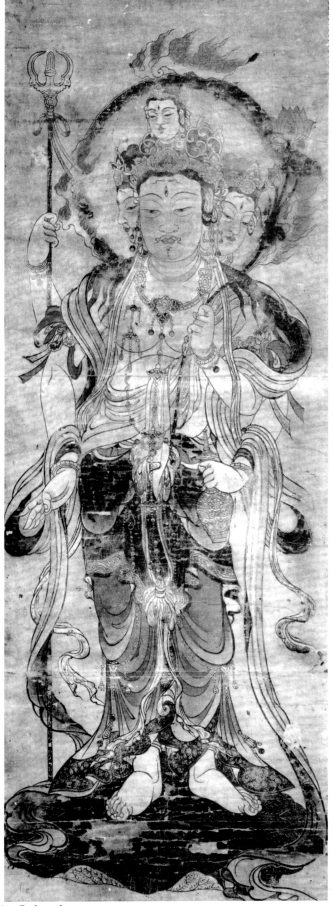

21. Brahma-deva

exhibited here was installed in the Initiation Hall (Kanjō-dō) there.

The twelve deities and the elements or qualities they signify are as follows: Indra, god of rain and justice; Agni, god of fire; Yama, god of death; Rākṣasa, god of demons; Varuṇa, god of waters; Vāyu, god of wind; Vaiśravaṇa, god of wealth, chief of the heavenly guardians; Iṣāna, a form of Śiva and god of wealth and protection; Brahma, counterpart to Indra and god of sacred Indian lore; Pṛthivī, god of the earth; Sūrya, the sun god; Candra, the moon god.

The deity shown here, Bonten (S Brahma-deva) became one of the symbols for the Supreme Creator in Hindu religion; in Buddhism, however, he was the representative of traditional Indian creeds that had recognized the superior religious values of Buddhism. In this guise, he was often paired with Indra (J Taishaku-ten), who was lord of the atmosphere, ruler of Vedic gods, and model of the ideal king. Brahma is depicted here in an Esoteric Buddhist guise, slightly demonized in form: he has four arms, four heads, and a third eye in the central head. In his upper hands he holds a spear and a lotus; one lower hand makes the varada (gift-giving) hand gesture and the other holds a vase. In the print, the deity stands upon a lotus. In the Mandala of the Two Worlds, however, he is shown seated upon his mount, a great goose, alongside Indra and the Four Heavenly Kings (shitennō), forming a six-member protective group.

This stately figure, with its faces in serene repose, is faithful to a tradition of the Twelve Devas that stretches back to a set of paintings on silk by Takuma Shōga at Tōji, dated in accordance with A.D. 1191. Apparent in the prints, however, is a hardening of form that would help date them to the early fifteenth century even if there were no inscription. Through the long period of repetition of the imagery, the gentle, feminized visages of earlier days and the sveltely swaying bodies have been altered. In this print, the primary face is fuller, more set, with a greater masculine character. The garments too are more schematized, with many nondescriptive lines, and the bursts of flame around the head halo have become somewhat conventionalized and do not dance in the lifelike manner seen in earlier works. Other impressions from the original blocks of 1407 have been preserved and published. These show that sometimes a wider range of color was used to paint these prints: in addition to browns, reds, and greens, we also see in these other prints tans, peaches, and blues.

References: Ishida Mosaku, *Kodai Hanga*, Nihon Hanga Zenshū vol. 1 (Tokyo, 1961), nos. 11, 181; *Tōji*, Hihō vol. 6 (Tokyo, 1969), pl. 43.

22. Vaiśravaṇa (Bishamon)

One of a set of Twelve Devas (Jūni-ten)

Dated in accordance with A.D. 1407
Hand-colored woodblock print on four sheets of paper
Mounted as a hanging scroll; 105.3 × 37.7 cm
The Art Institute of Chicago; Kate S. Buckingham Collection

This woodblock-printed image of Bishamon belongs to the same dated set as the Bonten picture (no. 21). As an Esoteric picture, it has remarkable similarities to the Boston Museum of Fine Arts painting of the Tobatsu form of Bishamon (no. 20): heavy, stolid proportions of the figure, elaborate and florid armor, and the fiery emanations from the head. These pictures all belong to a tradition of imagery that originated in Sung China and that was absorbed and perpetuated in Japan. The distant prototype for the woodblock prints, the 1191 painting at Tōji attributed to Takuma Shōga, was very much part of this tradition; the Takuma painters were noted for their mastery of Chinese idioms (nos. 25, 26). Bishamon is seen here in his customary form, with armor and helmet, holding in his left hand a miniature stūpa or reliquary, a symbol of the Buddhist Law that he is pledged to protect. In his right hand he holds a mace surmounted by three small flaming, wish-granting jewels, symbolic of his military might as well as of his power to grant the desires of his devotees.

The production of woodblock-printed devotional images came into vogue during the Kamakura period, perhaps in response to increasing popularization of the faith. In China, prints had long played a significant role in the visual imagery of Buddhism, chiefly as frontispiece illustrations to printed sutras, or as single sheet images distributed at temples. Such customs were slow to develop in Japan. During the late Heian period, crude and rapidly printed images often were placed as dedicatory objects inside Buddhist statues; but during the Kamakura period, large-scale block-printed images as objects of devotion were often made for use in private homes or by small temples. By the late fourteenth century, such printed images would be hand colored, sometimes with high skill, by a well-trained painter, and the practice became increasingly common. The two prints exhibited here belong to the period of perhaps greatest interest and facility in this branch of Buddhist imagery, and a number of other prints from the same blocks may be found, some colored and some in simple black and white.

Reference: Ishida Mosaku, *Kodai Hanga*, Nihon Hanga Zenshū vol. 1 (Tokyo, 1961), no. 184.

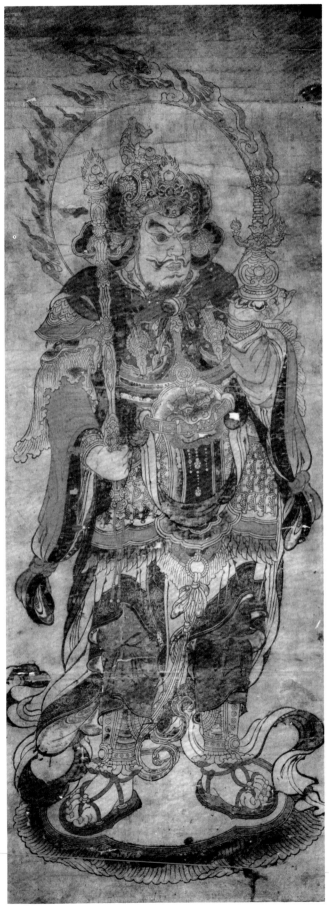

22. Vaiśravaṇa

23. Yamāntaka (Daiitoku Myō-ō) Riding a Bull into the Sea

Early seventeenth century A.D.
Ink, colors, and gold pigment on paper
Hand-colored woodblock print; 49.2 × 27.6 cm
Fogg Art Museum, Harvard University; Purchase,
 Horace M. Swope bequest

Engulfed in swirling flames and charging into the sea on the back of his water buffalo is Yamāntaka (literally, the Eater of Death; J Daiitoku, the Great Majestic One). He has six arms, legs, and heads; a skull is shown prominently over the central head, and he bristles with offensive weapons—a bow and arrow, a great halberd, a club, a sword, and a discus. For a late work essentially mass produced, this small composition has amazingly high aesthetic quality. The fact that the underlying composition was established by a block print can be determined only on careful examination under strong light; it was completely and carefully painted with fresh and vital colors that reinforce the inventive composition.

The deity, one of the Five Great Wisdom Kings (Godai Myō-ō) of the early Esoteric tradition in Japan, plays a prominent role in the visual arts, but primarily as a member of the group. This particular version, however, is a rare example in which he was intended to serve as the object of an independent cult. His name and symbols, particularly the water buffalo, were derived from those of Yama, the god of death in the Vedas, India's most ancient religious hymns. However, as with so many of the Esoteric Buddhist deities who arose in India, original symbolic values were inverted. Instead of the god who receives the dead, he became the god who defeats death, and also ignorance and other spiritual obstructions. He is considered to be an emanation of Mañjuśrī among bodhisattvas, and of Amitābha among the tathāgatas. In Tibetan forms of Esoterism, Yamāntaka became extremely popular, and his brutish figure with the head of the water buffalo is ubiquitous in Tibetan religious art.

The image type shown here, with Yamāntaka standing on the water buffalo and aggressively descending into the sea, is quite rare. Only three early examples are known: a badly abraded painting of the Kamakura period in Tōshōdai-ji, Nara; another, slightly later one in the Nezu Museum, Tokyo; and the third, also badly worn, in the Jinmu-ji in Kamakura, an old Tendai temple that had close ties to the Kamakura bakufu. The motif also appears in iconographic manuals. The monk

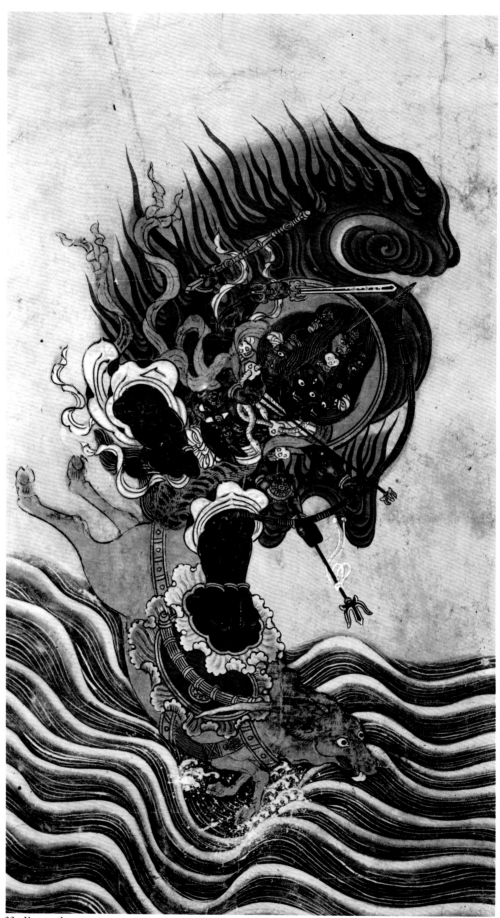

23. Yamāntaka

Shinkaku (died 1180), in the *Besson Zakki,* showed Daiitoku standing on the back of his water buffalo with an entourage of eight demons; the sea, however, was not depicted, and Shinkaku in his text confessed that he was unable to explain the origins of the theme. The *Kakuzen-shō* of about 1218 reproduces a less refined image showing eight child attendants standing on lions, and the twelve zodiacal gods; it also depicts the water buffalo approaching the sea, from which emerge two dragons offering flowers. The text of the *Kakuzen-shō,* condensed and cryptic, gives an inkling of the image's basic iconic significance: the water buffalo and its rider enforce the vision of enlightenment in the waters of existence.

> Hidden within the sea are poisonous evil dragons; the water buffalo dwells there, ruling as a Benevolent King, and crossing the great sea with power. The sea is that of life and death [i.e. saṃsāra]. The skull [as a symbol of life and death] is an illusion; it knows that life and death are nirvāṇa [i.e. the Mahayana concept that in nirvāṇa is saṃsāra; in saṃsāra is nirvāṇa]. The Sutra of Benevolent Kings states: Before the bodhisattva attains Buddhahood, bodai (enlightenment, or the Buddhist way) is suffering and hardship; after Buddhahood, suffering and hardship are nirvāṇa.

The image of Daiitoku entering the sea served as the focal point of a ritual based on an Esoteric text (T 1219) translated by I-hsing (683–727), Chinese disciple of the Indian missionary Vajrabodhi. The *Kakuzen-shō* records the ritual being performed in 1152 and 1156. In 1183, it was performed in the Rengeō-in in Kyoto by enemies of the Taira family in order to obtain their defeat.

The reasons for the revival of interest in this form of Yamāntaka in the early Edo period have not yet been determined; the fact that it was the subject of a woodblock print implies that it must have become part of popular religion. The Cleveland Museum has recently purchased a large and handsome painting very similar in composition to the Fogg print.

Published: Blanche Magurn, "Daiitoku Myō-ō," *Fogg Museum Bulletin,* 9 (November 1942).

References: *Tōshōdai-ji,* Nara Rokudaiji Taikan vol. 13 (Tokyo, 1969), pl. 169, pp. 78–79; *Bukkyō Geijutsu,* 64 (May 1967): pl. 1, pp. 90–91; Takakusu J. et al. (eds.), *Taishō Shinshū Daizō-kyō Zuzō,* vol. 3 (Tokyo, 1932), pp. 437–447; vol. 4 (Tokyo, 1933), pp. 360–372; *Kamakura no Butsuga,* Kamakura Kokuhōkan Zuroku vol. 6 (Kamakura, 1958), pl. 18; *Seizansō Seishō (Illustrated Catalogue of the Nezu Collection),* vol. 10 (Tokyo, 1943), p. 17.

24. Drawing of the Eleven-Headed Avalokiteśvara (Jūichimen Kannon)

Thirteenth century A.D.
Ink on paper
Hanging scroll; 140 × 82 cm
The Art Museum, Princeton University; Gift of J. Lionberger Davis

Exceptional for its large scale, this drawing vividly illustrates the process by which styles and themes were transmitted over the centuries by Japanese Buddhist artists. Although now mounted as a hanging scroll, the image was originally intended neither for public viewing nor as an object of worship. In all likelihood it was carefully copied from a now lost painting of the late Heian period in order to serve as a model for artists creating a new picture. It shows considerable reworking and experimentation—the search with pale lines for the ideal contour, the shifting of the direction of arms and feet. Most striking is the careful painting of the eyebrows in a doubled line, the same technique that would be used in the finished painting, where customarily a line of dark blue (gunjō) would be placed carefully next to one in black ink.

The Japanese term zuzō (literally drawing-image) has in recent years been applied to a wide range of Buddhist drawings and has often been translated "iconographic drawing." The many kinds of zuzō share in common only the fact that they were normally done on paper, were often uncolored or lightly colored, and were not intended as formal objects of worship. Otherwise, they have a wide range of functions: as precise instructions given to a workshop for the preparation of a formal painting; as encyclopedic records of famous works of religious art; and as detailed manuals of symbolic meaning to be studied by young monks (nos. 25, 26). Frequently, the drawings made by distinguished monk-painters were themselves copied as important records of correct iconographic detail (no. 30). The custom of making such drawings was most strongly implanted in Esoteric monasteries such as Tōji or Enryaku-ji, or on Mount Kōya, where thousands of drawings have been preserved. The custom may well have begun with the ninth-century Esoteric monks, for example Kūkai and Ennin, who voyaged to China and returned with drawings and paintings in large numbers.

This painting is closely based on the form of the Eleven-Headed Kannon as it appears in the Taizō mandala, in the eleventh (S Susiddhi) of the twelve sectors

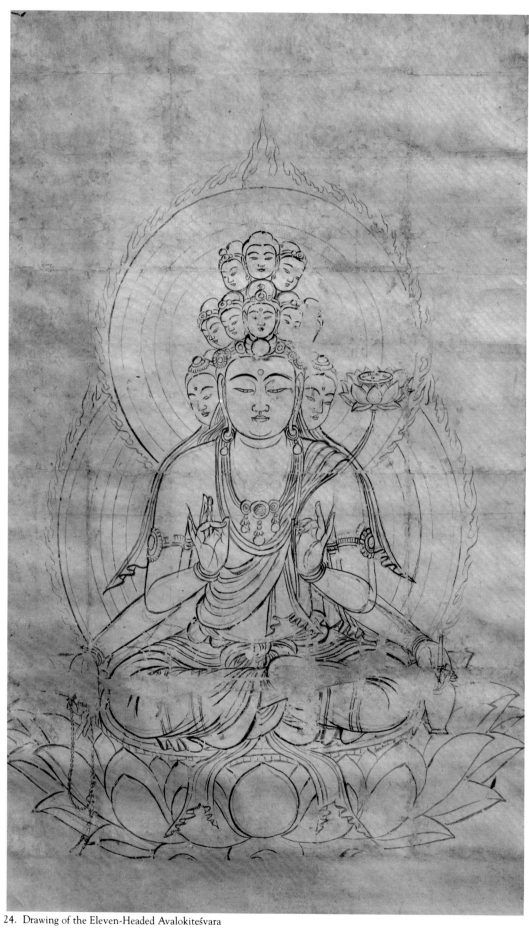

24. Drawing of the Eleven-Headed Avalokiteśvara

or assemblies. The figure holds the graceful lotus stem and bud, one of the fundamental emblems of Avalo-kiteśvara, as well as a rosary and water vessel; the upper right hand makes a teaching gesture with thumb and ring finger joined. As in so many other images of Esoteric Buddhist deities, there is close correspondence between their representations in the mandalas and as independent objects of devotion. It is, however, unusual to see this form of the Eleven-Headed Kannon represented alone in drawing or painting.

The Eleven-Headed Kannon was one of the forms of the deity most widely worshipped throughout the Heian period, serving for example as the focal point of a rite of repentance (keka) by which laymen and monks would confess their misdeeds in order to avoid retribution. One of the Esoteric texts (T 1070) upon which its worship is based, translated from Sanskrit into Chinese in the sixth century A.D., states that the great bodhi-sattva makes a spiritual vow called "eleven-headed" for the sake of all sentient beings: to relieve them of illness, misfortune, suffering, and worries; to free them of evil intentions; to turn their thoughts toward good karma—for a total of eleven saving deeds. In some of the early Heian period sculptures, faithful to the textual sources, the heads were given different expressions. The three in the center were shown as compassionate, thereby suited to the devotee of good karma; the three on the left had angry expressions directed toward evil beings in order to save them; the three on the right had white tusks from the top of their mouths to assist people with pure karma to find the Buddhist way; a single face in the back was shown with a violent laugh to reform evildoers; and the Buddha face on the top of the head was to preach the Dharma to those capable of following the doctrines of Mahayana. In most images, however, as can be seen in the Princeton drawing, the faces were uniform and the general aspect of the deity benign and consoling.

In collaboration with Christine Guth Kanda, Princeton University

Published: Shimada Shūjirō (ed.), *Zaigai Hihō*, vol. 2 (Tokyo, 1969), no. 6.

References: Hamada Takashi, *Zuzō*, Nihon no Bijutsu no. 12 (Tokyo, 1970); Takakusu J. et al. (eds.), *Taishō Shinshū Daizō-kyō Zuzō*, vol. 3 (Tokyo, 1932); Takata Osamu and Yanagisawa Taka, *Butsuga*, Genshoku Nihon no Bijutsu vol. 7 (Tokyo, 1969), pl. 111.

25. The Bodhisattva Jokaishō

Attributed to Takuma Tametō (active mid-twelfth century A.D.)
Ink and colors on paper
Page of notebook mounted as hanging scroll; 25.3 × 14.2 cm
The University of Michigan Museum of Art; Margaret Watson Parker Art Collection

This light and gracious painting, together with the one that follows (no. 26), came from a notebook of ninety-five almost identical illustrations used for the secret instruction of monks about the deities of the Kongō-kai mandala—their names, their mantras, and other symbols. In purely aesthetic terms, because the artists drew with sure and fluid lines and colored in subtle, lively hues, these are among the finest iconographic drawings of the era. In this painting, the dominant colors are blue and yellow. Deep yellow is the color of the scarf over the chest; the treasure box in the foreground is an indigo blue touched with yellow at the edges; it rests upon a green lotus and the bands around it are painted red. In the halo are variations of yellow and a rose red, with the most intense yellow immediately around the deity's head.

The two pages shown here came from an illustrated notebook that was discovered in 1927 by a team of art historians in the Gangō-ji, a small temple in Kumamoto prefecture, Kyushu. In fact, however, the book had been rediscovered, for it had been treasured and even copied during the Japanese middle ages, and a facsimile with commentary had been published in 1921 by the distinguished scholar of Buddhist art Ōmura Seigai. Its full import, however, was not apparent until studied by the research team in 1927. Excited by their find, these specialists took legal steps to register and protect the book. But before these could be completed (it was not until 1929 that the government enacted stringent requirements to protect cultural treasures), the book was sold and the individual leaves were cut apart and offered for sale both in Japan and abroad. Twelve pages are now found in the Yamato Bunkakan in Nara; fifteen pages from the beginning and three from the end of the book, formerly in the Mutō collection in Kobe, are now in the collection of Kososhi Bunkichi,

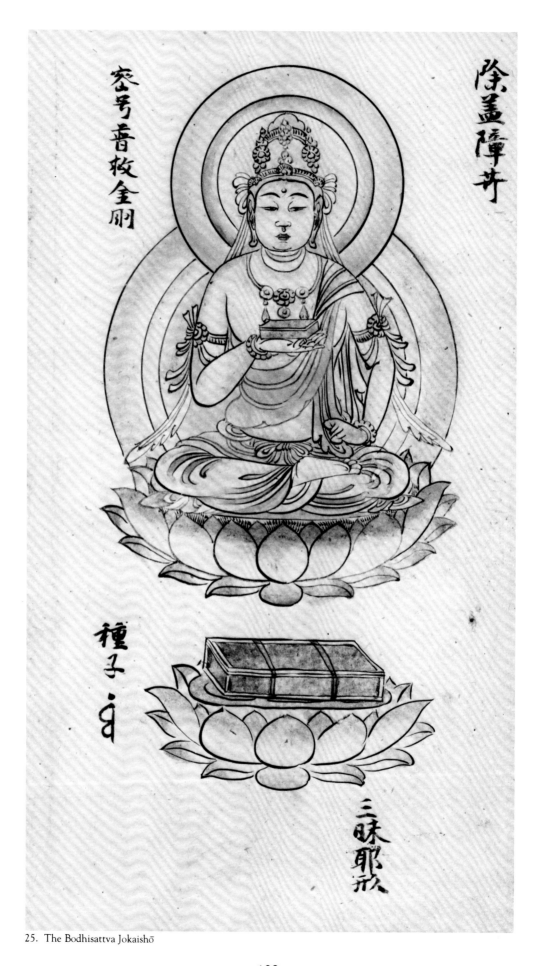

25. The Bodhisattva Jokaishō

Kyoto; others are in the Tokyo National Museum and the Tokyo Fine Arts University, and at least six are in the United States.

The Kososhi Collection pages from the front of the book are five simple black-and-white drawings of the Diamond World mandala in large double-page format, followed by a brief description of the mandala; the rest of the book consists of figures of ninety-five deities, one to a page, each a divinity from the Kongō-kai mandala. Colophons are found on the last two pages of the book, also in the Kososhi Collection. The earliest, dated in accordance with A.D. 1420, says that the book had been kept on Mount Kōya, in a northern subtemple, the Kōdai-in, and given by a certain monk named Chō-son to another called Kōshin. Another inscription, dated in accordance with A.D. 1531, by Shinson, the eighth abbot of the Gangō-ji, states that the drawings were done by "the painter, Shōchi, whose lay name was Takuma Tametō, Governor of Bungo, whose ecclesiastical rank was Hōin (Seal of the Law)," and then goes on to give the title of the book—the *Kontai Butsuga-chō*.

The attribution to Takuma Tametō has not been confirmed, but it is at least plausible on several counts. The Takuma family was a hereditary line of professional painters that continued for over three centuries, from the 980s to the 1310s. It was an early example of one of the familiar and yet unique features of Japanese cultural life: schools of professional men—artists, craftsmen, poets, actors, and even critics—which maintain their identity for many generations. As with the Kanō or Tosa painting schools of more recent times, the heads of the Takuma school must have carefully passed on to their successors the family's composition books, records, workshop secrets, and precious artists' materials like fine brushes, ink stones, and rare pigments.

Tametō and his two known predecessors held appointments in the imperial court, and indeed, for the most part, the Takuma painters were court artists with strong ties to the Buddhist monastic system. The first known Takuma master, Tameuji (died 987), is recorded as having painted screens in the apartment of the imperial consort of the Emperor Murakami. The second master, Tamenari, is said to have been the head of the Painting Bureau (edokoro) within the imperial palace compound. Tamenari is also said to have done the scenes of Amidist salvation on the interior walls of the Phoenix Hall of the Byōdō-in, near Kyoto, but this has not been sustained by strong evidence.

Tametō himself held an honorific court rank, Buzen no kami, or Governor of Buzen province in Kyushu. Such governorships, however, were usually honorary in character and involved few or no actual administrative duties. He was also granted the title of Hōin (Seal of the Law), the highest of the honorary religious ranks given by the imperial court to artists and men of letters. Not long before his death, and in an act characteristic of pious Buddhist laymen, he took the tonsure and assumed a monastic name, Shōchi, literally triumphant wisdom. Further details of his life are given in the next entry. Even if the drawings exhibited here are not from his hand, their disciplined and harmonious line quality reveal them to be the product of a professional master of the highest order.

The page from the University of Michigan Museum of Art, the fortieth in the original notebook, is representative of all the illustrations in terms of format. The deity, identified in the upper right corner as Jokaishō Bosatsu (S Sarvanivaraṇa-viṣkambhin, the bodhisattva who dispels spiritual hindrances) is an important one in Esoteric Buddhism, appearing in Indian Buddhist sculpture as well as in both of the main Esoteric mandalas. In the upper left, his "secret name" is given as Fukyū Kongō (Thunderbolt of Universal Salvation). Below that is his shūji, his "seed syllable" or mantra: dhvaṃ, written in a form of Indian script called Siddham. At the lower right is the term sam'maiya-gyō, meaning symbolic attribute, a reference here to the bound treasure box on a lotus beneath him, the device used to represent him on the altar tables of Esoteric rituals; the deity himself holds a similar box in his right hand.

Published: John M. Rosenfield, *Japanese Arts of the Heian Period* (New York, 1967), no. 5c.

References. Tanaka Ichimatsu, *Nihon Kaiga-shi Ronshū* (Tokyo, 1965), pp. 100–121; Miyeko Murase, *Japanese Art: Selections from the Mary and Jackson Burke Collection* (New York, 1975), no. 14; Phyllis Granoff, "A Portable Buddhist Shrine from Central Asia," *Archives of Asian Art*, 22 (1968–1969): 87–90.

26. The Bodhisattva Tōnan'un Kongō

Attributed to Takuma Tametō (active mid-twelfth century A.D.)
Ink and colors on paper
Page of notebook mounted as hanging scroll;
25.3 × 14.2 cm
Collection of Kimiko and John Powers

Seated poised on the lotus pedestal, his head in three-quarter view and held with aristocratic hauteur, this deity is one of the most crisply rendered of all ninety-five in the original notebook from Gangō-ji, from which the previous leaf (no. 25) also was taken. This page is noteworthy for the fact that it lacks much of the descriptive text written on the majority of the other leaves. The deity's name is given in the upper right-hand corner as Tōnan'un Kongō (Thunderbolt of the East-South Cloud) and also as Ishi Kongō (Thunderbolt Produced by the Will; Iṣṭavajra in Sanskrit). At the lower left the Chinese characters for shūji or seed syllable appear, but the seed syllable itself is absent. Below this appears the notation that this deity's color is black; his secret names are not present, nor is the symbolic device used to represent him on Esoteric table altars. His emblem may of course be the one he holds in his two hands, but, strictly speaking, this implement ought also to appear on the page below him.

The deity shown here is an unusual one not found in the two great mandalas of the Esoteric tradition. It is further evidence in support of the attribution of the notebook to Takuma Tametō, for the notebook itself belonged to a heretical form of Shingon Buddhism called Shingi (New Meaning) Shingon, to which Tametō, who must have been thoroughly familiar with the religious currents of his day, was once closely linked.

Tametō was mentioned in the records of the Shingon monastery atop Mount Kōya. In 1131, he painted the Mandalas of the Two Worlds and portraits of the sixteen Shingon patriarchs for the Daidempō-in, a building that was to be destroyed nine years later in the disputes over formation of the Shingi sect. He was joined in this commission by Jōchi, a monk-painter of distinction who is also represented in this exhibition (no. 30).

Tametō worked in the Emperor Konoe's (reigned 1139–1155) project to build and decorate the Gakuō-in on Mount Kōya, for which he painted twenty-seven deities on pillars of the inner sanctuary.

Spiritually, Tametō came under the influence of the monk Kakuban (1095–1143), one of the more controversial religious leaders of the day. Kakuban, born to an unusually pious family in Hizen (Kyushu), had been trained in the leading Esoteric Buddhist monasteries—Ninna-ji, Daigo-ji, Onjō-ji, as well as Mount Kōya. Impressed by the ideals of Pure Land Buddhism, he sought, as did many others, to eliminate sectarian divisions in the faith, and to bring about a rapprochement between Esoterism and the Pure Land creed by claiming that Amitābha, as well as Vairocana, can serve as the emblem of the generative principle of creation. This was a point that more orthodox Shingon thinkers could not accept, and that led them to burn Kakuban's sanctuary. In 1140, together with 700 monks, Kakuban left Mount Kōya to found the Shingi Shingon sect and, with the assistance of the Retired Emperor Toba, to rebuild the Daidempō-in at what is now the Negoro-dera in Wakayama.

We may only speculate about the precise relationship between Tametō and Kakuban; but Tametō made paintings for Kakuban's original Daidempō-in and thus may well have illustrated the deities of the new versions of the Shingon mandalas required by Kakuban's new doctrines. Nonetheless, he went back to Mount Kōya in 1174 to execute a commission, whereas Kakuban and his followers refused to return. Moreover, Tametō's sons and grandsons, who were noted for incorporating Sung Chinese stylistic elements into their paintings, continued to work for orthodox Shingon monasteries such as Tōji and Jingo-ji.

Published: John M. Rosenfield and Shūjirō Shimada, *Traditions of Japanese Art: Selections from the Kimiko and John Powers Collection* (Cambridge, MA, 1970), no. 30; Rosenfield, *Japanese Arts of the Heian Period* (New York, 1967), no. 5d.

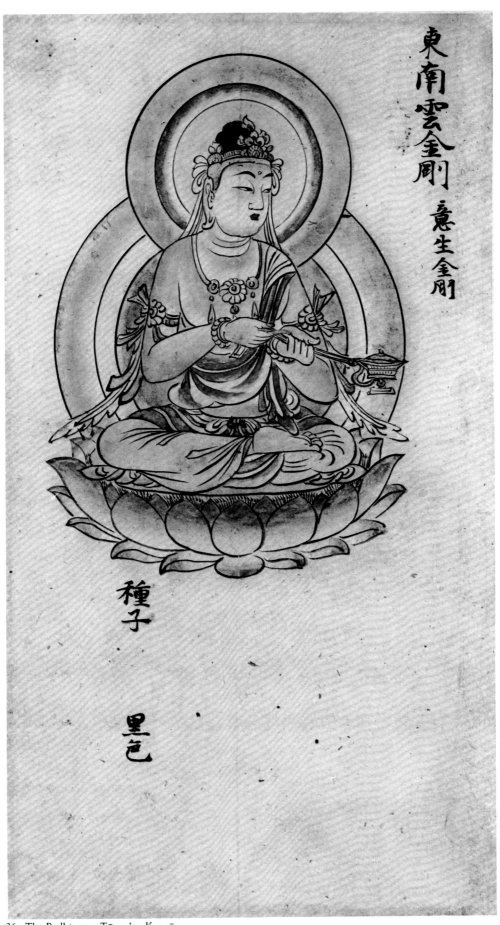

東南雲金剛 意生金剛

種子

黒色

26. The Bodhisattva Tōnan'un Kongō

105

27. Kuyō Hiryaku (The Secrets of the Nine Luminaries: An Astrological Treatise)

Early twelfth century A.D.
Ink and pale colors on paper
Book, 55 pages; each page 18.5 × 15.7 cm
The New York Public Library, Astor, Lenox, and
Tilden Foundations; Spencer Collection

Astrology played an important role in the lives of many practitioners of Esoteric Buddhism. As part of their intensive striving for purification of their emotions and deeds, many East Asian monks studied the influences of the planets and stars on individuals and on the world at large. Their studies in this area were at times encouraged and sponsored by rulers who held that properly ordered calendars and forewarning of untoward astrological events were indispensable for harmonious and stable government. Many texts on astrology were circulated in T'ang China, and a number of them attained scriptural status; the standard modern edition of the Chinese Buddhist canon includes fourteen T'ang texts on astrology in the section on esoteric teachings. Many other treatises composed by Buddhist astrologers, though not included in the scriptures, have been preserved in manuscript form; the Spencer Collection manuscript of the Kuyō Hiryaku is one such work.

The Kuyō Hiryaku conveys teachings on the mysterious astrological significance of nine heavenly bodies, including the Sun, the Moon, the five planets of traditional visual astronomy—Mars, Mercury, Jupiter, Venus, and Saturn (discussed in that order in the manuscript) —and two invisible phenomena related to eclipses, the two lunar nodes. Even though the luminaries are physical entities (with the exception of the lunar nodes, their motions can be observed and plotted in the sky), they are also perceived as potent spiritual forces or deities. The seventeen illustrations in this manuscript depict the deities of these heavenly bodies.

The illustration shown here, second in the manuscript, is the Moon, identified as the quintessence of yin energy. She is portrayed as the celestial empress, the counterpart of the Sun, shown in the preceding illustration as the embodiment of yang energy. With soft rounded face, elegantly long eyes and brows, and flowing robes appropriate to her rank, done in pale colors of peach and mustard, she is the epitome of gracious feminine majesty. She holds in her right hand a radiant moon disc, ringed with flames; in her left hand, she holds a red lotus flower.

Several copies of the Kuyō Hiryaku are known to exist. The Spencer manuscript is undated, but is related to a version in the Museum of Fine Arts, Boston, copied by the monk Jōken in A.D. 1224, and a version in The Metropolitan Museum of Art signed by the

monk Sokan, who copied it in 1125, based on an earlier version dated 940 (both the Boston and Metropolitan manuscripts are in handscroll form). The Spencer version, whose line drawing and faint color scheme are elegantly refined, can be dated to the first half of the twelfth century on the basis of style and must be the earliest of these manuscripts.

Though portions of the text of the Spencer manuscript are lost because of worm holes and wear, the contents can be fully reconstructed through comparison with the Metropolitan scroll. Following the introductory passages, which state basic principles and advise the reader to pray to the White-Robed Avalokiteśvara (nos. 52, 53) for aid in overcoming difficult astrological configurations, the contents of the text hold to a distinct order in the succeeding chapters. First the names of the luminary are given in various languages, and the Sanskrit mantra is written out in Siddham characters. Then the significance of the luminary is discussed (the moon symbolizes the ministers and nobles at the court —probably because they reflect the light of the sun-emperor). Various auspicious and inauspicious factors related to the luminary are revealed. For example, on the Moon's day, Monday, it is auspicious for the ruler to consider the reports and discussions of the officials, and it is auspicious to engage in activities related to fluids, such as digging wells and making wine. It is inauspicious for the emperor to ascend the throne under the strong influence of the Moon—perhaps because he would be overshadowed by strong ministers—and major financial decisions should not be made at this time, because the Moon causes financial fluctuations and inspires fantasies and vain hopes. Children born on the day ruled by the luminary are described. Monday's child will have difficulties in infancy, and should be well cared for. A child born in the morning will be easygoing; one born in the evening will be obstinate.

The contents of the treatise point to T'ang China as the likely source for the original text or texts from which these several copies have ultimately emanated. The source was most likely composed in the ninth century, perhaps by a disciple in the tradition of the brilliant Buddhist master and astrologer I-hsing (683–727), who was advisor to Emperor Hsüan-tsung.

In the text, concepts of Indian Buddhist astrology (represented by Sanskrit mantras for each of the luminaries, and the inclusion of the lunar nodes Rāhu and Ketu, an important feature of Indian astrological teachings) are merged with earlier Chinese traditions (shown by the assignment of the traditional Chinese elements to designate the five planets, a practice dating back to at least the early Han period, second century

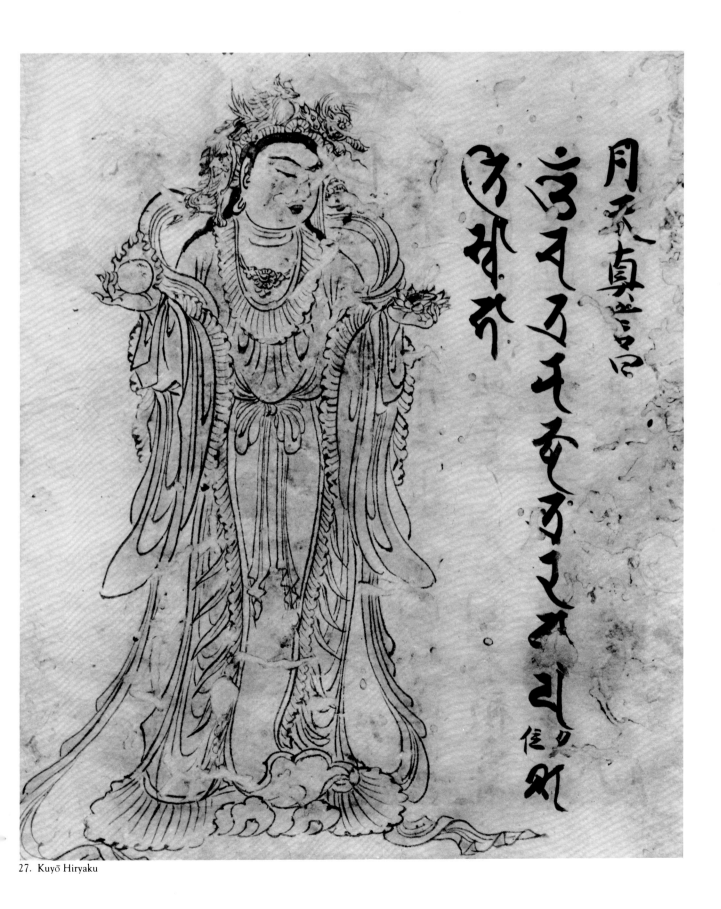

27. Kuyō Hiryaku

B.C.). The inclusion in the manuscript of the Sogdian, Persian, and Sanskrit names of each of the luminaries recalls the middle period of the T'ang dynasty (A.D. 681–907), a dynamic time when astronomers and astrologers from all over the ancient Orient were gathered in the capital Ch'ang-an to compete for imperial favor.

The illustrations follow two separate T'ang period iconographic traditions. The first set of illustrations, including the drawing of the Moon shown here, plays a vital role in the treatise, for each figure illustrates a relevant chapter of the text. Here the nine luminaries are shown as beings with normal human appearance (with the exception of Mars, who has four arms, and the lunar nodes, who both have several heads and arms). The iconographic tradition of these illustrations may stem from a text attributed to I-hsing, *The Hours of Brahmadeva and the Nine Luminaries* (*Fan-t'ien huo-lo chiu-yao*) (T 1311).

Following the last chapter of the text, eight pages of illustrations are included as an appendix or supplement. The luminaries here are depicted in a strikingly different manner. For example, the Moon is presented as a young woman wielding a sword, whereas Mars (shown in the earlier section as a warrior in armor) is portrayed as an elephant trumpeting a great cry toward the heavens. Only seven luminaries are included in this group, eliminating the lunar nodes. This unusual iconographic tradition is clearly described in the initial passages of a text entitled *Formulas for the Avoidance of Calamities Caused by the Seven Luminaries* (*Ch'i-yao jang tsai chüeh*), translated into Chinese in the late eighth or early ninth century by a monk from western India named Chin-chü-cha (T 1308).

Certainly the style of the Spencer manuscript reflects a T'ang prototype. The plumpness of the faces, with tiny mouths and long eyebrows, the special type of ruffles on the sleeves of the female deities such as the Moon (seen also in paintings of royal figures in mid-T'ang caves at Tun-huang, such as the west wall of cave 159), the style of armor worn by Mars, and especially the way in which the figures fill up the space, seeming to breathe and expand to the edges of the page —factors such as these are indications of a mid-T'ang prototype. That the late Heian copyist was able to imbue these figures with vibrancy and with a special elegant flair (seen also in his Siddham script) is tribute to his own formidable artistic talents.

Raoul Birnbaum, The Metropolitan Museum of Art

Published: Shimada Shūjirō (ed.), *Zaigai Hihō*, vol. 2 (Tokyo, 1969), no. 35, pp. 50–51; Nakano Genzō, "The *Kuyō Hiryaku* Owned by the Kanchi-in," *Museum*, no. 218 (May 1969): 13–24.

28. Iconographic Drawing of the Planet Saturn

Late twelfth century A.D.
Ink on sized paper
Hanging scroll; 55 × 28.3 cm
The Metropolitan Museum of Art; Purchase, The Harry G. C. Packard Collection of Asian Art, Gift of Harry G. C. Packard and Purchase, Fletcher, Rogers, Harris Brisbane Dick and Louis V. Bell Funds, Joseph Pulitzer Bequest, and the Annenberg Fund, Inc. Gift, 1975

The striding figure of Saturn is represented here with great billowing sleeves and scarves streaming into space. His face creased with age, the deity gazes intently at a radiant book of wisdom that bears a talismanic sign on its cover. His richly ornamented robe, bejeweled scabbard, leopard-skin cloak, and long flowing beard present a picture of a stately sage-emperor, a conception that takes its inspiration from Sung Chinese traditions.

In texts such as the second century B.C. *Shih chi*, written by the Han dynasty imperial historian and court astrologer Ssu-ma Ch'ien, important principles associated with the planet (and hence deity) Saturn are set forth. In the cosmological system based on yin/yang and the five phases or five elements (wu-hsing: wood, fire, earth, metal, and water), Saturn is considered the embodiment of a type of cosmic energy characterized by "earthiness." Saturn rules over earthy animals such as the ox, the earthy color yellow, sweet tastes, and fragrant odors. Among physical organs, it rules the heart, whereas among the virtues it represents faith and sincerity. Of the five directions, Saturn governs the center. According to these early concepts, Saturn is closely associated (and sometimes identified) with the Yellow Emperor, the mythic sage-ruler and stern teacher who brought various civilizing arts to ancient China.

Pre-T'ang texts follow these traditions, amplifying and expanding them slightly. In the astrological chapters of the *Chin-shu* (*Official History of the Chin Dynasty*, A.D. 265–420), it is stated that the spirit deities of the five planets may manifest themselves on the earth, each taking on a special form:

The essence of the planets descends upon mankind during the advances, retrogradations, and rapid movements of the planets through the constellations. The spirit of Jupiter may descend to become a noble official. Mars takes the form of a youth, singing folk-songs and making merry, Saturn changes into a gaffer or an old wife, Venus assumes the appearance of a stout forester, while Mercury descends as a woman. Good and evil fortune attend upon their acts and conversation. (Translation by Ho Peng Yoke)

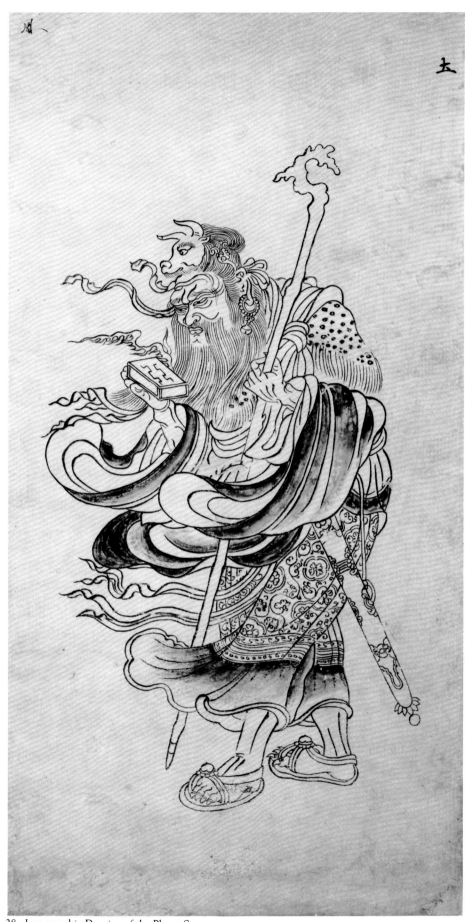

28. Iconographic Drawing of the Planet Saturn

It can be speculated that these forms were represented in early depictions of the astrological deities.

New astrological teachings were introduced to China in the eighth century A.D. by Indian masters such as Gautama Siddhārtha and the monk and aged patriarch of Esoteric Buddhism, Śubhākarasiṃha. These teachings included somewhat different conceptions of the planetary deities. Two of the major iconographic traditions of this period are represented in the preceding Spencer Collection *Kuyō Hiryaku* manuscript.

In the Spencer manuscript, Saturn is shown both as a contemplative old man seated barefoot on a loyal-looking ox, and as a wrinkled ascetic, bare from the waist up, striding with the aid of a staff. In this latter version, he is depicted as a rather fierce Indian sage, with a large nose, bulging round eyes, and bristling eyebrows. Atop his head he wears the head of a bull, which strangely looks quite as alive and filled with vitality as the old man.

The Metropolitan scroll also shows Saturn as an old man vigorously striding forth with the aid of a staff. He has a large nose and wears a heavy earring, conforming to Chinese concepts of Indians and Central Asians. The resemblances to the *Kuyō Hiryaku* end there, however, for the richly decorated robes and furs, the long full beard flowing luxuriously down his chest, and the Sinitic eyes all point to a reassertion of Chinese concepts. Saturn is no longer conceived as an old Indian sage; instead he is once again viewed as the Yellow Emperor.

The style of the drawing is also quite different from the T'ang style of the *Kuyō Hiryaku* manuscript version. The *Kuyō Hiryaku* portraits of Saturn place great emphasis on the depiction of the semiclothed (by Chinese standards) body of the deity. Employing a succession of bold, dark lines (often of the "nail-head and rat's tail" type), the artist imbues the deity with a sense of vigor and vitality. In contrast, the body of the Metropolitan Saturn is almost entirely covered. Energy is depicted here by the billowing and fluttering robes and scarves, made more emphatic by the broad bands of graded shading on the deity's clothing. The emphasis on the expressive drapery, coupled with a new iconographic scheme, points to a Sung rather than a T'ang date for the original Chinese prototype upon which this drawing was based.

Raoul Birnbaum, The Metropolitan Museum of Art

Published: Shimada Shūjirō (ed.), *Zaigai Hihō*, vol. 2 (Tokyo, 1969), no. 35.

Reference: Ho Peng Yoke (trans.), *The Astronomical Chapters of the Chin Shu* (Paris and The Hague, 1966), p. 126.

29. The Planet Mars

Late twelfth century A.D.
Ink on sized paper
Hanging scroll; 55 × 28.5 cm
The Brooklyn Museum; Purchase, Frank L. Babbott, Carl H. De Silver, and A. L. Pratt Funds

The deity of the planet Mars, so charged with inner fire that his hair stands on end, is depicted in this iconographic drawing as a heavily muscled warrior. Leaning his weight on his right foot, he stands ready for battle, wielding a weapon in each of his four hands. In the Chinese Buddhist astrological teachings that inspired this ink drawing, Mars is associated with fiery energy (hence the character for "fire" in the upper right corner). He is related to brave and daring defense and aggression, to weapons and soldiers, horses and cavalry.

As in the Metropolitan Saturn scroll, there is considerable difference between this conception of Mars and the T'ang-style illustrations in the *Kuyō Hiryaku*. Whereas the T'ang-style Mars is a youthful warrior who appears quite human (despite his four arms) and wears protective armor, the Brooklyn Mars is clearly a deity: he has a ferocious face and seems so impervious to harm that he has no need to wear armor. The horse, his special symbol, appears to grow organically out of the top of his head.

The style of this drawing is remarkably similar to the Metropolitan Museum image of Saturn: elements such as the broad heavy drapes with shaded panels, the fluttering scarves, the method of depicting fur and of arranging the hair into fine, regular patterns all point to the hand of the same artist. In both, a similar

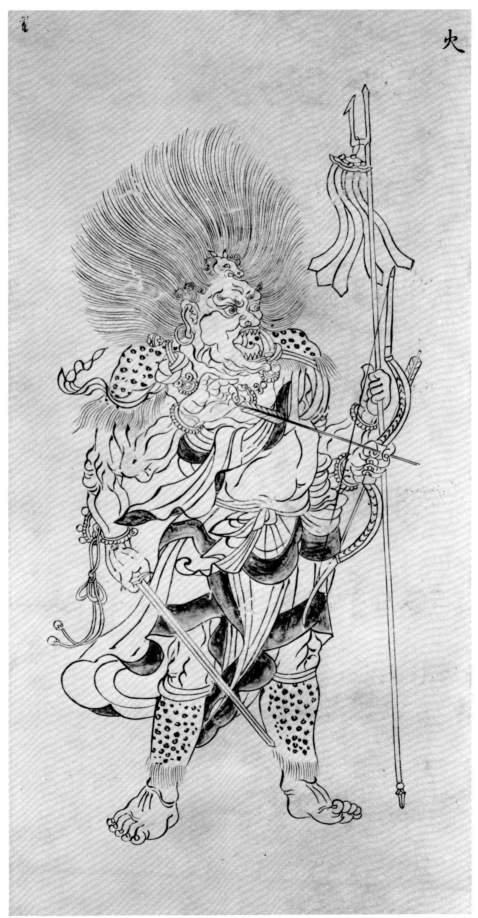

火

29. The Planet Mars

cipher-like signature appears in the upper left corner, a Heian-style signature that does not match any of those found in the standard Japanese compendia.

According to Kyoto City Hall records compiled by the Kyoto City Cultural Activities Committee (Kyōto-fu Kyōiku Iin Kai) in 1957, these two drawings and one other were kept as a set in the Shōren-in, Kyoto. These works appear to have been dispersed shortly after the survey, and are reunited here for the first time. The third drawing is said to be in a private collection in Philadelphia; its subject is not known at present.

As comparative material there are two handscrolls, one a National Treasure in the collection of the Daigo-ji, Kyoto, the other in the Kanchi-in of Tōji in Kyoto, both of which include images of Saturn and Mars in a series of representations of ten astrological deities. The scrolls are nearly identical, and both are dated by inscription in accordance with A.D. 1164.

The hanging scrolls of Saturn and Mars shown here differ from the handscrolls only in minor details, such as the addition of broad bands of shading and rich floral ornamentation in the robes. The stylization of hair and beard, and more formalized imagery, however, suggest the hand of a copyist working shortly after 1164.

Raoul Birnbaum, The Metropolitan Museum of Art

Published: *The Brooklyn Museum Handbook* (Brooklyn, 1967), pp. 168–169.

Reference: Takakusu J. et al. (eds.), *Taishō Shinshū Daizō-kyō Zuzō*, vol. 7 (Tokyo, 1924–1928), pp. 737–759.

30. Vikarāla (Bikatsura)

One of the Twelve Divine Generals (Jūni Shinshō) of Bhaiṣajyaguru (Yakushi)

Attributed to the style of Jōchi (active mid-twelfth century A.D.)

Late twelfth–early thirteenth century A.D.

Ink and pale red color on paper

Hanging scroll; 59.9 × 32.3 cm

Private collection

Drawn in strong black ink with a practiced hand, the ominous warrior in heavy armor begins to sight along his arrow and to lean back as though to pull it against the bow that still hangs from his shoulder. He is Vikarāla, literally the Formidable One, last of the Twelve Divine Generals who personify the twelve vows made by the Healing Buddha in the basic sutra texts (T 449–451); his vows, for example, are to shine with his radiance upon all beings, to heal those whose senses are impaired, to give perfect health of body and mind, and —the final one, symbolized by the deity shown here— to provide garments for the needy. The cult of Yakushi played a prominent role in the early history of the faith in Japan, and among the most dramatic and familiar eighth-century A.D. sculptures in the Nara region are the twelve stucco statues of the Divine Generals that surround the wooden statue of the Healing Buddha in Shinyakushi-ji.

This drawing belongs to a set that was once kept at Kōzan-ji near Kyoto, then came into the Masuda Collection, and, after World War II, was dispersed. Two other drawings from the set are in the United States: Anila (J Anteira) now in the Packard Collection in the Metropolitan Museum, and Mahoraga (J Makora) in a private collection. On the painting in the Metropolitan Museum, along the bottom where the roller was once attached, are a date equivalent to A.D. 1154 and the

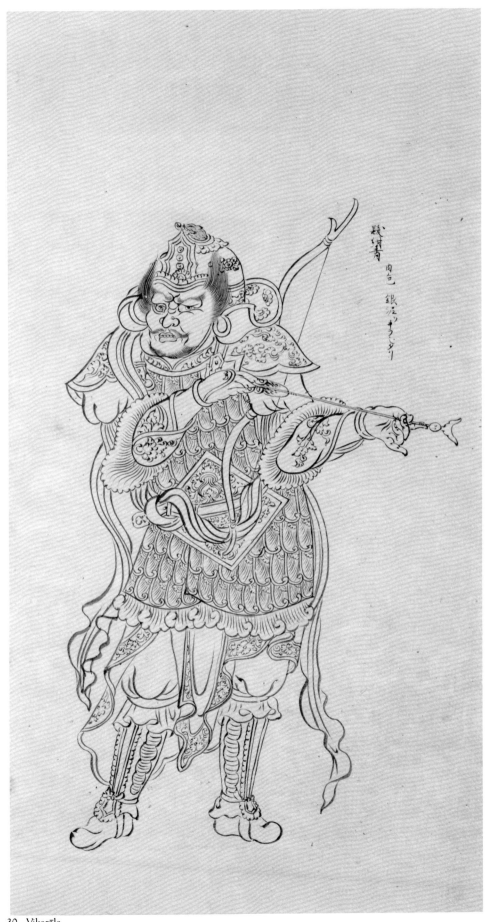

30. Vikarāla

notation "Jōchi version." Jōchi is the name of a late Heian period monk-painter who worked atop Mount Kōya and who was associated for a while with Takuma Tametō (nos. 25, 26). He is recorded as being the painter in 1145 of a fine, Chinese-style picture of a dragon king, which survives in a somewhat battered condition in the collection of the Kongōbu-ji on Mount Kōya. The strongly Chinese flavor of that painting as well as the line quality are compatible with the style of the Jūni Shinshō drawings, but clearly of a higher level of originality and execution.

A separate sheet of paper is attached to the back of the Metropolitan scroll bearing the cipher of a very well known master of Buddhist iconography, Genshō (1146–1206), and the name of his residence, the Jogetsu-in on Mount Kōya. It is also inscribed to the effect that the Metropolitan painting is a copy by Genshō of a painting by Jōchi, who had been ordered to copy a Chinese original. Unfortunately, the writing style of the inscription is not in Genshō's own hand, and cannot be accepted uncritically. Nor can the connection with Jōchi, but the inscriptional evidence has at least a plausible connection to the history of these scrolls. Stylistically, however, they were painted with great skill and care, but are somewhat hardened and conceptualized, as though they were done further down the chain of copying than the inscriptions suggest; just as iconographic drawings were copied, so also were their inscriptions.

Emerging from the helmet of Vikarāla is the head of a boar, which is the twelfth sign of the East Asian zodiac, one of the so-called twelve stems by which the houses of the zodiac are designated. In Japan, the ancient Chinese system of astrology was admixed with the Buddhist content of the cult of Yakushi at some time in the Heian period. Evidence of this appears in the iconographic manual, the *Kakuzen-shō*, which reproduces a set of drawings of the Twelve Divine Generals with zodiacal signs in their helmets, said to reproduce images discovered in the ceiling of Kōfuku-ji in 1018.

References: Shimada Shūjirō (ed.), *Zaigai Hihō*, vol. 2 (Tokyo, 1969), pl. 36 and supplementary pl. 1; *Kōya-san*, Hihō vol. 7 (1968), pl. 17; Takakusu J. et al. (eds.), *Taishō Shinshū Daizō-kyō Zuzō*, vol. 4 (Tokyo, 1933), p. 422.

PART THREE
Pure Land and Popular Buddhist Imagery

Esoterism was the dominant force in Japanese Buddhism through the ninth century A.D. and much of the tenth, until a combination of social and religious factors caused the resurgence of Pure Land beliefs and art forms. Internally, Japan enjoyed the stability implied by the name of its seat of government, the Heian-kyō, capital of peace and tranquility. The closing down of formal diplomatic relations with mainland China in the 890s insulated Japan from the turmoil of the collapsing T'ang state. A large and literate aristocracy, dominated by the Fujiwara clan, devoted itself with increasing zeal to calligraphy, poetry, painting—the arts of peace. In this social climate, the doctrines of Pure Land Buddhism, with their emphasis on salvation through faith in Amitābha and his paradise in the West, came dramatically to prominence in the last decades of the tenth century.[1]

Pure Land Buddhism had existed in China from as early as the fifth century, although it ceased to be an independent school from the end of the T'ang period onward. For several hundred years previously, however, other sects, such as the T'ien-t'ai (Tendai in Japan), had been incorporating its ideas and practices.

The founder of the T'ien-t'ai school in China, Chih-i (A.D. 538–597), had actually developed a religious exercise devoted to Amitābha called, in Japanese, the jōgyō-zammai. Over a ninety-day period, the devotee would repeat the Nembutsu, the six-character prayer formula of homage to Amitābha Buddha (Na-mu A-mi-da Butsu in Japanese). While walking and concentrating on an image of the deity he would experience the state of samādhi (J sammai), deep contemplation and perfect absorption in the object of meditation. Ennin (794–864), a Tendai Buddhist monk-pilgrim to China, brought this exercise to Mount Hiei in 847 and built the first hall devoted to its practice a few years later. The influence of this Amida hall was significant, and two others were built on Mount Hiei in the next hundred years. Literary sources indicate that the main devotional image of Amida in each hall was given an ornate crown, evidence of the influence of Esoteric Buddhist concepts.

Even though the worship of Amitābha had been part of the Buddhist faith in Japan since the late sixth century, it was thus largely through the influence of Tendai that a more concrete religious activity centered on Amitābha began to be practiced in Japan. That all the great leaders of the nascent Pure Land tradition in Japan emerged out of this Tendai matrix comes as no surprise. One of the most important of these was the Tendai monk Genshin, or Eshin Sōzu (942–1017), who, dismayed by the growing corruption and arcane ritualism on Mount Hiei, retired to a secluded spot on the mountain where, in the early months of 985, he finished writing a monumental essay that

was to inspire countless persons in his own and future generations. This book, the Ōjō Yōshū, or *Essentials of Salvation*, a collection of principles essential for birth in Amida's paradise, was a compilation of earlier Buddhist scriptures and commentaries, written in a popular vein.[2] In particular, Genshin drew on a commentary by Shan-tao (613–681), the third patriach of the Pure Land school in China. According to tradition, it was through the Ōjō Yōshū that Hōnen (1133–1212), the founder of the Jōdo-shū or "Pure Land" sect in Japan, first learned of the teachings of Shan-tao, whom he later came to regard as the infallible authority in doctrinal matters (no. 36).

The sections of the Ōjō Yōshū that most caught the popular fancy of the day, and that began to inspire a new type of artistic imagery, were the parts in which Genshin described the horrors of the six realms of rebirth (rokudō), which he contrasted with the glories of the Western Paradise. Sentient beings must continually incarnate through these six realms — of hell, hungry ghosts, demonic beings, animals, human beings, and heavenly beings—until they are freed from bondage to the wheel of death and rebirth by being born in the sublime perfection and peace of the Western Paradise.

Japanese society was increasingly receptive to the ideas expressed in the Ōjō Yōshū because of the impact of the concept called mappō, the age of the degeneration or end of the Buddhist Law. Originating in India, this concept was not entirely foreign to a Hindu one of the inevitable deterioration of mankind's moral and physical abilities through four long ages (S yuga) of creation, ending with the current Kaliyuga, the age of strife, illness, and widespread suffering. This concept caught the imagination of the Chinese and then the Japanese, who worked out their own calculations of the process. Japanese Buddhists believed that there would be three eras after the death of Śākyamuni : the first, lasting one thousand years, was the age of the Perfect Law (shōbō), when the teachings were perfectly followed; the next one-thousand years was the age of the Copied Law (zōbō), when true faith had declined. The third would be the age of the Latter Law (mappō), ten thousand years of rampant vice, conflict, and corruption. Believing that the historical Buddha had died in 949 B.C., the Japanese reckoned that the dreaded era of mappō would begin in A.D. 1052.

Credence to the idea that the age of mappō was actually at hand arose from the steady disintegration of political stability in the mid-eleventh century, followed by civil war in the twelfth, and the concomitant economic and social collapse. In addition, outbreaks of pestilence and famine, as well as a series of natural disasters — earthquakes and typhoons — caused widespread suffering. The previously powerful sects of Shingon and Tendai, corrupt within their own establishments, could not succor the populace at large. They were not intended as popular forms of religion, having addressed themselves to the upper strata of society—court, aristocracy, ecclesiastical elite—who were educated, sophisticated, and wealthy, and who could engage in the one-to-one, master-to-disciple relationship necessary to obtain the benefits of the faith. However, wonder-working mountain ascetics, who had incorporated many of the Esoteric teachings into their religious practices, began to move among the masses. But in general the rise of the Pure Land sects can be understood as an effort by dedicated monks to work for the spiritual well-being of the masses and to reject the mystic ostentation of the Esoteric sects.

The evangelist Kūya (903–972), a Tendai monk, popularized Amida pietism among the common folk by teaching the Odori Nembutsu—the Nembutsu sung and danced to popular melody. He was a forerunner of the charismatic thirteenth-century monk and founder of the Ji or Time sect of Pure Land Buddhism, Ippen (no. 41). But it was Ryōnin (1073–1132), another Tendai monk and ardent Nembutsu reciter, who established the first real Amidist sect, the Yūzū Nembutsu (see nos. 39, 40), thus paving the way for Hōnen and his disciple Shinran (1173–1262), founder of the Jōdo Shin-shū or True Pure Land sect.

The teachings of salvation through faith and of birth into the Western Paradise demanded a new type of artistic imagery.[3] Most of the important paintings of the Pure Land tradition center on the figure of Amida, who is shown either seated in the midst of his splendid paradise (no. 31), or in an attitude of Welcoming Descent (raigō), appearing before the devotee at the moment of death to conduct him to the Western Paradise (no. 32). The earliest extant representations in Japan of the raigō theme in independent pictorial form adorn the interior doors and walls of the Phoenix Hall at the Byōdō-in in Uji, southeast of Kyoto. The Byōdō-in was a temple dedicated to the memory of the famous minister Fujiwara no Michinaga (966–1027), built by his son on the site of Michinaga's villa. Done about 1053, perhaps by the painter Takuma Tamenari, these raigō paintings attest to the growing popularity of Amidist teachings in aristocratic as well as popular circles. In time, Pure Land painting came to include representations of the Welcoming Descent of deities other than Amida— for example, Fugen, Miroku, Kannon, and Jizō—and attention was paid to the paradise dwellings of deities besides Amida—for example, the Potalaka mountain island paradise of Kannon (see nos. 33, 52, 53).

The most significant development in Pure Land imagery, in addition to the new subject matter, was the movement toward a greater emphasis on narrative elements. This fact becomes especially striking when Pure Land paintings are compared to the formal, iconic, nonnarrative paintings of the Esoteric tradition. Strictly speaking, Pure Land mandalas such as the Taima mandala (no. 31), ought to be called hensō-zu, literally, transformed configuration pictures, the depictions of doctrinal themes or legends. Hensō-zu, which are strongly narrative in character, contrast with the orthodox mandalas of the Esoteric tradition (no. 14), which are geometric and nonnarrative. The influence of Esoteric concepts and terminology was so strong, however, that Pure Land thinkers, most of whom had received Esoteric training, appropriated such terms as mandala for their own icons. The same appropriation of Esoteric nomenclature can be seen in the so-called Shrine Mandalas of the Shinto tradition (nos. 34, 35). Here, the settings—well-known landscapes or map-like views of shrine compounds with their inherently strong narrative and pictorially evocative character—assume great importance.

The raigō scenes are also highly narrative, as are the many engi, often in emaki handscroll format, which tell of the legendary founding of temples, or of activities of distinguished religious leaders, such as Ippen. We also see the pictorialization of parables that have to do with Pure Land teachings such as the famous White Path Crossing Two Rivers (J Niga Byaku-dō) (nos. 37, 38). This emphasis on narrative imagery suggests one of the essential functions of Pure Land art, its use in preaching (e-toki).[4] Paintings could serve as didactic aids in attempts to reach out to little-educated or unsophisticated people, for whom doctrine had to be presented in an easily comprehensible fashion. Many of the surviving works, especially paradise scenes, are badly abraded because monks, using them as graphic illustrations during sermons, would touch them roughly with pointers. Narrative scrolls depicting the miracles of Jizō or Kannon or the legends of a temple would frequently be rolled and unrolled by monks instructing small groups of devotees.

A natural concomitant to paradise imagery was the depiction of the alternative possibilities, the six realms of existence, in particular the realms of hell. Genshin's Ōjō Yōshū had dealt in grim detail with the horrors of the eight major hells, each with its sixteen attached minor hells, as suggested in the sutras and commentaries. Depictions of the hells occur in China, particularly at Tun-huang, but rarely in Japan until the late Heian period, with its social upheavals and new religious ethos. Then artists began to explore the potentials of representing realistically the most grotesque kinds of suffering in settings of terrifying pandemonium. The new sensibilities unleashed an unprecedented imagery of punishment and suffering, one of the grandest yet most awful achievements of the age (nos. 45–48).

NOTES

1. H. H. Coates and R. Ishizuka, *Honen, the Buddhist Saint: His Life and Teaching* (Kyoto, 1949). For general cultural background, see Ivan Morris, *The World of the Shining Prince: Court Life in Ancient Japan* (New York, 1964).

2. Allan A. Andrews, *The Teachings Essential for Rebirth: A Study of Genshin's Ōjō Yōshū* (Tokyo, 1973).

3. Jōji Okazaki, *Pure Land Buddhist Painting,* Japanese Arts Library vol. 4 (Tokyo, 1977); Kyoto National Museum (ed.), *Jōdo-kyō Kaiga* (Tokyo, 1975); Toshio Fukuyama, *Heian Temples: Byodo-in and Chuson-ji,* Heibonsha Survey of Japanese Art vol. 9 (Tokyo, 1976).

4. Barbara Ruch, "Medieval Jongleurs and the Making of a National Literature," in John Hall and Takeshi Toyoda, *Japan in the Muromachi Age* (Berkeley, 1977), pp. 288, 295–299.

31. Taima Mandara

Ca. A.D. 1300
Ink, colors, gold and silver pigment, and kirikane on silk
Hanging scroll; 140 × 134.8 cm
Private collection

The grand interior court of this composition shows the spectacle of the Western Paradise presided over by Amida and his attendants. Larger in scale than any other figure is Amida, seated on an ornate lotus throne, his body radiant in gold, his hands in a variant form of the gesture of teaching. Slightly smaller are the two flanking seated bodhisattvas, Kannon and Seishi, and their attendants; smaller still are the persons undergoing birth in Paradise, shown enveloped in lotus buds or kneeling in prayer on open lotus blossoms in the pond in front of the Buddha. Musicians and dancers in the foreground add to the atmosphere of exultation. Enclosing the central assembly of divine beings is a vast regal palace with pillared halls and galleries, towers, and stairways. Because this painting was based on an original composition of the T'ang period, it contains remarkable similarities in composition and architectural forms to the eighth century A.D. wall paintings of Amida's paradise at Tun-huang. In its subtle color harmonies and fine detail, however, it preserves many features of the native Japanese style of Buddhist painting that came to its maturity in the twelfth and thirteenth centuries.

Complex in both composition and underlying meaning, the Taima Mandara is perhaps the single most significant image of Hōnen's Pure Land sect, for it depicts in minute detail the splendid future promised to the devotee. The original mandala was an almost four meter square silk tapestry probably imported into Japan from China in the eighth century and housed at the Taima-dera, a small temple located in the countryside south of Nara. This mandala does not appear in historical records of the Heian period, but was rediscovered in 1217 by Shōkū Seizan, a disciple of Hōnen (no. 36), who was overjoyed to find an icon that rendered so faithfully in pictorial terms his master's teachings. Thereafter, numerous painted and woodblock-printed versions of the Taima mandala were made, a few with dimensions similar to the original tapestry, but most were reduced in scale. Copied and recopied over the centuries, with hardly any variation in iconography, many examples of the Taima mandala appear hackneyed and lifeless. No such charge could, however, be leveled against the work exhibited and published here for the first time. Standing near the beginning of the tradition of copying, done by an artist or artists highly skilled and sensitive, this work is inspired in draftsmanship, color harmonies, and the technical application of ornamental effects such as kirikane.

The three outer courts of the Taima mandala retell pictorially the content of the Kammuryōju-kyo, Sutra of Meditation on the Buddha of Infinite Life, one of the three major sutras of the Pure Land tradition in China and Japan. The outer court on the left presents from bottom to top the story of Prince Ajātaśatru of Magadha in India, who imprisoned and attempted to starve to death his father King Bimbisāra. Later he imprisoned his mother Queen Vaidehī as well, because she had smuggled food to her husband. In prison Vaidehī begged Śākyamuni to offer her some hope of salvation. The historical Buddha responded by showing her the Paradises of the Ten Directions and asked her in which she wished to be born. Vaidehī chose the Western Paradise of Amitābha and, in response to her further questions, Śākyamuni outlined a series of sixteen meditations, the practice of which would lead to birth in that Pure Land. Thirteen of these meditations are rendered, from top to bottom, in the outer right-hand court of the mandala.

The last three meditations, further subdivided into nine, are found in the horizontal court on the bottom, which is read visually from right to left. Its content concerns the birth in Paradise in nine degrees (kubon ōjō)—from the most exalted birth (the upper birth of the upper degree) to the most lowly birth (lower birth of the lower degree)—as promised in the Kammuryōju-kyo. This doctrine of the nine stages of birth provided incentive for moral and righteous behavior while still promising salvation even for the evildoer, who would be born in the lower sectors of Paradise. Moreover, in this lower horizontal court of the Taima mandala also appear scenes of the raigō, Amida's descent to earth or return to Paradise in order to welcome those to be born there (no. 32).

In the middle of the lower horizontal court is a dedicatory inscription that suggests a miraculous origin for the original mandala, as the Japanese conceived it in various legends and records. In the middle eighth century, it is said, a sad young noblewoman who yearned for the Western Paradise became a nun and prayed earnestly that she might receive a vision of Amida. Shortly afterward, a nun appeared and spun and dyed thread extracted from lotus stems that had been gathered by an order of the imperial court. Another nun then appeared who, in the space of one night, wove the large tapestry that we know as the *Taima Mandara*. Before departing to the west in the midst of clouds, the first nun revealed that she was a manifestation of Amida, and that the weaver was the Bodhisattva Kannon in human form.

Four inscriptions of dedication and repair are found

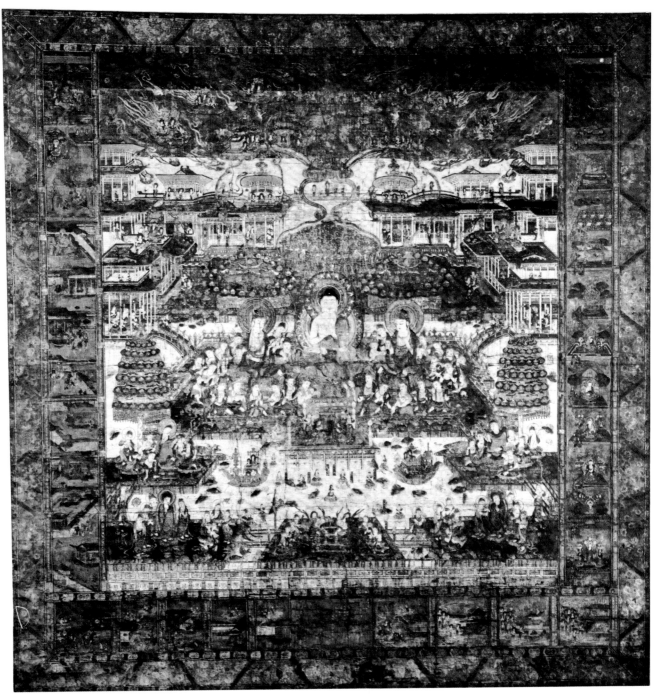

31. Taima Mandara *(color illustration, p. 32)*

on the back of this painting, helping to trace its history. The earliest is a fragmentary document preserving only a date in accordance with the year A.D. 1435. The second, dated in accordance with 1583, is a dedicatory inscription that gives the name of the temple in which the mandala was housed—the Saikō-ji at Azuchi along the eastern shore of Lake Biwa. Belonging to the Jōdo sect, the Saikō-ji was constructed in 1579 for the monk Teian, also known as Kyōrensha Shōyō, one of the leading Pure Land prelates and advocates of the day. It was built by the famous military leader Oda Nobunaga, whose huge Azuchi Castle stood nearby.

The third inscription, dated in accordance with 1660, is rather poetic in nature and an eloquent representative of the type of repair inscription that often appears on Buddhist paintings; it was written by a monk named Shōrensha Kōyo:

To begin with, this single hanging scroll of the Taima mandala is a most precious treasure, it is the brushwork of the monk Genshin Sōzu, the former master of the Ryōgon-in, and the chief priests of this subtemple have transmitted it through the generations. By now, this hensō-zu has become antiquated, and the silk and rollers are in a state of disrepair. I have always grieved about this, and on the day (devoted to) wiping off the bookworms at the time of seasonal change, I took this mandala out of storage and reverently inspected it in the company of several ardent lay-followers. They also lamented, and in a few days, having recruited good religious friends of the same fellowship and having requested the assistance of the Nembutsu group, they repaired the losses, remounted the surface, and restored the painting. Now (the whole project) has been completed. Looking upward, I pray for the welfare of all departed relatives by blood and marriage of myself and others (as well as the repose of) fellow beings throughout the dharma-dhātu (i.e., the whole world).

Kōyo (1629–1686) was a Jōdo sect monk of the Daiun-in in Kyoto who was famous for his teaching, scholarship, and in particular his restoration of antiquities. In 1677, for example, he went to the Taima-dera and was instrumental in causing the repair of several mandalas there. In 1682 he restored an old site in Kyoto associated with Kūya Shōnin and built a hall for Nembutsu recitation there. The Daiun-in had been built in 1587 by imperial decree, and Teian had been appointed to oversee it, so from the inception of both temples, there had been a close connection between the Saikō-ji and the Daiun-in. It is also interesting to note that Kōyo attributes the mandala to the brush of Genshin: such attributions to this giant figure of the Pure Land tradition in Japan appear frequently.

Following the inscription by Kōyo is a list of names. The lower part of the list gives the names of seventeen male lay-followers (a number of them merchants, with their shop names included), who contributed to the repair of the painting, for the sake of the individuals named in the upper list. The upper list contains the names of fifteen men and four women.

The fourth inscription, also of repair, is dated in accordance with 1827 and states that two nuns added their contributions for the repair of the mandala, in order to benefit two deceased lay-women. It is significant that women's names appear frequently in repair and dedicatory inscriptions on Pure Land paintings. One of the contributions of Pure Land thought was to declare that women also qualify for salvation.

This painting was probably created in the following manner: the outlines were done in sumi ink, after which colors, gold, and silver were added; final detailing was done in sumi, pigment in shades of peach, red, blue, and green, and kirikane. We know that most of the gold-painted bodies of deities were painted over a little tan on the front of the silk and a layer of white pigment applied from the back of the silk to strengthen the image. The blackish hair of the deities in the central portion is repair paint; this hair should be gunjō blue, and, in fact, a little of the original gunjō does remain. The outer courts all have a whitish application of urazaishiki and gindei, silver paint, now oxidized, applied from the front as the background color for these courts. This gindei is also found in the trees of Paradise and as a band, now oxidized and darkened, underneath the very upper band of gunjō at the top of the composition. The pond and lower part of the sky are done in kindei, as is the architecture, which also shows haku gold leaf detailing on such architectural elements as railings.

This painting may be dated to the early fourteenth century A.D. on the basis of style. The slender, elongated face of the central Amida recalls such paintings as the *Amida Crossing the Mountains (Yamagoshi Amida)* from the Konkaikōmyō-ji. This face, with its distinctive proportions, contrasts with the fuller, more volumetric treatment of the face of the central Amida in the *Taima Mandara* from Chion-ji, a hitherto unstudied painting that must have been done at the very beginning of the tradition of copying. In addition to the internal proportions of the figures and their relationship within the entire composition, other details corroborate our suggested dating. One of these is the presence of light relief (moriage) in gold on the finials of the central veranda, a technical application that became increasingly popular in the fourteenth century. Closely resembling this painting in both style and size is the *Taima Mandara* from the Kōmyō-ji, Shinagawa prefecture.

References: Jōji Okazaki, *Pure Land Buddhist Painting*, Japan Arts Library vol. 4 (Tokyo, 1977), pp. 42–60; Kyoto National Museum (ed.), *Jōdo-kyō Kaiga* (Kyoto, 1975).

32. Descent of the Amitābha Trinity (Amida Sanzon Raigō)

Second half of the thirteenth century A.D.
Ink, colors, and kirikane on silk
Three hanging scrolls; each 137.2 × 50.2 cm
The Art Institute of Chicago; Kate S. Buckingham
 Collection

This triptych is an outstanding example of the theme of the Welcoming Descent (raigō), which is central to Pure Land Buddhist thought. Amida, the Buddha of the Western Paradise, is the majestic, front-facing figure in the middle; Kannon, at his left, bends forward to offer the lotus throne on which the devotee will be born into Paradise. Seishi, at the Buddha's right, clasps his hands in prayer. Paintings of this type were often hung by the bedsides of dying believers to encourage them to recite the Nembutsu during the critical last minutes of life, and to console them about the certainty of birth into Paradise.

Amida makes the gesture, with upraised right hand and lowered left hand, thumb and middle fingers touching, which indicates that he is welcoming those who will be born into the lowest sector of the middle range of births. This degree of birth is the sixth of nine possible degrees of birth in Paradise, meant for those beings who are close to attaining arhatship. The rays of light shooting out behind Amida, delineated with kirikane, number forty-eight and represent the forty-eight vows made in ages past by the Bodhisattva Dharmākara, who was later to become the Buddha Amitābha. Deeply moved by the suffering of sentient beings and determined to create a blissful paradise for their emancipation, Dharmākara vowed he would not accept full enlightenment unless the conditions of his vows were fulfilled and he could offer salvation to the faithful. This type of halo with its radiating spokes is popularly called karakasa or Chinese-style paper umbrella and is often associated with works from the Muromachi period on. It is of interest to note its early appearance here. Nine rays of alternating double and triple kirikane lines shoot out from behind the heads of both Kannon and Seishi; this is exactly the arrangement seen on the Eleven-Headed Avalokiteśvara on Mount Potalaka in the Metropolitan Museum (no. 33).

The central Amida, his figure and facial features in calming equipoise, stands on lotus pedestals of dark green over yellow. His body and the background of his robes are painted a pale yellowish color and his body is outlined in the traditional red tessen, iron-wire lines; his hair is the customary dark blue gunjō. Varied, elegant kirikane designs appear on his robes. Kannon and Seishi, with flesh and garment and hair color similar to those of Amida, and with the same red-outlined bodies, are even more sumptuously adorned, befitting their

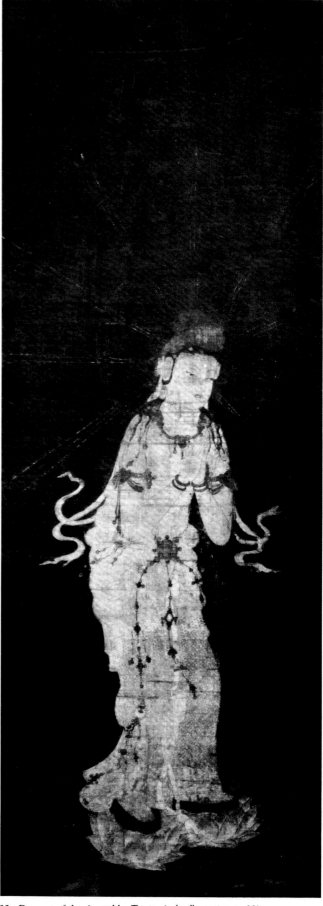

32. Descent of the Amitābha Trinity (*color illustration, p. 33*)

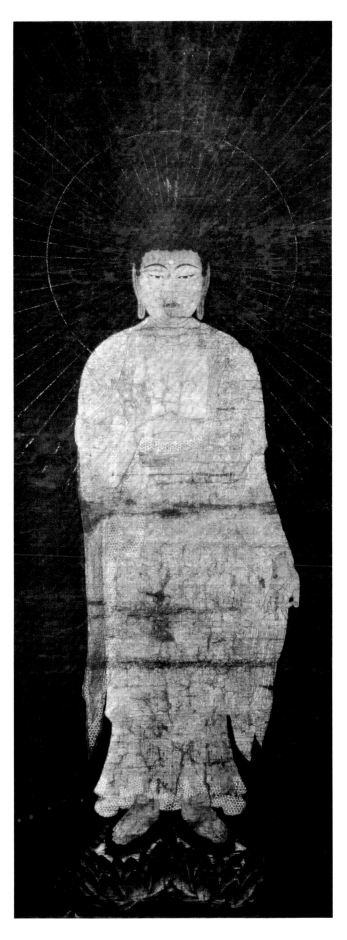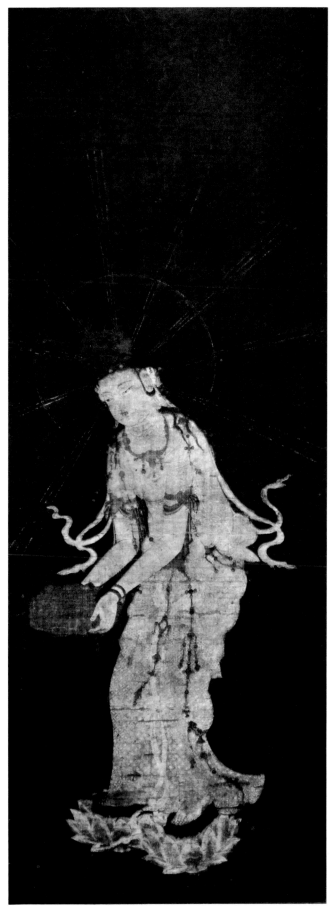

status as bodhisattvas. Their crowns, bracelets, necklaces, and belt buckles seem to have originally been highlighted by gold leaf applied from the back of the painting silk; most of this leaf has now fallen away. Gorgeous, finely detailed balls and ribbons in red, blue, and green still decorate their ornate jewelry.

Shades of the palest green and white appear on the leaves on the lotus pedestals of Kannon, whereas shades of pink and white are used for the pedestals of Seishi. Fine kirikane lines mark the veins in the petals. As many as nine different kirikane design motifs can be easily detected on these paintings, attesting to the refinement and technical precision of kirikane application characteristic of the late Heian and early Kamakura periods. One typically Kamakura period feature is the juxtaposition of scrolling floral motifs on the edging of the robes with geometric designs on the inner part of the garments.

The fact that this *Amida Trinity Raigō* is standing and not seated helps date it well into the Kamakura period. But the gentle treatment of faces and figures, especially of the more traditional faces of Kannon and Seishi, suggests a date of the second half of the thirteenth century, rather than the fourteenth. Moreover, the bodies and garments of the deities are not done in gold paint but in a yellowish pigment. By the fourteenth century much of this imagery had hardened, both in conception and execution; the use of gold paint as background for body and robes was more usual and kirikane designs were less delicately rendered. The mid-thirteenth century *Amida Crossing the Mountains* (Yamagoshi Amida) in the Zenrin-ji in Kyoto shows close correspondences to this triptych, particularly in the treatment of the faces of the deities. The *Kongō-kai Dainichi* at the Kongōbu-ji on Mount Kōya dated in accordance with A.D. 1245 evinces some similarities in facial features to the Chicago Amida, including the same unusual goatee of circles of decreasing size and the absence of lines indicating the vertical outline of the nose. By contrast the *Amida Crossing the Mountains* from the Konkai-kōmyō-ji dated to the late thirteenth century is more hardened and stylized, suggesting that the Chicago triptych was painted closer to the middle of the century than to its final years.

Published: Shimada Shūjirō (ed.), *Zaigai Hihō*, vol. 2 (Tokyo, 1969), nos. 18–20.

References: F. Max Müller (trans. and ed.), *The Larger Sukhāvatīvyūha, The Smaller Sukhāvatīvyūha, and the Amitāyurdhyāna Sūtra*, Sacred Books of the East vol. 49 (Oxford, 1894), p. 94; Kyoto National Museum (ed.), *Jōdo-kyō Kaiga* (Tokyo, 1975), pls. 30, 99; *Kōya-san*, Hihō vol. 7 (Tokyo, 1968), pl. 26.

33. Eleven-Headed Avalokiteśvara (Jūichimen Kannon) atop Mount Potalaka

Ca. A.D. 1300
Ink, colors, gold pigment and kirikane on silk
Hanging scroll; 108.6 × 41.2 cm
The Metropolitan Museum of Art; Purchase, The Harry G. C. Packard Collection of Asian Art, Gift of Harry G. C. Packard and Purchase, Fletcher, Rogers, Harris Brisbane Dick and Louis V. Bell Funds, Joseph Pulitzer Bequest, and the Annenberg Fund, Inc. Gift, 1975

This strikingly lyrical painting shows an Eleven-Headed Kannon sitting on top of his mountain-island paradise, called Potalaka in Sanskrit, Fudarakusen in Japanese. Various sutras, particularly the so-called Shin Kegon-kyō of A.D. 695–699 (a Chinese re-editing of the Avataṃsaka-sūtra, T 279), describe the wonders of this paradise, said to be located in the sea south of India, but later identified with certain sites in China and Japan. These sources record glorious palaces and lakes found on the summit of a precipitous mountain on which springs flow and trees and flowers emitting aromatic odors bloom profusely. The Shin Kegon-kyō also relates the visit of the boy-pilgrim Sudhana (J Zenzai Dōji) to this paradise, where he hears the Law preached by the enthroned Kannon.

The Metropolitan painting captures the splendor of Potalaka. The craggy mountain is colored in greens and blues; trees, some with whitish blossoms, others with what seem to be red maple leaves, adorn the mountain, while petals waft down its side. White waterfalls ripple down the slopes and many, once brightly colored birds dot the landscape. What appear to be lotus ponds with pink and white blossoms can be discerned in the crevices on the rocky mountain. On top of the peak itself sits the golden-bodied Kannon on a lotus throne whose petals are colored in the faintest tones of green and pink. This lotus throne is incorporated into an outer circular halo and is supported on a bank of bluish clouds edged in gold paint. Kirikane lines detail the veins of the lotus petals as well as the nine rays of alternating double and triple lines that shoot out from the deity. Two halos, one behind the head and the other behind the body, are edged in tones of pink and

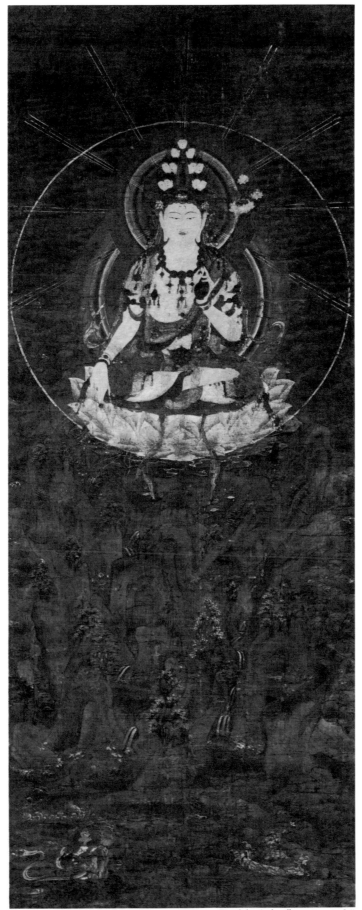

33. Eleven-Headed Avalokiteśvara atop Mount Potalaka *(color illustration, p. 34)*

red; bits of remaining gold suggest that these halos were originally a far more luminous golden color.

Kannon sits in the full lotus position, his right hand making the varada gift-giving mudrā, his left holding a vase out of which lotus flowers emerge. The deity's robes are done in pale shades of blue, pink, and green, and at least five different delicate and intricate design motifs in kirikane adorn his garments. The bodhisattva wears magnificent jewelry, which must originally have sparkled with gold leaf applied from the back; balls of predominantly blue and green colors help ornament the necklace. The type of jewelry, the alternating double- and triple-line rays of the halo, the treatment of the garments, especially the kirikane designs, and the gentle demeanor of the deity recall another set of paintings in the exhibition, the *Amida Trinity Raigō* from Chicago (no. 32), which is dated slightly earlier than this work.

Two unusual details of iconography appear on the Metropolitan figure. The arrangement of subsidiary heads on top of the deity's main head is in four tiers, rather than the customary three. Also, the halo of the figure of Amida in the arrangement of subsidiary heads is the flaming, rather than the customary funagata (boat-shape) type.

Literary sources record that as early as the Nara period there were representations of Mount Potalaka on the walls and sliding doors of halls dedicated to Kannon at the monasteries of Kōfuku-ji and Saidai-ji. But devotion to Kannon enthroned on his mountain paradise became more widespread from the late Heian period onward; for example, the Eleven-Headed Kannon on Mount Potalaka was worshiped in the Nigatsu-dō at Tōdai-ji in this period. Attempts were made to locate this paradise at specific sites in Japan; the belief arose that Potalaka was to be found at the Nachi Falls within the Kumano Shrine complex near the ocean on the Kii Peninsula, or in the mountains at Nikkō, as well as at the Kasuga Shrine in Nara.

At the lower left of this painting is a demonic, red-bodied figure with a dragon in his headdress, holding a jewel; a phoenix-prowed boat appears at the lower right. Literary sources refer to the departure for Paradise by boat from a site near the Nachi Falls, but the figures in the Metropolitan painting may relate to a legend that developed at the Shido-ji on the island of Shikoku. The main devotional image at this temple is an Eleven-Headed Kannon whose history is told in an engi (legendary history) illustrated in six hanging scrolls also found at the temple, probably painted about 1317. The legend relates how a man named Chiko enshrined in a hermitage a sacred tree that had floated up onto the Shido beach. He then started searching for a Buddhist sculptor who could carve a statue from the wood. Shortly afterward, a dōji (divine child) appeared and in one day carved an image of the Eleven-Headed Kannon. The dōji then uttered an invocation before the statue and from out of the sky a voice was heard saying, "This is the Kannon of Potalaka." At that point, the dōji, who had been a manifestation of Kannon, disappeared. The engi then goes on to relate the story of Fujiwara no Fuhito, whose daughter was betrothed to a Chinese nobleman. A special jewel was dispatched in a boat from China to her father as a gift, in the keeping of an official messenger. As the boat approached Shido harbor, a typhoon sprang up, and a dragon king appeared who rescued the jewel and offered it to the Potalaka Kannon.

This painting, with its gentle, harmonious treatment of the figure, facial features, and finely detailed garments and ornamentation, belongs to the late Kamakura period. The highly refined landscape elements relate to such works as the *Ippen Shōnin Eden* of 1299 and to the early fourteenth-century *Shido-ji Engi-e*, particularly in the depiction of the water and seascape. The handling of the waves, both their formal elements and the manner in which they rise and cover almost the entire picture plane, recalls the *Monju Crossing the Sea* in the Daigo-ji in Kyoto dated to the second half of the thirteenth century. The treatment of the landscape in particular suggests that the painter of the work was an exceptionally highly trained eshi (master painter) perhaps connected with the imperial court.

Published: Shimada Shūjirō (ed.), *Zaigai Hihō*, vol. 2 (Tokyo, 1969), no. 22.

References: *Tōdai-ji*, Hihō vol. 5 (Tokyo, 1969), pl. 215; *Daitoku-ji*, Hihō vol. 8 (Tokyo, 1968), pl. 8.

34. Mandala of the Kasuga Shrine

First half of the fourteenth century A.D.
Ink, colors, and gold pigment on silk
Hanging scroll; 78.8 × 35 cm
Collection of Kimiko and John Powers

Like a pilgrim making a nocturnal journey to the Kasuga Shrine in the light of a full moon, the viewer is drawn gradually into the depths of this composition along the dark, slightly angled path that marks the route extending from west to east into this Nara landmark. Passing beneath the first of two torii, the gateways that signal a sacred Shinto site, the visitor views to the left the Kōfuku-ji with its distinctive pagodas and frolicking deer. Upon traversing a broad plain dotted with cherry trees, partially obscured by a dense mist, he reaches the walled compound enclosing four adjoining shrine buildings. Some distance away, isolated from the main compound, stands the shrine to Kasuga Wakamiya, the fifth of the principal deities of the Kasuga cult. Beyond the sanctuaries, the conical form of Mount Mikasa and the heavily wooded Mount Kasuga behind it are visible.

The artist has used various conventions of pictorial illusion to create this panorama of the shrine and its surroundings, notably a sharply tilted ground plane and a parallelogram-like layout of the shrine compound, both of which convey the effect of an aerial view. In spite of this approach to pictorial space, the arrangement of the shrines and their architectural details are remarkably accurate. As a result, the viewer experiences the pilgrimage to this sanctuary in a fashion that is both aesthetically and spiritually rewarding.

Constructed in the eighth century as the tutelary shrine of the mighty Fujiwara family, the Kasuga Shrine houses five Shinto kami intimately associated with the clan's origins and rise to prosperity. The adjacent Kōfuku-ji, also founded by the Fujiwara, is dedicated to various Buddhist divinities who came to be viewed as the special guardians of the family's fortunes. From the Heian period onward, the already existing bonds between the two establishments, combining with the growing interaction between Buddhism and Shinto throughout Japan, led to the equation of the five deities of Kasuga with five divinities of Kōfuku-ji; Buddhist and Shinto gods came to be viewed as two expressions of a single truth. In this painting, the relationship between Kasuga and Kōfuku-ji and their respective deities is implied by the inclusion of a section of Kōfuku-ji in the foreground; in other Kasuga mandalas, the deities themselves are depicted.

Although paintings showing bird's eye views of shrines may owe their origins at least in part to the need for accurate records of shrine layouts and architecture for reconstruction purposes, as well as to the popularity of the meisho-e, depictions of beautiful landmarks, the elevation of such imagery to a form of devotional art came about largely through Buddhist influence. The Buddhist contribution underlies the designation shrine mandala (miya-mandara) by which such works are commonly known.

Assigning a firm date to this painting is difficult because of the absence of a clearcut chronological sequence of comparable works. Only one dated Kasuga Shrine mandala is known; it is inscribed by the Emperor Kameyama (A.D. 1249–1305) in accordance with the year 1300. However, a vista of Mounts Mikasa and Kasuga is also found in the *Kasuga Gongen Genki-e*, a scroll illustrating the history and miracles associated with this shrine and its kami, dated in accordance with 1309. The present painting is far more tightly structured and the handling of the mist-hidden plains less harsh than in the 1300 mandala. On the other hand, the almost pointillist rendering of massed foliage on Mount Mikasa, as well as the extensive use of white highlighting on the hills are conventions used in the Kasuga Gongen scroll. Consequently, a date in the first half of the fourteenth century A.D. would seem appropriate.

Christine Guth Kanda, Princeton University

Published: John M. Rosenfield and Shūjirō Shimada, *Traditions of Japanese Art: Selections from the Kimiko and John Powers Collection* (Cambridge, MA, 1970), no. 58.

References: Haruki Kageyama, *The Arts of Shinto*, Arts of Japan vol. 4 (Tokyo, 1973), pp. 79–94; Nara National Museum (ed.), *Suijaku Bijutsu* (Tokyo, 1964); Noma Seiroku, *Kasuga Gongen Genki-e*, Nihon Emakimono Zenshū vol. 15 (Tokyo, 1963).

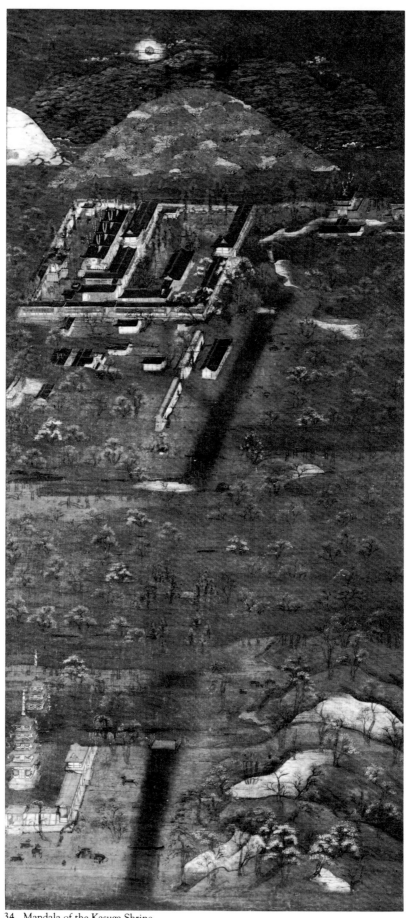

34. Mandala of the Kasuga Shrine

35. Mandala of the Kasuga Shrine

Ca. A.D. 1400

Ink, colors, and gold pigment on silk

Hanging scroll; 100.2 × 37 cm

Museum für Ostasiatische Kunst, Staatliche Museen Preussischer Kulturbesitz, Berlin (West)

The gradual changes in style within a single pictorial theme may be seen by comparing this painting with the somewhat older version in the Powers Collection (no. 34). The organization of this composition is stiffer, and the relationship among the elements within it more geometric than that of the Powers painting. The strict vertical line of the path that bisects the picture and the repeated horizontal lines of the mist make this nocturnal scene somewhat less lyrical; at the same time, it has greater conceptual clarity and a stronger iconic quality. It is more a votive image and less a scenic view.

In a glance, the viewer can take in the complex of five Shinto sanctuaries that house the deities sacred to the Fujiwara family, as well as the Kōfuku-ji with its five-storied pagoda, and the verdant plain in between. Immediate directional orientation is provided by the moonlit path that draws the eye from foreground to background. This vertical path does not point directly to the Kasuga Shrine but rather toward the two sacred mountains behind it, whose worship is at the heart of the original cult in this vicinity. Long before the eighth century A.D. when the Kasuga Shrine was constructed by the Fujiwara clan, these mountains were venerated by local inhabitants.

The reverence for nature and natural phenomena so basic to the Shinto creed underlies the subtle interweaving of architecture and landscape seen here; the strong feeling for landscape beauty is characteristic of the broad category of devotional paintings called shrine mandalas. Representations of Kasuga Shrine, first recorded in the second half of the twelfth century, may have been among the earliest of such works, but by the following century, shrine mandalas were being produced for many major Shinto-Buddhist sanctuaries in western Japan, especially for the popular Kumano shrines and the Sannō cult on Mount Hiei near Kyoto.

During the twelfth century, as the Fujiwara clan fell from its dominant position, the Kasuga Shrine was worshiped and supported by the populace at large; branches of the shrine were established in other parts of Japan. Devotees of the cult formed religious associations called the Kasuga-kō, particularly in western Japan, and each group possessed its own devotional paintings. Large numbers of Kasuga mandalas survive today, and it is likely that most of them were commissioned by the various Kasuga-kō from painting ateliers located within the Kōfuku-ji compound itself, in the Daijō-in and Ichijō-in subtemples. Many Buddhist paintings now in Hōryū-ji, Saidai-ji, and Yakushi-ji, dating from the thirteenth through the fifteenth centuries A.D., suggest that the Kōfuku-ji artists in fact supplied votive paintings for the entire Yamato region. Their work, when compared to that of the more innovative Takuma school (nos. 25, 26), was more conservative in thematic range and in style, more in harmony with traditional Japanese aesthetic values. The two Kasuga mandalas exhibited here typify this outlook.

Christine Guth Kanda, Princeton University

Published: Museum für Ostasiatische Kunst, Staatliche Museen Preussischer Kulturbesitz, Berlin (ed.), *Ausgewählte Werke Ostasiatische Kunst* (Berlin, 1977), no. 89.

References: Haruki Kageyama, *The Arts of Shinto,* Arts of Japan vol. 4 (Tokyo, 1973); Haruki Kageyama and Christine Guth Kanda, *Shinto Arts: Nature, Gods, and Man in Japan* (New York, 1976); Nara National Museum (ed.), *Suijaku Bijutsu* (Tokyo, 1964); Naniwada Tōru, *Koezu,* Nihon no Bijutsu vol. 75 (Tokyo, 1972).

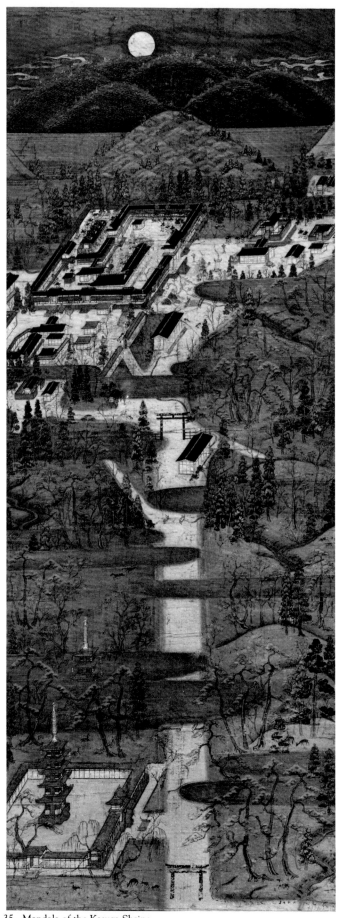

35. Mandala of the Kasuga Shrine

36. Hōnen Envisions Shan-tao

Ca. A.D. 1400
Ink, colors, gold pigment, and kirikane on silk
Hanging scroll mounted on a panel; 77.5 × 42 cm
Collection of Robert J. Poor

This rare and evocative painting, exhibited and published here for the first time, shows the founder of the Japanese Pure Land sect, Hōnen Genkū (A.D. 1133–1212), envisioning the Chinese Pure Land master Shan-tao (613–681). In the miraculous vision, Shan-tao, the lower half of his body radiant with gold, confirmed Hōnen as his spiritual successor, creating thereby a mystical link between the Japanese monk and this prominent T'ien-t'ai thinker, the third patriarch of the Pure Land school in China.

The event, which seems to have taken place on the first day of the fifth month of the year corresponding to A.D. 1198 (variant accounts give the date as corresponding to 1175), may be summarized as follows.

Hōnen dreamed one night that he climbed halfway up a high mountain. Looking westward, he saw a mass of purple clouds fifty feet above the earth, issuing forth countless beams of light and many marvelous birds, approaching the place where he stood. As Hōnen was thinking that surely there must be someone at hand who was about to experience birth in Paradise, the cloud turned and stopped in front of him, covering the whole sky. A priest emerged from the diaphanous cloud mass and walked up to Hōnen. He was clad in a golden garment from his waist down, in black clerical robes waist up.

Bowing respectfully, Hōnen asked, "And who might you be?" The priest replied, "I am Shan-tao." "And why have you come here?" "To show my appreciation of your devotion to the practice and dissemination of the one and only discipline of the Nembutsu."

With this Hōnen awoke, and later he had a painter named Jōdai paint his dream.

Hōnen and Shan-tao greet one another with a prayerful gesture, the gasshō. From Shan-tao's mouth emerges a wisp of cloud with three tiny figures of Amitābha, emblematic of his reciting the Nembutsu prayer formula. Each of the monks stands upon lotus pedestals, the right foot on a green flower, the left on a dark blue one, as is often the case in images of Buddhas and bodhisattvas. The pedestals and halos, carefully defined with kirikane, indicate that the two monks were indeed more than ordinary mortals. Kirikane was also used on the bounding lines and drapery folds of Shan-tao's robe, but the design motifs were executed in gold paint (kindei). The setting of the vision is amorphous and lacking specific detail other than the dark green mountain forms and a swirl of pale gray mist.

Although the faces of Hōnen and Shan-tao are given some individuality, neither is a portrait in the sense of a precise rendering of physical appearances. The image of Shan-tao can be compared to the famous Kamakura period portrait of the patriarch in the Chion-ji, Kyoto, which, less faithful to the legend however, shows his right-hand side radiant with beautifully detailed kirikane designs. In the painting exhibited here, Shan-tao's eyes are, startling to note, blue in color, suggesting a foreign or exotic birth, whereas in the Chion-ji painting they are brown. Another portrayal of the patriarch is found in the portrait painting of the five patriarchs of the Pure Land sect in China brought from China by Shunjōbō Chōgen (1121–1206) and kept in the Nisonin. The image of Hōnen is based on a general portrait type established in such Kamakura period paintings as those in the Konkaikōmyō-ji and Nison-in, both in Kyoto. They depict the monk with the same strong chin and slightly flattened crown of the head.

A sheet of paper with a long inscription in the cursive calligraphic script called gyōsho was affixed to the back of the painting. The text is a copy of one of Hōnen's famous writings, the *Ichimai Kishōmon* or *One-Page Oath*. Two days before his death, Hōnen agreed to the request of one of his favored disciples, Seikanbō Genchi, who later became abbot of the Otani-dera, the present-day Chion-in and head temple of the Pure Land sect, that he write a last testament. Several versions of this document now exist; the present example may be translated as follows:

The method of final salvation that I have propounded is neither a sort of meditation, such as has been practiced by many scholars in China and Japan, nor is it a repeti-

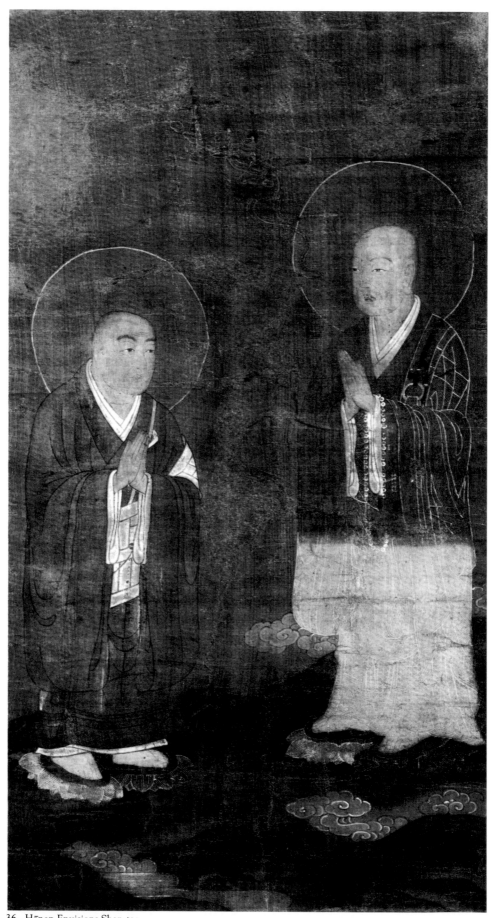

36. Hōnen Envisions Shan-tao

tion of the Buddha's name by those who have studied and understood the deep meaning of it. It is nothing but the mere repetition of the "Namu Amida Butsu," without a doubt of his mercy, whereby one may be born into the Land of Perfect Bliss. The mere repetition with firm faith includes all the practical details, such as the three-fold preparation of mind and the four practical rules. If I as an individual have any doctrine more profound than this, I should miss the mercy of the two Honorable Ones, Amida and Shaka [Śākyamuni] and be left out of the Vow of the Amida Buddha. Those who believe this, though they clearly understand all the teachings Shaka taught throughout his whole life, should behave themselves like simple-minded folk, who know not a single letter, or like ignorant nuns or monks whose faith is implicitly simple. Thus without pedantic airs, they should fervently practice the repetition of the name of Amida, and that alone.

In testimony hereof, I seal this document with both my hands. The faith and practice of Jōdo believers are fully set forth on this one sheet. To my mind nothing remains to be said. I have written all my principles here to prevent heterodoxy after my departure.

(Signed) Genkū on the 23rd in the 1st month in the 2nd year of Kenryaku (March 5th, 1212). (Translation by Harper Coates and Ishizuka Ryūgaku)

Proportionally larger in size and inked more darkly are the characters for the prayerful Nembutsu formula— Namu Amida Butsu—toward the center of the text, and the second line from the left, which gives Hōnen's name and the date that he wrote the *One-Page Oath.*

The last line at the left records the name of the priest who copied the document as a form of devotion, an unknown monk who, judging from the style of the calligraphy, probably lived in the mid-Edo period. He signs his work "the reverential writing of Jikō of the Kanroen, Naniwa [present-day Osaka city], Settsu [the old name of Osaka prefecture]."

References: Jōji Okazaki, *Pure Land Buddhist Painting,* Japanese Arts Library vol. 4 (Tokyo, 1977), pls. 1, 3, 6, 181, Uratsuji Kendō, "Zendō Daishi-zō no Ichikōsatsu," *Bukkyō Geijutsu,* 6 (1950); H. H. Coates and R. Ishizuka, *Honen the Buddhist Saint: His Life and Teaching* (Kyoto, 1925), pp. 205– 206, 220, 743, trans. 728–729; *Kokka,* no. 343 (December 1918).

37. The White Path Crossing Two Rivers (Niga Byaku-dō)

Late thirteenth century A.D.
Ink, colors, gold and silver pigment, and kirikane on silk
Hanging scroll; 123.5 × 51 cm
The Cleveland Museum of Art; Gift of the Norweb Foundation

This painting and the following one are based on a parable by Shan-tao (A.D. 613–681), the third patriarch of the Pure Land tradition in China (no. 36):

A man, Everyman, is traveling to the west for a hundred thousand li. Halfway along his journey he suddenly sees two rivers: to the south stretches a river of fire; to the north a river of water. In depth and length both are unfathomable. Between the two rivers is a white path scarcely four or five inches wide, going from the eastern to the western bank and about a hundred strides long. The waves of the river of water and the flames of the river of fire pass over the path and intermingle ceaselessly.

There is nothing in this solitary place except robbers and vicious beasts who will kill the man if he turns back. Despite the fact that there is no escape, the man fears that if he treads the narrow white path, he will be inundated by the flames or the water. He thinks to himself, "If I turn back, I am sure to die; if I stay I will certainly die. Since it seems that no matter what I do, death awaits me, I will take my chances and proceed west along the white path."

At the moment he makes this decision, he hears a voice from the eastern shore—Śākyamuni—urging him on: "You have decided to cross the path; you will not die. If you remain here, death awaits you." Then he hears a voice from the western bank—Amida—calling him: "Come at once with single-hearted intention. I will protect you. Fear not that you will fall into the rivers of fire and water." Despite the fact that the thieves shout to him to come back, that they wish him no harm, that he will never be able to cross the white path, the man steadfastly proceeds along the path. Finally he reaches the western shore and escapes all evil forever.

This parable appears in the fourth chapter of Shantao's commentary on the Kammuryōju-kyō, and was often quoted by Hōnen, the founder of the Pure Land sect in Japan. The story was meant both to prepare devotees seeking birth into Paradise for the perils awaiting them, and to assure them that steadfast faith would enable them to overcome all obstacles because Śākyamuni and Amida stood ready to assist them.

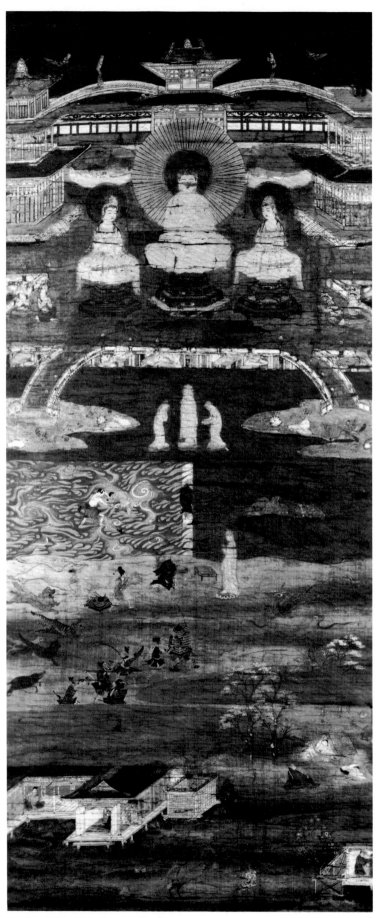

37. The White Path Crossing Two Rivers

The configuration became popular during the Kamakura period, and there are a number of fine extant works dating from the middle of the thirteenth century A.D. onward. They all exhibit the same general format, although details of composition differ. The upper portion of each painting (the west) depicts the paradise of Amida; the lower foreground section shows the mundane world inhabited by ever-incarnating creatures from the six realms of existence. In the central part of the composition a river of fire, symbolizing (as Shan-tao explains in his exegesis on the parable) the violent anger of mankind, stretches out to the left (the south). To the right (the north) flows the river of water, signifying man's greed and avarice. These qualities of greed and anger can overcome and drown men, making it impossible for them to reach the Western Paradise; the earnest devotee can avoid them thanks to the grace of Śākyamuni and Amida.

The composition of the Cleveland painting is typical of paintings of this theme from the second half of the thirteenth century; a similar example is found in the Kōmyō-ji in Kyoto. The paradise of Amida occupies almost half of this composition, and the vertical white path divides almost exactly in two the two raging rivers. The Amida trinity—painted first in white pigment and then in gold paint with kirikane highlighting on the robes—dominates the paradisiacal realm, of which the right and left halves are virtual mirror-reversed images. Three-storied flanking structures and a two-storied central pavilion with gold-painted pillars and architectural details are set against a now darkened silver band at the top of the picture plane and a sky done in gunjō pigment recalling the more elaborate arrangement seen in the *Taima Mandara* (no. 31). Two arched bridges connect the central platform with spits of land in the middle of the blue lotus pond of Paradise; these spits are painted in gold and silver (now oxidized) over a white base.

Standing on lotus pedestals near the edge of the raging rivers is an Amida trinity done in gold. Kannon offers the lotus throne to the devotee traversing the white path, while Seishi waits in the customary prayerful gesture. Blues, greens, peaches, reds, and gold dominate the color scheme of this upper half of the composition; the halo behind the central Amida, with many radiating gunjō spokes, is the karakasa, paper umbrella type also seen behind the Buddha in the Chicago *Amida Trinity Raigō* (no. 32).

The now smudged green terrace of Paradise was, in its original form, presumably the green ishi-datami or tile platform typical of many of these paradise representations, for example, the Taima mandala. There is a childish, naive quality, however, to this depiction of the Pure Land and its inhabitants, apparent particularly in the round, sweet, youthful, but somewhat slack, faces of the Amida trinity. Lacking are the firm tessen (iron-wire lines) of traditional Buddhist painting, and the mathematical rigor underlying proportions of face and figure. By contrast, the artist seems far more interested in his delineation of the raging rivers and its possessed inhabitants and the various activities of the earthly realm. Here we see, moving down the picture plane, the figure of our devotee in monk's attire shown twice—just as he is about to step onto the white path, and again in the middle of it. Faithful to the parable, a golden figure of Śākyamuni stands on the shore of the mundane world, right hand upraised in the abhaya ("fear not") hand gesture, urging the pilgrim forward. The thieves, in elegant armor, pursue the devotee while various animals follow close at hand. In the foreground, to the right, a monk meditates on the sorrow and transiency of life in a graveyard with realistically decomposing corpses and ephemerally blooming cherry trees. Further down, a man tames a wild horse and two human dwellings are seen. One of the most exquisite details in the painting is of two courtiers in the house at the lower left, one playing a flute, the other a biwa: one can almost hear the plaintive notes of these refined gentlemen who seem unaware of the drama unfolding nearby.

Details of landscape and architecture recall such thirteenth-century works as the *Senzui Byōbu* at the Jingo-ji or the 1299 *Ippen Shōnin Eden*. The rather folkish, naive treatment of the deities contrasted with this inspired portrayal of secular elements is perhaps a clue to the identity of the artist of this painting. He was probably an eshi—a professional secular painter, skilled at depicting people, architecture, and landscape—rather than an ebusshi, or Buddhist monk-painter, better trained in formal, iconic painting. We offer this suggestion even though in the lower right corner of the painting appear two signatures, Jō-shin and Kyō-shin, which seem to be monks' names and which could possibly signify the artists. On the other hand, because most Buddhist painting is unsigned, these two signatures could be the religious names of non-monk, professional painters, or the names of donors, or simply later additions, perhaps of devotees who contributed to the painting's repair.

Published: Shimada Shūjirō (ed.), *Zaigai Hihō*, vol. 2 (Tokyo, 1969), no. 25.

References: Jōji Okazaki, *Pure Land Buddhist Painting*, Japanese Arts Library vol. 4 (Tokyo, 1977); Takata Osamu and Yanagisawa Taka, *Butsuga*, Genshoku Nihon no Bijutsu vol. 7 (Tokyo, 1969), pl. 143.

38. The White Path Crossing Two Rivers (Niga Byaku-dō)

Last half of the fourteenth century A.D.
Ink, colors, gold pigment, and kirikane on silk
Hanging scroll; 82.6 × 39.7 cm
Seattle Art Museum; Eugene Fuller Memorial Collection

This version of the *White Path Crossing Two Rivers* from the Seattle Museum dates about a century later than the Cleveland painting (no. 37) and is quite different both in composition and mood. Although abraded over the years, it has been well restored, so that the viewer can experience something of the original image. In the foreground appear houses in a pastoral setting with animals running about; above them the Pure Land devotee appears twice, perhaps three times, once rushing from the thieves who are trying to kill him, then again running on the white path, and possibly a third time if he is indeed the figure experiencing birth on a lotus in a pond in the lower left part of Paradise, near the river's edge. The two rivers lie on a diagonal line sloping toward the upper right; and, as in the Cleveland painting, vignettes suggesting anger and greed appear in the midst of each river. The Western Paradise is like other representations of the Pure Land, with its tiled terraces, flowers and birds, flying heavenly angels, musicians, and dancers. The Amida trinity dominates the scene at the upper left, and other palaces of Paradise appear at the upper right.

In the earliest renderings of this configuration, such as the Cleveland painting, certain distinctive features are exhibited; the two rivers appear as a horizontal band in the middle of the composition and the thin white path is a vertical line dividing the two rivers (and, by extension, the central part of the composition) in half. The palaces of Paradise are not elaborate, and the configuration tends toward brevity and conciseness, faithfully depicting the parable.

Later works, such as this one, are characterized by a looser, more complicated compositional structure. The rivers lie on a dramatically slanting diagonal line, and the conception of the whole painting tends to be more pictorial or painterly. The parable is not always rendered according to the text. As in the case of similar paintings in the Yakushi-ji and Seiryō-ji, the figure of Śākyamuni is absent from the shore of the mundane world. Later works often show a more complex and diffuse architectural setting for the Western Paradise as well, as is evident in this painting.

One example of a story-telling element derived from illustrated narrative handscrolls and characteristic of both the Cleveland painting and this one is the device known as iji-dōzu ("different time, same illustration"), in which multiple actions of a figure are shown in an unchanging setting; here, as we have seen, the devotee is shown twice, possibly three times. Configurations like the White Path Crossing Two Rivers are an excellent example of the interest in and exploitation of the potentials of narrative imagery characteristic of Pure Land Buddhist art. Paintings like this were used as teaching aids, to help make more concrete and viable the doctrines of the faith to a largely unlettered populace.

Published: Henry Trubner et al., *Asiatic Art in the Seattle Art Museum* (Seattle, 1973), no. 190, p. 218.

References: Kanazawa Hiroshi, "Niga Byaku-dō," in *Jōdo-kyō Bijutsu no Tenkai* (Kyoto, 1974), pp. 21–23; Jōji Okazaki, *Pure Land Buddhist Painting,* Japanese Arts Library vol. 4 (Tokyo, 1977), pls. 145, 146.

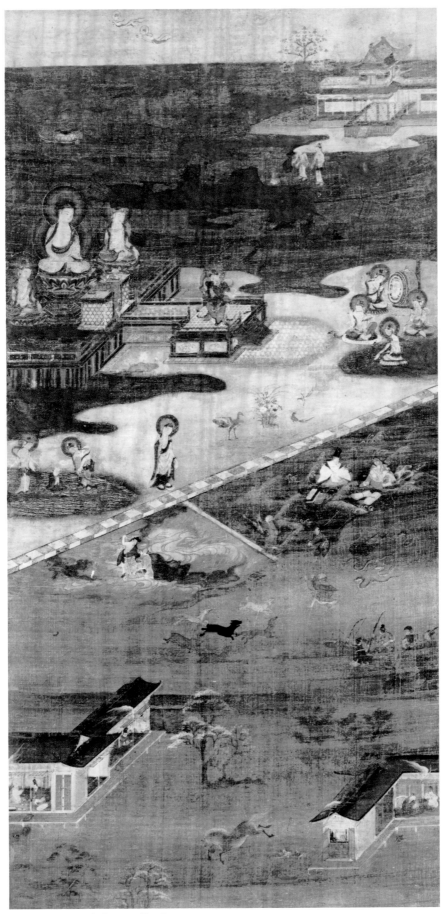

38. The White Path Crossing Two Rivers

39. Illustrated Legends of the Yūzū Nembutsu Sect (Yūzū Nembutsu Engi), Scroll 1

Early fourteenth century A.D.
Ink, colors, and gold pigment on paper
Handscroll; H. 30.3 cm, L. 14 m 86.5 cm
The Art Institute of Chicago; Kate S. Buckingham
 Collection

The two scrolls of the *Yūzū Nembutsu Engi* (nos. 39, 40) originally formed a single set and are among the finest and oldest examples of Japanese scroll painting in the West; only the Boston Museum *Kibi* and *Heiji* scrolls, for works remaining intact, are older. This scroll, belonging to The Art Institute of Chicago, illustrates the life and teachings of Ryōnin (1073–1132), the founder of the first of the Japanese Pure Land sects, given the name Yūzū Nembutsu. The second scroll, now in Cleveland (no. 40), begins with the death and birth into Paradise of Ryōnin and then depicts the activities of his followers after his death.

The Yūzū Nembutsu sect grew out of the Tendai and Kegon conception that the particles that form all things in the universe are interrelated and interpenetrated (yūzū) and, ultimately, identical. This interrelationship, by which one man is fundamentally identified with all and all with one, can be realized through Nembutsu recitation, because when one person recites the Nembutsu, he can benefit all others. Devotees of this sect would enroll themselves in a registration book or list and would pledge a certain number of recitations for a specific time period.

The Chicago scroll, consisting of five long illustrations each preceded by a section of text, shows the monk Ryōnin living as a recluse at Ōhara, north of Kyoto. There, for over twenty-four years, he devoted himself to austerities, prayer, and meditation. His reputation as a holy figure began to spread; younger monks attached themselves to him, and courtiers and townspeople from the capital came to see and then revere him.

The first pictorial section, reproduced here, is an unusually long and beautiful passage of continuous narrative, showing Ryōnin puzzling over his books, walking through the hills near the Mudō-ji temple, praying in his humble dwelling, and envisioning a golden deity who appears in front of his altar on a swirl of clouds; finally, the monk is seen praying outside a hall of worship capped by a large golden jewel-finial.

The second scene in the scroll shows Ryōnin asleep in his little hut at Ōhara. A waterfall ripples down a

39. Illustrated Legends of the Yūzū Nembutsu Sect, Scroll 1, details

かう山の池を又よそと小すはやくに
毎生廣地と玉ひをそ順次中の
萬国小ろ川かうくくやくくき頂行共
種目を一人を杯りよいてもろ申数
金にいふ　群通去れに一大物をきて
毎のわう毎へ初とをしも一人也
をる故わ仙使ひ廣夫なくうはる順次をう
一人は生つけて津主とこそ
じまうさいまうくすくるぢゆ慇懃
北元現うものこと～そそくら
まふ　うくきろあ午

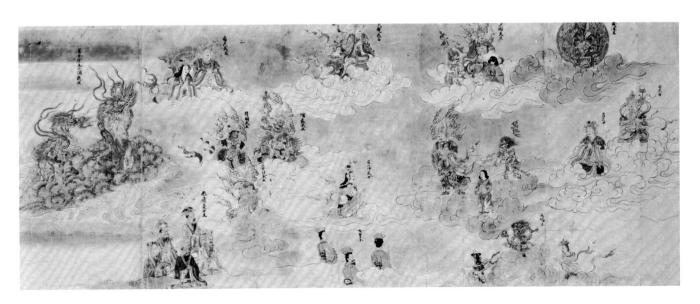

rocky landscape at the left, over which appears a figure of Amida on a swirl of clouds. The figure of the Buddha is only six centimeters high, from tip of halo to lotus pedestals, but the color harmonies used in its treatment are exquisite and echo the fine and subtle color scheme that characterizes the scroll painting as a whole. Amida's vibrant blue halo is outlined in gold and two golden rays project downward to the sleeping Ryōnin; the Buddha's body is done with kindei and his robes are painted in fine blue, red, green, and brown pigments. Tiny floral designs in gold are added to the robe, and the veins of the green petals of the lotus pedestals are also etched in gold. The portion of text that precedes this scene tells us that one summer day, when Ryōnin was in his forty-seventh year, Amida appeared to him in a vision while he slept. The Buddha suggested that it would be difficult for Ryōnin to attain birth in the Western Paradise through his pious deeds and austere, contemplative life alone. Amida then taught him the quicker and more certain practice of Yūzū Nembutsu.

The succeeding scene shows Ryōnin's acceptance of the advice of Amida and his propagation of the Yūzū Nembutsu among all classes of people, including the emperor and his court as well as monks, nuns, and laymen: all these devotees are enrolled in the registration book, with the number of recitations pledged by each.

The following scene shows a young priest in blue and green robes appearing at Ryōnin's retreat in Ōhara, requesting to enroll his name in the registration book.

After signing, he disappears and the accompanying text tells us that when Ryōnin opened the book he found that the priest was in fact a manifestation of the deity Bishamon (nos. 20, 22), pledging one hundred recitations of the Nembutsu (presumably per day).

The last textual and pictorial section, one portion of which is reproduced here, records the events surrounding Ryōnin's visit to the Kurama temple on the fourth day of the fourth month in his final year of life. During a period of prayer in the dawning hours of the morning, Bishamon appeared again to the priest and informed him that a large group of deities had pledged one hundred prayers each and had enrolled their names. As if awakening from a dream, Ryōnin saw the list of eighty-five deities, both Buddhist and Shinto, and then he saw the deities themselves—a host of extraordinary beings, some pacific and others fiercely demonic— enveloped in fluttering flames and scarves. Rich coloring and an extensive use of gold characterize this scene, in which the virtuoso brush of the artist achieved its full potential. The influence of Shinto is strong in this last section, with the inclusion not only of many Shinto deities but also, in the next scene, of little representations of many important Shinto sanctuaries, clearly labeled on the scroll as such.

Published: Jack Sewell, "*Yūzū Nembutsu Engi Emaki* — Illustrated Scrolls of the History of Yūzū Nembutsu," *Bulletin of the Art Institute of Chicago* (April 1959).

40. Illustrated Legends of the Yūzū Nembutsu Sect (Yūzū Nembutsu Engi), Scroll 2

Early fourteenth century A.D.
Ink, colors, and gold pigment on paper
Handscroll; H. 29.7 cm, L. 12 m 96.5 cm
The Cleveland Museum of Art; Purchase, Mr. and Mrs. William H. Marlatt Fund, John L. Severance Fund, and Edward L. Whittemore Fund

The second scroll of the *Yūzū Nembutsu Engi,* which has eleven sections of text and ten pictorial sections comprising fourteen scenes, opens with a description of the virtues of the Yūzū Nembutsu ("interpenetrating" or "circulating" Nembutsu). The second scene, reproduced here, depicts the beatific death and ōjō (birth into Paradise) of Ryōnin, the founder of the Yūzū Nembutsu sect, when he was sixty years of age. A magnificent raigō (Welcoming Descent, see no. 32) comes to guide the priest to Paradise: although Amida is not visible, the rays of light that emanate from his head reach down into the humble dwelling where Ryōnin has died. The raigō is headed by Kannon offering the lotus throne, followed by Seishi in the prayerful gesture, both riding on a swirl of clouds.

The third scene shows Ryōnin, himself now a raigō-like figure, appearing before a sleeping monk. The preceding text tells us that after his death Ryōnin appeared to his disciple Kakugan at Ōhara in a dream and reported that he had been born on a lotus in the upper birth of the upper degree (the highest level of birth in Paradise)—thanks solely to his practice of the Yūzū Nembutsu. The next scene shows the former Emperor Toba, now in priestly retirement, participating in the Yūzū Nembutsu recitation ritual; this scene is followed by a section showing highborn ladies at the Kōryū-ji who, it is reported, practiced Nembutsu recitation for one hundred days. The sixth section deals with another woman, the daughter of a governor of Izumi province —so the text tells us—receiving the tonsure and entering the order of the faithful; we next see this nun in prayer in front of an altar and hanging painted images; finally we see her at her death, just as she is about to attain birth in Paradise, sitting quietly facing the west, hands clasped in prayer.

Succeeding this section is a charming genre scene that illustrates the story of the wife of a cowherd of the Kii-dera, who, by becoming a member of the Nembutsu order, recovered from a difficult childbirth in which she almost died. This scene is followed by a depiction of judgment in the nether world which records the story of a woman who had joined a service in which the Nembutsu was recited three thousand times, and who was sent back to life from the hellish regions after her death because of the merit she had gained by her recitations.

The second detail of this scroll comes from the next pictorial section, which, according to the accompanying text, tells the following story: the Shōka era (A.D. 1257–1258) witnessed a widespread and horrific pestilence. In order to turn the disease away from his home, a squire at Yono in Musashi province (present-day Tokyo) decided to lead his family in a practice of the Betsuji (different times) Nembutsu, which is continuous repetition of the Nembutsu by a number of different persons taking fixed turns in the ritual. The day before this service was to begin, the squire listed the members of the group in the order of their recitations and that night dreamed that a group of ghostly and demonic beings (representing the plague) appeared at his gate and tried to enter his house. The squire went to the gate and enjoined the spirits to stay away because the members of the household had decided to practice the Betsuji Nembutsu and had already put the list of their names on the altar. The beings stayed at the gate but asked to see the list as proof of the veracity of his words, the scene illustrated here. Having seen it, they put their sealmarks under the names, but refused to grant the squire's request that a daughter, living at some distance, be included in the list. Here the squire's dream ended, but the next morning he found strange sealmarks on the registration list and, in fact, all the members of the family remained in good health throughout the plague except for the daughter living far away, who died of the disease. The spirits are drawn and colored with particular skill, and individual personality is well conveyed. They are dressed in garments of gold, red, orange, green, and brown.

The last section of text speaks of the efficacy of Nembutsu recitation and exhorts all people to its practice, inspired by the examples of the individuals with which this scroll has dealt. The final pictorial section illustrates the spiritual interaction or interpenetration of all beings with Amida, and through Amida, with each other, by means of Nembutsu recitation: a golden-bodied Amida is shown in the midst of a circular group of seventeen Nembutsu practitioners—lay men and women, nuns and monks, all chanting or fingering rosaries. Eight gold double rays shoot out from the Buddha, a golden Buddha figure at the end of each double ray.

These two scrolls form the earliest set of twenty known, extant versions of the *Yūzū Nembutsu Engi.*

141

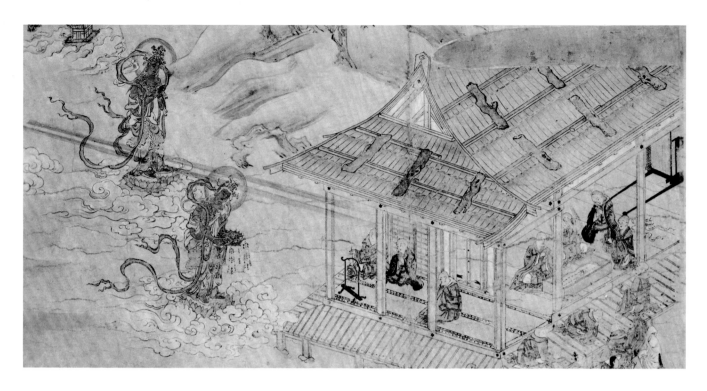

40. Illustrated Legends of the Yūzū Nembutsu Sect, Scroll 2, details

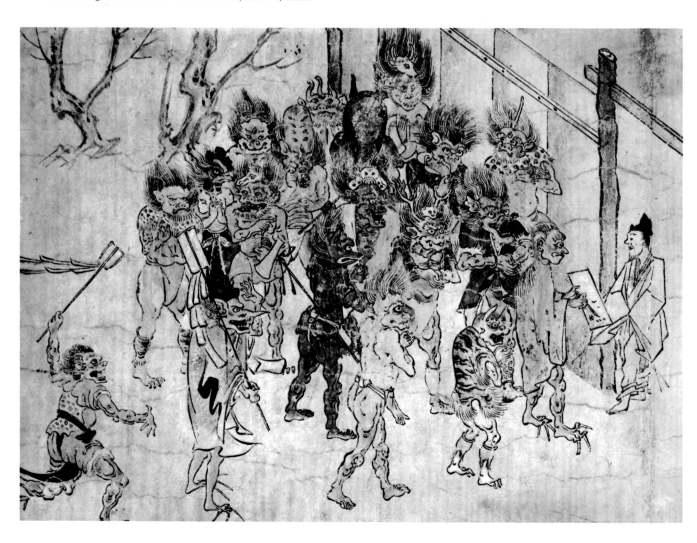

The date Showa 3, corresponding to A.D. 1314, is given at the end of the scroll and recalls an earlier, now lost, version of 1314 of which the present paintings are probably copies made slightly later. Colophons added in the Edo period at the end state that the calligraphy in this work is by the hand of the Abbot Kōshu of the Ishiyama-dera and the painting by Tosa Mitsunobu (1434–1525), but these attributions are probably apocryphal. In recent centuries the set was in the possession of the Kashima family, wealthy merchants of Edo, but a copy of the two scrolls made in 1826, now housed in the Tokyo National Museum, was the only evidence of their existence until they suddenly emerged on the art market after World War II and were sold to the two American museums.

The colors on the Chicago scroll are rather more vivid than on this scroll, and it may be the work of one hand. Several hands, by contrast, seem visible on this painting. Both scrolls are representative of orthodox, professional engi-e painting of the first half of the fourteenth century A.D., and exemplify a refined sense of scale and proportion, delicate coloring, and fluid line drawing. The figures are comparatively small in relation to their settings, the coloring is restrained yet lyrical, and the application of gold paint, as detailing on landscape, figures, and architecture, is judicious. The delineation of rocks and trees and landscape elements is particularly skillful. These features recall fine emaki of the second half of the thirteenth century such as the *Ippen Shōnin Eden,* the *Taima Mandara Engi,* and the *Saigyō Monogatari Emaki.* On stylistic grounds alone, the two scrolls are securely dated in the early fourteenth century.

A set of scrolls like this provided the iconographic and stylistic basis for a large number of copies of the illustrated *Yūzū Nembutsu Engi.* Toward the end of the fourteenth century, the priest Ryōchin was especially active in commissioning the production of such handscroll paintings; seven versions were made after 1385, one of which is now in the Freer Gallery of Art in Washington. In 1390 Ryōchin also supervised the creation of the first large-scale woodblock-printed version of the emaki. In later centuries copies of the engi included both hand-painted and block-printed versions based on the fourteenth-century prototypes.

Published: *Bulletin of The Cleveland Museum of Art,* 45 (May 1958), 48 (January 1961); Tokyo National Museum (ed.), *Emaki Tokubetsuten* (Tokyo, 1974), no. 97.

References: *Kokka,* no. 744 (March 1954), no. 745 (April 1954); Shimada Shūjirō (ed.), *Zaigai Hihō,* vol. 2 (Tokyo, 1969), text p. 83; John M. Rosenfield, Fumiko E. Cranston, and Edwin Cranston, *The Courtly Tradition in Japanese Art and Literature* (Cambridge, MA, 1973), no. 93.

41. A Nembutsu Gathering at Ichiya, Kyoto

From The Pictorial Biography of the Monk Ippen (*Ippen Shōnin Ekotoba-den*)

Early fourteenth century A.D.
Ink and colors on paper
Section of handscroll mounted as hanging scroll;
 35.5 × 54 cm
The Metropolitan Museum of Art; Purchase, The
 Harry G. C. Packard Collection of Asian Art, Gift
 of Harry G. C. Packard and Purchase, Fletcher,
 Rogers, Harris Brisbane Dick and Louis V. Bell
 Funds, Joseph Pulitzer Bequest, and the
 Annenberg Fund, Inc. Gift, 1975

This handsomely composed scene, a fragment from a long handscroll, suggests the enthusiasm and excitement aroused by the popular Pure Land Buddhist movements in the early middle ages. In a humble wooden hall built on the outskirts of Kyoto, a crowd of monks, laymen, and children are gathering to await the performance of an ecstatic recitation of the Nembutsu by the charismatic monk Ippen (A.D. 1239–1289). Members of the military class, the samurai, may be identified by their swords and stiff laquered black hats (eboshi); high-born women come wearing kimono in pale shades of green, peach, blue, and brown. An esoteric mountain ascetic, a shugenja, sits in the structure at the upper right in his brown patterned robe and distinctive pointed cap. The other monks are dressed in sober gray and black vestments.

Ippen, founder of the last of the major Amidist sects, the Ji or Time sect, was an itinerant monk who incorporated many features of earlier Pure Land movements into his teachings. Like his predecessor Ryōnin, who founded the Yūzū Nembutsu sect (nos. 39, 40), Ippen also enrolled devotees in a registration book or kanjinchō; like Kūya (903–972), he taught and practiced an ecstatic Nembutsu, sung and danced to popular melodies (Odori Nembutsu). Ippen also preached the Rokuji Raisan, a hymn extolling Amida to be recited six times a day, and distributed cards or handbills on which the sacred Nembutsu characters were written. He believed that his was the religion for the age or time in which he lived, a time in which men must lose themselves entirely in total reliance on the Buddha Amida.

Born into the Ochi clan on Shikoku in 1239, Ippen became a novice in the Tendai sect at the age of ten years. At twenty-five years, he began his life as a traveling monk. He studied with Pure Land teachers (in particular Shōtatsu, a disciple of Zennebō), but the crucial event in his life occurred in 1275 when he went to the Kumano Shrine and prayed to its deity for one hundred days. On the final day of his vigil, the oracle of the shrine, in the form of a white-haired yamabushi or mountain priest wearing a hood, emerged from the shrine proclaiming

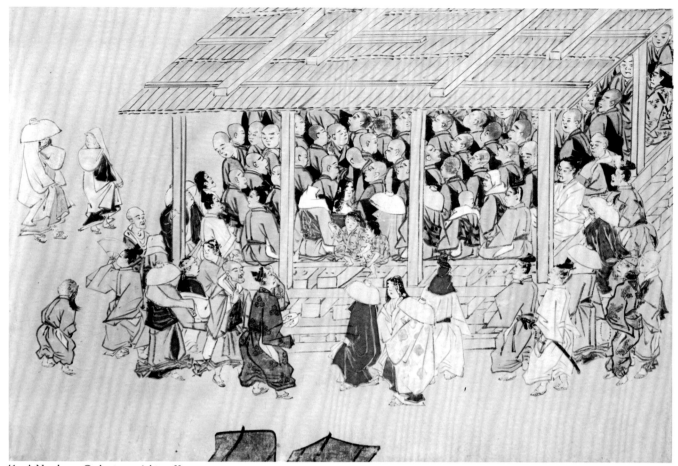

41. A Nembutsu Gathering at Ichiya, Kyoto

that the Nembutsu represents the absolute law and the universal practice. Encouraged by this, Ippen traveled all over the country, spreading his faith. His practice of the Odori Nembutsu is said to have started in Shinano province (Nagano prefecture) in the year A.D. 1279 during a visit to a warlord. While reciting the Nembutsu in the garden of his host's house, he began to dance ecstatically. People gathered, were mesmerized, and could not help but participate as well.

Numerous pictorial versions of the life of Ippen exist. The earliest and best known is the 1299 *Ippen Hijiri-e* on silk in twelve scrolls. Its text was written by Shōkai, the younger brother of Ippen and the founder of the Kankikō-ji in Kyoto, where eleven of the twelve scrolls are kept (the seventh is in the Tokyo National Museum). The illustrator of the Kankikō-ji scrolls was En'i, who held the honorary title of Hōgen.

The Kankikō-ji scrolls inspired a number of subsequent versions, but even more were based on the other great pictorial biography of Ippen's life, the *Ippen Shōnin Ekotoba-den* in ten scrolls, which was more widely disseminated than the *Ippen Hijiri-e*. The author of this biography was a monk named Sōshun, and the original illustrated version was completed by the year 1307. The first four scrolls were devoted to the life of Ippen; the last six to the biography of the second chief priest of the Ji sect, Ta-a Shinkyō.

The Metropolitan fragment seems to come from a set, most of which is still in the Konkō-ji in Kyoto, based on the 1307 *Ippen Shōnin Ekotoba-den*. It is sometimes called the Ichiya dōjō version. Ichiya dōjō recalls an event prominently treated in these scrolls that took place in the summer of 1284. Ippen, who had just returned to Kyoto, made pilgrimages to various spots in the city. At Ichiya, a place long associated with the memory of Kūya, he built a stage (dōjō) for preaching to the masses and for practicing the dancing Nembutsu.

Many sections of the Konkō-ji scroll painting have been lost in fires or sold to private dealers and collectors. The Metropolitan fragment probably comes from the third scroll and depicts the stage for lectures and dancing built by Ippen at Ichiya. The line drawing is sure, swift, and expressive, and the demeanor of the participants is lively, sometimes even caricatured. The scene is charged with anticipatory excitement, as people chat animatedly among themselves. This Konkō-ji scroll painting must closely reflect the style of the original Sōshun version and date not far in time from that prototype, namely, the first third of the fourteenth century.

References: Miya Tsugio, *Ippen Hijiri-e*, Nihon Emakimono Zenshū vol. 10 (Tokyo, 1960); Miya Tsugio, *Ippen Shōnin E-den*, Nihon no Bijutsu no. 66 (Tokyo, 1971); Shimada Shūjirō (ed.), *Zaigai Hihō*, vol. 2 (Tokyo, 1969), text pp. 88–89.

42. Hōshō Gongen Appearing Before En no Gyōja

From The Illustrated Legends of the Jin'ō-ji (*Jin'ō-ji Engi Emaki*), Scroll 1
Second half of the fourteenth century A.D.
Ink, colors, and gold pigment on paper
Section of handscroll mounted as hanging scroll;
 34.4 × 55.8 cm
Mary and Jackson Burke Collection

This scene, with vivid reds and greens dominating the color scheme, comes from the early portion of the first of two long handscrolls illustrating the history of the founding of a small, obscure temple in the southwest of Osaka, the Jin'ō-ji. Painted by a professional atelier in the second half of the fourteenth century A.D., the scrolls retain many of the stylistic traits that the most sophisticated Japanese narrative artists had perfected in the previous century: the ability to present a story, episode by episode, across the surface of the long narrow page, moving the events back into pictorial space and then bringing them closer to the picture plane; imbuing the presentation with lively incidental details; integrating the human figures and landscape without diminishing the emphasis upon the former; applying colors in thin washes so that the imagery possesses a bright luminosity; and executing the outlines and details in thin ink washes with the sure and rapid strokes of the virtuoso brush.

Fragments of these two scrolls began appearing on the art market around 1940. Before that time, scholars had been unaware of their existence; moreover, the textual portions of the scrolls had not been recorded elsewhere. The cutting apart of these important narrative paintings was one of the most deplorable cases of commercial vandalism in recent years; the fragments were selected in such a way that they would be suitable for mounting as hanging scrolls, and unsuitable sections may have been destroyed. Until Akiyama Terukazu, then of the Tokyo National Art Research Institute, undertook an intensive study of the fragments in the early 1960s, no one had identified the subject of these paintings or reconstructed the original order of scenes.

In Akiyama's reconstruction, greatly aided by the small indigo blue paper tabs pasted onto the scenes and inscribed with the names of the persons and locations shown, the first scroll was comprised of seven sections of text and seven of illustrations. It began with events of the seventh century, with the arrival of a famous wonder-working monk named En no Gyōja (A.D. 643–?) at the site of the temple in the southern part of Izumi province. The guardian deity of the place, Jinushi Myōjin, asked En no Gyōja to settle at the foot of Mount Jin'ō and to make

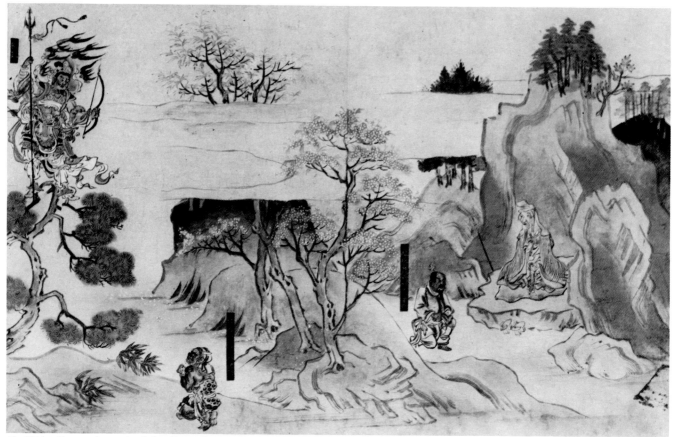

42. Hōshō Gongen Appearing Before En no Gyōja

the place a center for ascetic disciplines. The hermit followed the deity's instructions, and then made a copy of the Lotus Sutra and buried it in a tumulus on a nearby hill; finally he summoned the Buddhist divinity Fudō Myō-ō to guard the place.

Hopeful of founding a temple befitting this sacred site, En no Gyōja traveled to the Korean kingdom of Silla. There he was inspired by a powerful local deity, Hōshō Gongen, to return to Japan and to establish the temple. In 684, with the help of Emperor Tenmu, Gyōja built the sanctuary, the lecture hall, and the temple pagoda. Having been summoned by the hermit, and followed by an entourage of minor gods, the Gongen then flew through the air to Japan and settled at the Jin'ō-ji.

The episode illustrated here depicts the appearance of Hōshō Gongen. The old hermit sits in meditation underneath a rocky crag at the right, holding a vajra—an Esoteric ritual implement—in his right hand and fingering a rosary with his left. He wears a light blue robe and a coat made of rushes. In front of him, clothed in an orange robe, kneels a Shinto medium and minor deity, Shikigami, who was designated as a messenger and guide by Hōshō Gongen. The Gongen appears at the upper left, standing atop pine tree branches; this fierce guardian figure, clothed in the Chinese T'ang style as a general in garments of red, green, blue, and white colors, has four arms: he holds a spear and an arrow in his right two hands, and a bow and a sheathed sword in his left two hands. A flaming red aureole behind his head proclaims his power. The devilish horned figure with bright orange-red skin and a leopard-hide garment, kneeling at the foot of the Gongen's tree, is an intermediary who has helped Gyōja invoke the great deity.

After Hōshō Gongen's arrival, many little halls were built in the mountains to worship him and his companions. En no Gyōja, however, was forced into exile; the temple became dilapidated, and was almost abandoned by the beginning of the eighth century. The Gongen was angered, and showed his wrath by causing earthquakes and wrecking havoc on the inhabitants of the region—a particularly dramatic episode that is illustrated in a fragment of the scrolls that is now in the Hofer Collection in Cambridge, Massachusetts.

Published: Miyeko Murase, *Japanese Art: Selections from the Mary and Jackson Burke Collection* (New York, 1975), no. 24.

References: Shimada Shūjirō (ed.), *Zaigai Hihō*, vol. 2 (Tokyo, 1969), no. 62; *Kokka*, no. 695 (February 1950); John M. Rosenfield, Fumiko E. Cranston, and Edwin Cranston, *The Courtly Tradition in Japanese Art and Literature* (Cambridge, MA, 1973), no. 92.

43. The Monk Kōnin Meditating in the Mountains

From The Illustrated Legends of the Jin'ō-ji (*Jin'ō-ji Engi Emaki*), Scroll 2

Second half of the fourteenth century A.D.
Ink, colors, and gold pigment on paper
Section of handscroll mounted as hanging scroll; 33.7 × 54.9 cm.
The Asian Art Museum of San Francisco; The Avery Brundage Collection

Surely one of the most evocative portions of the *Jin'ō-ji Engi* is this fragment in the Brundage Collection. It was taken from the opening portion of the second scroll, which features Kōnin, an eighth century A.D. Korean monk from Paekche who restored the Jin'ō-ji after it had fallen into disrepair. This painting shows how Kōnin, traveling in the Izumi area, had a vision of Hōshō Gongen, who told him of the ruined temple.

The episode begins at the right, with the Korean sage, lost in the mountains, being miraculously led by a young bull to the temple. Beneath them, Hōshō Gongen appears to Kōnin and urges him to rebuild and reconsecrate the Gongen's sanctuary. Kōnin is shown twice again, once seated in meditation attended by deer and monkeys and vowing to rebuild the temple, and again at the far left wandering around the site near a waterfall and mountain stream and another small temple. Many of these natural and man-made elements (the waterfall, the sanctuaries), as well as all the personages (including the bull) are identified in the cartouches.

In the remainder of the scroll, Kōnin makes a long pilgrimage to advertise the importance of Hōshō Gongen and to solicit contributions for the rebuilding of the temple. Word of the project finally reached the emperor, who decided to patronize the reconstruction of the temple. Kōnin was summoned in A.D. 777 by the minister Fujiwara no Fuyutsugu (died 826), who conveyed the message of imperial support. The temple began to flourish and Kōnin, contented at last, died in the year Hōki 6 (778). The handscroll then depicts a visit to the site by the great monk Kūkai, founder of the Shingon sect, who officiated over a ceremony reciting a prajñā-pāramitā sutra at Kōnin's grave, and a ceremony of purification in the nearby river.

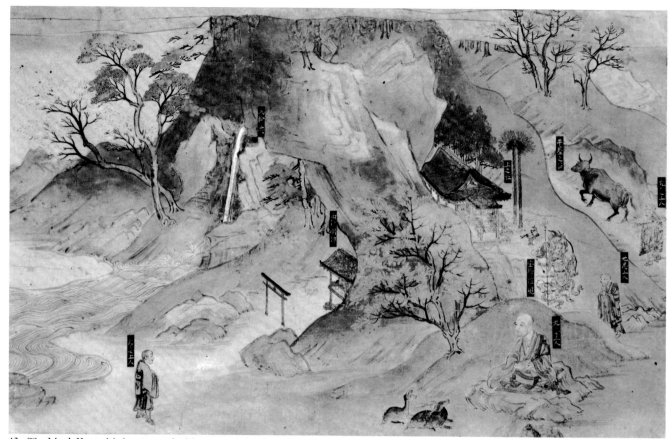

43. The Monk Kōnin Meditating in the Mountains (*color illustration, p. 35*)

This fragment, as well as the others exhibited here, shows an almost perfect state of preservation. X-ray analysis revealed little retouching or repainting except for the gold-painted characters in the cartouches. The fact that these scrolls were little known and probably infrequently handled in an isolated country temple explains the extraordinary freshness of the colors. The opacity of the white paint apparent under radiographic study proved that lead white (enpaku), a rather precious pigment, was used in this scroll. During the fifteenth century, enpaku was largely replaced by calcium white (gofun); some so-called *Jin'ō-ji Engi* fragments that have come to light and that have been painted with gofun rather than enpaku have been ascertained to be forgeries.

The *Jin'ō-ji Engi* was painted in a style that is sometimes called otoko-e, literally masculine painting, to contrast it with the more static and brightly colored courtly style called onna-e (feminine painting). The otoko-e are characterized by rapid line drawing and a realistic, or even caricatured, treatment of facial and figural features. Another device typical of otoko-e emaki evident in this fragment is termed iji dōzu, or different time, same illustration. This device conveys a continuous narrative sequence by showing the same figure several times, engaged in various activities, against a static background; in this scene Kōnin is depicted four times.

Typical also of paintings in the handscroll format is the willful manipulation of scale. To emphasize the importance of his meditation, Kōnin is shown far larger proportionately than the other figures and than the natural elements. The two devotional halls are much smaller than the figures and ought to seem far distant in space, but in fact there is little sense of illusionistic depth, and as a result it is difficult for the viewer to accept these structures as being tucked away in the mountains. Trees that should be even farther away, in terms of their placement in the composition, are in fact large in scale.

Reference: Terukazu Akiyama, *The Identification and Reconstruction of the Illustrated Scroll Known as the "Kōnin-shonin-eden,"* International Symposium on the Arts of Asia (San Francisco, 1966), unpublished manuscript.

44. Procession of Monks in Honor of Maitreya

From The Illustrated Legends of the Jin'ō-ji *(Jin'ō-ji Engi Emaki),* Scroll 2

Second half of the fourteenth century A.D.
Ink, colors, and gold pigment on paper
Section of handscroll mounted as hanging scroll;
 32.1 × 64.5 cm
Nelson Gallery–Atkins Museum; Nelson Fund

This fragment must come from the last part of the second scroll, which details and depicts the various festivals and ceremonies conducted by Kūkai at the Jin'ō-ji. The three lines of text at the right are a recent addition and bear no relation to the pictorial section. The scene is identified by the characters in the single cartouche as a Miroku Dai-e, or Great Assembly Honoring Maitreya, the Buddha of the Future. A procession of priests wends its way through the landscape: four carrying offerings are followed by three playing wind instruments and two wearing the basket hats used by monks when begging. Two laymen in front and a woman at the rear complete the procession.

This subtle and restrained composition, with its rhythmic, harmoniously positioned band of marching priests, breathes with the cool, thin washes of color that are a hallmark of the entire scroll painting. Because of the essentially pale green and blue tonalities of the composition, the bright color accents are all the more striking—the red of the maple tree at the upper left and its fallen leaves, as well as the red offering stands that the priests carry.

The temple itself, isolated and little known, is located in the foothills of Mount Katsuragi thirty kilometers southwest of Osaka. Called either the Jin'ō-ji or Ko-nō-ji (the Chinese characters of its name may be read differently), the temple must have been a center of Shugendō, a form of Esoteric Buddhism whose adherents practice ascetic disciplines in the mountains, and whose founder is said to have been the hermit En no Gyōja. Akiyama Terukazu discovered in this temple two illustrated handscrolls, both entitled the Jin'ō-ji Engi, which, although not very old, were obviously a copy made before most of the original emaki was cut and scattered. These scrolls helped him in the reconstruction of the original form of the scroll painting. Each scroll copy had the conventional lengthy opening preface, and textual portions preceded pictorial sections. But because of discrepancies between text and illustration, and because of the existence of original fragments that did not appear in the copies, it became clear that some illustrations had already been lost when the copies were made.

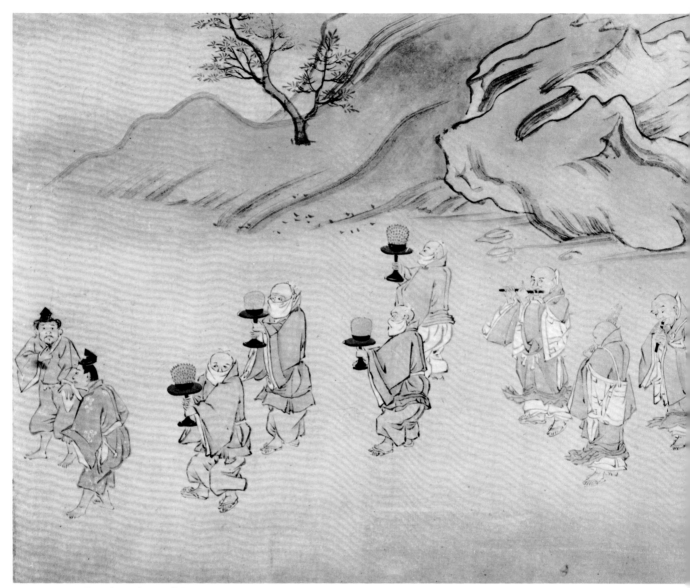

44. Procession of Monks in Honor of Maitreya

Despite the fact that the illustrated scrolls of the *Jin'ō-ji Engi* depict events, both supernatural and historical, of the temple history in a specific and concrete manner, all evidence suggests that the legendary story is an invention of the twelfth century A.D. No document of the eighth century suggests the existence of a temple called the Jin'ō-ji or Ko-nō-ji in Izumi province. A monk called Kōnin may well have played a principal role in the founding of the temple, although it is uncertain when he lived; no such name appears in early Buddhist records. Clearly, we have here an attempt on the part of the authors and illustrators of this emaki to legitimize and glorify the existence of a small country temple dedicated to an obscure deity called Hōshō Gongen, by linking it to prestigious figures like En no Gyōja and Kūkai. The inclusion of a dramatic element such as imperial patronage for both En no Gyōja and for Kōnin only serves to underscore the importance of the local tradition.

A date of the second half of the fourteenth century is suggested for this scroll painting, because of the various stylistic elements, in particular the composition and the slightly stereotyped brushwork, which lack the inventiveness and vigor of earlier works. However, childish naïveté and folkish qualities that are typical of so many handscroll paintings from the fifteenth century onward are not yet apparent in these scrolls.

Published: *Handbook of the Collections in the William Rockhill Nelson Gallery of Art and Mary Atkins Museum of Fine Arts,* vol. 2 (Kansas City, MO, 1973) p. 102.

45. Hell of Shrieking Sounds

From an Illustrated Hell Scroll (*Jigoku Zōshi*)

Ca. A.D. 1200

Ink and colors on paper

Section of handscroll mounted as hanging scroll;
painting 26 × 27.3 cm; calligraphy 26 × 33 cm

Seattle Art Museum; Eugene Fuller Memorial
Collection

Buddhist monks who torture animals on earth can expect to be driven into the unbearable fires of hell by horse-headed demons brandishing iron rods. Such painful retribution for misdeeds in a previous life is shown in harrowing detail in this fragment from one of the earliest hell scrolls (jigoku zōshi) and is also described by the accompanying calligraphic text: "Many monks for such cause arrive at the Western gate of this hell, where the horse-headed demons with iron rods in their hands bash the heads of the monks, whereupon the monks flee shrieking through the gate into hell. There, inside, is a great fire raging fiercely, creating smoke and flames, and thus the bodies of the sinners become raw from burns and their agony is unbearable." (Translation by Kojiro Tomita)

Four pitiful little nude figures, painted in thin, tremulous lines, flee before the onslaught of the demons; one man has tripped and fallen, one turns around in a futile attempt to escape the fire. The gruesome demons, done in stark colors of red and white, overpower their charges with ease. Bold, thick outlines and skillful calligraphic strokes show coarse sinews that bespeak raw, demonic strength. Despite the painful subject matter, however, the image has a slightly humorous or caricatural flavor.

At about the turn of the thirteenth century A.D., Japan's altered social and religious ethos caused a major change in its artistic life. As the genteel, aristocratic culture of the upper classes was shattered by civil war and social upheavals, artists showed increasing interest in the possibilities of retribution, both in this life and

45. Hell of Shrieking Sounds

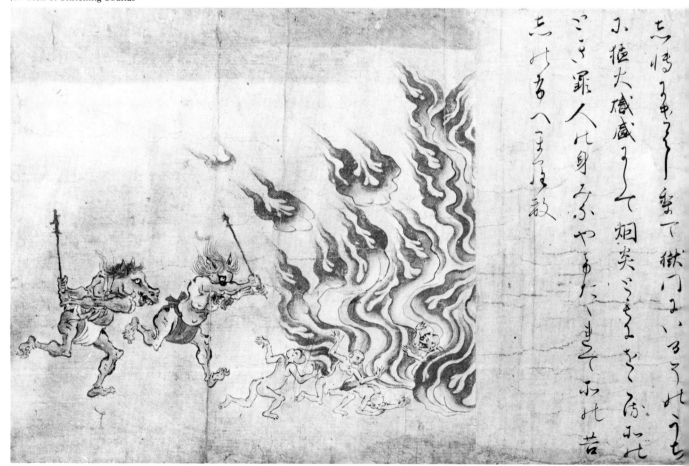

in the next. They started to depict, often in horrifyingly graphic terms, the Six Realms of Existence (rokudō) through which sentient beings are born until they are freed from bondage to the wheel of birth and death. These representations show the impermanence of human life, subject always to painful disease and death. They depict ghosts who are doomed to a hunger and thirst that can never be satisfied because of the greed and cruelty they displayed in a former life. These ghosts appear as menacing, pathetic creatures with grotesque, distended bellies, feeding on corpses or on the excrement of human beings.

Perhaps the depictions of the Realm of Hell are the most disgusting of those of the six realms. Four scrolls of outstanding artistic merit remain from the late twelfth and early thirteenth centuries, and these portray the suffering of the doomed in sadistic detail. Always present is painful heat; Genshin, whose *Ōjō Yōshū* helped inspire these paintings, had remarked that a portion of hell fire as small as the light of a firefly would immediately consume our world. Amid the fires of the inferno are shown the damned being boiled or skinned alive, having their eyes and entrails gouged out, being roasted, having molten iron poured over them, or being ground up in a mortar, attacked by frightful monster-animals, or drowned in a vile mass of dead bodies, excrement, and insects.

One of the four early hell scrolls, formerly in the Anjū-in Collection and now in the Tokyo National Museum, depicts four of the sixteen minor hells within the great Hell of Screams (one of the eight principal hells), as described in the Shōbō Nenjo-kyō. A second, formerly in the Hara Collection and now in the Nara National Museum, illustrates seven of the eight infernos mentioned in another sutra, the Kisei-kyō. The Seattle fragment comes from the first of two hell scrolls from the Masuda Collection. Because the second scroll depicts deities from Chinese popular religion conquering malevolent spirits, it might not even be a hell scroll at all, although it is usually considered as such. The name of each hell depicted in the first of the Masuda scrolls is written in the text preceding each picture; the name of the relevant sutra or commentary on which the scheme was based was not included, and remained an enigma until Kobayashi Taiichiro pointed out the correspondences between this emaki and the Sutra Questioning Karmic Retribution for Monks (and Nuns). Kobayashi says that this text was based on a T'ang period (A.D. 618–907) "forged sutra" in sixteen chapters, the Horse-Headed Demon Buddha-Name Sutra (Batō Rasetsu Butsumyo-kyō), which entered Japan in the Heian period and later inspired works like the present handscroll.

In terms of drawing style, this fragment shows similarities to handscroll paintings of the mid to late twelfth century, notably the *Ban Dainagon Ekotoba* and the *Shigisan Engi.* By comparison with the other extant hell scrolls of the same period, the first Masuda scroll version exhibits some distinctive characteristics. Foremost among these is the scale of the figures, which is in general far smaller in proportion to the rest of the composition. In addition, each scene is set in more empty space. This scroll is done with a strongly modulated brush, which recalls some of the finest late Heian period iconographic drawing (see nos. 19, 25–27).

Published: Henry Trubner et al., *Asiatic Art in the Seattle Art Museum* (Seattle, 1973), no. 191, p. 218; Ienaga Saburō, *Jigoku-zōshi; Gaki-zōshi; Yamai-zōshi,* Nihon Emakimono Zenshū vol. 6 (Tokyo, 1960); Shimada Shūjirō (ed.), *Zaigai Hihō,* vol. 2 (Tokyo, 1969), no. 49.

Reference: Kobayashi Taiichiro, "Butsumyo to Shamon Jigoku Zōshi," in *Yamato-e Shiron* (Tokyo, 1946).

46. Nichizō's Journey through Hell

From The Illustrated Legend of the Kitano Tenjin Shrine (*Kitano Tenjin Engi Emaki*), Scroll 4

Ca. A.D. 1300
Ink and colors on paper
One of five handscrolls; H. 30.2 cm,
 L. 5 m 63.8 cm
The Metropolitan Museum of Art; Purchase,
 Fletcher Fund, 1925

Over thirty sets of handscroll paintings of the legendary founding of the Kitano Tenjin shrine in Kyoto are known to exist. All these versions, dating from the early thirteenth to the nineteenth centuries A.D., relate the story of Sugawara no Michizane (845–903), a dis-

tinguished scholar, poet, and government minister who died in exile, banished to a remote spot because of false charges brought against him by a political rival. On his deathbed Michizane uttered malevolent curses, and after his death his vengeful spirit wrecked havoc on the populace until a shrine, the Kitano Tenmangū on the northern edge of the Heian capital, was built to pacify it. There, Michizane was deified as Tenjin, patron of literature and music especially pledged to succor those persons falsely accused. The various emaki depict the crucial events of Michizane's life, the destruction and death caused by his spirit, and finally the manner by which people in subsequent generations were rewarded or punished depending on their devotion to his shrine. The full cycle of episodes covers a period of about two

46. Nichizō's Journey Through Hell

hundred and thirty years, from Michizane's birth in 845 to the year 1075.

The different versions of this handscroll painting also include depictions of the tenth-century monk Nichizō's travels through the Six Realms of Existence (rokudō). The Metropolitan version of the *Kitano Tenjin Engi Emaki* is unique, however, because of the attention paid to Nichizō's journey through Hell, reproduced here. Whereas other scroll paintings generally include only two or three scenes of the visit to Hell, the Metropolitan work devotes an entire scroll to it. The accompanying text, found only in the Metropolitan version, is based on the *Dōken Shōnin Meido-ki (A Record of the Monk Dōken's* [Nichizō's] *Tour of Hell)*. In the final section Nichizō appears dressed as a shugenja or moun-

tain ascetic, with shoulder-length hair, brown robe, and pointed cap, meeting a scarlet-faced Emma-Ō, the Overlord of Hell, who is surrounded by devil-jailers and some of their prisoners. King Emma informs Nichizō that soon the priest will return to earth. Next Nichizō is shown with his crimson-coated demon-guide standing at the gate of the fiery hellish inferno, which is guarded by a horrifying animal with four legs, a nine-pronged tail, and eight heads, each with four eyes. This animal is colored a pale blue-gray, with red highlights at mouths and eyes and at the flange-like projections off his legs. The setting is a surrealistic, burned, barren, moonlike landscape with pincushion mountains and jagged little peaks. Reddish-orange flames spit out of the gate of Hell.

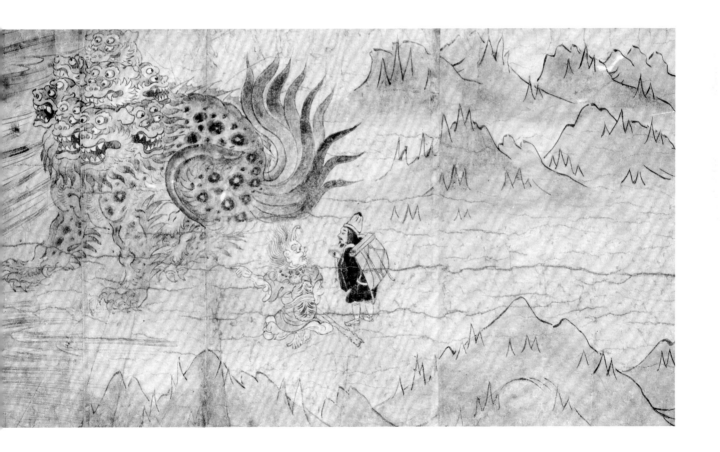

Inside the inferno itself, two large demons prod with poles four unfortunates in a swirling mass of flames that covers the entire picture plane. Beyond the cauldron-like scene, Nichizō and his devil-guide encounter the Former Emperor Daigo (reigned 897–930) sitting in the midst of flames guarded by a bullock-headed demon. The emperor, a dejected figure with his topknot limply in disarray, speaks to Nichizō about his bad fortune, and asks that persons on earth perform good deeds on his behalf, for his relief. Three other sinners, terrifying dark gray figures with no features, who can be recognized as once human only by their general bodily contours, sit behind the emperor with vultures picking at their heads. Although it is still vivid and horrifying, originally this handscroll painting was far more brightly colored, and these scenes of Hell would have evoked even more horror on the part of the viewer. The entire painting gives the impression of being only lightly colored, but this is because much of the pigment has fallen away.

The oldest extant text of the *Kitano Tenjin Engi* dates from the reign of Emperor Go-toba (reigned 1186-1198), and the earliest extant illustrated version, in eight scrolls, now in the Kitano Jinja in Kyoto, has an inscription of Jōkyū 1, corresponding to the year A.D. 1219. For the first seven episodes, the Metropolitan version closely follows the text of the Jōkyū scrolls, and many of the scenes through the work resemble the Jōkyū version. From the eighth episode on, however, the text of the present painting more closely resembles that of another scroll painting, the Egara version of 1319. In turn the Metropolitan piece, directly, or indirectly through another unknown version, may have influenced later *Kitano Tenjin Engi Emaki*, such as the Sugitani and Sugō versions of 1419 and 1427. The Sugi-tani piece deals rather more extensively with Nichizō's journey than other scroll paintings, but even here the representation is abbreviated.

Professor Miyeko Murase, whose work on this scroll painting caused it to be reassembled and remounted correctly by the Metropolitan in 1973, increasing the number of scrolls from three to five, believes on the basis of style that the work dates to the late thirteenth or early fourteenth centuries. The landscape is treated in the gentle, traditional yamato-e fashion, without the unnatural sharpness or angularity that begins to appear in the fourteenth century. Evidence of a date around the year 1300 includes mist bands without clearly defined contours or bounding lines that drift through the painting to suggest movement in time and space; the small scale of figures in the landscape; and the layout of the architectural settings. Similar elements are found in the *Ise Shin Meisho Uta Awase Emaki* (ca. 1295), the *Obusama Saburō Emaki* (ca. 1295), and the *Zenkuen Kassen Emaki* (first half of the fourteenth century). One calligrapher and two painters seem to have been at work on the Metropolitan *Kitano Tenjin Engi Emaki*.

Published: Murase Miyeko, "Tenjin-engi Emaki," *Bijutsu Kenkyū*, nos. 247, 248 (July, September 1966); Shimada Shūjirō (ed.), *Zaigai Hihō*, vol. 2 (Tokyo, 1969), no 58; Asia House Gallery (ed.), *Masterpieces of Asian Art in American Collections II* (New York, 1970), no. 49.

Reference: Miyeko Murase, *The Tenjin-engi Scrolls – A Study of Their Genealogical Relationship*, unpublished doctoral dissertation, Columbia University, 1962.

47. Ten Kings of Hell and Scenes of Punishment

Ca. A.D. 1350

Ink, colors, and gold pigment on eight pieces of
 rough silk

Two hanging scrolls; each scroll 161.5 × 138.8 cm

Collection of Kimiko and John Powers

This pair of paintings, registered as an Important Cultural Property by the Japanese government, depicts the ten kings who preside over Hell and judge the dead on certain specified days after death. Descriptions of the Buddhist hells are found in Indian texts, but a formal cult of the Ten Kings was codified in China in the ninth and tenth centuries A.D., largely based on a forged text of the late T'ang dynasty, the Sutra of the Ten Kings (Jū-ō-kyō). The cult represents a fusion of Indian Buddhist and native Chinese, particularly Taoist, beliefs, and is prominently reflected in Chinese Buddhist painting from the Sung period (960–1279) onward (no. 48).

Sung paintings of the Ten Kings were first introduced into Japan in the late twelfth century, and Japanese versions of the theme appear in large numbers from that time on. In the civil wars and social disorders attendant upon the collapse of the aristocratic rule of the Fujiwara, the Japanese saw earthly existence as far more precarious and cruel than in previous times, and translated this perception into horrifying, realistic pictorial terms in their depictions of suffering in the Buddhist afterlife. These two paintings, done about a century and a half after the importation of the cult into Japan, reveal the considerable changes that took place in the interpretation of the Chinese prototypes. Most notable are the small Buddha images above the heads of the kings, representing the Buddhist divinities of whom the Ten Kings are emanations. The treatment of the figures, especially of the victims amid the flames of Hell have been strongly influenced by traditional yamato-e.

The wrathful kings are shown here seated in front of screens with ink landscape paintings, and are flanked by officials and attendants holding books. The individuals to be judged are brought before each king by demon jailers, and scenes of awful punishments take place below the row of judges. The first seven kings preside over the days on which Buddhist funeral services are held: the seventh day after death, the second seventh day, the third seventh, and so on until the forty-ninth day (seventh seventh), the most important

of all, for this is the day in which the stage of rebirth for most people is decided. After that, and reflecting pre-Buddhist Chinese forms of ancestral devotion, services are held one hundred days after death, one year, and then three years later—to arrive at the full complement of ten kings.

The left-hand scroll depicts the odd-numbered kings from left to right as follows: (1) Shinkō—presides over the first seventh day, and is identified with Fudō Myō-ō; (3) Sōtei—third seventh (twenty-first) day, identified with the Bodhisattva Monju; (5) Emma (S Yama)—thirty-fifth day, often known as the Overlord or chief king of Hell (see no. 48), identified with the Bodhisattva Jizō. The sinner in front of this king is forced by a demon to look in a mirror in which is reflected his crime, the murder of a Buddhist monk; (7) Taizan—forty-ninth day, the King of Mount T'ai in Shantung province, in China, the site of a pre-Buddhist cult of the dead, identified with the healing Buddha Yakushi; and (9) Toshi—one year, identified with the Buddha Akushu (S Akṣobhya).

The scenes below the row of kings depict the Eight Hot Hells, according to the affixed inscriptions. At the extreme right is a vignette of a man impaling himself on a tree of thorns as he struggles in vain to reach a beautiful, half-nude woman atop the tree. To the left of this, three great demons press against large rocks to squeeze, as in a vice, victims whose blood spurts from the side. Elsewhere demons with clubs force sinners into a boiling cauldron; one demon drives a chisel against the chest of a man, while another shows parts of bodies collected in a winnowing basket to a little child. Further left is a stream on whose bank three victims face the Datsu-i-ba, the Old Hag who takes away the clothing of the dead. Confiscated garments are hanging on a tree nearby. The only note suggesting escape and salvation in this grotesque terrain is the figure of Jizō leading two people across the bridge over the stream, out of the hellish realm.

The right-hand scroll is read visually from right to left and depicts the kings presiding over the even-numbered days: (2) Shokō—second seventh (fourteenth) day, identified with Śākyamuni; (4) Gokan—twenty-eighth day, known as the King of Five Officials, charged with recording the crimes of murder, robbery, lust, lying, and drunkenness, and identified with the

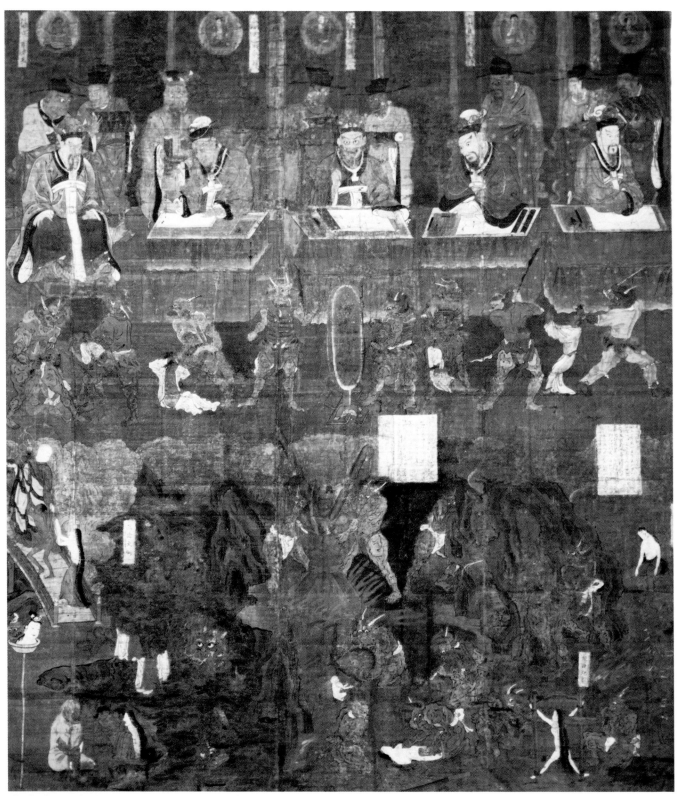

47. Ten Kings of Hell and Scenes of Punishment

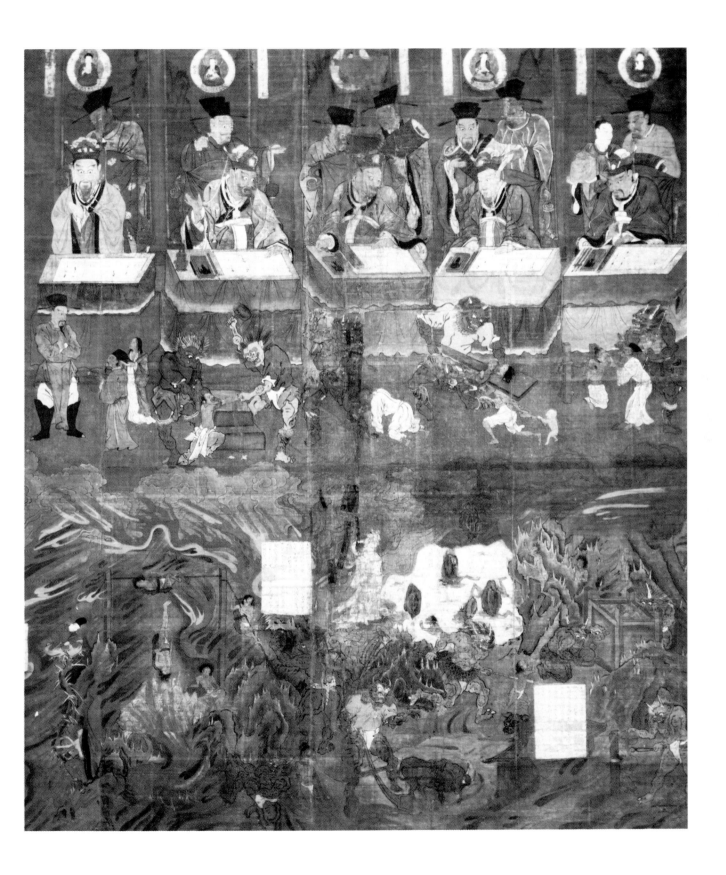

159

No. 47. Detail

Bodhisattva Fugen. The victim in front of this king is a woman locked by a demon into a heavy wooden stock; a child, presumably the baby she has aborted, is clinging to her skirt; (6) Hensei—forty-second day, the King of Metamorphoses, identified with the Future Buddha Miroku (S Maitreya); (8) Byōdō—one hundred days, the King of Impartiality identified with the Bodhisattva Kannon; and (10) Godōtenrin—three years, the Wheel-Turning King of the Five Spheres of Existence. Indic in concept, he is identified with Amida. Here the individuals standing before the king are a respectfully attired, demure couple, the only ones for whom judgment is favorable and who may leave Hell unscathed.

The scenes below these five kings show (beneath the tenth king) another thorn tree, this time with a half-draped woman struggling to reach a male courtier atop the tree. In another scene, victims with heavy rocks on their backs are forced to walk a tightrope over a flaming pit into which they fall because of their burdens. Elsewhere a demon forces a victim tied to a stake to drink a bowl of blood, while in the lower center portion of the composition, a demon plows a field of blood and flames with a green ox, while another devil beside him impales a small man with a spear. Once again, though, there is a single ray of hope: in the center of the scroll stands the figure of the Bodhisattva Kannon.

Dating from about 1350, this painting shows resemblances to the *Ten Kings* on ten scrolls in the Nison-in in Kyoto and, in style and certain details, to the *Ōjō Yōshū Emaki* in the Asata Collection, datable to the late fourteenth century. It is slightly more folkish or caricatured (in such features as the bulging eyes of the kings) than earlier Kamakura period versions of the theme, for example, the one in the Shōju Raigō-ji (Sakamoto city), or the Kyoto Zenrin-ji rendition of Jizō and the Ten Kings. In these earlier works, the Chinese influence is greater and the details more finely executed.

Published: Miya Tsugio in *Kobijutsu*, no. 23 (September 1968): 89–92; John M. Rosenfield and Shūjirō Shimada, *Traditions of Japanese Art: Selections from the Kimiko and John Powers Collection* (Cambridge, MA, 1970), no. 49.

References: Kyoto National Museum (ed.), *Jōdo-kyō Kaiga* (Tokyo, 1975), pl. 147; Ienaga Saburō, *Jigoku-zōshi; Gaki-zōshi; Yamai-zōshi*, Nihon Emakimono Zenshū vol. 6 (Tokyo, 1960).

48. Ten Kings of Hell

By Kanō Tan'yū (A.D. 1602–1674)
Copied from paintings by Lu Hsin-chung
 (thirteenth century A.D.)
Dated in accordance with A.D. 1658
Inscription on cover attributed to Tani Bunchō
 (1763–1840)
Ink and colors on paper
Sketches mounted as a handscroll; H. 42.7 cm
Private collection

Opening this scroll of a lively, if incomplete, set of sketches of the *Ten Kings of Hell* by Kanō Tan'yū is the statement that it is based on a Chinese model. Tan'yū noted that he copied a group of paintings of the Ten Kings in eleven hanging scrolls done by the Sung painter Lu Hsin-chung. Although Lu's name and biography have not been preserved in any Chinese source, it is thought that he must have lived in the Ningpo area, south of the modern Shanghai, between the years 1195 and 1277. In fact, most extant Chinese paintings of the Ten Kings in Japan are attributed to this man and some are inscribed with his name. His atelier must have produced Buddhist paintings, particularly of the arhats and the Ten Kings, which were imported into Japan in the traffic between the two countries encouraged by the military government in Kamakura and actively solicited in the port city of Ningpo, then called Sse-ming. Lu's name is mentioned in the *Kundaikan Sōchōki*, the connoisseur's guide compiled in the late fifteenth and sixteenth centuries by three generations of the Ami family, artistic advisers to the Ashikaga shogunate.

Kanō Tan'yū was the leading official painter of his age, holding appointments both to the imperial court in Kyoto and to the military regime of the Tokugawa family in Edo. Even while he supervised the operations of an active atelier outside the Blacksmith Bridge (Kajibashi) leading into the Edo Castle, he was a serious student of earlier painting, both Chinese and Japanese, and frequently made careful copies of original works brought for his inspection. Of the many copies from his hand, this one is unusual for its large size, high quality, and scrupulous attention to the details in the original. Tan'yū's motives in making these drawings are not clear, but they may have been preliminary drawings for a set of formal copies or replicas of the originals, which already were considerably damaged.

In this scroll figures were copied on twenty-one joined sheets of differing sizes of paper in a sporadic fashion, without directional consistency. Some of the figures are completely colored, but others are not. The first fifteen sheets show seven of the Ten Kings— Emma, an unidentified king, Toshi, Shinkō, Byōdō,

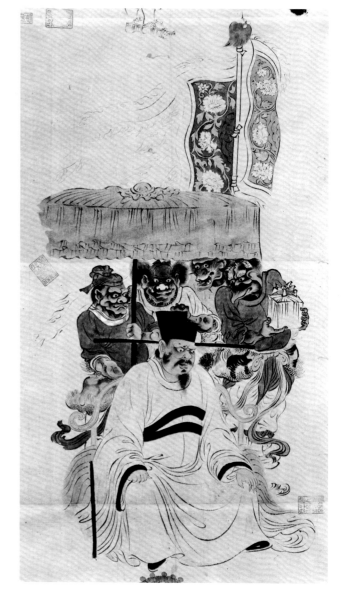

48. Ten Kings of Hell, details

Hensei, and Sōtei (see no. 47). More sketches may have been originally included in the set, but the fact that so many figures are absent and that some of those present are uncolored indicates that although Tan'yū must have intended a serious study of Lu Hsin-chung, he probably did not mean to produce a finished work.

The very same paintings by Lu Hsin-chung that Tan'yū copied recently entered the collection of the Kanagawa Prefectural Museum in Yokohama. Tan'yū was so faithful in copying that he even left damaged areas blank; but he was also selective, omitting the traditional landscape screens behind the kings, various figures, and certain details of clothing and furniture. Most of the Kanagawa paintings evince a strong resemblance stylistically and iconographically to a version of the Ten Kings now in the Daitoku-ji, Kyoto.

Shown here are the first two kings, Emma (S Yama) and an unidentified ruler. Dressed in red and gray, Emma sits with a brush poised behind his desk with its colorful floral skirt. In front of him stands an expressive bull-headed demon and the so-called Pure Crystal Mirror, also known as the Mirror of Shining Brightness, which reflects the sins of those appearing for judgment. The sinner and two standing officials accompanying him are not shown here, in their proper places as in the Kanagawa prototype, but rather appear later at the right of the eighth and sixth sheets. The mirror, however, proclaims the fellow's sin—beating a man off a boat. Emma, the fifth king of Hell, who is often illustrated alone as the Overlord of the Ten Kings, was in ancient Indian Vedic literature Yama Rāja, the god of death. King Emma appears by himself as the hero in legends from as early as the ninth century, in the anthology of Buddhist tales, the *Nihon Ryōiki*.

Seated under a pale blue canopy, the unidentified judge behind Emma proclaims his wrath with roaring mouth, bulging eyes, and furrowed brow. He wears a hat with stiffly protruding lateral bands; absent are the conventional king's crown and desk. Behind him stand demons disguised in the robes of officials, one with a green face, one with a blue face, two with red robes. The demon-official at the right is holding an official seal protected in a cloth-wrapped square box. Particularly eye-catching are the flying banners behind the group with their white and green peony-like floral designs done on backgrounds of red and peach. In the Lu Hsin-chung original, this assemblage, which is not found in any other extant Ten Kings representation, and which is still unidentified iconographically, includes some other figures found elsewhere in Tan'yū's scroll. The sinner, who is being beaten by a demon with a short club and who should appear before the king, is seen in the last section of the present scroll. Two other demons and a horse's head appear just above this scene.

This scroll has a great deal of art historical and iconographic significance. Tan'yū's brush, consistently vigorous and sure throughout, attests to his extraordinary draftsmanship and his ability to create expressive forms. The inscription on the plain paper cover, presumably written by the former owner, the distinguished literati painter Tani Bunchō, informs us that the original box bore the writing of Hōgen Tan'yū-sai himself. That box has not, however, been preserved. The scroll shows signs of having been newly remounted: relatively newly stamped seals were impressed over the paper joints, reading "Matsutani Koka fumpon (original version)"; "Ritsuen zō (collection)"; and "Matsutani bunko (library)."

Fumiko E. Cranston, Fogg Art Museum

Published: John M. Rosenfield, Fumiko E. Cranston, and Edwin Cranston, *The Courtly Tradition in Japanese Art and Literature,* (Cambridge, MA, 1973) no. 29.

References: Suzuki Kei, *Mindai Kaigashi Kenkyū: Seppa* (Tokyo, 1969), pp. 103–121; *Kokka*, no. 621 (August 1942).

PART FOUR
Zen Buddhist Paintings

The rise of the Zen sect in the thirteenth century A.D. heralded profound changes in Japanese religious art and, indeed, in all of the high culture of the nation. The new religious and aesthetic system, sometimes called the gozan-bunka, or culture of the great Zen monasteries, came to maturity in the 1380s and flourished until the destruction of the medieval Japanese social order in the civil wars of the sixteenth century.[1] The later middle ages were indeed the last occasion in which a Buddhist creed was to dominate the thinking of the Japanese ruling classes and intelligentsia. With the end of the civil wars and the establishment of the authoritarian regime of the Tokugawa family in the early 1600s, Japan adopted a "premodern" outlook in which the authority of religion was diminished and that of secular values increased. Many elements of the new secularism, however, had already appeared in the gozan-bunka, so much so that the mixture of religious and worldly values in medieval Japan was comparable to that in the Renaissance Italy of Petrarch or Fra Angelico.

Early Zen Painting

Buddhist painting by no means died out in the Zen community, but its character and function, modes of production, and aesthetic values changed considerably.[2] Despite a few flamboyant legends of monks destroying images and tearing up sutras, both Chinese Ch'an and Japanese Zen had strong scholastic and artistic interests and proselytized actively among laymen as well as monks. Rituals continued to be performed before such traditional icon types as Śākyamuni flanked by Mañjuśrī and Samantabhadra (no. 3), the nirvana of the Buddha (no. 2), and arhats (spiritually perfected monks) shown in groups of sixteen, eighteen, or five hundred (nos. 3, 4). Paintings of the White-Robed Kannon were made in large numbers as objects of personal devotion of monks and laymen (nos. 52, 53). Illustrated frequently were events from the legendary history of the sect, especially those of the founder Bodhidharma in China (nos. 58, 59). Portrait painting was of high importance (no. 54); a distinguished monk would give his portrait to a disciple whom he chose to be his successor; a portrait would be kept in a temple where a great monk had lived and would be displayed at yearly memorial services in honor of the sitter.

In a custom that began in China in the thirteenth century as a radical departure from older Buddhist traditions, Ch'an monks began to paint themes that, on the surface at least, were purely secular in content: two tiny figures walking on a snow-covered path in a mountain village, a crane boldly striding away from a bamboo grove, a humble turnip, a gibbon mother and child, a dragon

twisting in clouds, or a solemn and militant tiger. Not only were the themes free from obvious Buddhist symbolism, the painting style was usually that of the Southern Sung painting academy, of such important masters as Ma Yüan, Hsia Kuei, or Liang-k'ai. Theirs was a style pervaded by a mood of subtle lyricism; their paintings, called suiboku-ga in Japanese (literally water ink pictures), were executed on silk or paper by soft brushes in black ink diluted with water. Subtle accents of color might be added, but the overall effect was that of sober restraint.[3]

The original role of such secularized paintings in Chinese Buddhist monastic life is not clear. By the fifteenth and sixteenth centuries in Japan, however, large-scale paintings of secular themes appeared prominently on sliding screens within monastic chambers. At the very least, they were in harmony with the basic spiritual purposes of the sanctuary. At the most, they were seen as expressions of an enlightened vision. As did other branches of Mahayana Buddhism, the Ch'an sect tried to dissolve the superficial barriers between the sacred and the profane. The specific way in which they did this opened the path to a kind of sanctified naturalism in art and literature that found a most welcome reception among cultivated people throughout East Asia.

The Prospering of Japanese Zen

Although the practice and ideology of Zen had been known in Japan since the introduction of Buddhism there, a unique set of circumstances brought it to prominence and prestige in the thirteenth century A.D. Only recently had the sect, called Ch'an in Chinese, become highly visible in Sung China, changing from an extremely austere, reclusive monastic order into a large ecclesiastical organization with state support.[4] The change in the character of Chinese Ch'an took place primarily in the Lin-chi (J Rinzai) school, one of its several subdivisions, or houses, and reached a peak in the activities of the famous prelate Wu-chun Shih-fan (1177 – 1249), who refurbished monasteries in the vicinity of Hangchou, the Southern Sung capital, and who attracted a large number of disciples, some of them Japanese.

With the reopening of trade contacts with China in the 1160s, Japanese monks began once again to travel to the mainland for religious instruction. One of the first to encounter Sung-style Ch'an Buddhism was the Tendai monk Eisai (1141 – 1215), who, on his second trip to China in 1187, studied Lin-chi doctrines on Mount T'ien-t'ai; he returned four years later to propagate them in Kyushu, then in Kyoto and Kamakura. Other Japanese monks studied in the monasteries around Hangchou; distinguished Chinese Ch'an masters came to teach in Japan. In Kamakura, seat of the new military regime of the Minamoto and Hōjō families, a series of vast new monasteries, such as Engaku-ji and Kenchō-ji, were constructed. In the imperial capital of Kyoto, the old monastery of Kennin-ji was converted into a Zen establishment, as was the palatial villa that became the Nanzen-ji; entirely new sanctuaries, such as Tōfuku-ji and Tenryū-ji, were built for the creed.

The social climate of thirteenth-century Japan was particularly favorable to Sung-style Ch'an Buddhism. With the triumph in civil war of the confederation of warriors led by the Minamoto clan, Japan was given a new form of government, its first bakufu, literally a (military) curtain government, with a strongly feudal system of authority and allocation of lands. This new military regime openly scorned the life-style of the hereditary aristocrats of the Heian capital whose political power it had destroyed. Whereas the old aristocracy had been notably pacifist and physically inactive, the new ruling samurai were militant, devoted to the skills of the warrior — archery, swordsmanship, the care and racing of horses. Where the discredited old regime had focused its spiritual aims largely upon Amidism, with its passive reliance on the gift of grace of Amitābha, the newly risen military clans responded favorably to Zen's insistence on austerity and personal self-discipline, through long hours of seated meditation, as the path to salvation. Aristocratic

Amidism flourished in an atmosphere of sumptuous luxury of the sort still preserved at the Byōdō-in, near Kyoto, built by the Fujiwara family at the height of its wealth. Zen encouraged a more frugal austere atmosphere, but its sprawling monasteries, with their Chinese-style ceremonial halls and residential subtemples and fine gardens, also gave Zen a striking architectural identity.

Later Zen Painting

The prosperity of the Japanese branches of the sect contrasted sharply with the tragic decline of Chinese Ch'an after the conquest of China by the Mongols, completed in A.D. 1279. Even though, under Mongol rule, Ch'an monasteries continued to be active and to attract Japanese student monks, the economic and social base of the sect had been seriously disturbed, and as an ecclesiastical institution, its days of great creativity were past. On the other hand, in Japan during the fourteenth century, the monasteries of Kyoto and Kamakura developed into major centers of art and learning. Some of them, like Kenchō-ji in Kamakura or Tōfuku-ji and Sōkoku-ji in Kyoto, cultivated their own distinctive schools of painting, with prominent monk-artists instructing younger students. The Sōkoku-ji monk Josetsu (died ca. 1428) was later regarded as the founder of a distinct tradition of Japanese ink painting; Kichizan Minchō (1352–1431), the most prominent of the Tōfuku-ji painters—and indeed, the best documented of any monk-painter of Japan or China— worked in a broad range of styles from the classic polychrome manner to a mixture of secular and traditional Buddhist elements to a pure suiboku landscape style.[5] The celebrated Sesshū Tōyō (1420 –1506) was extremely mercurial, working in a large number of styles, including even the native Japanese portrait mode called nise-e (likeness picture).

In the generation after Sesshū, many Japanese monk-painters became so proficient that they were virtually professional artists. Moreover, the secular workshop of the Kanō family in Kyoto, official painters to the military regime of the Ashikaga family, produced screens and hanging scrolls that were similar stylistically to those coming from the monasteries of Kyoto and Kamakura (no. 53). By the end of the sixteenth century, however, the monasteries ceased to be major centers of painting. This may have been due to the disruption and turmoil of the civil wars, or to the artistic prowess and prestige of the Kanō school. Whatever the reason, by the early 1600s monasteries no longer produced even the paintings needed for their own use, but ordered them from the Kanō school or from its various offshoots and competitors.

As the secular ateliers came to monopolize the production of suiboku-ga in Japan, Zen monk-painters and some lay Buddhists reverted to a highly simplified form of ink painting that is called Zenga (Zen painting), a term of modern vintage.[6] Takuan Sōhō (1573–1645), for example, abbot of Daitoku-ji in Kyoto and one of the most influential Zen prelates of his day, depicted the Chinese patriarchs of Ch'an with almost childlike simplicity, showing little interest in using virtuoso calligraphic brush techniques or subtle modeling and complex composition. His friend, the monk Isshi Bunshu (1608–1646), had actually been well trained in traditional ink painting; but, perhaps under Takuan's influence, he turned his back on this to produce exceedingly simplified pictures, especially of Bodhidharma. The same kind of direct, unsophisticated imagery was painted by such highly educated courtiers as Konoe Nobutada (1565–1614), by Sōtatsu's patron and friend Karasumaru Mitsuhiro (1579–1638), and even by the Emperor Go-yōzei (1571–1617).

Once established, the tradition of Zenga became a powerful current in Edo period Japanese culture. Some of the most distinguished and revered Zen monks of the era, Hakuin Ekaku, for example (nos. 56-58), and even monks who were not formally affiliated with Zen, such as Jiun

Onkō (no. 59), used its simple, straightforward imagery and powerful style of calligraphy to convey religious messages. Painters of other Edo period schools, especially literati artists like Ikenō Taiga or Yosa Buson, were markedly affected by Zenga's emotional power.

That the brusque, almost primitivist quality of the Zenga idiom became one of the prime vehicles of genuine religious expression in the Edo period was ironic indeed, for this was a reversal of the equation of sanctity with elegant and idealistic form in art that had been established by Mahayana Buddhism. By the beginning of the Edo period, that ancient artistic tradition had become weakened through repetition; it was played out, no longer able to enlist the enthusiasm of first-rate artists. Zenga, through the visceral power of its expressionism, restored emotional authenticity to Buddhist painting in much the same way that Expressionism in the late nineteenth and early twentieth centuries overcame the hyperrefinement and idealism of the art academies and salons of Western Europe.

NOTES

1. Following a Sung Chinese precedent, the leading five Zen monasteries in each of Japan's two capital cities, Kyoto and Kamakura, were officially designated as the Gozan, or Five Mountains.

2. Jan Fontein and Money L. Hickman, *Zen: Painting and Calligraphy* (Boston, 1970); Takaaki Matsushita, *Ink Painting,* Arts of Japan vol. 7 (Tokyo, 1974); Yoshiaki Shimizu and Carolyn Wheelwright (eds.), *Japanese Ink Paintings from American Collections* (Princeton, NJ, 1976); Ichimatsu Tanaka, *Japanese Ink Painting: Shūbun to Sesshū,* Heibonsha Survey of Japanese Art vol. 12 (Tokyo, 1972); Shin'ichi Hisamatsu, *Zen and the Fine Arts* (Tokyo, 1971).

3. James Cahill, *Chinese Painting* (Lausanne, 1960), chaps. 6–8; Osvald Sirén, *Chinese Painting: Leading Principles and Masters,* vol. 2 (New York, 1956), pp. 90–153.

4. Heinrich Dumoulin, *A History of Zen Buddhism* (New York, 1963); Dumoulin, *The Development of Chinese Zen After the Sixth Patriarch in the Light of the Mumonkan* (New York, 1953).

5. Tanaka Ichimatsu, *Kao, Mokuan, Minchō,* Suiboku Bijutsu Taikei vol. 5 (Tokyo, 1974); Kanazawa Hiroshi, *Kao, Minchō,* Nihon Bijutsu Kaiga Zenshū vol. 1 (Tokyo, 1977).

6. Yasuichi Awakawa, *Zen Painting* (Tokyo, 1970); Stephen Addiss, *Zenga and Nanga: Selections from the Kurt and Millie Gitter Collection* (New Orleans, 1976); Kurt Brasch, *Zenga (Zen Malerei)* (Tokyo, 1961).

49. Śākyamuni Descending from the Mountains

Ca. A.D. 1300
Ink on paper
Hanging scroll; 90.8 × 41.9 cm
Seattle Art Museum; Eugene Fuller Memorial
Collection

Emaciated and worn, yet sure now of his direction, Śākyamuni walks down from the mountains where he has spent six years in an attempt to experience enlightenment through ascetic practices. He knows from his early life that too comfortable an existence does not provide the spur necessary to break through the barriers of a deluded mind, but now he is aware that the other extreme of self-abnegation is not the solution either. Henceforward he will practice the Middle Way or Middle Path. Soon he will accept food from villagers and then go to the nearby town of Bodhgayā. Here he will seat himself under the spreading Bodhi tree and when he rises from that spot, he will have experienced perfect enlightenment and will be ready to engage in an active ministry on earth.

This event from the legendary life of Śākyamuni, called in Japanese Shussan no Shaka or Śākyamuni Descending from the Mountains, was painted frequently by Ch'an artists, but not by the artists representing other schools or sects. In fact, none of the major accounts of the Buddha's life, such as the Buddhacarita by Aśvaghoṣa or the Lalitavistara-sūtra, locate the place of his ascetic practices in the mountains. This physical setting seems to have been a variation of the legend devised by Chinese Ch'an thinkers, who, perhaps because of their own beautiful, mountainous country, could not imagine seeking enlightenment anywhere but in the hills.

The historical Buddha is shown here as a skeletal figure, with bony arms and emaciated chest counterbalanced by a calm and thoughtful face. It is not surprising that the Ch'an sect chose to develop the imagery of Śākyamuni at this exact moment in his life. This sect of Buddhism was attempting to focus once again on the person and teachings of the historical Buddha, restoring him to prominence after his eclipse by the vast pantheon of deities of Esoterism and by transhistorical Buddhas such as Amitābha. Thus it was natural to emphasize the human dimension of his struggle, and his vulnerability, with which the common man could identify and by which he could be inspired. The fact that Śākyamuni's uṣṇīṣa, or protuberance on the top of his head signifying great wisdom, is represented as a swol-

len bald spot is indicative of the Zen artists' attempts to demystify, to humanize their Buddha, who was, after all, a man, and whose example can be followed by all men. An image like this is still hung in Buddha Halls in Zen monasteries in Japan today. It is most frequently venerated on the sixth night of the seven-day period of intensive meditation that occurs the first week in December to honor the enlightenment of the Buddha.

Some confusion exists as to whether this scene depicts Śākyamuni before or after his enlightenment, because of the presence of signs such as the ūrṇā, or tuft of hair in the middle of his forehead, one of the thirty-two marks of a Buddha. This issue may, in fact, not pose such a problem, for according to some accounts, those signs were present on Śākyamuni's body even before he experienced perfect enlightenment, as the following passage from the Introduction to the Jātaka (a collection of stories of previous lives of the Buddha) shows:

> And the Future Buddha, thinking, "I will carry austerities to the uttermost," tried various plans, such as living on one sesamum seed or on one grain of rice a day. . . . By this lack of nourishment his body became emaciated to the last degree, and lost its golden color, and became black, and his thirty-two physical characteristics as a great being became obscured. . . . And coming to the decision, "These austerities are not the way to enlightenment," he went begging through villages and market-towns for ordinary material food, and lived upon it. And his thirty-two physical characteristics as a great being again appeared, and the color of his body became like unto gold. (Translated by Henry Clarke Warren)

Literary records indicate that this theme of Śākyamuni descending from the mountains was painted in the northern Sung period, by the celebrated Li Kung-lin (died A.D. 1106), among others. Paintings of the subject were brought to Japan in the early Kamakura period. At least one entered the country before 1203, the date of the return of the third and last expedition to China made by Shunjōbō Chōgen, the monk who spearheaded the rebuilding of the Tōdai-ji in Nara. An inventory of objects brought back by Chōgen makes the first mention of a Shussan no Shaka in Japan.

Today, Liang K'ai's famous painting in the Shima Collection, dating from about the year 1200, is the earliest extant work of the theme. That painting evinces similarities to this work in the general treatment of

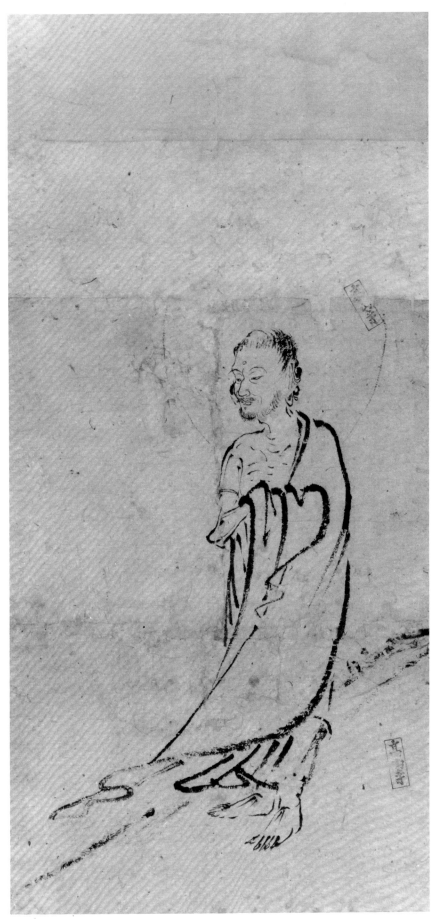

49. Śākyamuni Descending from the Mountains

169

facial features and dress, but Liang K'ai's figure turns differently in space, and—more significantly—is placed in the midst of a fully suggested landscape. Only a diagonal line hinting at the edge of a cliff and his garments blowing forward from behind locate the Seattle Śākyamuni in a windy, mountainous setting.

This painting was no doubt modeled on a Southern Sung prototype, evident in part by the fact that its artist is beginning to explore the full potentials of expressive, calligraphic line, seen particularly in the vivid contrast between thick, bold lines on the garments and thin, wispy lines to indicate beard and scrawny chest and arm. But other forces also seem to be at work here, most notably the native tradition of iconographic drawing. Two seals identify the temple from which this painting originally came—the Kōzan-ji in Kyoto, which had once been part of the Jingo-ji, but which became independent under the aegis of its founder Myō-e Shōnin (1173–1232). In the time of Myō-e, a Kegon sect monk sympathetic to Zen, the temple became an important center for artistic production. Its fine collection of Chinese paintings, drawings, rubbings, and books was studied and copied. Many iconographic drawings were also produced in the Kōzan-ji workshop, including some in the monochrome ink tradition. Two specific features of this Śākyamuni recall traditional iconographic drawing of the twelfth and early thirteenth centuries: the semicircular outlines around the eyes (the upper part of this line lies between the eyebrow and the top of the eyelid), and the little wedge-shaped endings to the brush strokes prominent on the chest. Thus, this *Shussan no Shaka*, with its characteristic line drawing and lack of interest in background setting, reflects the tradition of Buddhist iconographic drawing; but in subject matter, and in its exploration of calligraphic potential, it is informed by the Southern Sung tradition.

Published: Shimada Shūjirō (ed.), *Zaigai Hihō*, vol. 2 (Tokyo, 1969), no 68; Sherman E. Lee, "Japanese Monochrome Painting at Seattle," *Artibus Asiae*, 14:43–61.

References: Jan Fontein and Money L. Hickman, *Zen: Painting and Calligraphy* (Boston, 1970), especially pp. 68–70; Henry Clarke Warren, *Buddhism in Translation: Passages Selected from the Buddhist Sacred Books* (Cambridge, MA, 1896, 10th issue 1953), pp. 70–71; Dietrich Seckel, "Shakyamuni's Rückkehr aus den Bergen," *Asiatische Studien*, 18–19 (1965): 35–72.

50. Patriarchs of the Three Creeds

Early sixteenth century A.D.
Ink and pale red color on paper
Hanging scroll; 90.5 × 32.1 cm
Museum für Ostasiatische Kunst, Staatliche Museen Preussischer Kulturbesitz, Berlin (West)

The custom of copying and reproducing notable pictures was not restricted to the older Buddhist traditions; it flourished also in Zen, as the Berlin version of the Three Saintly Ones will demonstrate. The subject is an allegorical one, depicting the three founders of China's major religious and ethical traditions standing together. Confucianism is represented by the figure in the front, a corpulent and unheroic Confucius; Buddhism is symbolized by the bearded Śākyamuni in the rear; and Taoism is represented by the bent figure of Lao-tzu. The modeling of the faces is reinforced by pale red color; otherwise the picture is done entirely in ink lines and washes. This painting is closely similar to one attributed to the famous monk-painter Josetsu now in the collection of the Ryōsoku-in of Kennin-ji, Kyoto, and dated to ca. A.D. 1400. However, even that painting is not the original of the series, which must have begun in Sung China; the Ryōsoku-in version is engulfed in severe problems of connoisseurship in its own right, and numerous closely related versions of the theme may also have been painted during the Muromachi period.

Compositionally the three men form a tight oval, as though to express in visual terms the underlying significance of the theme: that the three creeds, which often quarreled and attacked each other in China, are fundamentally compatible and together form the sound basis of a national ideology. A comparable image in a different context would combine the figures of Moses, Jesus, and Muhammad in an allegory of peace and harmony in the Middle East. However, in both the Berlin and Ryōsoku-in paintings, the figures are highly satirical in character, and the theme of unity was surely being presented in a humorous or skeptical manner.

The theme of the Three Patriarchs is but one of several in Sino-Japanese ink painting that expressed the ideal of ecumenism. The Three Laughers of the Tiger Ravine was based on an anecdote about the Chinese Buddhist monk Hui-yüan (334–416) being visited by the famous poet T'ao Yüan-ming (ca. 365–427) and a Taoist scholar Lu Hsiu-ching (ca. 406–477) and joining together gleefully in brotherly unity. The same three

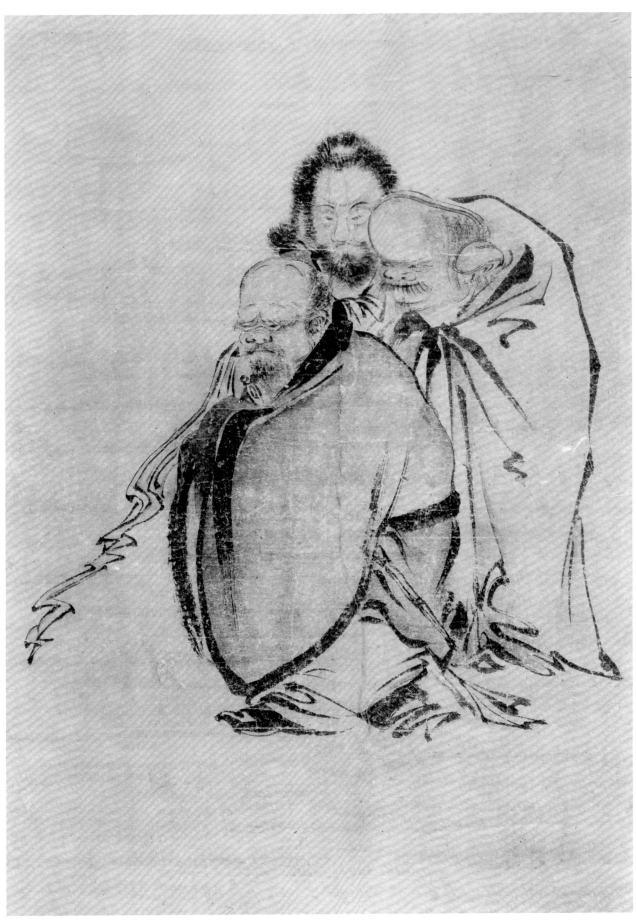

50. Patriarchs of the Three Creeds, detail

171

men are also shown together in the allegory of the Three Sages Tasting Vinegar, in which they, as representative of the three creeds, drink from a wine vat and discover that the wine has turned to vinegar. All of these themes are satirical in character. The surprising experience of vinegar shocks the three sages into realizing the inadequacies of their own doctrines; the Three Laughers of the Tiger Ravine are drawn together in brotherhood as they violate one of the vows of the Buddhist monk and realize that each has been disloyal to his own creed and thereby has gained higher insight. The inscription on the Ryōsoku-in painting of the Three Patriarchs, written in 1493 by the well-known monk Seishū Ryūtō, reads in part:

> Gautama, Confucius, and Lao. The three are like one. One is like three. Together the three produce all virtues. They may be compared to three boatmen in the same great vessel containing heaven and earth and laden with the sacred and the profane. They sailed for 108,000 leagues with the rudder twisting; they sailed for 108,000 leagues to the east while the compass needle pointed to the south. For 350 years they drifted with the wind, then for 350 years they used the sail. Strange, is it not? . . .

The Three Patriarchs are first praised and then made fun of; they are likened to boatmen lost and aimlessly wandering. The unity of the three creeds is not so much an affirmation of their wisdom and insight as a confession of their mutual inadequacy, or the inadequacy of any doctrine, even Buddhism itself, in the face of the great reality that transcends all intellectual formulations.

The Berlin painting has a long empty space above the image for the inscription that was normally added to pictures of this kind. The image itself is so close in detail to the Ryōsoku-in version that the two must be directly linked: one may be a direct copy from the other, or else they were both derived (at different times) from a common prototype. In many ways, however, the Berlin painting is more accomplished technically than the Ryōsoku-in version; it was painted in a more calculated manner, befitting, perhaps, a careful copyist. It lacks, consequently, a strong sense of unity and harmony of its parts. A different spirit of execution is seen in the flying scarves when contrasted with the carefully defined eyes and noses of the sages; and the handling of the shoes and lower hems of the robes approaches the incoherent. Lying behind the Berlin and Ryōsoku-in pictures is a separate strand in Japanese ink painting that can be traced back to Southern Sung China, to Liang K'ai (active ca. 1201–1210) or Li Ch'üeh, and transmitted to Japan by men like Mokuan Reien (active 1323–1345) and Kaō (died 1345), and later emulated and copied. As in the other branches of Buddhist painting, this mode of copying was essential to the survival of the tradition, but in an idiom such as this one in which spontaneity and individualism were esteemed, the act of copying loses a vital element.

The Berlin painting lacks signature or seals, and its date of production must be deduced almost entirely on the basis of its style. Its storage box is labeled with the name of Oguri Sōtan (1413–1481), one of the chief followers of the monk-painter Tenshō Shūbun and appointed official painter to the military regime of the Ashikaga family; unfortunately, however, no work has survived that can be safely ascribed to him. Unpublished records of the Ostasiatische Museum of the comments of visiting Japanese connoisseurs frequently mention another follower of Shūbun, Ten'yū Shōkei, active in the mid-fifteenth century in Kyoto. Although these attributions are indeed plausible, the Berlin painting has some consonance with figure paintings of the Kamakura school of ink painting in the late fifteenth and early sixteenth centuries, in the work of men like Kenkō Shōkei (active ca. 1479–1506) and Chūan Shinkō. Even though the correspondences are not terribly strong, they are convincing enough to suggest that the painter of the Berlin picture may have worked in that circle.

Published: Shimada Shūjirō (ed), *Zaigai Hihō*, vol. 2 (Tokyo, 1969), text illustration to no. 81; Museum für Ostasiatische Kunst, Staatliche Museen Preussischer Kulturbesitz, Berlin (ed.), *Ausgewählte Werke Ostasiatischer Kunst* (Berlin-Dahlem, 1970), no. 92, with further references; Matsushita Takaaki and Tamamura Chikuzō, *Josetsu, Shūbun, San'ami*, Suiboku Bijutsu Taikei vol. 6 (Tokyo, 1974), reference fig. 4.

References: Nakamura Tanio, *Shōkei*, Tōyō Bijutsu Sensho no. 9 (Tokyo, 1970), figs. 21, 29, 30; Susan H. Bush and Victor H. Mair, "Some Buddhist Portraits and Images of the Lü and Ch'an sects in Twelfth- and Thirteenth-Century China," *Archives of Asian Art*, 31 (1977–1978): 39; John M. Rosenfield, "The Unity of the Three Creeds: A Theme in Japanese Ink Painting of the Fifteenth Century," in John W. Hall and Toyoda Takeshi, *Japan in the Muromachi Age* (Berkeley, 1977), pp. 205–226.

51. Mañjuśrī Dressed in a Robe of Grass (Nawa Monju)

Inscribed by Gugyoku Reisai (A.D. 1363–1452)
Ca. 1425–1450
Ink and colors on silk
Hanging scroll; 91.1 × 39 cm
Collection of Kimiko and John Powers

The great Bodhisattva of Wisdom, Mañjuśrī, is shown here as a young boy dressed in the most humble and rustic of garments, a robe made of braided grass. This image has none of the ornamental splendor of typical Mahayana imagery (nos. 3, 5, 6), even though his hair is luxuriantly long and he holds a scroll, symbol of the wisdom of Mahayana of which he is the embodiment. Instead, the image is restrained and understated in keeping with the sober, ascetic temper of Zen taste. The youth wears an armlet of braided grass; his robe is painted in tawny browns, his hair a dark blue-black.

This form of Mañjuśrī arose from one of the many legends associated with the Chinese mountain sanctuary at Mount Wu-t'ai, the chief center of Mañjuśrī's cult in Asia. In A.D. 1085, a certain Lü Hui-ch'ing, a Northern Sung scholar and official, went to the mountain to seek guidance on matters of Buddhist doctrine. As he was approaching the central terrace, a frightening thunderstorm occurred. In the clouds appeared a young blue dragon, which turned itself into the young man dressed in grass, with his right shoulder bared. When the youth asked why he had come to the mountain, Lü raised some of the issues for which he sought help. The youth, in an answer cherished by Zen Buddhists, replied that the truth of the Buddhas is simple, easy, and clear, but had been obscured by excessive writing and commentary. Lü scolded the youth for his impertinence, whereupon the young man transformed himself into the familiar princely form of Mañjuśrī riding on his golden lion and went back into the skies. Later, Lü had a painting made to represent this miraculous apparition.

The theme of the Nawa Monju proved to be quite popular in Zen circles. A recent study of the theme by Hwi-joon Ahn identified sixteen closely related paintings, both Chinese and Japanese, surviving from the fourteenth and fifteenth centuries A.D. The Powers painting was long attributed to a Yüan period Chinese master, Hsüeh Ch'ien, even though the inscription is by a prominent figure in Kyoto Zen circles, the monk painter and calligrapher, Gugyoku Reisai (1363–1452), who lived and worked at Tōfuku-ji, where the theme seems to have had special appeal. His inscription places the youthful appearance of Mañjuśrī into a series of occasions when he came in different guises:

> When the Buddha Krakucchandha (fourth of the seven Buddhas of the Past) was born in the world, the auspicious one (Mañjuśrī) appeared at the home of a wealthy householder riding upon his golden-haired lion. In the time of Śākyamuni Buddha, he was the son of a blessed Brahman. As a king (as recounted in the Lotus Sutra) seated on a precious lotus flower, he emerged from the bottom of the sea. For an incalculable period of time he had been searching for the dull and foolish, but had been unable to save living beings. Hence he rises, (in this new form) wearing a grass robe, without revealing his entire body. (Signed) The Aged Gugyoku. (Translated by Hwi-joon Ahn)

The appeal of this image-type to Zen Buddhists lay in two directions. Not only did it stress the fact that the mass of traditional religious literature obscures the essential truths of the faith, it also emphasized that even though appearances are deceptive, behind all appearances is a profound unity, a fundamental principle. The bodhisattvas can change their shape at will, but their mission of salvation remains constant; no one form of Mañjuśrī is more sacred than another.

Published: Hwi-joon Ahn, "Paintings of the Nawa Monju: Mañjuśrī Wearing a Robe," *Archives of Asian Art*, 24 (1970–1971): 37–39; John M. Rosenfield and Shūjirō Shimada, *Traditions of Japanese Art: Selections from the Kimiko and John Powers Collection* (Cambridge, MA, 1970), no. 65; Shimada Shūjirō (ed.), *Zaigai Hihō*, vol. 2 (Tokyo, 1969), no. 66; *Kokka*, no. 450 (May 1928); *Shina Meiga Hokan (The Pageant of Chinese Painting)*, vol. 2 (Tokyo, 1936), pl. 408.

References: Tanaka Ichimatsu, *Nihon Kaiga-shi ronshū* (Tokyo, 1966), pp. 289–307; *Kokka*, no. 410 (January 1925); no. 126 (August 1900); *Seizansō Seishō (Illustrated Catalogue of the Nezu Collection)*, vol. 1 (Tokyo, 1929), pl. 48.

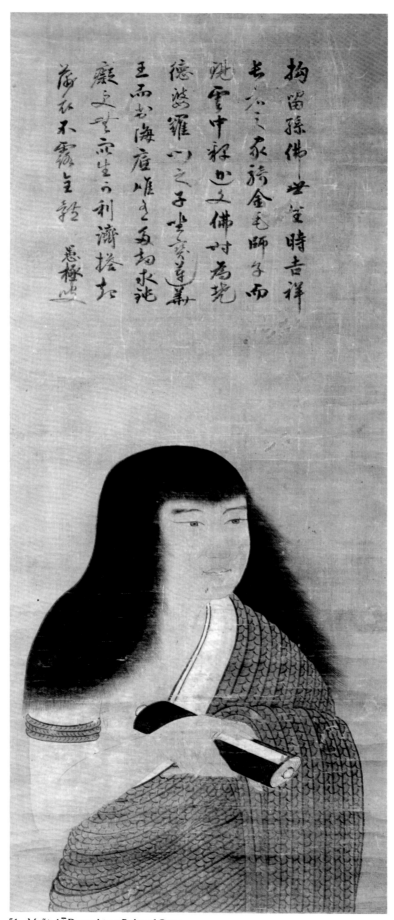

拘留孫佛出世時吉祥
長者之家孫金毛師子而
跳雲中釋此文佛付為號
徳婆羅門之子嘗覺連繋
王而老海庵惟老毎劫永誕
嚴文堂言宗生不利済搭お
蔵衣不露呈話　思極此

51. Mañjuśrī Dressed in a Robe of Grass

174

52. White-Robed Kannon (Pāṇḍaravāsinī Avalokiteśvara; Byaku-e Kannon)

Ca. A.D. 1475–1500
Ink on paper
Hanging scroll; 91.2 × 35.3 cm
Collection of Kimiko and John Powers

The lyrical Kannon of this composition is seated in the pose of royal ease on a craggy rock meant to suggest Mount Potalaka, legendary home of Avalokiteśvara (no. 33). Pools of water executed in stylized wave patterns surround the outcropping, and a cave indicated by the dark overhanging foliage in the background lies behind the figure. Space in the painting is shallow. The boulder upon which Kannon sits is almost two-dimensional. Depth is expressed only by the overlapping rock facets and by the contrast of the patterns of light and dark. Pale and contemplative in quality, this image may well have derived from the tradition of apparition painting (mōryō-ga), the style of softly defined figure painting that arose in Southern Sung China and that caught the imagination of Zen Buddhist painters (no. 55).

The Powers White-Robed Kannon—like Leonardo's paintings of the Madonna of the Rocks, which, coincidentally, were made at about the same time—expresses humanistic and natural values that had entered an ancient tradition of formal iconic imagery. From the twelfth century onward, the White-Robed Kannon had begun to appear in East Asian Buddhist art with increasing frequency; among the intelligentsia of China and Japan, it became the most characteristic single emblem of Buddhist piety, relatively free from association with older values and institutions. But even though the imagery of the White-Robed Kannon flourished greatly in Zen Buddhist circles, it was by no means limited to them, and was but one element in a whole series of conceptions of divine beings in more humanized or familiar guises (no. 51).

The White-Robed form of Kannon emerged gradually, however, from a traditional Buddhist context. Called in Sanskrit the Pāṇḍaravāsinī (literally white-clothed; in the feminine gender), she appears in the Taizō mandala in the sector allotted to Avalokiteśvara (in the lower left corner) in conventional Indian guise: seated in the lotus position, wearing a dhoti, scarf, and lavish crown, and by no means feminine in form. For reasons that are not yet entirely clear, she seems to have caught the imagination of monks and laymen, and emerged as the object of an independent cult.

Japanese iconographic manuals document the emergence of the cult. The Kakuzen-shō of ca. A.D. 1218, for example, describes the celebrated Shingon monk Ninkai (955–1045) performing a Byaku-e ritual to dispel calamities, and notes that the Retired Emperor Shirakawa (1052–1129) was devoted to this deity and had a sixteen-foot image made. In this context, the Kakuzen-shō illustrates the White-Robed Kannon as a standing, feminized figure with a scarf over her head and shoulders; the Besson Zakki also illustrates a tall feminized form with an elaborate scarf drawn over head and arms, standing on lotuses that emerge from the water. In China, an image of the White-Robed Kuan-yin attributed to the great Sung court painter Li Kung-lin (1040–1106), was preserved in a stone engraving in a soft, naturalistic, and also unassuming guise. In this way the deity seems to have entered the stream of Buddhist imagery in both countries, especially in the growing tradition of Zen painting. The great hanging scroll of the White-Robed Kannon by Mu-ch'i (died between 1269 and 1274), now in the collection of the Daitoku-ji in Kyoto, is one of the most eloquent and historically significant works in the entire international tradition of Zen ink painting.

The Powers picture has no seal or signature; in fact, it has none of the box inscriptions or certificates that normally accompany paintings of this kind, and it must be dated purely on stylistic grounds. The figure is posed in a remarkably relaxed manner, almost in a state of lassitude; the drapery appears diaphanous and falls in fluid, harmonic curves; it reveals little of the underlying body. Moreover, the halo has no outline, but is defined only in contrast to the darker ink wash of the background. The hair and face, however, are painted with sharp and precise lines, and the rocks also with "axe-strokes" very much in the style of the early Kanō school. Among the dozens of Japanese ink paintings of the White-Robed Kannon of the Muromachi period that have survived, and hundreds more that are recorded in the connoisseur's sketches of Kanō Tan'yū (1604–1674), no precisely equivalent work has yet been located, but all indications of style point to a date around A.D. 1475–1500 and a location in Kyoto for the artist.

Published: John M. Rosenfield and Shūjirō Shimada, *Traditions of Japanese Art: Selections from the Kimiko and John Powers Collection* (Cambridge, MA, 1970), no. 70.

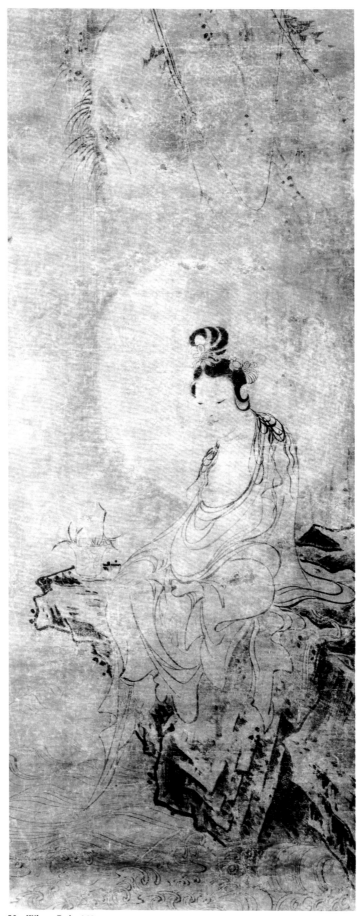

52. White-Robed Kannon

53. White-Robed Kannon (Pāṇḍaravāsinī Avalokiteśvara; Byaku-e Kannon)

Attributed to Kanō Motonobu (A.D. 1476–1559)
Ink, white pigment, and gold on silk
Hanging scroll; 157.5 × 76.5 cm
Museum of Fine Arts, Boston; Fenollosa-Weld Collection

Starkly frontal, the whites of her robes strongly contrasted with the darkened silk and black ink tones of the background, the White-Robed Kannon sits in deep meditation on a rocky crag as waves break against its base. This remarkable painting—one of the most unusual among the many masterworks of Japanese Buddhist art in the Boston Museum—is a successful combination of the values of traditional devotional Buddhist painting and the more naturalistic tenor of Zen-influenced imagery. An eerie sense of a darkened night scene comes from the two halos, like two pale moons, and the silhouettes of vines and bushes before them. The naturalism of the light effects, however, is contradicted by the symmetry, frontality, and flatness of the seated Kannon.

This painting bears the seal of Kanō Motonobu, Japan's leading master of ink painting during his long and fruitful career. He was the eldest son of Kanō Masanobu (1434–1530), founder of the hereditary Kanō family school, which provided Japan with its orthodox academic tradition of painting for over five hundred years. From an important contemporary record, the Onryō-ken Nichiroku (the daily records of the Onryō-ken of the Roku'on-in, a subtemple of the Sōkoku-ji, written by several of its abbots between 1435 and 1493), it appears that Masanobu at first specialized in Buddhist painting and portraiture. In fact, his earliest recorded work, no longer extant, is a painting of Avalokiteśvara and arhats, which Masanobu did for the Unchō-in, another subtemple of Sōkoku-ji in 1463 at the age of about thirty years. Motonobu was the next generation head of the family and presided over its rise to great prestige and prosperity. Since he worked with a large atelier that produced a huge volume of paintings for secular and clerical patrons, the attribution of works in his oeuvre has many points of controversy. There is now a large number of paintings that are executed in the characteristic Motonobu manner, but in which different hands may well be distinguished. Some may have been done in his atelier only under his guidance. In contrast, there is a very limited number of his Buddhist and portrait paintings, the family's main field of special-ization. It would seem less likely that he entrusted these to aides in his atelier. Also, in view of the high quality and firmness of brushwork, the attribution of the Boston Byaku-e Kannon to Motonobu has to be considered seriously.

Most germane to an understanding of the Boston Byaku-e Kannon, however, is a triptych of Śākyamuni, Mañjuśrī, and Samantabhadra in the collection of Daitoku-ji in Kyoto; even though these paintings have no seals or signatures, they have long been attributed to Motonobu's father, Kanō Masanobu. In the image of Śākyamuni in particular, the resemblances to the Boston painting are striking, although in all respects the Daitoku-ji paintings seem to belong to a slightly earlier date or stage of development. Although the two halos around the Buddha's head are identical in proportion and placement to those of Kannon, landforms may be seen inside them. Both deities are seated on grass, but that in the older picture is more delicate and more varied in placement. The main garments in both paintings are established from both rear (urazaishiki) and front, leaving the lines of the garment folds to be painted in dark ink; but those in the Daitoku-ji paintings are slightly more harmonious and balanced in design.

Another version of the Daitoku-ji paintings, done on a single hanging scroll on paper, is in the collection of the Zenrin-ji in Kyoto and bears the signature of Motonobu, Governor of Echizen, sixty-five years of age. Although this painting is somewhat weak in brushwork, it is further evidence of the importance of devotional imagery in the early Kanō school repertoire.

The Boston Byaku-e Kannon emerges from a tradition within East Asian Zen painting that sought to create images of striking iconic power by fusing the values of classical devotional Buddhist painting with those of suiboku-ga. From classic imagery came the use of symmetry and frontality in the depiction of a deity, along with traditional Indian-style ornaments such as lavish jewelry and scarves. From Chinese ink painting came the use of natural settings and muted color schemes dominated by ink tones. In Japan, this mixed mode of Buddhist imagery grew in strength throughout the fourteenth and fifteenth centuries. Its origins can be seen in the famous Bodhidharma in a Red Robe, inscribed about A.D. 1271 by Lan-chi Tao-lung in the Kōgaku-ji (in Yamanashi); it was continued in paintings by artists such as Ryōzen and later Minchō, affiliated with the Tōfuku-ji. One of its most dramatic expressions is the well-known Sesshū painting of the meditating Bodhidharma in profile with his disciple Hui-k'o, dated in accordance with 1498.

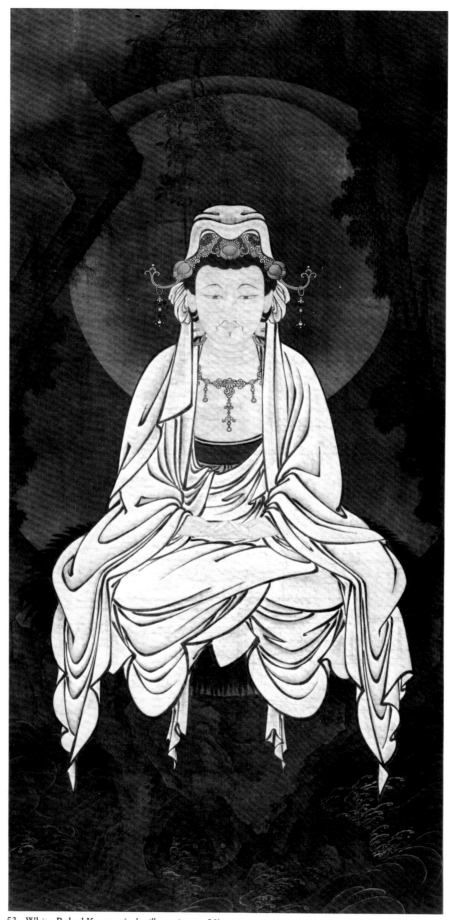

53. White-Robed Kannon *(color illustration, p. 36)*

In order to assess its art-historical place, the Boston painting should be compared with the painting of *Byaku-e Kannon* by Ryōzen (active mid-fourteenth century) with an inscription by the Zen priest Kempō Shidon (1285–1361) in the Myōkō-ji, Aichi prefecture. Despite differences in brushwork, there are compositional similarities. There the bodhisattva is also depicted with the same central frontality in a natural setting of rocks and water and with a large halo. This type stands in contrast to the more relaxed pose of Kannon that was so popular in Zen circles or to the three-quarters view. This early painting of Ryōzen, who seems to have been affiliated with the Tōfuku-ji, apparently belonged to a tradition of which a later example can be seen in a compositionally similar painting by Reisai (active mid-fifteenth century), a pupil or follower of the great Tōfuku-ji monk-painter Kichizan Minchō (1352–1431). The Reisai painting, on paper, has a reduced natural setting (the background has disappeared) and a simplified, slightly informal brushwork that recalls the Kannon in a relaxed pose by Sekkyakushi, another follower of Minchō. The Boston *Byaku-e Kannon* thus followed a tradition of the central, frontal image type that was centuries old at the time it was painted.

The Boston painting was once in the collection of Ernest Fenollosa, and according to a manuscript inventory of the Fenollosa collection recently discovered in the library of the late Akiyama Teruo, Fenollosa saw a copy after this Motonobu painting by Kanō Tan'yū (1602–1674) in the collection of the Kanō family in Tokyo. He rightly treasured the original as one of the greatest paintings in his collection. It was displayed in 1910 in the Boston Museum and published in its *Bulletin* of that year. Later it was published by Anesaki Masaharu, who recognized its evocative power, but it has not been on public display in recent decades. Fortunately it has recently been cleaned and remounted and now resumes a prominent place among the many masterworks of Buddhist as well as Kanō school painting in the Boston Museum.

Published: F.G.C. (Francis G. Curtis), "Exhibition of Japanese Paintings in Rooms 2, 3, and 4," *Museum of Fine Arts Bulletin*, 8 (December 1910); Masaharu Anesaki, *Buddhist Art in Its Relation to Buddhist Ideals* (Boston, 1915), pl. 32.

References: Yamaoka Taizō, *Kanō Masanobu, Motonobu*, Nihon Bijutsu Kaiga Zenshū vol. 7 (Tokyo, 1978), pls. 12–14; *Kokka*, no. 155 (October 1896), pl. 4; Kanazawa Hiroshi, *Kaō, Minchō*, Nihon Bijutsu Kaiga Zenshū vol. 1 (Tokyo, 1977), pls. 24, 30, 31, 33, 39, 46, 52.

54. Portrait of the Chinese Priest Tai Li, or Dokuryū

Dated in accordance with A.D. 1671
By Kita Genki, active ca. 1664–1698
Ink and color on paper
Hanging scroll; 111.5 × 50.2 cm
The Cleveland Museum of Art; Purchase,
 Mr. and Mrs. William H. Marlatt Fund

This portrait of the Chinese priest Tai Li, or Dokuryū, shows a curious intermingling of realistic and non-naturalistic features. The face of the priest—rendered in terms approaching pictorial realism with its wrinkles, pale, flesh-colored skin, and tufts of white-gray hair—is seen at eye level. Moving down the picture plane, the perspective shifts and his lap and his highly abstracted, patternized straw mat are seen from a bird's eye view. The body, even though modeled in light and shade to suggest volume, is still a highly simplified mass; but the portrait was executed with such intensity of observation and haptic clarity of detail that it approaches the modern Western idiom of magic realism.

The painter of this portrait was Kita Genki (active A.D. 1664–1698), a little known master living in Nagasaki at the time when it was virtually the only conduit through which foreign influences could enter Edo period Japan. Genki was influenced both by contemporary styles of Chinese portraiture and by Western models. Known in traditional sources as a Western style painter, he specialized in portraits of local samurai, of the Chinese who lived in Nagasaki, and of priests particularly of the newly established Huang-po, or Ōbaku, branch of Rinzai Zen. Like this painting, many vigorous and unusual Ōbaku portraits are from his brush. Genki presents Dokuryū as a serious, direct man of principle. Blue edging to his gray-black robes and the red of his scepter provide a vivid and welcome bit of color in this otherwise restrained and sober portrait.

The subject of this portrait was a Chinese literatus known as Tai Li or Tai Man-kung, a gentleman-scholar, particularly skilled as a poet, seal carver, calligrapher, and medical expert. He had emigrated to Japan in the year 1653, having been deeply disillusioned by the fall of his native Ming dynasty in 1644 to the foreign Manchus. He arrived in Japan one year before the famous Chinese Ch'an master Yin-yüan (J Ingen, 1592–1673), who founded the Huang-po or Ōbaku sect of Zen Buddhism in Japan. The fifty-eight year old Tai was so impressed by Yin-yüan when he subsequently met him in Japan that he shortly after became his disciple, taking the priestly name of Dokuryū. When this portrait was painted, Dokuryū had been a monk for just less than twenty years. In the original poem he

54. Portrait of the Chinese Priest Tai Li, or Dokuryū

inscribed himself at the top of the painting, he speaks about a moment of personal enlightenment. While meditating, he had experienced a startling, almost extrasensory awareness of transcendent reality:

> Contemplative emptiness: the moon suspended over the village at midnight.
> Suddenly my soul is startled by the howl of an ape.
> Who could know that it would arouse me beyond my senses,
> And bring me an inner vision from Mount Sumeru.
> (Translation from Stephen Addiss, *Obaku: Zen Painting and Calligraphy*)

In China there was no such entity as a Huang-po or Ōbaku sect of Ch'an Buddhism. Huang-po referred to a mountain near Fu-chou in Fukien province, which was so named because of an aromatic shrub growing on its slopes whose leaves turned a striking yellow color every autumn. On top of this mountain was a monastery called the Wan-fu-ssu that had been founded in the seventh century. A ninth-century abbot of the place was given the name of the mountain after his death; the compilation of his writings became an important Zen text and his most famous disciple was Lin-chi (J Rinzai), whose school was transmitted to Japan in the early Kamakura period. In China the teachings of Lin-chi were modified, and by the seventeenth century the school had absorbed Esoteric and Pure Land concepts; Nembutsu practice was encouraged and Amitābha revered. Yin-yüan and the other monks who arrived in Japan considered themselves followers of Lin-chi, but their syncretic creed seemed so foreign to the Japanese Rinzai masters, whose doctrines and rituals had been more or less frozen since the Kamakura period, that the Chinese monks were not welcomed by the Zen community.

In 1658, Yin-yüan was invited to meet the Shogun Ietsuna, and the following year Ietsuna gave permission to the newly constituted Ōbaku sect to build a major temple near Kyoto at Uji. The reigning emperor, who had also met and been impressed by Yin-yüan, donated land for the monastery. The temple was called Manpuku-ji, the Japanese transliteration of the Chinese name Wan-fu-ssu; construction commenced in 1661 and was completed by 1663. Late Ming Chinese style prevailed in the architecture and sculpture of this sanctuary; the Chinese language was used in the daily ritual and practice; and the temple became a center of Chinese learning.

At its height the Ōbaku sect listed about five hundred temples and subtemples scattered over Japan, although from the eighteenth century onward, the school experienced a decline in popularity. Its most significant contribution was not in the doctrinal, but rather in the cultural, sphere. At a time when foreign interaction was restricted to only a slight trickle of Dutch and Chinese traders in and out of Nagasaki, the Ōbaku sect was a gateway to Ming culture and learning. A scholar-poet-calligrapher like Dokuryū, for example, is also considered one of the originators of seal carving in the literati manner in Japan; and Ōbaku priests conveyed much of Chinese literati ideals in their poetry, painting, and above all in their calligraphy, which became renowned across Japan and which was eagerly sought by collectors.

Published: Stephen Addiss, *Obaku: Zen Painting and Calligraphy* (Lawrence, KA, 1978), no. 14; Nagami Tokutarō, *Nagasaki no Bijutsu Shi* (Osaka, 1927); Nishimura Tadashi, *Ōbaku Gazō Shi* (Tokyo, 1934).

References: *Kobe Shiritsu Namban Bijutsukan Zuroku*, vol. 5 (Kobe, 1972), pls. 3, 4; Jan Fontein and Money L. Hickman, *Zen: Painting and Calligraphy* (Boston, 1970), especially no. 68; John M. Rosenfield and Shūjirō Shimada, *Traditions of Japanese Art: Selections from the Kimiko and John Powers Collection* (Cambridge, MA, 1970), no. 100.

55. Pu-tai (Hotei)

Seal of Yamada Dō'an (died ca. A.D. 1573)
Inscription signed Tokei Dōjin (unidentified)
Ink on paper
Hanging scroll; 85.7 × 35.3 cm
The Cleveland Museum of Art; Purchase.
 Mr. and Mrs. William H. Marlatt Fund

Pu-tai (J Hotei) was the punning nickname, meaning either Big Belly or Cloth Bag, given to a semihistorical Chinese figure of the tenth century A.D., an eccentric Ch'an monk named Ch'i-tz'u, who is said to have wandered through the countryside in the region of Ssu-ming (modern Ningpo), going from village to village seeking alms that he placed in a large dark bag, and muttering cryptic, often incomprehensible statements. The common folk came to think that he was an incarnation of Maitreya, Buddha of the Future. Pu-tai became a favored subject both in Chinese and Japanese ink painting and in the work of the Edo period Zenga masters (no. 56). He was also included among the Seven Gods of Good Fortune, the lucky household gods of Japanese popular tradition.

In this painting, the smiling monk grabs his bag in his left hand, right hand pointing at the sky, his walking staff on the ground beside him. Painted in thin washes of gray ink, Pu-tai seems rooted in a timeless space, an enlightened figure who transcends mundane attachments. Over his head is an inscription by an unidentified Buddhist, probably a monk, called Tokei Dōjin:

> Big stomach, gaping garment,
> Treasures gathered deep in the bag's bottom,
> Passing through the sky is another road,
> Do not seek what his fingertip points out.

The admonition not to seek what the finger points out refers to the impossibility of attaining enlightenment or even describing it through rational means alone. The silent gesture of this kind is a recurring metaphor in the Zen tradition. When Śākyamuni selected his disciple Kāśyapa, to whom he would entrust the concepts on which Zen is based, he said nothing but merely turned a flower in his fingers and broke into laughter; Kāśyapa immediately understood. Similarly, a finger pointing at the moon is a mute admonition that ultimate truth can never be logically taught; it can only be hinted at. To be fully realized, it must be experienced intuitively, at first hand. Words or concepts or gestures can point to the proper direction in life; they themselves are not the ultimate goal; the finger is not to be confused with the moon.

The seal of the artist, reading Yamada-shi Dō'an, is found on the bag in the lower right corner of the painting. After thorough research Ann Yonemura has concluded that this artist must be the so-called Dō'an I (of three painters bearing the name Dō'an recorded in traditional painting histories). This first Dō'an may be identified as Yamada Junchi, lord of Yuwakake castle in Yamada, Yamato province. He was a samurai and an official (Lower Junior Fifth Rank) in the Department of Finance (minbu-shō). An energetic patron of Buddhism, he contributed to the restoration of the Great Buddha in Nara and donated a lantern to the Kasuga Shrine. Kanō Einō described Dō'an in his *Honchō Gashi* (1678) as follows:

> Yamada Dō'an. He was initially known as Minbu; his given name is unknown. Dō'an was his Buddhist name (which he assumed) after taking the tonsure. For generations his family have been warriors who lived in Fukuzumi Township, located south of Mount Kasuga, in Yamato province. Some say it is a branch of the Tsutsu'i family. Dō'an was naturally good at painting. He followed Shūbun and Sesshū, and also studied Sung painting and used its ideas. His brushwork, however, is rough and abbreviated. Since then, three generations of the family have been skilled in painting and used the same seal (of Dō'an). However, in brush-strength, there are differences of superiority and inferiority among them. . . . (Translations by Ann Yonemura)

Although the connoisseurship of the works attributed to the three Dō'an is an extremely complex problem, this painting is of outstanding quality and, at the very least, close to the time and context in which the first Dō'an worked. The Dō'an style is purposely restricted in subject matter and technique, and slightly amateurish in quality; the first Dō'an was a samurai and seems to have painted in a highly personal manner

大肚今闊襟

寶聚靈臺深

逼害別甘路

勾同指尖尋

楷溪道人題

55. Pu-tai

anticipating that of the famous warrior Miyamoto Musashi (1584–1645). The reference by Kanō Einō to Dō'an's knowledge of Sung painting is important because this work seems to have been modeled on those of Japanese Zen monk painters of the fourteenth century who had in turn based theirs on Chinese models of the Southern Sung and early Yüan periods. The earliest extant examples of the Pu-tai theme in fact date from the Southern Sung period, and in two specific features this painting reflects its heritage. One is the forward movement made by Hotei as he steps over his stick, recalling a painting of Pu-tai by the Southern Sung master Liang K'ai. Usually Hotei is not shown walking. The second feature is the treatment of the ink used to delineate the figure: the pale ink tones (with only slight, dark detailing) and the light, rapid brushstrokes are features of Southern Sung figure paintings known as mōryō-ga (C wang liang hua) or apparition paintings. In this type of painting attention is focused on facial expressions, especially the brightness of the eyes, which suggests awareness of enlightenment. This focus is achieved by a contrast between the generally pale tones used for the figure and dark ink accents restricted to the eyes and the corners of the mouth. The use of this specific technique suggests that the painter was aware of Southern Sung apparition paintings, studied directly or through copies. It is remarkable that a late Muromachi painter should have captured so well the intense spiritual vision of that earlier age, when a great number of the figure paintings of his own day were rather earthbound in conception.

Published: Ann Yonemura in Yoshiaki Shimizu and Carolyn Wheelwright (eds.), *Japanese Ink Paintings from American Collections* (Princeton, NJ, 1976), pp. 88–93; *Kokka*, no. 924 (August 1970).

References: Jan Fontein and Money L. Hickman, *Zen: Painting and Calligraphy* (Boston, 1970), no. 7; John M. Rosenfield and Shūjirō Shimada, *Traditions of Japanese Art: Selections from the Kimiko and John Powers Collection* (Cambridge, MA, 1970), no. 76.

56. Pu-tai (Hotei) in Seated Meditation

Hakuin Ekaku (A.D. 1686–1769)
Ca. 1765
Ink on paper
Hanging scroll; 97 × 28.5 cm.
Collection of Kurt and Millie Gitter

The distinctive face in this painting of the legendary Pu-tai (see also no. 55) appears not only in Hakuin's paintings of other religious subjects—Kannon, Daruma, Zen patriarchs, and even the household god Daikoku-ten—but also in some idealized self-portraits such as the small one in the Ryōshō-ji in Iida (Nagano prefecture). Because the resemblance of the faces is so strong, Hakuin may well have been seeking to establish an identity between himself and the subjects depicted by giving them a face in which something of his own appearance was present.

The Gitter painting of Pu-tai is a superb example of Hakuin's style in the last years of his life. A soft and searching line defines the contours of Pu-tai's head, body, and his large bag; a dark black fills in between the gray lines of the robe that has slipped down from his shoulders, giving a primary focal point to the composition. This use of solid, unmodulated black seems to be derived from Hakuin's custom of imitating in brush and ink Chinese rubbings taken from inscriptions or from reproductions of paintings engraved on stone monuments. For the Japanese, rubbings were important records of Chinese culture, and Hakuin was not the only eighteenth-century Japanese artist to emulate their dramatic contrasts of black and white. Hakuin employed the strong black in other rubbing-like paintings, especially those of Kannon, which he made in the last years of his life. The Gitter painting can be dated on stylistic grounds and also its very close resemblance to a painting of Pu-tai in the collection of the Eisei Bunko Foundation in Tokyo, dated in accordance with 1766, his eightieth year.

Hakuin's inscription on the Gitter painting, written from left to right, is somewhat ambiguous in meaning, but it is likely that he was referring to the ancient Pu-tai as well as to himself:

> Through a field of reeds,
> Step by step, opening a path,
> The ancient way of the Dharma.
> Oh, this old bonze!

The first word (ashiwara, literally field of reeds) is prominently used in early Japanese histories as a

reference to Japan itself, but it also imparts a nuance of Buddhist meaning: that to be born in this world is to be subject to delusion and desire. The main verb, fumiwakeru, suggests walking and dividing, as through a thicket or a trackless field, implying that the way of the Buddhist Dharma is not clearly marked but is opened up by the monks who understand it. Hakuin, like Pu-tai, was a frequent traveler in the countryside, preaching and demonstrating the faith to villagers, and he must have modeled himself to some degree on Pu-tai's role of the selfless, amiable mendicant.

His historic role involved far more than amiability, however, for Hakuin was one of the outstanding figures in the entire history of Japanese Buddhism. He was also a painter and calligrapher of transcendent ability whose work has only recently been recognized for its artistic worth apart from its value as a record of one of the holiest figures of his age. A member of the Rinzai school of Zen, which had become weak and devitalized by the mid-Edo period, he based his practice and ideas on the Chinese master Hsü-t'ang Chih-yü (1185–1269) and the early Japanese Zen monks Nampō Jōmyō (Daiō Kokushi, 1235–1309) and his successor and the founder of Daitoku-ji, Shūhō Myōchō (Daitō Kokushi, 1282–1338). He was more than a revivalist; he was also an innovator, for he reorganized and systematized the kōan system of provocative questions employed in monastic training. So pervasive was Hakuin's influence that all Rinzai Zen masters today trace their religious lineage back to him.

Born in 1686, in the village of Hara, Suruga district (present-day Shizuoka prefecture) to a commoner family, Hakuin was a physically frail child possessed of a vivid imagination and strong religious inclinations encouraged by his mother. Once, having heard a terrifying sermon on the Eight Hot Hells (no. 48), he feared to enter the bath whose wood flames reminded him of fiery torments. Shortly after this experience, the boy became impressed with the Lotus Sutra and he fervently recited the chant it recommended to gain protection from fire and water.

At the age of fifteen years, Hakuin took his first monastic orders at the Zen temple of Shōin-ji in Hara, where he was given the name Ekaku. In his nineteenth year, he experienced a religious crisis when he read of the tragic murder of the thirteenth-century Chinese Zen master Yen-t'ou in Japan. His ever-lurking despair

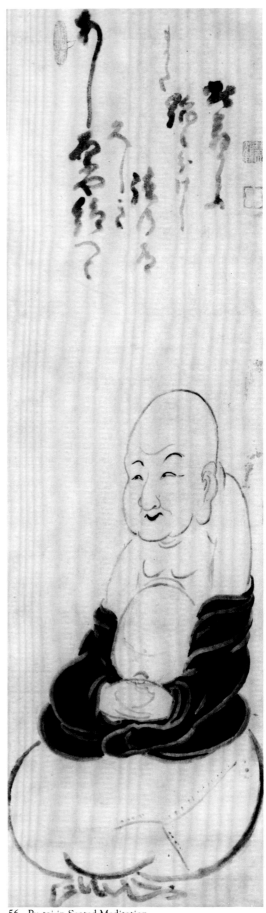

56. Pu-tai in Seated Meditation

and doubt as to the efficacy of religion was aggravated by this experience, and he set out on a study-pilgrimage. He spent some time with the poet Baō at the Zuiun-ji in Mino, where his literary talent was encouraged.

Hakuin continued to visit provincial temples, searching for good teachers and striving for spiritual awakening through disciplined meditation. Finally, at the Eigan-ji in Echigo in the remote northeast, he underwent what he considered a most crucial experience of Buddhist enlightenment; he was then twenty-four years old. In the same year he visited the prominent Zen master Shōju Rōjin (1642–1721) and trained for eight months under his vigorous, even merciless tutelage. After leaving Shōju, Hakuin continued to practice seated Zen meditation with increasing intensity, and underwent a number of ecstatic experiences. He drove himself relentlessly and, overtaxing his strength, suffered a series of nervous breakdowns. After his recovery, Hakuin continued to have religious experiences but the older he became, the more mature these experiences seemed to be. The overwrought ecstacies and jubilation of his youth had subtly developed into more profound and constant states characterized by deep, intuitive insights. Hakuin later described the early experiences in detail in his letters and essays.

In his early thirties, Hakuin returned to his native village, where he became abbot at the Shōin-ji. Although he continued to travel widely throughout Japan during the rest of his life, the Shōin-ji was his main residence, and it was here that Hakuin did most of his writing and painting.

Upper left seal, oval in red with white characters: Ko-kan i, literally, look back, take warning, utter a sigh!—a Zen aphorism from the *Wu-men-kuan* expressing the idea that words are inappropriate for expressing fundamental truths.

Upper right seal, square in red with white characters: Ekaku.

Lower right seal, rounded square with red characters: Hakuin.

Published: Stephen Addiss, *Zenga and Nanga: Selections from the Kurt and Millie Gitter Collection* (New Orleans, 1976), no. 13.

References: Takeuchi Naoji et al., *Hakuin* (Tokyo, 1964), figs. 135–138; Heinrich Dumoulin, *A History of Zen Buddhism* (New York, 1963), pp. 242–268; Philip Yampolsky (trans.), *The Zen Master Hakuin: Selected Writings* (New York, 1971); Osaka City Museum of Art (ed.), *Hakuin Zenji Iboku-shū* (Osaka, 1938), pl. 16.

57. Two Blind Men Crossing a Log Bridge

Hakuin Ekaku (A.D. 1686–1769)
Ca. 1755
Ink on paper
Hanging scroll; 28 × 83 cm
Collection of Kurt and Millie Gitter

The image of blind men feeling their way across a perilous log bridge had great appeal for Hakuin, who painted it a number of times; it expressed dramatically the Buddhist concept of man's frailties and limitations. Here on a sheet of absorbent paper the bridge was executed in a single long stroke of gray ink that began near the right edge as a narrow line, then doubled back on itself to make a bold, irregular horizontal path to the opposite edge. The blind men were painted in intense black inks with a brilliant sense of gesture and given a tiny scale that increases their sense of vulnerability. In the background, suggesting mountaintops, are spidery lines that relate to those of Hakuin's inscription in gray ink, which reads from right to left:

Both man's inner cultivation and the floating world
Are like the round log bridge of the blind men,
Who, wishing to cross, feel their way with their hands.

Underlying the inscription is the Mahayana conception of nonduality; inner discipline and cultivation

57. Two Blind Men Crossing a Log Bridge

(yōjō) as well as immersion in the world of pleasure and daily affairs (ukiyo, a familiar term in Edo period literature and art) will both lead to the other shore (enlightenment), but the route is as perilous as that of the blind men on the makeshift bridge of logs.

Although the theme calls to mind images in Chinese Taoist literature, it may well have evolved from Hakuin's personal experience of a bridge made of three logs joined together crossing the dangerous Kanō river near his temple of Shōin-ji; those who fell from it would be lost in the torrent that flooded the deep chasm. Hakuin depicted the bridge and its setting with much circumstantial detail in a painting now in the Eisei Bunko, showing temple buildings, a waterfall, the nearby ocean, and travelers crossing the log bridge with the same trepidation shown by the figures in the Gitter painting. However, in the Gitter painting and others similar to it, Hakuin took the theme out of a specific geographic context and placed it in a timeless aphoristic setting.

This is one of a large number of themes taken by Hakuin from popular folklore, mythology, or his own imagination that were not part of the established iconography of the Zen tradition—the lucky household gods, for example, or the Chinese god of agriculture Shen-nung, or the haikai poet Bashō. Sometimes humorous or even bawdy, they reflected Hakuin's lifelong concern with the values and viewpoint of villagers and common people. Hakuin's career was spent largely removed from Japan's great urban centers even though he visited the Myōshin-ji, one of Kyoto's largest Zen monasteries, and was well known throughout the nation. He purposely remained aloof from the complex urban life of Edo or Kyoto, but attracted devotees in large numbers to his temple, the Shōin-ji, in Hara on the Tōkai-dō. In 1764, for example, more than seven hundred disciples came to honor him and listen to his sermon, but he continued to direct much of his energy to the well-being of the humble and unlettered. He composed simple poems and devotional songs for them, and in paintings such as this one, he revealed his ability to create images of clear and universal comprehensibility.

Upper right seal, oval white characters on red: Ko-kan i (see no. 56).
Left upper seal, square, red characters on white: Hakuin.
Left lower seal, square, white characters on red: Ekaku no in.

Reference: Takeuchi Naoji et al., *Hakuin* (Tokyo, 1964), figs. 184–185, 194.

58. Bodhidharma (Daruma)

Hakuin Ekaku (A.D. 1686–1769)
Ca. 1765
Ink on paper
Hanging scroll; 107 × 49.5 cm
Private collection

The large face of Bodhidharma, legendary founder of the Ch'an sect in China, is defined in bold, solid strokes of a wide brush. The brownish ink was mixed in an irregular manner and applied with direct, vigorous strokes on paper of low absorbency, resulting in lines that are a blend of physical accidents and human creativity.

The inscription, written from left to right with the same brush and ink as the face, was placed in perfect compositional harmony with the painting, the upper and lower borders of the text forming a diagonal pattern. The text, kenshō jōbutsu, signifies that by looking into his own nature a person attains Buddhahood. This phrase is the closing passage of a longer aphorism, attributed to Bodhidharma himself, from which Hakuin often quoted in his inscriptions on his paintings of Bodhidharma:

Kyōge betsuden	Beyond scriptures a special transmission
Furyū monji	Not founded on words
Jikishi ninshin	Man, pointing directly to his own heart,
Kenshō jōbutsu	Sees his own nature and becomes a Buddha.

This painting, exhibited and published here for the first time, is similar to dozens of other Daruma paintings by Hakuin that bear the same inscription and that have the same order and kind of brush strokes. Yet remarkably they are all different in expression and quality; each one is in fact unique owing to the rough irregularities of the ink and brush and the clarity and freshness of Hakuin's vision. In premodern Japan, paintings of this kind were esteemed more as mementos of a holy teacher than as formal works of art, and certain modern scholars feel that Hakuin's work as an artist was a diversion from the main purposes of Buddhist discipline. Actually, Buddhists had long made use of pictorial imagery in the spread of the doctrine. Leading figures in the history of Japanese Buddhism— from Shōtoku Taishi and Kūkai to Shunjōbō Chōgen, Ikkyū, and Hakuin himself—believed that the visual arts embodied vital aspects of the faith; the arts enlisted their deep concern if not their actual practice.

For Hakuin, it is true that the great majority of his surviving paintings and calligraphies date from the latter part of his life, from 1750 until his death in 1769— well after his formative religious experiences and achievements; but there can be no question of the primal intensity of expression in his work with the brush, or of its incredible volume once Hakuin had attained a basic technical mastery. The very fact that he was not a formally trained artist released him from concern with mere technical virtuosity and allowed him to function as an amateur. Nonetheless, like self-taught artists in the West, his frequent repetition of simple themes, such as the Bodhidharma portraits, allowed him to master formal elements such as placement, proportion, texture, line quality, and modulation of light and dark. His travels throughout Japan brought him into contact with leading artists; his paintings reveal a wide range of experimentation and formal awareness. All of his paintings and calligraphies were intended to convey a religious message to his colleagues, pupils, or laymen at different levels of sophistication; their emotional intensity enhanced their effectiveness as instruments of religious propaganda. The unique depth and fervor of Hakuin's religious vision imbued his pictures and writings with expressive power that has lifted them into the highest levels of artistic achievement.

The message intended by this painting and the dozens of other Hakuin portraits of Bodhidharma is that kenshō, seeing into one's own true nature, is the path to enlightenment. The root of Zen faith is the belief that every man possesses within himself the path to insight, into the Fundamental Principle that can be completely comprehended only through intuition and religious practice. The large and frowning faces of Bodhidharma are an exhortation to adhere to this fundamental principle.

Upper left seal, oval in red with white characters: Ko-kan-i (see no. 56).

Right upper seal, square with white characters: Hakuin.

Right lower seal, square with red characters: Ekaku.

References: Isshū Miura and Ruth Fuller Sasaki, *Zen Dust* (New York, 1960), pp. 41–43, 229–230; Philip Yampolsky (trans.), *The Zen Master Hakuin: Selected Writings* (New York, 1971), pp. 8–9, 27; Takeuchi Naoji et al., *Hakuin* (Tokyo, 1964), figs. 1–4, 310–337, 339.

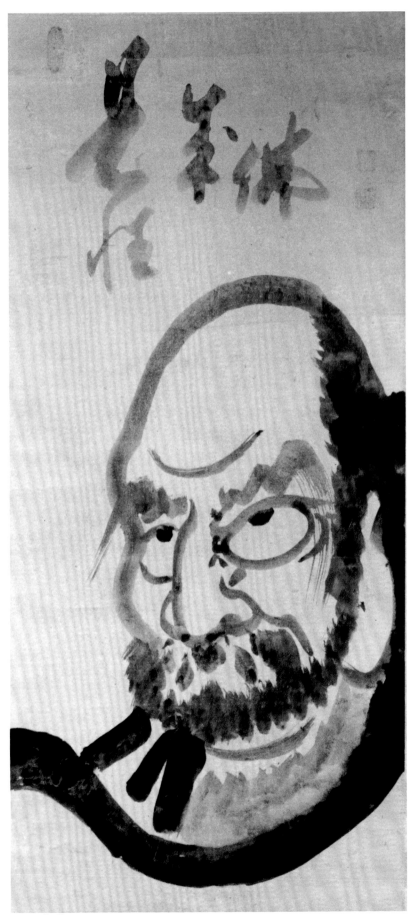

58. Bodhidharma

59. Bodhidharma Seated in Profile

Jiun Onkō (A.D. 1718–1804)
Ink on paper
Hanging scroll; 123.4 × 55.4 cm
Private collection

In the most simplified form possible, Jiun Onkō has illustrated a dramatic episode in the legendary history of the Zen sect, the end of an interview between Bodhidharma and Emperor Wu of the Liang dynasty at Ching-liang (the modern Nanking). Having reached the Liang capital in A.D. 520, Bodhidharma was lavishly welcomed by the emperor, who was famed for his Buddhist piety and generous patronage of monasteries. When the emperor asked how much spiritual merit he had accumulated, Bodhidharma replied "No merit whatsoever." The emperor then asked what was the first principle of the Holy Doctrine. Bodhidharma replied, "Vast emptiness, and nothing holy therein." Puzzled, the emperor could not understand that merit making was useless and that the primary truth of Buddhism was an emptiness that, of itself, had no sanctity, and he asked, "Who is it then that now confronts me?" And the monk replied, "I know not."

In this painting, Bodhidharma's answer is summarized in the two powerful characters written over his head: fu-shiki (not know). The figure is shown in profile seated in meditation, the lines of his head and body executed with decisive speed with a stiff brush that left much white paper showing in a manner akin to the flying white (hihaku-tai) style of calligraphy. Reduced to its absolute minimum of descriptive detail, the image belongs to the tradition of the ippitsu Daruma (one-stroke Bodhidharma) images, which in Japan can be traced as far back as Shōkai Reiken (1315–1396), a monk with strong influence among the Ashikaga military regime who was an amateur painter. Closer in time and spirit to Jiun was the monk-artist Isshi Bunshu (1608–1646), a Zenga painter of the early Edo period who made Daruma images in the same reductionist idiom as did Jiun.

Jiun painted numerous variations of the composition shown here, with the profile figure of Bodhidharma in a hyper-simplified mode. He inscribed fu-shiki on several of them; on others he wrote mu-kōtoku, no merit, which was Bodhidharma's response to the emperor's boasting of his religious benefactions. Others were inscribed sai-rai, come from the west, indicating the monk's origins in India. Others referred to the five schools of Chinese Ch'an Buddhism. The simple figure of Bodhidharma was thus used as a pivot around which a number of ideas could be expressed.

Much more active as a calligrapher than as a painter, Jiun was a master of line quality, ink tonality, and the placement of compositional elements on the page. His work was imbued with great directness and intensity of feeling, as in the rough twisting end of the diagonal down-stroke in shiki, or the dot at the head of the character, which looks like a cannonball hurtling through space. Strictly speaking, he should not be considered a Zen painter because he was an ordained Shingon monk. But, intellectually eclectic in character, he studied and practiced Zen meditation, and his work pulsates with the intuitive power and freshness of the best of Zenga. Both style and content of his calligraphy reflect the powerful influence of Rinzai Zen.

Jiun was born in Naniwa (present-day Osaka), the seventh son of Kōzu Yasunori, a noted scholar of Buddhism, Confucianism, and Shintoism, who passed on these interests to his son. When Jiun was thirteen years of age he began his monastic training in Shingon at the Hōraku-ji in Kawachi (near Osaka), and became abbot of this temple when he was only twenty-two years old. Two years later, he left on a study-pilgrimage and went to Shinano to train under the famous Zen monk Daibai. After three years he returned to Kawachi and took up residence at the Chōei-ji, where he founded a subsect of the Shingon school called the Shōbōritsu (True Doctrine Discipline). This sect, which was a fusion of practice and teaching of the orthodox Shingon Esoteric sect and the earlier Ritsu (Vinaya or Monastic Discipline) sect, reflected Jiun's concerns with the development of intuitive insight in a strongly disciplined context.

For the next twenty years Jiun traveled extensively through western Japan, typical of the deeply religious Buddhist monks who spent most of their lives away from the bustling cities of the Edo period. He gave lec-

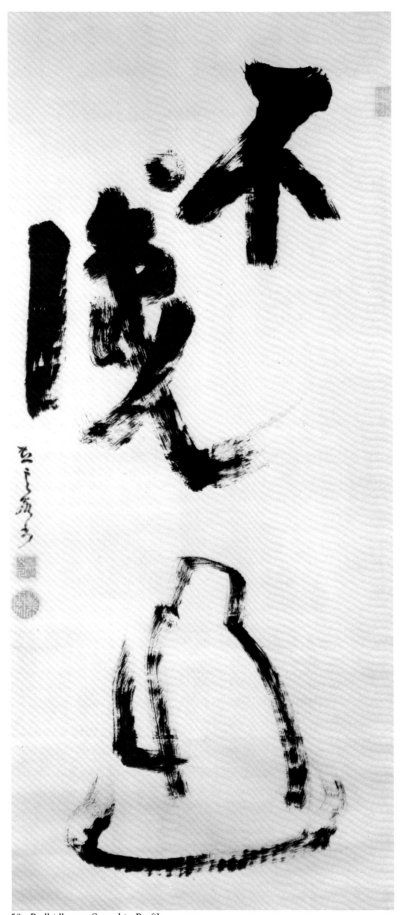

59. Bodhidharma Seated in Profile

tures, continued to study Sanskrit avidly, and began writing what by the end of his life would amount to an enormous literary oeuvre. One work, the *Bongaku Shinryō* in one thousand volumes, would trace the entire history of Sanskrit studies in China and Japan and would attempt to systematize for Japanese the grammatical rules of that language; nothing of this scope had ever been attempted before.

In 1777 Jiun became abbot of the Kōki-ji on Mount Katsuragi in Kawachi, which was decreed the head temple of the Shōbōritsu sect by imperial order. This temple would be Jiun's base for the rest of his life. Long interested in Shinto, Jiun also created at this time the Unden school, an eclectic form of Shinto in which Confucian and Buddhist ideals were combined with elements from the native Japanese religion. He died in Kyoto in 1804 at the great age of eighty-seven years, one of the most honored and revered figures of his generation.

Signature: Jiun keisho. Respectfully written by Jiun.

Right upper seal, rectangular, red on white ground: Zenka no ryū. Literally, flow of the Zen stream; figuratively, the extinguishing by Zen of passion and delusion in the heart as water extinguishes fire.

Left upper seal, rectangular, red on white ground: Katsuragi-sanjin. Literally the man of Mount Katsuragi; figuratively, sanjin implies a reclusive man of letters.

Left lower seal, round, red characters on white ground: Jiun.

Published: Awakawa Yasuichi, *Zen Painting* (Tokyo, 1970), pl. 134; *Bokubi*, no. 25 (1953), p. 31; *Sansai*, no. 112 (1959), p. 60.

References: Kinami Takiuchi, *Jiun no Sho* (Osaka, 1963); Kōzu Myōgon, *Jiun Sonja Ihō* (Kyoto, 1938); *Bokubi*, no. 127 (1963), special issue devoted to Jiun; Jan Fontein and Money L. Hickman, *Zen: Painting and Calligraphy* (Boston, 1970), pl. 43; Kuramitsu Ogu, *Isshi Oshō Iboku-shū* (Tokyo, 1926), pls. 9–12.

GLOSSARY/INDEX

All dates given are those of the Christian era.

ai (J): vegetable dye producing an indigo blue color. [17]

Aizen (J): see Rāgarāja.

Ajantā: Buddhist cave sanctuaries in western India dating from 200 B.C. to A.D. 600. [19, 44]

Amida (J): see Amitābha.

Amitābha (S): Lord of Infinite Light; the most popularly revered of the transhistorical Buddhas, who presides over the Western Paradise (saihō jōdo), where the faithful are born after death. Also called Amitāyus, Infinite Life. [9, 11, 38, 39, 61, 73, 81, 97, 103, 104, 115, 116, 117, 119, 121, 122, 124, 126, 131, 133, 135, 136, 140, 141, 143, 161, 165, 168, 181]

Amoghavajra (S; 705–774): Indian master of Esoteric Buddhism who came to China in 720 with his master Vajrabodhi to engage in missionary and translation projects. [23, 85, 94]

Ānanda (S): the cousin and most learned of the disciples of the Buddha. [44]

arhat (S; J rakan): Buddhist sages who protect and practice the Dharma in the period between the death of Śākyamuni and the coming of Maitreya, Buddha of the Future. [46, 47, 49, 50, 122, 161, 164, 177]

Asaba-shō: iconographic compendium compiled by the monk Jōchō (1205–1282). [90]

Avalokiteśvara (S): Lord Who Looks Down (with Compassion); popular bodhisattva of compassion, who assumes many forms, including Esoteric (thousand-armed, eleven-headed) and Exoteric (chief attendant of Amitābha offering the lotus throne of Paradise). Has earthly dwelling on Mount Potalaka. [38, 39, 70, 74, 82, 84, 92, 99, 101, 106, 117, 119, 122, 124, 126, 135, 141, 161, 164, 175, 177, 179, 184]

Avataṃsaka (S): body of literature and name of a sect prominent in Japan during the Nara period, with its headquarters at the Tōdai-ji. [40, 71, 124, 138, 170]

bakufu (J): government institution of warrior overlords or shoguns, literally, curtain government, in existence from the later twelfth until the mid-nineteenth centuries. [165]

Batō Kannon (J): see Hayagrīva.

bengara (J): red-brown pigment produced from iron oxide; iron oxide red. [17]

Besson Zakki: iconographic compendium compiled by the monk Shinkaku (died 1180). [99, 175]

Bhaiṣajyaguru (S): the medicine Buddha, offering twelve vows to care for the physical and spiritual illnesses of mankind. [9, 37, 38, 73, 92, 112, 114, 157]

Bishamon (J): see Vaiśravaṇa.

Bodhidharma: legendary Indian monk who is said to have transmitted the Ch'an or Zen doctrine from India to China in the sixth century. [164, 166, 177, 184, 188, 190]

bodhisattva (S; J bosatsu): an inherently enlightened being within the hierarchy of Buddhism who postpones his own complete emancipation from the world so that he can save all sentient beings. [9, 17, 21, 38, 39, 40, 46, 52, 54, 57, 59, 61, 64, 66, 68, 70, 73, 76, 92, 97, 101, 103, 104, 119, 124, 126, 131, 157, 173, 179]

Bonten (J): see Brahma.

Brahma (S): Indian deity who entered the Buddhist pantheon as a divine guardian of the faith. Often paired with Indra (S; J Taishakuten); one of the Esoteric Jūni-ten or Twelve Devas who protect Buddhism. [39, 41, 95, 96]

Buddha (S; J hotoke): fully awakened or enlightened being. The Buddha refers to the Indian sage Siddhārtha Gautama (ca. 563–483 B.C.) also known as Śākyamuni, "the sage of the Śākya clan." See also tathāgata. [9, 12, 15, 17, 19, 20, 21, 22, 37, 38, 41, 43, 44, 46, 47, 49, 54, 57, 61, 64, 66, 68, 70, 72, 73, 82, 92, 116, 119, 131, 133, 136, 140, 141, 157, 164, 168, 170, 172, 173, 177, 182]

Byōdō-in: Mid-eleventh century temple converted from villa of Fujiwara no Michinaga; Amida Hall of 1053 survives today with original statues and fragments of wall paintings of paradise and raigō scenes. [103, 117, 166]

Ch'an (C): see Zen.

Chinkai (1091–1151): monk-painter of Daigo-ji. [52]

Chōen (1016–1081): Tendai monk well known for his scholarship of Esoteric Buddhism; wrote Yonjūjōketsu. [90, 92]

Chūson-ji (Hiraizumi, Iwate prefecture): Buddhist sanctuary of northern branch of the Fujiwara clan developed throughout the twelfth century until the fall of the family to Minamoto no Yoritomo in 1189. [61, 63, 64, 66, 68, 79]

cintāmaṇi (S; J nyoi-hōju): fabulous gem held by certain Buddhist deities, for example, Kṣitigarbha, capable of gratifying every wish. [59]

Daigo-ji: Shingon monastery complex southeast of Kyoto, founded in 874. [43, 52, 59, 90, 104, 112, 126]

Dai-itoku Myō-ō (J): see Yamāntaka.

Dainichi Nyorai (J): see Mahāvairocana.

Daitoku-ji: Rinzai Zen monastery compound north of Kyoto, founded in 1319. [163, 166, 175, 177, 185]

Dharma (S): "Law," usually the law or truth of Buddhist doctrine and faith. [12, 20, 22, 38, 41, 44, 46, 70, 84, 96, 101, 116, 124, 184, 185]

dōji (J; S kumāra): youth hoping to become a monk; servant boy of monks and deities; divine child associated with rejuvenation and spiritual power. [126]

Dokuryū (J; C Tai li or Tai Man-kung): seventeenth-century Chinese literatus who emigrated to Japan after the fall of Ming; became an Ōbaku priest there under Yin-yüan. [179, 181]

ebusshi (J): master of Buddhist painting; originally a painter attached to the court who specialized in Buddhist subjects. From the Kamakura period onward, ebusshi were found in the painting ateliers of temples and monasteries, as for example, Kōfuku-ji, Tōji, Daigo-ji, and Kōzan-ji. [52, 135]

eden (J): pictorial biographies of important historical personnages, usually monks. [126, 135, 143, 145]

edokoro (J): official bureau of painting set up by the imperial court and later, the shoguns; can also refer to a painting atelier in a temple. [19, 103]

Eisai (1141–1215): Tendai monk who studied Lin-chi Ch'an (Rinzai Zen) in China and introduced it into Japan in the early Kamakura period. [165]

Eizon (1201–1290): evangelistic monk of Saidai-ji, Nara. [52, 54, 90]

ekotoba (J): literally, picture and word; usually refers to scroll paintings in which text and illustration alternate. [143, 145, 153]

emakimono or emaki (J): illustrated horizontal handscroll, usually with narrative content; particularly popular art form in Japan from the twelfth century onward. [19, 41, 43, 117, 138–156, 161, 163]

Emma-Ō (J): Fifth king of hell; king of the realm of the dead. [155, 157, 161, 163]

Enchin (814–891): Tendai pilgrim-monk to China; fifth abbot of Enryaku-ji. [90]

engi (J): in Buddhist doctrine, dependent origination; refers to the teaching that everything results from certain causes and circumstances, according to the doctrine of karma. Also refers to the legendary origins of a shrine or temple. [117, 126, 138–143, 145–150, 153]

Ennin (794–864): Tendai monk-pilgrim to China; diary available in English translation by E. O. Reischauer. [99, 115]

En no Gyōja: seventh-century mountain recluse and miracle worker; traditionally, the founder of the Shugendō practices. [145, 147, 149, 150]

enpaku (J): white lead; white pigment produced from lead oxide. [17, 149]

Enryaku-ji: headquarters of Japanese Tendai sect, located atop Mount Hiei northeast of Kyoto; founded in 788 by Saichō; burned in 1571 by Oda Nobunaga, but soon rebuilt. [54, 75, 84, 90, 94, 99]

entan (J): crimson red pigment produced from lead oxide; red lead. [17, 47, 82, 84, 121]

eshi (J): master painter; painter of secular subjects. [126, 135]

Esoteric Buddhism: also called tantric or Vajrayana Buddhism (J Mikkyō), developed from fifth century A.D. as part of a complex religiophilosophic movement affecting all Indian creeds. Devotees seek to attain enlightenment by penetrating the three mysteries of body, speech, and mind, represented respectively by mudrā (hand gestures), mantra (spiritually charged syllables), and mandala. Injected into Buddhism new, secret practices. Formally introduced into Japan in the early ninth century by Kūkai and Saichō. [9, 38, 39, 54, 61, 72–75, 76, 85, 90, 94, 103, 106, 110, 115, 116, 117, 149, 168, 181]

Fenollosa, Ernest (1853–1906): pioneer art historian and collector; curator of Asiatic art at the Museum of Fine Arts, Boston. [11, 179]

Five Wisdom Buddhas (J Gochi Nyorai): the five tathāgatas found, for example, in the center of the Taizō mandala, symbolizing the five types of wisdom leading to supreme enlightenment; in their center is Dainichi. [52, 76, 79, 85]

Fudō (J; S Acala): one of the fierce kings of knowledge (J myō-ō); the Immovable One; symbol of steadfastness in the face of passion, egoism, and temptation. [74, 90, 92, 147, 157]

Fugen (J): *see* Samantabhadra.

Fujiwara no Hidehira (died 1187): third generation Fujiwara overlord associated with major patronage projects in northeastern Honshū; notably sutras donated to the Chūson-ji. [63, 64, 66, 68]

Fujiwara no Kiyohira (died 1126): built city of Hiraizumi modeled on the Heian capital; Fujiwara overlord in northeastern part of Honshū; donated illustrated sutras to the Chūson-ji. [63, 66]

Fujiwara no Michinaga (966–1027): preeminent statesman and pious Buddhist devotee; patron of the arts, including temple building and sculpture. [50, 84, 117]

Fujiwara no Motohira (died 1157): second generation Fujiwara overlord associated with Chūson-ji and Hiraizumi building and sutra dedication projects. [63]

gamboge: transparent yellow vegetable pigment; a gum resin produced largely in Southeast Asia. [17]

Genshin (Eshin Sōzu; 942–1017): Tendai monk whose Ōjō Yōshū (Essentials of Rebirth) helped mold the Pure Land tradition in Japan and influenced the forms of Pure Land art. [115–116, 117, 121, 153]

Genshō (1146–1206): master of Buddhist iconography; lived in Jogetsu-in on Mount Kōya. [114]

gindei (J): silver paint produced by mixing silver dust in a sizing solution. [17, 61, 63, 64, 66, 68, 71, 88, 121, 133, 135]

gofun (J): white pigment produced from ground calcium carbonate. [17, 149]

Gohimitsu (J; S Pañca-guhya): The Five Esoteric (or Secret) Ones, symbolizing the Vajrayana doctrine of Mahāsukha, the Great Pleasure, by which human passions are viewed as positive forces leading to enlightenment. [85, 88, 90]

gozan-bunka (J): culture of the gozan, literally, five mountains. Originally the five temples that stood at the top of the hierarchy of the Sung Chinese Ch'an monastery system. The Japanese copied this system, with some variation: five Kamakura and five Kyoto monasteries were designated as gozan. [164]

Gugyoku Reisai (1363–1452); influential Zen monk-painter and calligrapher of Tōfuku-ji. [173]

gunjō (J): ultramarine blue mineral pigment made of powdered lapis lazuli or azurite. [17, 49, 88, 99, 121, 122, 135]

Gupta period (A.D. 320–ca. 600): cultural era named for dynasty of northern India, founded by Candragupta I; a golden age of national unity and prosperity which saw the perfection of a canon of idealized form adopted by Buddhist artists. [17]

Hakuin Ekaku (1686–1769): Edo period Zen monk who revitalized the Rinzai sect; original and inspired master of Zenga. [166, 184, 185, 186, 187, 188]

Hayagrīva (S): the "Horse-Headed" or "Horse-Necked" Avalokiteśvara; Esoteric Buddhist deity also classed as a myō-ō; presides over the realm of animals in the Six Realms of Existence. [74, 82, 84]

hensō-zu (J): transformed configuration; visual renderings of doctrinal themes and legends; strongly narrative in character. [117, 121]

Hinduism: Indian creed claiming fidelity to ancient Vedic tradition; centered on three supreme deities, Brahma, Viṣṇu, and Śiva, as well as a host of other divinities who are their manifestations. [74, 85, 88, 96, 116]

Hōnen (1133–1212): founder of the Pure Land sect (Jōdo-shū) of Japanese Buddhism. [116, 119, 131, 133]

Hōryū-ji: monastery compound southeast of Nara founded in 607 by Prince Shōtoku adjacent to his Ikaruga Villa. [16, 44, 50, 129]

hōsōge (J): floral design probably modeled on the peony used in Buddhist decorative art. [68]

Hotei (J; C Pu-tai): literally, Big Belly or Cloth Bag; punning nickname given to tenth-century Chinese Ch'an monk considered an incarnation of Maitreya. [182, 184, 185]

Hsüan-tsang (ca. 596–664): famous T'ang period Chinese pilgrim to India and translator of Indian Buddhist texts. [15, 19, 50, 94]

Ichiji Kinrin Buccho (J; S Ekākṣara-uṣṇīṣa-cakra): form of Dainichi symbolizing the wisdom and generative power concentrated in his three significant emblems: the seed syllable bhrūṃ; the protuberance on his head (uṣṇīṣa); and the wheel of the Law (cakra). [79, 81]

I-hsing (683–727): Chinese disciple of the Indian missionary Vajrabodhi; brilliant Esoteric Buddhist master and astrologer. [99, 106, 108]

iji-dōzu (J): different time, same illustration; method of pictorial narration by which successive episodes are depicted in a single setting. [136, 149]

Indra (S; J Taishaku-ten): Hindu deity who entered Buddhism as a protective figure; lord of all Vedic gods; often paired with Brahma; one of the Jūni-ten. [39, 41, 96]

Ippen (1239–1289): founder of the Amidist Time (Ji) sect. [116, 117, 143, 145]

ishi-datami (J): checkerboard paving-stone pattern based on stone floors in Chinese palaces; often used for representations of the terraces of Paradise. [52, 135]

Itsukushima Shrine: Shinto sanctuary on an island in Hiroshima Bay adopted by Taira no Kiyomori as tutelary shrine of Taira clan in the twelfth century. [64, 69]

Jingo-ji: Shingon monastery in the hills west of Kyoto founded in the Enryaku era (782–805). [69, 82, 104, 135, 170]

Jin'ō-ji: also called Ko-nō-ji; small temple southwest of Osaka in the foothills of Mount Katsuragi associated with the Shugendō sect. [145, 147, 149, 150]

Jiun Onkō (1718–1804): Shingon monk who created the Unden School, which embraced Confucian and Shinto concepts; celebrated scholar and calligrapher-painter. [166–167, 190, 192]

Jizō (J): see Kṣitigarbha.

Jōchi: late Heian period monk-painter who worked on Mount Kōya; associated with Takuma Tametō. [104, 112, 114]

Jōdo (J; S Sukhāvatī): literally, Pure Land; term used to describe the paradise dwellings of Mahayana Buddhist deities, but especially the Western Paradise of Amida. [121, 133, 135, 136, 140, 141]

Josetsu (died ca. 1428): Zen monk-painter associated with the Kyoto temple of Sōkoku-ji. [166, 170]

jūni shinshō: twelve divine generals; embodiments of twelve vows made by Yakushi to assist mankind. [112, 114]

jūni-ten (J): twelve heavenly beings (devas); used in Esoteric Buddhist ceremony to protect the nation and the ruling house. [82, 95, 96]

jū-ō (J): literally, ten kings; judges presiding over Hell, each of whom pronounces judgment on a specified day after death, from the first week to the third year anniversary. [157, 161, 163]

kakemono (J): vertical, hanging scroll.

Kako-genzai E-inga-kyō: Illustrated Sutra of Cause and Effect; depicts the biography of Śākyamuni; first translated into Chinese by the Indian monk Guṇabhadra (died 468). [41, 43, 50]

Kakurin-ji (Hyōgo prefecture): Tendai temple said by tradition to have been founded by Shōtoku Taishi; later became a center of Amidism. [50, 92]

Kakuzen-shō: iconographic compendium compiled by the monk Kakuzen ca. 1218. [79, 90, 99, 114, 175]

Kammuryōju-kyō (J): Sutra on the Meditation of the Buddha of Infinite Life; holy text of Pure Land Buddhism that is pictorialized in the Taima mandala; contains the teachings of the sixteen contemplations and the nine possible degrees of birth in Amida's Western Paradise. [119, 133]

Kannon (J; C Kuan-yin): see Avalokiteśvara.

Kanō school: hereditary line of painters begun in late fifteenth century by Masanobu; specialists in Chinese-style ink paintings. [103, 166, 175, 177, 179]

Kanō Masanobu (1434–1530): founder of Kanō school as official artists to the Ashikaga shogunate. [177]

Kanō Motonobu (1476–1559): son of Masanobu; leading sixteenth-century ink-painting master. [177]

Kanō Tan'yū (1602–1674): leader of Kanō school in Edo. [161, 163, 175, 179]

karma or **karman** (S; J gō): the continuing process of action and reaction, cause and effect, whereby thoughts and deeds in the past or in a previous life affect the present, and present thoughts and deeds affect the future. [21, 43, 72, 101]

Kasuga Shrine: Shinto sanctuary of tutelary deities of Fujiwara family; from eighth century, located adjacent to and closely affiliated with the Buddhist monastery of Kōfuku-ji, Nara. [126, 127, 129, 182]

Kegon (J): *see* Avataṃsaka.

Kenchō-ji: Rinzai Zen monastery founded in Kamakura in 1253 by Hōjō Tokiyori. [47, 54, 165, 166]

kindei (J): gold paint produced by mixing gold dust in a sizing solution. [17, 44, 46, 47, 52, 54, 57, 59, 61, 63, 64, 66, 68, 69, 70, 71, 76, 82, 88, 92, 97, 119, 121, 124, 127, 129, 131, 133, 135, 136, 138, 140, 141, 143, 145, 147, 149, 157, 177]

kirikane (J): literally, cut gold; thin sheets of gold leaf cut into geometric or floral decorative designs and applied to painting, lacquer, and sculpture; widely used in Japan from the late tenth century onward. [17, 18, 52, 54, 59, 76, 79, 82, 85, 88, 92, 119, 121, 122, 124, 126, 131, 133, 135, 136]

Kita Genki (active ca. 1664–1698): painter in Nagasaki deemed "Western-style"; specialized in portraits of warlords and priests and the Chinese who lived in Nagasaki. [179]

Kitano Tenjin Shrine: also Kitano Tenmangū; Shinto shrine on the northern edge of Kyoto built to placate the angry spirit of Sugawara no Michizane. [154, 156]

kōan (J): literally, announcement issued by the government; also refers to the enigmatic propositions posed by Zen teachers to test the understanding of disciples; commonly used in Rinzai Zen monastic training. [185]

Kōfuku-ji: Japanese headquarters of Hōssō sect; moved to Nara in 710 as tutelary temple of Fujiwara family; affiliated with the Shinto Kasuga Shrine. [40, 43, 52, 114, 126, 127, 129]

Kōmyō (701–760): wife of Emperor Shōmu and primary donor of the great Shōsō-in Collection. [43, 68]

Kongō-kai Mandara (J): *see* Taizō Mandara.

Kōnin: eighth-century Korean monk from Paekche associated with the Jin'ō-ji near Osaka. [147, 149, 150]

Konkaikōmyō-ji: Pure Land sect temple northeast of Kyoto, founded in 1175 by Hōnen. [121, 124, 131]

Kōzan-ji: Shingon temple on Mount Togano-o west of Kyoto adjacent to Jingo-ji; originally part of Jingo-ji until it became independent under Myōe Shōnin. [112, 170]

Kṣitigarbha (S): bodhisattva usually shown in guise of a monk, with shaven head, carrying a staff and a wish-granting jewel; revered as the savior of women in childbirth, children, warriors, travelers, and beings in Hell. [39, 59, 61, 117, 157]

Kūkai; Kōbō Daishi (774–835): extraordinary religious thinker, calligrapher, patron of the arts; introduced Esoteric Buddhism into Japan; founder of the Shingon sect. [22, 74, 75, 79, 94, 99, 147, 149, 150, 188]

Kumano Shrine: group of three Shinto sanctuaries along the southern coast of the Kii peninsula, Wakayama prefecture. [126, 129, 143]

Kūya Shōnin (903–972): Tendai monk who popularized Amida pietism among the common folk by teaching the Odori (dancing) Nembutsu. [116, 121, 143, 145]

Liang-k'ai (active ca. 1201–1210): Southern Sung academic painter with strong Ch'an affiliations; his work greatly influenced the development of ink painting in Japan. [165, 168, 170, 172, 184]

Lin-chi: *see* Rinzai Zen.

Lotus Sutra (S Saddharma-puṇḍarīka-sūtra; J Myōhō Renge-kyō or Hoke-kyō): early and vividly descriptive Indian Mahayana sutra; main text of the Tendai sect in China and Japan; important for its teaching of the One Vehicle (Ekayāna) under which are subsumed the usual Hinayana and Mahayana divisions. [16, 19, 37, 39, 47, 57, 59, 61, 63, 68, 69, 70, 71, 147, 173, 185]

Lu Hsin-chung (thirteenth century): Chinese painter of Buddhist themes, particulary of the Ten Kings and the arhats, thought to have lived and worked in the Ningpo area. [161, 163]

Mahāparinirvāṇa-sūtra (S): Mahayana text claimed to be the last sermon of the Buddha, preserved in Chinese versions alone. [44]

Mahāvairocana (S): central figure of the Esoteric Buddhist pantheon. [41, 47, 72, 73, 74, 75, 76, 79–81, 82, 85, 88, 104, 124, 182]

Maitreya (S): bodhisattva and Buddha of the Future; now living in the Tuṣita heaven, awaiting time for rebirth on earth. [9, 38, 46, 61, 92, 117, 149, 161, 182]

mandala (S maṇḍala, meaning circle; J mandara): formal geometric representations showing deities or the relationships among deities; may also depict the abodes of deities, usually Buddhist but also Shinto, in Paradise and in sanctuaries on earth. [73, 74, 75, 76, 79, 88, 90, 92, 94, 96, 101, 103, 104, 117, 119, 121, 127, 129]

Mañjuśrī (S): bodhisattva embodying the wisdom and insight of the Buddha. With Samantabhadra, the chief attendant of Śākyamuni; often rides a lion and has five tufts of hair (Gokei Monju) symbolizing the five types of knowledge inherent in the Five Wisdom Buddhas. [39, 46, 47, 49, 52, 54, 57, 61, 70, 92, 97, 126, 157, 164, 173, 177]

Manpuku-ji: headquarters of the Japanese Ōbaku (Huang-po) sect of Zen; located in Uji south of Kyoto; founded in 1665 by the Chinese monk Yin-yüan (J Ingen). [181]

mantra (S): mystically charged syllable, syllables, or phrase, recited to achieve identification with divinity; one of the Three Mysteries of Esoteric Buddhism. [52, 73, 74, 75, 81, 84, 94, 101, 103, 106]

mappō (J): the end of the Law; the third and final stage in the devolution of the Buddhist faith from the first phase in which the Law was understood and practiced perfectly; period of strife, vice, and degeneration believed to have begun in 1052. [59, 116]

Mikkyō (J): see Esoteric Buddhism.

Minchō, or Kichizan Minchō (1352–1431): Zen monk-painter of Tōfuku-ji. [44, 166, 177, 179]

Miroku (J): see Maitreya.

Monju (J): see Mañjuśrī.

Monkan Sōjō (1278–1357): influential monk with Tendai and Shingon affiliations active in the circle of Emperor Go-daigo. [54]

monogatari-e (J): picture (e) telling a story (monogatari). [18, 19]

moriage (J): relief-like application of pigment, often gold, prominent in formal Buddhist painting from the fourteenth century onward. [90, 121]

Mount Hiei: mountain with numerous monastery and shrine buildings northeast of Kyoto; center of the Tendai sect; chief temple is the Enryaku-ji. [75, 84, 94, 115, 129]

Mount Kōya: rugged mountain 985 meters high in the center of Wakayama prefecture; seat of the Kongōbu-ji, headquarters of the Shingon sect. [44, 54, 59, 63, 75, 79, 81, 84, 92, 99, 103, 104, 114, 124]

Mount Wu-t'ai (C; Five Terrace Mountain): mountain with monastery complex in Shansi province sacred to the cult of Mañjuśrī; 3,040 meters above sea level. [39, 52, 173]

Mu-ch'i (died between 1269 and 1274): Southern Sung Ch'an monk-painter greatly admired by the Japanese and an important influence in the development of the Japanese ink painting tradition. [175]

mudrā (S; J in): gesture or sign made with the hands signifying the vows or enlightenment or practice of a Buddha, bodhisattva, or other divinity. [22, 73, 79, 84, 96, 101, 122, 126, 131, 135]

Myōe Shōnin; also Kōben (1173–1232): abbot of Kōzan-ji; master of Kegon doctrines and great patron of the arts. [81, 170]

myō-ō (J; S vidyārāja): fierce deities of bodhisattva rank prominent in Esoteric Buddhism; the manifestation of the Five Wisdom Buddhas' wrath against evil. [74, 84, 88, 90, 95, 97]

Nembutsu (J): originally, meditational recollection of the Buddha (S Buddhānusmrti), but with development of Chinese Pure Land Buddhism, came to mean also invoking the name of the Buddha. In Japan generally used to indicate the six-character prayer formula Namu Amida Butsu (Homage to Amida the Buddha). One variation is the Odori Nembutsu—the Nembutsu sung and danced to a popular melody; the Betsuji Nembutsu is recited by different people in turn so that the recitation never stops. [115, 116, 121, 122, 131, 133, 138, 140, 141, 143, 145, 181]

niga byaku-dō (J): literally, the two rivers and the white path; parable taught by Shan-tao that inspired paintings of the theme. [117, 133–135, 136]

Ninkai (955–1045): Shingon monk responsible for major religious enterprises and construction projects in the eleventh century. [88, 175]

Ninna-ji: Shingon temple on the western edge of Kyoto, founded in 888 at the order of Emperor Kōkō. [52, 104]

Ninshō (1217–1303): evangelistic monk of Saidai-ji. [52, 54]

nirvana (S nirvāṇa; J nehan, or satori): final liberation from earthly existence; supreme attainment of all Buddhists. [20, 21, 38, 44, 46, 49, 59, 70, 81, 85, 99, 164]

Nison-in: Tendai sanctuary in the Saga district west of Kyoto, founded in the early ninth century by Ennin at the order of the Saga emperor. [47, 131, 161]

Oda Nobunaga (1534–1582): powerful military leader who supplanted the shogunal regime of Ashikaga family; destroyed the Tendai sanctuary of Enryaku-ji in 1571. [84, 121]

ōdo (J): yellow ochre; pigment made from native earth colored with hydrated iron oxide. [17]

ōjō (J): birth in Paradise; kubon ōjō are the nine possible degrees of birth in Amida's Western Paradise as promised in the Kammuryōju-kyō. [119, 122, 136, 141]

Potalaka (S; J Fudarakusen): island-mountain paradise of the Bodhisattva Kannon, traditionally said to be located somewhere in the sea south of India, but also identified with certain sites in China and Japan. [117, 122, 124–126, 175]

prajñā-pāramitā (S; J hannya haramitsu): the perfection of wisdom, the sixth and most exalted perfection to achieve on the path toward full enlightenment; involves the ability to understand the characteristics of all phenomena, their mutual relations, the conditions that generate their appearance and disappearance, and finally the ultimate unreality or emptiness (śūnyatā) of their individual existences. A vast body of literature is devoted to these concepts. [40, 52, 59, 61–63, 64, 66, 68–69, 85, 147]

Pure Land Buddhism: religious tradition encouraging reliance on the Buddha Amitābha to obtain salvation in his Western Paradise; see also Amitābha; Jōdo. [9, 20, 38, 59, 75, 104, 115–118, 119, 131, 133, 138, 143, 181]

Pu-tai: see Hotei.

Rāgarāja (S): literally, King of Passion; Esoteric Buddhist deity; one of the myō-ō; symbolizes the identity of human passions and illusions with enlightenment. [74, 85, 88, 90, 92]

raigō (J): the descent of deities, usually Amida and his retinue, but also others, to welcome and escort back to Paradise a devotee who has just died; promised in Amida's nineteenth vow in the Muryōju-kyō (Sutra of the Teaching of Infinite Life; in Sanskrit, the Larger Sukhāvatıvyūha). [59, 84, 117, 119, 122–124, 126, 135, 141]

Rinzai Zen: Zen tradition deriving from the Chinese master Lin-chi (J Rinzai); introduced into Japan, traditionally by Eisai in 1191, to become the dominant Zen sect of the ensuing centuries. [165, 179, 181, 185, 190]

rokudō (J; S gati): the six realms of birth to which one is fated until enlightenment and release from the wheel of birth and death are achieved: (1) heavenly beings (J ten; S deva); (2) human beings (J nin, S manuṣya); (3) beasts (J chikushō, S tiryagyoni); (4) bellicose demons (J ashura, S asura); (5) hungry ghosts (J gaki, S preta); (6) hell (J jigoku, S naraka). [59, 70, 84, 116, 117, 135, 153, 155]

rokushō (J): green pigment made of powdered malachite. [17, 47, 82, 88, 95]

Ryōgai Mandara (J): *see* Taizō Mandara.

Ryōnin (1073–1132): Tendai monk who founded the first Japanese Amidist sect, the Yūzū Nembutsu. [116, 138, 140, 141, 143]

Saichō; also Dengyō Daishi (767–822): founder of the Tendai sect in Japan; along with Kūkai, pioneer Japanese teacher of Esoterism; studied in China 804–805. [75]

Saidai-ji: headquarters of combined Shingon and Ritsu sects, founded on the west edge of Nara in 765 at the order of the Empress Shōtoku. [52, 54, 90, 126, 129]

Śākyamuni: *see* Buddha.

Samantabhadra (S): bodhisattva of Universal Virtue, manifestation of the active, practice-oriented aspect of Śākyamuni's teaching—the Buddha's meditation and ministry. One of the two chief attendants of Śākyamuni (with Mañjuśrī); also seen as the guardian of the Lotus Sutra and its devotees; often rides a white elephant. [39, 46, 47, 49, 54, 57, 59, 61, 70, 90, 117, 161, 164, 177]

Saṃgha (S): the Buddhist community of monks and their lay supporters. [12]

Seishi or Daiseishi (J; S Mahāsthāmaprāpta): with Kannon, one of the two main attendants of Amida; usually recognizable by the water jar in his crown. [119, 122, 124, 135, 141]

sekiō (J): orpiment; yellow pigment produced from arsenic sulphide. [17]

Sesshū Tōyō (1420–1506): Preeminent suiboku painter of his day; Zen monk who studied with Shūbun in Kyoto; traveled to Ming China in 1468. [166, 177, 182]

shakujō (J; S khakkhara): the staff of a Buddhist monk with metal rings at the top that jangle to announce his approach. [59, 84]

Shan-tao (C; J Zendō; 613–681): the third patriarch of the Pure Land tradition in China whom Hōnen considered an incarnation of Amida and whose writings he accepted as scripture. [116, 131, 133, 135]

shimbutsu-shūgō (J): fusion of Buddhist deities and Shinto gods in which Buddhist deities are seen as the original forms (honji) and the Shinto gods as their manifestations (suijaku). [127, 129]

Shingi Shingon sect: subsect of Shingon; twelfth-century syncretic combination of Amidism with Esoteric Buddhism; headquarters at Negoro-dera. [104]

Shingon (J): sect of Esoteric Buddhism introduced into Japan by Kūkai, with headquarters on Mount Kōya in Wakayama prefecture. [54, 75, 79, 88, 104, 116, 147, 175, 190]

Shinran (1173–1262): disciple of Hōnen; founder of the Jōdo Shin-shū or True Pure Land Sect. [116]

Shinto (J): indigenous religion of Japan in which deified ancestors, heroes, and the personified powers of nature are worshiped. [37, 39, 68, 73, 90, 117, 127, 129, 140, 147,192]

shita-e (J): underdrawing; preliminary drawing, usually by a master artist. Assistants may fill in colors according to plan later. [18]

shitennō (J): four deva kings; ancient Indian deities guarding the four cardinal points of the compass. Depicted in early Buddhist art as protectors of Śākyamuni, their role as guardians became more prominent in China and Japan. [39, 96]

Shitennō-ji: temple built in 595 by Prince Shōtoku in gratitude for his success against anti-Buddhist forces; in Settsu province, modern Osaka. [39, 68]

Shōju Raigō-ji: Tendai temple at Sakamoto, near Otsu city, Shiga prefecture; converted into Pure Land sanctuary by Genshin in 1010. [161]

Shōmu (701–756): forty-fifth emperor of Japan; pious Buddhist; builder of Tōdai-ji and the Nara Daibutsu; inaugurated era of vast state support of Buddhist institutions. [68]

Shōren-in: subtemple of Enryaku-ji located in the eastern suburbs of Kyoto. [90, 112]

Shōsō-in: wooden storehouse for temple treasures of Tōdai-ji, Nara, donated largely by Empress Kōmyō after the death of Emperor Shōmu in 756. [43, 61, 68]

Shōtoku Taishi (574–622): prince regent of Japan who was the greatest single patron of Buddhism in its early phase; author of Constitution in Seventeen Clauses. [9, 39, 188]

shu (J): intense orange-red pigment produced from cinnabar. [17, 82, 84, 90]

Shugendo: Japanese tradition of wandering mountain-climbing ascetics, with Shingon and Tendai affiliations and with some Shinto elements; adherents are called yamabushi, those who sleep in the mountains. [149]

shūji (J; S bīja): seed syllable; usually a Sanskrit character symbolizing a particular Esoteric Buddhist deity; each syllable is considered to be imbued with the essence of the force of the deity itself. *See* mantra. [103]

Shunjōbō Chōgen (1121–1206): monk of Tōdai-ji; led rebuilding of monastery; traveled to China. [131, 168, 188]

Śiva (S): one of the three supreme deities of the Hindu pantheon. [74, 96]

Six Realms of Existence: *see* rokudō.

sōgon (J; S alaṃkāra or vyūha): concept suggesting that artistic beauty and ornamentation are outward manifestations of the inner truths of the Buddhist faith. [16]

sonzō (J): object, usually a statue or a painting, of devotion, veneration, or worship. [18, 19]

Śubhākarasiṃha (637–735): Indian Esoteric Buddhist master who emigrated to China in 716. Translated many important texts. [110]

Sugawara no Michizane (845–903): Heian period courtier who was falsely slandered and exiled; after his death, he was worshiped as a Shinto deity, Kitano Tenjin, patron of literature and music and persons falsely accused. [154, 155, 156]

suiboku-ga (J): painting in ink on paper or silk. [165, 166]

śūnyatā (S): translated as emptiness or the void, a fundamental Mahayana Buddhist concept. [40, 64]

sutra (S sūtra; J kyō): sacred Buddhist scripture, purported to be the words of the Buddha, although none dates back to the time of the Buddha. [22, 38, 61, 63, 64, 66, 68, 70, 71, 72, 88, 96, 124, 147, 153, 157]

Taima-dera: combined Shingon-Pure Land temple in Nara prefecture founded in 612 by Prince Maroko, son of Shōtoku Taishi; location of the original Taima Mandara, an eighth-century tapestry weaving imported from T'ang China. [119, 121]

Taima Mandara: the most complex image in Pure Land painting, focusing on the Western Paradise of Amida in the center of the composition with narrative elements from the Kammuryōju-kyō in the outer courts; ought properly to be called a hensō-zu because of its strongly narrative character. [117, 119, 121, 135]

Taira no Kiyomori (1118–1181): head of Taira clan of warriors; supplanted Fujiwara family as head of civil administration and de facto ruler of Japan. [69, 81]

Taizō Mandara: mandala of the Matrix or Womb World (of Great Compassion). One of a pair of mandalas that together represent the entirety of the Buddhist cosmos, according to some schools of Esoteric Buddhism. Oriented to the potential, innate, undisclosed aspect of the universe, roughly equivalent to the Platonic noumenon. Its counterpart is the Kongō-kai Mandara, oriented to the active, dynamic aspect of the universe or the Platonic phenomenon. Together, called the Ryōgai Mandara (mandala of the Two Worlds). [74, 76, 79, 96, 99, 101, 103, 104, 124, 175]

Takuma: hereditary school of Buddhist painters from late Heian into Muromachi periods. [44, 96, 103, 117, 129]

Takuma Tametō: mid-twelfth century Japanese Buddhist painter. [101, 103, 104, 114]

tan (J): *see* entan.

tantrism: *see* Esoteric Buddhism.

tathāgata (S; J nyorai): an Enlightened ("Thus Gone") Buddha, fully identified with Ultimate Reality and Truth (tathatā); epithet of the Buddha. [38, 41, 46, 73, 74, 79, 97]

ten kings: *see* jū-ō.

Tendai (J): eclectic sect of Buddhism of Chinese origin that absorbed much Esoteric doctrine and ritual; introduced into Japan by Saichō (767–822), with its center at Enryaku-ji on Mount Hiei; the matrix out of which Pure Land and Zen thinkers and leaders eventually emerged. [54, 57, 75, 76, 79, 84, 88, 90, 94, 97, 115, 116, 131, 138, 143, 165]

tessen (J): literally, iron wire line; thin, firm, usually red lines traditionally used to outline the bodies of Buddhist deities in paintings. [17, 122, 135]

Three Jewels (S tri-ratna; J sambō): three fundamental aspects of Buddhism—the Buddha, the Dharma or Buddhist Law, and the Saṃgha or the Buddhist community. [12, 37]

T'ien-t'ai (C): *see* Tendai.

Tōdai-ji: vast temple of Kegon sect in Nara, founded in mid-eighth century by Emperor Shōmu as headquarters of nation-wide system of official monasteries; site of great bronze image of Vairocana, the Nara Daibutsu. [40, 41, 47, 61, 75, 126, 168]

Tōfuku-ji: Rinzai Zen monastery southeast of Kyoto, founded in 1236 by Fujiwara Michiie and the monk Ben'en. [44, 165, 166, 173, 177, 179]

Tōji: Buddhist sanctuary built inside southern gate to Kyoto in 796; in 823 entrusted to Kūkai, who made it a major center of Shingon training and ritual. [54, 75, 82, 95, 96, 99, 104, 112]

tri-kāya (S): Three Bodies of the Buddha: the Body of Transformation (nirmāna-kāya) is the form in which the Buddha appeared on earth to preach; the Body of Bliss (saṃbhoga-kāya) is the visionary form in which Buddhas appear in paradisiacal settings; the Body of the Law (dharma-kāya) is the timeless, absolute truth equivalent to the ultimate, generative principle of reality. [40, 73]

Tun-huang: important Chinese political, military, and commercial center in northwest Kansu province, at the eastern end of the Silk Route, during the first millennium; site of the Thousand Buddha caves, a magnificent repository of fifth- to thirteenth-century Buddhist painting and sculpture. [16, 17, 19, 43, 44, 94, 108, 117, 119]

urazaishiki (J): painting from the back of the silk, used to reinforce and strengthen the image or to create a muted tonal effect. Urahaku is gold or silver leaf applied from

the back of the silk, creating a shimmering, other-worldly impression. [*18, 47, 82, 88, 92, 121, 177*]

ūrṇā (S; J byakugō): white curl between the eyebrows; one of the thirty-two major signs of a Buddha, but also seen on the foreheads of other deities. [*70, 168*]

uṣnīṣa (S): The protuberance on top of the Buddha's head symbolizing his transcendent knowledge; one of the thirty-two major signs of the Buddha. [*81, 168*]

Vaiśravaṇa (S): chief of the four guardian (deva) kings (shitennō); divine guardian of the north; also known as Kubera in Sanskrit, he originated as an ancient Indian folk deity, lord of wealth, and regent of the northern quadrant. [*39, 71, 92, 94, 95, 96, 140*]

vajra (S; J kongō): thunderbolt; Indo-Aryan symbol to suggest the diamond-like, indestructible character of ultimate truth; a ritual implement in Esoteric Buddhism. [*72, 79, 85, 88, 147*]

Vajrabodhi (S): Indian Esoteric Buddhist master who arrived in China in 720 to carry out missionary and translation activities; considered the fifth patriarch of the Shingon sect. [*88, 99*]

Vajrayana: *see* Esoteric Buddhism.

Viṣṇu (S): One of the three supreme deities of the Hindu pantheon. [*74, 84*]

Wu-chun Shih-fan (1177–1249): preeminent Ch'an prelate and teacher in Hangchou region; among his students were Japanese monks such as Ben'en and several Chinese Ch'an masters who came to Japan. [*165*]

Yakushi (J): *see* Bhaiṣajyaguru.

Yakushi-ji: major temple of the Hōssō sect, built first in Asuka district in 681 and moved to Nara around 710. [*129, 136*]

Yamada Dō'an (died ca. 1573): first of three painters called Dō'an. Yamada Junchi, lord of Yuwakake Castle in Yamada, Yamato province; energetic patron of Buddhism. [*182, 184*]

Yamāntaka (S): deity symbolic of the conquest of death by Buddhist enlightenment; usually rides a bull; one of the myō-ō. [*92, 97, 99*]

Yama Rāja (S): *see* Emma-Ō.

yamato-e (J): Japanese-style painting, often done in color, depicting Japanese scenes and concerns. [*156, 157*]

Yin-yüan (C; J Ingen; 1592–1673): Chinese refugee monk who established the Ōbaku (Huang-po) sect of Zen Buddhism in Japan, with its headquarters at Manpuku-ji. [*179*]

Yūen: fourteenth-century monk-painter; an inscribed and dated (1384) painting of Jizō by Yūen is preserved on Mount Kōya. [*44, 59*]

Yūzū Nembutsu: first Japanese Amidist sect, founded by Ryōnin (1073–1132), characterized by a collective and social approach to practice; belief that merit resulting from one person's recitation of the Nembutsu can be transferred (yūzū) to others. [*116, 138, 140, 141, 143*]

Zen (S dhyāna; C Ch'an): major form of Buddhism that arose in China and that achieved prominence in Japan during the thirteenth century; stressed self-discipline through meditation and appealed especially to the warrior class; eschewed the elaborate ritualism of Esoterism and the salvation doctrines of the Pure Land creeds. [*9, 20, 38, 46, 47, 50, 75, 164–167, 168, 170, 173, 175, 177, 179, 181, 182, 184, 185, 186, 187, 188, 190*]

Zenga (J): literally, Zen painting, simplified form of ink painting, often teasing and light-hearted, on Zen themes or done by Zen masters in the Edo period; term of modern vintage. [*166, 167, 182, 190*]

Zenrin-ji: Pure Land sect temple in the eastern suburbs of Kyoto, begun in 855 as a Shingon sanctuary and converted into an Amidist center by Eikan (1032–1111); includes the subtemple Eikan-dō. [*124, 161, 177*]

zuzō: literally, drawing image, applied to wide range of Buddhist drawings, often called iconographic drawing; normally done on paper, uncolored or lightly colored, not intended as formal objects of worship. [*90, 92, 99–114, 153, 161, 163, 170*]

BIBLIOGRAPHY
Major sources in Western languages

Addiss, Stephen. *Zenga and Nanga: Selections from the Kurt and Millie Gitter Collection.* New Orleans, 1976.

Addiss, Stephen. *Obaku: Zen Painting and Calligraphy.* Lawrence, KA, 1978.

Akiyama, Terukazu. *Japanese Painting.* Basel, 1961.

Andrews, Allan A. *The Teachings Essential for Rebirth: A Study of Genshin's Ōjō Yōshū.* Tokyo, 1973.

Anesaki, Masaharu. *Buddhist Art in Its Relation to Buddhist Ideals.* Boston, 1915.

Anesaki, Masaharu. *History of Japanese Religion.* London, 1963.

Aston, W. G., trans. *The Nihongi.* London, 1896.

Awakawa, Yasuichi. *Zen Painting.* Translated by John Bester. Tokyo, 1970.

de Bary, William Theodore, ed. *Sources of the Japanese Tradition.* New York, 1958.

de Bary, William Theodore, ed. *The Buddhist Tradition in India, China, and Japan.* New York, 1969.

Beal, Samuel. *Si-yu-ki: Buddhist Records of the Western World.* London, 1906.

Bhattacaryya, B. *An Introduction to Buddhist Esoterism.* London, 1932.

Brasch, Kurt. *Zenga (Zen Malerei).* Tokyo, 1961.

Cahill, James. *Chinese Painting.* Lausanne, 1960.

Chapin, Helen B. *A Long Roll of Buddhist Images.* Rev. Alexander C. Soper. Ascona, Switzerland, 1972.

Ch'en, Kenneth K. S. *Buddhism in China: A Historical Survey.* Princeton, NJ, 1964.

Ch'en, Kenneth K.S. *The Chinese Transformation of Buddhism.* Princeton, NJ, 1973.

Chou I-liang. "Tantrism in China," *Harvard Journal of Asiatic Studies,* 8 (1945): 241–332.

Coates, H. H., and R. Ishizuka. *Honen, the Buddhist Saint: His Life and Teaching.* Kyoto, 1925.

Conze, Edward. *Buddhism: Its Essence and Development.* Oxford, 1951; paperback edition New York, 1959.

Conze, Edward. *Buddhist Thought in India.* London, 1962.

Conze, Edward. *The Perfection of Wisdom in 8,000 Lines and Its Verse Summary.* Berkeley, 1973.

Conze, Edward, ed. *Buddhist Texts Through the Ages.* Oxford, 1954.

Coomaraswamy, A. K. *Elements of Buddhist Iconography.* Cambridge, 1935.

Dasgupta, S. B. *An Introduction to Tantric Buddhism.* Calcutta, 1950.

Davidson, J. Leroy. *The Lotus Sūtra in Chinese Art.* New Haven, CT, 1954.

Dumoulin, Heinrich, S. J. *The Development of Chinese Zen After the Sixth Patriarch in the Light of the Mumonkan.* New York, 1953.

Dumoulin, Heinrich, S. J. *A History of Zen Buddhism.* New York, 1963.

Dutt, Nalinaksha. *Aspects of Mahāyāna Buddhism.* London, 1930.

Earhart, H. Byron. *Japanese Religion: Unity and Diversity.* 2nd ed. Encino, CA, 1974.

Eliot, Sir Charles. *Japanese Buddhism.* London, 1935.

Elisséeff, Serge, and Matsushita Takaaki. *Japan: Ancient Buddhist Paintings.* UNESCO World Art Series vol. 2. Greenwich, CT., 1959.

Fontein, Jan, and Money L. Hickman. *Zen: Painting and Calligraphy.* Boston, 1970.

Fontein, Jan, and Pratapaditya Pal. *Museum of Fine Arts, Boston: Oriental Art.* New York, 1969.

Fontein, Jan, and Wu Tung. *Han and T'ang Murals.* Boston, 1976.

Fukuyama, Toshio. *Heian Temples: Byodo-in and Chuson-ji.* Translated by R. K. Jones. Heibonsha Survey of Japanese Art vol. 9. Tokyo, 1976.

Getty, Alice. *The Gods of Northern Buddhism.* Oxford, 1914, 2nd ed. 1928.

Govinda, Lama Anagarika. *Psycho-Cosmic Symbolism of the Buddhist Stūpa.* Emeryville, CA, 1976.

Granoff, Phyllis. "A Portable Buddhist Shrine from Central Asia," *Archives of Asian Art,* 22 (1968–1969).

Granoff, Phyllis. "Tobatsu Bishamon," *East and West,* n.s. vol. 20, nos. 1–2 (March–June 1970).

Gray, Basil and J. B. Vincent. *Buddhist Cave Paintings at Tun-huang.* Chicago, 1959.

Grousset, René. *In the Footsteps of the Buddha.* Paris, 1932.

van Gulik, R. H. *Hayagrīva.* Leiden, 1935.

Hakeda, Yoshito S. *Kūkai: Major Works Translated, with an Account of His Life and a Study of His Thought.* New York, 1972.

Hisamatsu, Shin'ichi. *Zen and the Fine Arts.* Translated by Gishin Tokiwa. Tokyo, 1971.

Ho Peng Yoke, trans. *The Astronomical Chapters of the Chin Shu.* Paris and The Hague, 1966.

Hurvitz, Leon, trans. *Scripture of the Lotus Blossom of the Fine Dharma (The Lotus Sūtra).* New York, 1976.

Kageyama, Haruki. *The Arts of Shinto.* Translated and adapted by Christine Guth. Arts of Japan vol. 4. Tokyo, 1973.

Kageyama, Haruki, and Christine Guth Kanda. *Shinto Arts: Nature, Gods, and Man in Japan.* New York, 1976.

Katō Bunnō et al., trans. *The Threefold Lotus Sutra.* Tokyo, 1975.

Keene, Donald. *Anthology of Japanese Literature.* New York, 1955.

Kern, H., trans. *Saddharma-Puṇḍarīka or the Lotus of the True Law.* Sacred Books of the East, ed. F. Max Müller, vol. 21. Oxford, 1909.

Kirfel, W. *Symbolik des Buddhismus.* Stuttgart, 1959.

Kitagawa, Joseph M. *Religion in Japanese History.* New York, 1966.

Kiyota Minoru. *Shingon Buddhism.* Los Angeles and Tokyo, 1977.

Lamotte, Étienne. *Le traité de la grande vertu de sagesse.* 2 vols. Louvain, 1949.

Lamotte, Étienne. *L'Enseignement de Vimalakīrti.* Louvain, 1962.

Loehr, Max. *Buddhist Thought and Imagery.* The Abby Aldrich Rockefeller Inaugural Lecture, Harvard University, February 24, 1961.

Matsunaga, Alicia. *The Buddhist Theory of Assimilation: The Historical Development of the Honji-Suijaku Theory.* Tokyo, 1969.

Matsushita, Takaaki. *Ink Painting.* Translated and adapted by Martin Collcutt. Arts of Japan vol. 7. Tokyo, 1974.

McCullough, Helen Craig. *The Taiheiki: A Chronicle of Medieval Japan.* New York, 1959.

Miura, Isshū, and Ruth Fuller Sasaki. *Zen Dust.* New York, 1960.

Morris, Ivan. *The World of the Shining Prince: Court Life in Ancient Japan.* New York, 1964.

Müller, F. Max, trans. and ed. *The Lārger Sukhāvativyūha, The Smaller Sukhāvatīvyūha, and the Amitāyurdhyāna Sūtra.* Sacred Books of the East, ed F. Max Müller, vol. 49. London, 1894.

Murase, Miyeko. *Japanese Art: Selections from the Mary and Jackson Burke Collection.* New York, 1975.

Museum für Ostasiatische Kunst, Staatliche Museen Preussischer Kulturbesitz, Berlin (ed), *Ausgewählte Werke Ostasiatischer Kunst.* Berlin-Dahlem, 1970.

Museum für Ostasiatische Kunst der Stadt Köln, ed. *Meisterwerke aus China, Korea und Japan.* Köln, 1977.

Naitō, Tōichirō. *The Wall Paintings of Hōryū-ji.* Ed. and trans. W. R. B. Acker and Benjamin Rowland, Jr. Baltimore, 1943.

Nakamura, Kyoko Motomichi, trans. and ed. *Miraculous Stories from the Japanese Buddhist Tradition: The Nihon Ryōiki of the Monk Kyōkai.* Cambridge, MA, 1973.

Noma, Seiroku. *The Arts of Japan, Ancient and Medieval.* Translated by J. M. Rosenfield. Tokyo, 1966.

Okazaki, Jōji. *Pure Land Buddhist Painting.* Translated and adapted by Elizabeth ten Grotenhuis. Japanese Arts Library vol. 4. Tokyo, 1977.

Okudaira, Hideo. *Narrative Picture Scrolls.* Adapted by Elizabeth ten Grotenhuis. Arts of Japan vol. 5. Tokyo, 1973.

Paine, Robert T. *Ten Japanese Paintings in the Boston Museum of Fine Arts.* New York, 1939.

Paine, Robert Treat, and Alexander Soper. *The Art and Architecture of Japan.* Pelican History of Art, rev. ed. New York, 1975.

Pelliot, Paul. *Les grottes de Touen-Houang* (Tun-huang). 6 portfolios of plates (text not published). Paris, 1920, 1921, 1924.

Reischauer, A. K. "Genshin's Ōjō Yōshū: Collected Essays on Birth into Paradise," *The Transactions of the Asiatic Society of Japan.* 2nd series, 7 (December 1930): 16–97.

Reischauer, Edwin O. *Ennin's Travels in T'ang China.* New York, 1955.

Reischauer, Edwin O., trans. *Ennin's Dairy.* New York, 1955.

Reischauer, Edwin O., and John K. Fairbank. *East Asia: The Great Tradition.* Boston, 1958.

Robinson, Richard. *Early Mādhyamika in India and China.* Madison, WI, 1967.

Rosenfield, John M. *Japanese Arts of the Heian Period.* New York, 1967.

Rosenfield, John M. "The Sedgwick Statue of the Infant Shōtoku Taishi," *Archives of Asian Art,* 22 (1968–1969).

Rosenfield, John M., Fumiko E. Cranston, and Edwin Cranston. *The Courtly Tradition in Japanese Art and Literature.* Cambridge, MA, 1973.

Rosenfield, John M., and Shūjirō Shimada. *Traditions of Japanese Art: Selections from the Kimiko and John Powers Collection.* Cambridge, MA, 1970.

Rowland, Benjamin, Jr. *The Ajanta Caves.* New York, 1963.

Rowland, Benjamin, Jr. *The Art and Architecture of India.* Pelican History of Art. Rev. ed. Harmondsworth, England, 1956.

Ruch, Barbara. "Medieval Jongleurs and the Making of a National Literature," in John Hall and Takeshi Toyoda, *Japan in the Muromachi Age.* Berkeley, 1977.

Sansom, G. B. *Japan: A Short Cultural History.* Rev. ed. New York, 1943.

Sansom, G. B. *A History of Japan.* 3 vols. Stanford, 1958–1963.

Saunders, E. Dale. *Mudrā. A Study of Symbolic Gestures in Japanese Buddhist Sculpture.* New York, 1960.

Sawa, Takaaki. *Art in Japanese Esoteric Buddhism.* Translated by R. L. Gage. Heibonsha Survey of Japanese Art vol. 8. Tokyo, 1972.

Seckel, Dietrich. *Grundzüge der buddhistischen Malerei.* Tokyo, 1945.

Seckel, Dietrich. "Das Gold in der japanischen Kunst," *Asiatische Studien/Études Asiatiques,* 12 (1959).

Seckel, Dietrich. *The Art of Buddhism.* New York, 1964.

Seidensticker, Edward, G., trans. *The Tale of Genji.* New York, 1976.

Shimizu, Yoshiaki, and Carolyn Wheelwright, eds. *Japanese Ink Paintings from American Collections: The Muromachi Period.* Princeton, NJ, 1976.

Sickman, Laurence, and Alexander Soper. *The Art and Architecture of China.* Pelican History of Art. Harmondsworth, England, 1956.

Sirén, Osvald. *Chinese Painting: Leading Principles and Masters.* 7 vols. London, 1956, 1958.

Soper, Alexander C. *Literary Evidence for Early Buddhist Art in China.* Ascona, Switzerland, 1959.

Sorimachi, Shigeo. *Catalogue of Japanese Illustrated Books and Manuscripts in the Spencer Collection of the New York Public Library.* Tokyo, 1978.

Speiser, Werner. *Die Kunst Ostasiens.* Berlin, 1956.

Stein, Sir Aurel. *The Thousand Buddhas. Ancient Buddhist Paintings from . . . Tunhuang* Text and portfolio. London, 1921.

Suzuki, D. T. *An Introduction to Zen Buddhism.* Kyoto, 1934.

Suzuki, D. T. *Zen Buddhism and Its Influence on Japanese Culture.* Kyoto, 1938.

Suzuki, D. T. *Zen and Japanese Culture.* New York, 1959.

Tajima, Ryūjun. *Les deux grands mandalas et la doctrine de l'ésotérisme shingon.* Paris and Tokyo, 1959.

Tanaka, Ichimatsu. *Japanese Ink Painting: Shūbun to Sesshū.* Translated by Bruce Darling. Heibonsha Survey of Japanese Art vol. 12. Tokyo, 1972.

Thomas. E. J. *The Life of Buddha as Legend and History.* 2nd ed. London, 1930.

Thomas, E. J. *The History of Buddhist Thought.* London, 1933.

Thurman, Robert A. F. *The Holy Teaching of Vimalakīrti.* University Park, PA, 1976.

Toda, Kenji. *Japanese Scroll Painting.* Chicago, 1935.

Tokyo National Museum. *The Pageant of Japanese Art.* 6 vols. Tokyo, 1952–1954.

Trubner, Henry, et al. *Asiatic Art in the Seattle Art Museum.* Seattle, 1973.

Tucci, Giuseppe. "Buddhist Notes: à propos Avalokiteśvara," *Mélanges Chinois et Bouddhiques,* 9 (1948–1949).

Tucci, Giuseppe. *Tibetan Painted Scrolls.* 3 vols. Rome, 1949.

Tucci, Giuseppe. *The Theory and Practice of the Mandala.* London, 1961.

Van Briessen, Fritz. *The Way of the Brush.* Tokyo, 1962.

de Visser, M. W. *The Bodhisattva Ti-tsang (Jizō) in China and Japan.* Berlin, 1914.

de Visser, M. W. *The Arhats in China and Japan.* Berlin, 1923.

de Visser, M. W. *Ancient Buddhism in Japan.* 2 vols. Leiden, 1935.

Waley, Arthur. *The Tale of Genji.* New York, 1960.

Warner, Langdon. *The Enduring Art of Japan.* New York, 1952.

Warren, Henry Clarke, trans. *Buddhism in Translations: Passages Selected from the Buddhist Sacred Books.* Cambridge, MA, 1896, 10th issue, 1953.

Watanabe, Shoko. *Japanese Buddhism.* Rev. ed. Tokyo, 1968.

Wayman, Alex and Hideko Wayman. *The Lion's Roar of Queen Śrīmālā.* New York, 1974.

White, William Charles. *Chinese Temple Frescoes.* Toronto, 1940.

Wright, Arthur F. *Buddhism in Chinese History.* Stanford, 1959.

Yampolsky, Philip. *The Zen Master Hakuin: Selected Writings.* New York, 1971.

Yazdani, Ghulam. *Ajantā.* 8 vols. Oxford, 1930–1955.

Edited by Katharine O. Parker
Design by Dana Levy
Composition by LCR Graphics
Printed by Eastern Press, Inc.

Photographs: 9, 11, 13, 19, 26, 27, 42, 56 by Otto E. Nelson;
14, 30, 31, 36 by Barry Donahue; 2 by Rheinisches Bildarchiv,
Köln; 3 by Sakamoto Photo Lab, Tokyo; 3 (color) by Dana
Levy; 57 by Roy Trahan. All color transparencies and all
other black and white photographs by courtesy of the lenders.